DESIRE
CHANGE

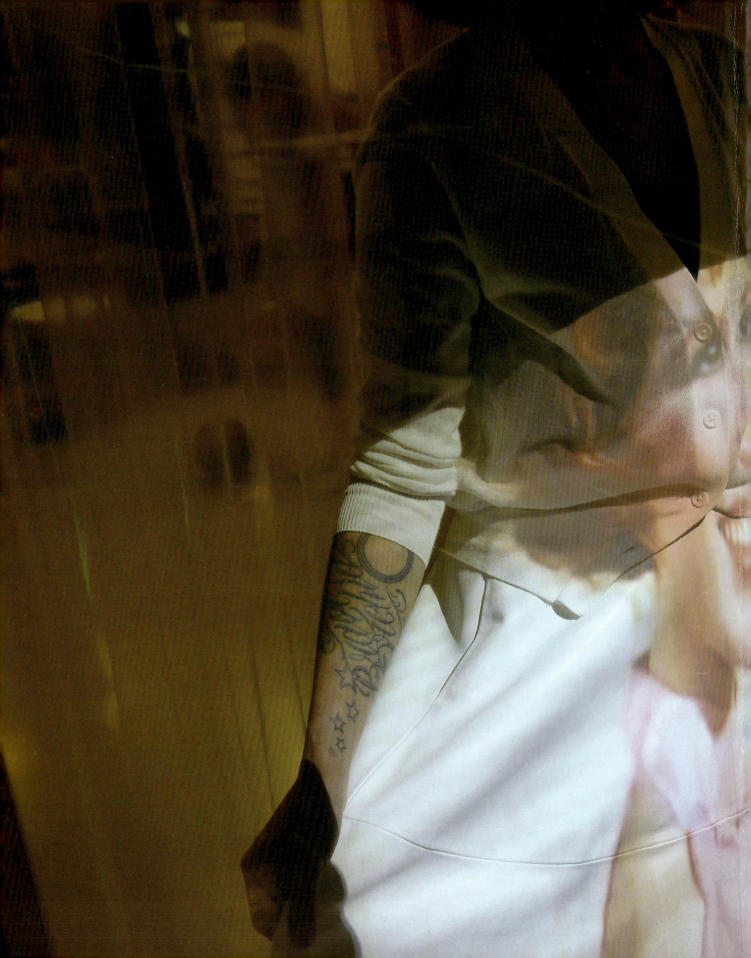

DESIRE
CHANGE

Contemporary Feminist Art in Canada

Edited by Heather Davis

McGill-Queen's University Press
Montreal & Kingston | London | Chicago

and

Mentoring Artists for Women's Art
Winnipeg

ISBN 978-0-7735-4937-1 (cloth)
ISBN 978-0-7735-5077-3 (ePDF)

Legal deposit second quarter 2017
Bibliothèque nationale du Québec

Printed in Canada on acid-free paper

This book has been published with the support of the Art Books
Program of the Canada Council, funded by the Writing and Publishing
and Visual Arts Sections.

McGill-Queen's University Press acknowledges the support of the
Canada Council for the Arts for our publishing program. We also
acknowledge the financial support of the Government of Canada
through the Canada Book Fund for our publishing activities.

Library and Archives Canada Cataloguing in Publication

Desire change : contemporary feminist art in Canada / edited by
Heather Davis.

Includes bibliographical references and index.
Issued in print and electronic formats.
ISBN 978-0-7735-4937-1 (hardcover).
ISBN 978-0-7735-5077-3 (ePDF)

1. Feminism and art — Canada. 2. Feminism in art. 3. Women in
art. 4. Women artists — Canada. 5. Art — Canada — History.
6. Feminist art criticism — Canada. I. Davis, Heather, 1979— , editor II.
Mentoring Artists for Women's Art, issuing body

N72.F45D47 2017 700'.45220971 C2017-900944-3
 C2017-900945-1

Contents

Acknowledgments

This book was made possible through the incredible vision and fundraising efforts of Shawna Dempsey, Dana Kletke, and the rest of the MAWA team. If only everyone could work with such wonderfully generous and thoughtful people with a deep commitment to feminist labour politics – the world would definitely be a better place! Their combination of engagement, trust, and willingness to change as the project grew made the inevitable difficulties of putting together a book feel so much easier. It has been a huge honour and pleasure to work with Shawna and Dana. I am also immensely grateful to managing editor Nicole Burisch, whose deep knowledge of feminist art in Canada made this book much richer. Her intelligence, kindness, guidance, Excel spreadsheets, and friendship have made all the difference in the quality of this book. I would like to thank each of the authors who contributed their vision, time, and talents to make this book as excellent as it is. It has been wonderful working with each of you. I am grateful also to the team of people at MQUP for realizing this project with such detailed and professional eyes.

I would also like to thank Michael Nardone for ongoing conversations, references, and his unending patience, support, and encouragement throughout this project. My parents, bringing up three girls, trained us from a young age to be critical thinkers and to become feminists. I am immensely grateful for their love and support, and for the friendship, honesty, and wisdom of my sisters Alison and Marcy. Alison inspires me with her rich sense of feminist ethics in art practice in her daily life, and Marcy's compassion and kindness has always been an immense source of comfort. This book is dedicated to Natasha Jategaonkar, whose deep friendship taught me about intersectional feminism before I knew those words.

HEATHER DAVIS

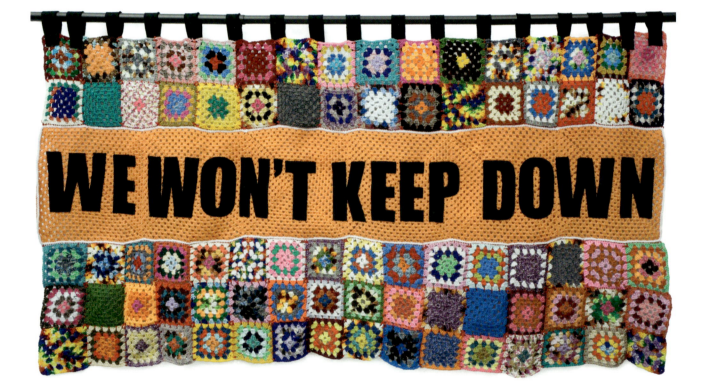

Looking back, I would say that when we formed Plug In's "women's committee" (as it was called back then), we certainly had no idea that it would turn into the kind of organization that it is today. We had no sense of how long this project would even last ... It was really an open-ended exploration or process; it wasn't as though we had a precise idea of where it would go or what exactly would happen – I would say more than anything our approach was pragmatic.

Diane Whitehouse, Founding Foremother, "Founding MAWA"

Mentoring Artists for Women's Art (MAWA) has always existed within two realms: that which is and that which we imagine.

On the one hand, the focus of the organization has been extremely practical, in keeping with a lineage of prairie cooperative movements: What needs to be done and how do we achieve it together? At its inception in 1984, the women and men of MAWA recognized that gender inequality in the visual arts was rampant, blatant, and normalized. And they knew this could be changed. Armed with little more than an ad hoc committee and an idea – mentorship – they created the framework for an alternative learning centre dedicated to equal opportunity for all people, recognizing that gender justice is central to this mission.

Many of MAWA's groundbreaking innovations, such as the year-long Foundation Mentorship Program (see Noni Brynjolson's contribution in this volume), were conceived of as tools for change: if we share skills and information, no one will be isolated, marginalized, sidelined, or forced to reinvent the wheel within the privileged and opaque art world. The problem was named: systemic sexism. MAWA programming offered and continues to offer a solution.

This is the spirit that led to the book in your hands. Shockingly, there has never been a book about the diversity of feminist visual art in Canada nor theoretical reflections on the breadth of Canadian feminist art practices. We need such a book! So MAWA has worked to create one, to begin this conversation.

The transformative artworks of many women and feminists, past and present, have not been adequately documented. The affects of these works, the conversations they have inspired, and the shifts they have created have been left untended, too often ignored or sidelined. Feminist art remains marginalized, despite the advances of the past thirty years. So it is telling that the task of beginning to redress these canonical omissions fell to MAWA, a small artist-run centre in Winnipeg. We are neither a university

nor a regional gallery: we are artists. And yet who better to begin to document feminist history and practices than a grassroots organization of and for women makers that has *always* asked what needs to be done and how do we achieve it together?

Many MAWA champions have come together to realize *Desire Change*. This project would not have been possible without the generosity of the Winnipeg Foundation, which provided seed money and production funds. Many individual "art godmothers" sponsored chapters: Lilian Bonin, Patricia Bovey, Helene Dyck, Bill and Shirley Loewen, Bill Miller, Mireille Perron, Terry Vatrt, the "Agony Aunts," Marcia Knight, and an anonymous donor in honour of Susan Glass. Countless others have contributed funds so that artists could be paid for use of their images. The MAWA community rolled up her collective sleeves, and got 'er done. The problem was named: exclusion from art history in Canada; MAWA offers this volume on contemporary art as the beginning to a solution. A practical solution. We hope that it is useful and inspiring to you.

The other terrain that MAWA inhabits is that of the imagination. We ask more than, what's wrong? We ask, who would we like to become? Editor Heather Davis, managing editor Nicole Burisch, and each of the writers have provided us with fodder for this brave questioning. We want the instability and possibility of desire. We want the instability and possibility of change. Within this frightening space of uncertainty, each of us creates. Art is always born of the terrifying unknown.

And MAWA itself continues forward, with one foot grounded in the commitment, political analysis, and hard work of those who came before and one foot in the air. As an organization, as a space, and as an idea, MAWA continues to evolve based on the needs and interests of our community. Who we have been is no longer who we are. And who we will be is up for grabs. It is a matter of collective imagining and collective hard work. Patriarchy and inequality of all kinds continue to limit us, but at the same time we discover new, fierce, and creative ways to circumvent and even (at times) defeat it. We do so with our artistic practices and our activism. We do it together.

We know we can change the world because we have changed the world. As we look to the history and contemporaneity of feminist art in Canada, let us also dream a better future.

Dana Kletke and Shawna Dempsey, Co-Executive Directors of MAWA

BIBLIOGRAPHY

Whitehouse, Diane. "Founding MAWA." In *MAWA: Culture of Community*, edited by Vera Lemecha. Winnipeg: Mentoring Artists for Women's Art, 2004.

DESIRE
CHANGE

Introduction

Heather Davis

Desire is complex and complicated. It is constantly reformulating, and does so by extinguishing itself, breaking apart, reconfiguring, recasting. Desire licks its own fingers, bites its own nails, swallows its own fist. Desire makes itself its own ghost, creates itself from its own remnants. Desire, in its making and remaking, bounds into the past as it stretches into the future. It is productive, it makes itself, and in making itself, it makes reality.

Eve Tuck and C. Ree, "A Glossary of Haunting"

[Feminism] often elicits more questions than answers and, although the impact of feminist thought and action are now a part of everyday life, the hard-won struggles on issues of representation and empowerment are increasingly normalized or deliberately unrecognized. The idea of feminism as an ongoing movement rather than something that took place during a fixed point in time (often cited as ending in the early 1980s) is frequently lost.

Alissa Firth-Eagland and Candice Hopkins, Introduction to *The F Word*

Desire Change is part of an ongoing movement of artists, curators, art critics, writers, art historians, and cultural organizers who have been working "under the influence of feminism."[1] It is birthed not simply from those who directly contributed – the labours of the artists, curators, writers, and thinkers that follow in these pages and those who compose Mentoring Artists for Women's Art (MAWA) – but from everyone who belongs to the long lineage fighting against patriarchy and phallocentrism in the arts and beyond, and to those who will come. Although this book takes contemporary art as its explicit focus – that is, art made in the past twenty-five years – this is not done to eschew or elide the work that has gone before. Rather, as Jayne Wark expresses in this volume, this book rides on the current cusp of "feminism's generational waves," with the previous ones still reverberating, pushing us forward. It is done with a sense that "the new does not cancel out the old; it would show us that the new is not a form of triumph but a recalibration of alliances."[2] It is this immense collective effort that subtends feminist action and art. Feminist art here is not meant as a style – the range within these pages is too great to be neatly contained – but is, rather, a political stance. What is found within this book speaks to the breadth and depth of feminist communities and movements, their vital conversations and organizations and practices. For feminism and feminist art have always been firmly rooted in an activist agenda that

centres on the desire for social change. And as has been shown throughout the history of feminist art, thought, and action, that feminism is not merely about creating a "level playing field" (which still has yet to happen), but is about fundamentally transforming the ways in which we understand notions of gender, sexuality, and social organization. In this, the work of feminism has always been both critical – providing insightful analysis and critiques of patriarchy and other systems of oppression – and also creative.[3] In the resistance to the violence of gender-based oppression, vibrant worlds have emerged, full of nuance and humour and beauty. It is this dual feminist project of critique and creativity to which this book responds.

Historiography, even contemporary historiography, is tricky business, and is subject both to institutional limitations, personal preferences, as well as the fallibility of memory. This process is particularly acute when writing a historiography of feminist art, as many artists struggle to maintain practices without adequate structural support, and many art centres and collectives simply do not have the time and resources to properly document the work they are doing. As Lisa Steele writes in her discussion of women's video art production in Canada, "Remembering became an act of survival: remembering our own lives, our mothers' lives, our neighbourhoods, our jobs, the lives of others we knew. Remembering before it disappeared. No one else was talking about it: we had to. History is produced by whomever writes it down first. History should never be mistaken for truth."[4] As such, this book wants to assert the vitality of contemporary Canadian feminist art while acknowledging that there is still much work to be done in providing adequate and plural feminist art histories. That said, there are a number of constraints in this book: there is a bias toward western, central, and southern art in Canada, which, although not deliberate, nonetheless remains; an orientation that works from the present moment to take stock and to chart future orientations and paths; a volume that is by and for artists, curators, critics, and other cultural workers as well as art historians and other academics.

There have been many valuable precursors that this project implicitly draws on, especially books that have come out of feminist art institutions, including artist-run centres. It is telling that so much of the work of feminist art historiography in Canada has been as a result of those working on the ground, with few resources. Important Canadian feminist art historical texts such as *Locations: Feminism, Art, Racism, Region: Writings and Art Works* (1989), *Instabili: La question du sujet / The Question of the Subject* (1990), and MAWA: *Culture of Community* (2004) were published by the Women's Art Resource Centre (WARC), La Centrale Galerie Powerhouse, and MAWA, respectively. These publications highlight the necessity of feminist institution building and the need to continue to pressure more established institutions to take on feminist concerns. Women's Press – another explicitly feminist organization – published *Work in Progress: Building Feminist Culture* (1987), which examines the links between feminism and art practice in the 1980s with contributions from video art, literary arts, and the theoretical foundations of feminism in Canada. There have also been collections that detail the works and practices of feminist performance artists, providing valuable context and depth, such as *Caught in the Act: An Anthology of Performance Art by*

Canadian Women, edited by Tanya Mars and Johanna Householder (2004), which includes numerous artist profiles from the 1970s and 1980s (as well as a second edition published in 2016). Jayne Wark's *Radical Gestures: Feminism and Performance Art in North America* (2006) traces the theoretical and organizational links of these practices, showing how performance art emerges from feminist politics and organizing in Canada and the United States, to the extent that they are now inextricably linked. *Rethinking Professionalism: Women and Art in Canada 1850–1970* (2012), edited by Kristina Huneault and Janice Anderson, examines the ways in which the professionalization of art shaped women's inclusion. *Other Conundrums: Race, Culture and Canadian Art* (2000), and *Representing the Black Female Subject in Western Art* (2010) each take up the intersections of race, feminism, and art in a historical context.[5] Until now, however, there has been no book that seeks to account for contemporary feminist art in Canada. This book is long overdue and responds to the call that the resurgence of feminist thought and practice in the last decade demands. It asks, who are we now and who would we like to become?

Although the book is explicitly contemporary, it is framed by two pieces that link current feminist art to its precursors. Kristina Huneault and Janice Anderson's essay at the beginning of this volume traces the rise of feminist art practice, from the 1960s and 1970s, to give some sense of its historical roots and the continuities with contemporary practice. At the end of the essays, Gina Badger has compiled an extensive timeline of events important to feminist art in Canada, by soliciting responses from over fifty feminist artists and cultural workers. The timeline shows the ways in which previous efforts have been influential to artists working today. This feminist chronology will serve as a valuable resource for those who are interested in investigating feminist art history in Canada in more depth, and importantly frames this history within the context of concurrent political movements. These two pieces provide a reminder that everything that emerges from the pages within is linked to these broader histories, movements, collectives, and individuals.

There is a recursivity to the production of feminist art, which cannot be detached from its historiography. This is what Huneault and Anderson address in their historical overview, "A Past as Rich as Our Futures Allow: A Genealogy of Feminist Art in Canada." They begin by asking, how did we arrive at this particular feminist moment? Arguing that, "since its beginnings in the 1970s, much of the effort of feminist artists has been directed towards breaking down rigid categorizations, essential identities, and restrictive limitations."[6] They build upon Joan Scott's and Drucilla Cornell's argument that feminist history takes place in the future anterior, that is not to account for *what was*, but what *will be seen to have been*.[7] This understanding of feminist history is one in which the future is constantly drawing from and remaking the multiple possibilities and lineages of the past. Importantly, they also insist that the characterization of second-wave feminism as essentialist reduces the complexity of what was actually happening at the time. They refuse an understanding of time as necessarily linear and teleological, instead positing history as the construction of the conditions of possibility for conceivable futures, where much of the complexity of gendered identity

was already being worked through decades ago.[8] This approach to feminist art writing has also been a part of theorizing feminist performance art. As Peggy Phelan writes, "'Remember the future,' [Orlan] proclaimed. That paradoxical pronouncement helps illuminate the promise of feminist performance: to bring about a future that remembers, without repeating, the history of sexism and all the other annihilating 'isms' that came to light with and because of feminism."[9] Although it would be a leap to attribute feminism as solely responsible for bringing to light racism, ableism, classism, and so on, its artistic and theoretical productions are central to a project of social justice. Further, there is something even more radical in the ways in which feminist historiography conceives of time than Phelan articulates. Instead of merely bringing about a future that remembers, as central as this may be to creating a different kind of world, a feminist project would seem to be creating the past as it draws from the future to instantiate itself in the present. In other words, in the excessive desires of creating a new world, we are pulling the potentials of a future that has not yet come to be, just as the past itself then becomes a resource for re-creating a vision of the present. This is not always a joyful project. Indeed, as Eve Tuck and C. Ree remind us, to grapple with a history that is fraught with injustice means that there "are specters that collapse time, rendering empire's foundational past impossible to erase from the national present."[10] The tormented ghosts will never leave us, and never leave us alone; nor should they, for the brutality of the past continues to inform so much of our present moment. We need to find a way to live with these spectres. Many of the artworks presented in this volume do just that, finding the possibilities of creative reconstruction out of this haunting.

On Desire

If the desire of feminism is for a future that is different from the world that we currently inhabit, the desire of the feminist historian is to enable other futures to be imagined. This is also the task of feminist art. This is a book framed by such a desire. It is a desire for social change, for the creation of spaces not dictated by patriarchy so that our imaginations will have more freedom to move. Desire pushes us beyond our boundaries. It breaks us apart. It dissolves the divisions between the self and the world, recognizing the permeability of the skin, the porousness and morphability of our bodies. Desire, as feminist artist and theorist Mary Kelly asserts, "is caused not by objects, but in the unconscious, according to the peculiar structure of fantasy. Desire is repetitious; it resists normalization, ignores biology, disperses the body."[11] It refuses containment. Desire cannot be pinned down. It has no location. It flees. It provides an opening and through the force of itself causes that opening to appear. Desire is a form of resistance. It is a way to push against damaging narratives and the narratives of damage that get continually retold about marginalized communities. Desire provides a way not just to resist but to insist: to insist on other realities and other movements, to insist on the strength of one's own power and the power of feminist communities. Desire is what propels, what insists on the possibilities of new kinds of worlds.

Feminism itself is multiple, riotous, expansive and refuses the boundaries and borders that women's bodies themselves were often said to undo. Yet, as Ella Shohat has argued, "most feminisms share the critique of masculinist ideologies and the desire to undo patriarchal power regimes."[12] As feminist art historian Kristine Stiles has written, "Feminists do, can, and must disagree. This is the only objective I hold 'essential' to the health of feminism."[13] In fact, some of the authors, such as Amy Fung and Gina Badger, take up the complex formation of feminism itself and its continued association with middle-class, white, cisgendered women.[14] There is no feminism as such, but rather feminisms that exist in the plural and that are constantly changing.

Indeed, feminism cannot proceed without the necessary self-reflexivity that is, as Monika Kin Gagnon argues, its greatest strength. She writes, "This tendency towards introspection and propensity for self-analysis in feminism can be seen as both its strongest and its most significant characteristic."[15] I would argue that the arts, and particularly the artists taken up within the pages that follow, are especially adept at this kind of critical self-reflection, reflecting back a complex and nuanced understanding of the interrelations between patriarchy, heteronormativity, racism, and colonialism. It is due to this self-reflexivity that feminism cannot hold too strongly to either a fixed notion of the gendered position of what a "woman" may be, especially in light of trans and genderqueer movements, and the insistence, from within feminist thought that a binary conception of gender is inadequate to our biological and social realities.[16] The importance of what is referred to as *third-wave feminism* comes from the hard work of racialized women who were excluded from the category of Woman to begin with, as well as from trans and gender non-conforming people who insisted that gender equality always means more than two.[17] An understanding of the inherently interconnected positions of gender, race, sexual orientation, and ability is central to the feminist project that this book articulates.[18] As embodied subjects, we cannot easily disentangle these formations; nor do they exist outside of the myriad and contradictory contexts that we find ourselves within. This is a position that is especially important within feminist art practice. It is impossible to understand any project of gender justice without understanding how our gendered bodies are already racialized, hierarchicalized, and valued according to normative formations of beauty, productivity, and identification.

Feminism is here understood as the dismantling of positions of power: "Any attempt to define the exhaustive and systematic limits [of feminist thought] would be a futile endeavour; the very foundations of feminism seek to deconstruct the notion of a master concept and its restrictive domination of discourse."[19] The lessons of a feminist politics of location – which says everyone's understanding of the world comes through their embodiment, as racialized, gendered, classed subjects – and other feminist self-reflexive practices provide concrete strategies for resisting domination.[20] There is no neutral position in the world. Nor is pure objectivity possible. Instead, we engage from multiple, entangled, historically situated, and contextually embodied positions. Acknowledging these positions, especially for those who are more privileged, is deeply important to addressing historical injustice and to providing creative and critical responses that work to undermine unquestioned authority.

What was most incredible for me, when I started this project, was the vast amount of people making feminist art and writing about feminism in Canada. Because of the obvious constraints of budget, time, and space, not all of these voices can be contained here. It is my sincere hope that this volume represents a starting place for numerous books to come, and for ongoing curiosity from readers about the talents of feminist artists. Summarizing this diversity has not been easy, but the essays collected here are organized around three dominant streams that I see as most important to contemporary feminist art in Canada. These include (1) how feminist art has significantly contributed to the complex understanding of gender as it intersects with sexuality and race; (2) the necessity of thinking through patriarchy in relation to colonization within the Canadian nation-state; and (3) the importance of institutional critique to feminism, feminist art, and feminist art history and the ways in which this form is expressed today. In between each of the sections in this book, I provide iterative and ongoing propositions for twenty-first-century feminism in Canada. These are not meant to be definitive pronouncements but are, rather, provocations that tie together the important insights of the authors in this volume, while giving readers a general sense of the stakes of contemporary feminist art.

Desire: Intersections of Sexuality, Gender, Race

This section takes on the central aims of feminism through examinations of art practices that question assigned gender roles, heteronormativity, race, and embodied forms of desire. In these texts, visual art practices are revealed to be a central place to work through the entangled relations of sexual difference and desire. Two of the essays here deal with queer and lesbian art practices, one with the intersections of race, desire, and gender, and the fourth addresses the myriad ways in which desire operates outside of the male gaze. Queer politics emerged in response to the growing normalization of mainstream lesbian and gay identities, and sought to be more inclusive to a diversity of genders and sexual roles beyond a sex binary. Queerness then can be thought as a refusal of the categories of sexual normalization, ones that were always difficult to contain as Thérèse St-Gelais shows, even within a presumed heterosexual milieu. The rich visual vocabulary, and the ability of art to contain contradictory positions with nuance, can become a mode to dis-identify from enforced gender, sex, and sexuality. As feminist philosopher Rosi Braidotti writes, "Feminist politics, framed by consciousness-raising and fueled by the politics of location (Rich 1986), entails the repositioning of the subject. The method or tactic is the dis-identification from socially enforced identities, familiar representations, and, often, unearned privilege."[21] In working through these processes of dis-identification and modes of self-identification, the visual arts have a rich tradition of grappling with these complexities. The essays in this section draw on this vocabulary to articulate the multiple, diverse desires and identifications of feminist positions that can never be wholly contained or captured.

Karin Cope addresses questions of desire from a decidedly queer perspective in her essay, "'They Aren't a Boy or a Girl, They Are Mysterious': Finding Possible Futures

in *Loving Animals and Aliens*." She questions the limits of the body, asking readers to consider the ways in which we are always composed of more-than-humans in her examination of works that take animals and aliens as central to a queer project of futurity. Genderqueer artists, such as Coral Short and Alvis Parsley (Alvis Choi), ask us to reconsider our relationships not just to concepts of gender, but to the world beyond the human. Opening up to other-than-human queerness, such as celebrating the beauty of genderless jellyfish or the creation of a friendly alien character who prefers the pronoun "it," can provide avenues to question the presumed naturalization of binary sexual beings. Cope also takes up Emily Vey Duke and Cooper Battersby's *Lesser Apes* (2011), which tells the story of a lesbian couple composed of a bonobo and a human. The video, in Cope's astute reading, reveals some troubling things about the limits and violences of human beings. Queerness, in Cope's articulation, becomes a mode of trans-species empathy and openness that simultaneously questions the boundedness of the self.

Alice Ming Wai Jim discusses the work of two Montreal-based artists, Cheryl Sim and Mary Sui Yee Wong, who both use clothing and textiles to discuss issues of gender, race, and racism in "Fashioning Race, Gender, and Desire: Cheryl Sim's *Fitting Room* and Mary Sui Yee Wong's *Yellow Apparel*." In her discussion of Sim's *Fitting Room*, Jim traces a fascinating history of the *cheong sam*, the iconic Chinese dress that reveals a complicated construction of an idealized Chinese femininity. *Yellow Apparel* is discussed as an intervention in the context of *Encuentro: Manifesta* (2014), a performance art conference hosted by Concordia University in Montreal in collaboration with the Hemispheric Institute of Performance and Politics. In response to a theatrical performance that used yellow face to portray a Japanese character, *Yellow Apparel* – a fashion line developed through the use of racist stereotypes printed on fabric – was used as a moment of intervention to highlight the long history of racism against people of East Asian descent within North America. Jim reveals the complex entwinements of gender, race, and desire through the use of fashion within contemporary art.

In "Queering Abjection: A Lesbian, Feminist, and Canadian Perspective," Jayne Wark reevaluates the potential of the concept of abjection through Julia Kristeva's writings and in light of lesbian, feminist Canadian artists. Through humour and risk, Rosalie Favell, Allyson Mitchell, and the team of Shawna Dempsey and Lorri Millan each take up the abject, as what "disturbs identity, system [and] order."[22] This more radical understanding of abjection, one that is tied to social movements and particularly to the articulation of lesbianism in the public eye, asserts a reappraisal of the term distinct from how it was used in the *Abject Art* show at the Whitney in 1993, aligning it more closely with a politics of social justice.

In "The Appearance of Desire," Thérèse St-Gelais examines how artists from Quebec represent desire through painting, performance, and video. Taking up the work of Olivia Boudreau, Christine Major, Myriam Jacob-Allard, and Les Fermières Obsédées, St-Gelais charts the choppy waters of female desire, and the desiring gaze. In each of these works, our expectations about how female desire operates, and for whom, are

challenged. Ranging from works that outwardly contest normative structures of femininity, such as the performances of Les Fermières Obsédées, to the subtle examination of stereotypes of the maternal figure in the work of Myriam Jacob-Allard, St-Gelais shows how desire can never be fulfilled. The male gaze is constantly thwarted in these complex examinations of the multiple workings of the body through desire.

Desiring Change: Decolonization

In the context of contemporary Canada – the geographical delimitation of both the essays and artworks presented here – one of the necessities for feminist thought is to address ongoing colonialism and cultural genocide of Indigenous peoples. It is imperative, if one wants to frame a collective identity through the appeal to a nation-state, to address the settler colonialism that is at its heart. The dissolution of women's power was and remains among the primary forces of colonialism. For it is within and through patriarchy that colonialism operates: "It is well documented that the disempowerment of our ancestral Native women within their cultural nations was among the first goals of European colonizers eager to weaken and destabilize indigenous societies," writes M.A. Jaimes Guerrero.[23] The ongoing processes of genocide and its collusion with patriarchy are readily apparent in the infuriating and heartbreaking numbers of missing and murdered Indigenous women and the relative inaction of governmental and police response.[24] It is obvious that within this state of "trickle-down patriarchy," as Guerrero calls it, the effects of colonization are particularly harmful for women and trans people. This is clearly not simply an issue for Indigenous peoples, nor is it only something to be addressed solely by white settlers (even if this is the group that bears responsibility). The formation of colonial Canada has shaped all of us that live within its borders. The same colonial logic that wages cultural genocide on Indigenous peoples is that which also polices the borders of this stolen land from immigrants, that manifested in a "whites only" immigration policy until 1967,[25] and that historically relied upon indentured labourers and slaves from Asia and Africa.[26] Three of the essays in this section deal with the consequences of colonial patriarchy and assert Indigenous modes of resurgence and vitality. I also include here Sheila Petty's essay on Camille Turner because postcoloniality needs to be understood in dialogue with the ongoing project of settler colonialism in Canada. Postcolonialism emerges from different historical and geographical concerns, generally examining questions of diasporic cultures and nation-states that have gained autonomy from colonial rule, but the theoretical project of postcolonialism that asserts hybridization and an analysis of power under ongoing white supremacy are useful for both feminism and projects of decolonization.

As Maile Arvin, Eve Tuck, and Angie Morrill write, feminism cannot be reduced to whiteness, as this unnecessarily re-privileges whiteness at the centre: "We argue that allying one's self with feminism should not require consenting to inclusion within a larger agenda of whiteness; indeed, we believe that Native feminist theories demonstrate that feminisms, when allied with other key causes, hold a unique potential to

decolonize the ascendancy of whiteness in many global contexts."[27] The ReMatriate Collective, a collective of Indigenous women from numerous cultural and professional backgrounds, has been at the forefront of the struggle for Indigenous womyn's self-representation. They call for new language that responds to and with feminist projects but that moves into an Indigenous frame of self-love.[28] As Jeneen Frei Njootli, one of the collective's founding members, writes,

> We require new language to articulate the diverse needs and politics of Indigenous women and we do not have a convenient pan-politic. This is why putting a race before the word isn't enough. Instead of Indigenous feminism, I propose we rematriate our sets of relationships to each other, to ourselves and the land. The word that most are familiar with, repatriate, means to return home. While the action the word holds is profoundly necessary for conciliation, the term repatriation itself is damaging as it embodies a patriarchal, colonial concept of and relationship to the fatherland. This word, rematriate, came to me while conversing with a group of Indigenous women. We gathered in outrage at the continued misrepresentations, and appropriations of our cultures for profit. We were looking for a name to call ourselves.[29]

It is the desire to decolonize the ascendancy of whiteness through feminist practice, while articulating self-representation and self-governance, that the essays in this section respond to.

The section starts with Ellyn Walker's essay, "Resistance as Resilience in the Work of Rebecca Belmore." Rebecca Belmore's work speaks directly to a decolonial feminist politics. Spanning thirty years and a range of media, her work is breathtaking, poignant, nuanced, and vital. Her critiques are biting, polemics that bring tears, gut-wrenching performances that cannot but induce a visceral response. Belmore embodies the continued struggle against brutal oppression that is felt not in the abstract, but in the concrete violences of everyday life for women who were left to die by a colonial system that sought only their erasure. Walker describes three of Belmore's performances – *Fountain, Ayum-ee-aawach Oomama-mowan: Speaking to Their Mother*, and *One thousand One hundred & eighty One* – showing the ways that each of these works embody and transmit the effects of colonialism while actively resisting this oppression. Walker concludes the essay with a brief analysis of younger generations of Indigenous feminist artists who work within the legacy that Belmore has created, an ongoing project of active resistance and resurgence in the face of colonization.

"Desirous Kinds of Indigenous Futurity: On the Possibilities of Memorialization" critically engages with reconciliation in the aftermath of residential schools, while recognizing that there is no prior conciliation to return to. Tanya Lukin Linklater argues for the necessity of decolonization, poignantly engaging with residential schools and their survivors through writing about her encounters with the works of filmmaker Lisa Jackson, artist Peter Morin, and the collaborative artistic team of Peter Morin, Ayumi Goto, and Leah Decter. Refusing the colonial epistemology of a will

to discover, to know, or to possess, Lukin Linklater evokes the movements of the works that she takes up, as embodied and embodying experiences of a feminist Indigenous project. The piece ends with a written text by Decter, Goto, and Morin as a reflection on their year-long work *Performing Canada*, a series of performances that began to enact a radical reconciliation in the wake of the residential schools.

In "'All That Is Canadian': Identity and Belonging in the Video and Performance Artwork of Camille Turner," Sheila Petty also deconstructs the Canadian nation-state as she engages with Turner's humorous, performative critique of the place of blackness in Canada. Drawing on the imagery of the beauty queen and, in another piece, Afrofuturism, Turner suggests another kind of place, for the welcome and reception of people who continue to be alien within Canada. As Petty asserts, "Race has never simply been about bodies in the first place but is instead anchored in the more tangential, even ephemeral, intersections of race, gender, politics, economics, and the discourses of nationhood, and, as such, is socially constructed and ever-shifting, rather than static or transhistorical."[30] Turner's work reveals and challenges preconceived understandings of Canadianness, beauty, and continual alienness.

Jenny Western engages the work of Faye HeavyShield, Danis Goulet, and Kenneth Lavallee in "Mother Me" to reposition the maternal in art. She explores the nuances and challenges of motherhood through these works, resisting the overly sentimental ways in which this position is often represented. Further, the project of Indigenous mothering, she argues, can be understood as a radical gesture in itself in light of colonial projects such as residential schools and the Sixties Scoop. Reclaiming matrilineal knowledge is a powerful experience, represented here by these three artists.

Forms of Desire: Institutional Critique and Feminist Praxis

The term *institutional critique*, used to describe the politicized art practice of the late 1960s and early 1970s, first appeared in print in Mel Ramsden's "On Practice" (1975).[31] Because of the explicit lack of women artists represented in museums and galleries, the practice was widely taken up by feminists who were both advocating for reforms (such as the Guerrilla Girls actions) while at the same time making a poignant critique of the ideological underpinnings of the structure of artistic practice. As Helen Molesworth writes in "How to Install Art as a Feminist" – which two of the authors in this section, Amy Fung and cheyanne turions, pay tribute to in their titles – "part of what I'm after, as a feminist, is the fundamental reorganization of the institutions that govern us, as well as those that we, in turn, govern."[32] The response by feminists was never just one of critique, but also involved processes of institution building. Due to state arts funding, from the Canada Council of the Arts as well as provincial and municipal arts councils, which included operating budgets for arts organizations, artist-run centres, publications, and individual artist grants, it was possible to build an extensive network of feminist arts institutions across Canada. Sadly, not all of these institutions are still around; for example, the Women's Art Resource Centre (WARC) based in Toronto closed its doors in 2014. Over the years, WARC supported artists in

numerous ways, including publishing the magazine *Matriart*, establishing a gallery, conducting surveys of gender representation in the arts, and compiling a curatorial research library, which is now housed at the Art Gallery of Ontario. The demise of this institution represents a blow to the continuity of feminist arts organizations in Canada; as Linda Abrahams and Irene Packer expressed in 2008, "It would be really terrible to lose a venue that has the experience that we have to offer a serious history of women's struggles and accomplishments."[33] However, other organizations have survived, including MAWA, which celebrated its thirtieth anniversary in 2014 by commissioning this book. And new organizations continue to emerge.

This section deals with various feminist art institutions, including MAWA and Crossing Communities, the Feminist Art Gallery, and the network of women artists who came together in Vancouver in 1989 through American artist Mary Kelly's workshop. Each of these examples grapples with the question of what it means to build feminist art communities and institutions. The writings by cheyanne turions and Amy Fung continue the legacy of feminist institutional critique; turions analyzes the National Gallery of Canada's first international Indigenous art exhibition and Fung examines the complexity of writing as a feminist art critic. The question of institutions and institutional structures are revealed through these essays to be central to feminist art practice and feminist art criticism.

"Vancouver 1989" brings together many of the artists who were central to Vancouver's feminist art scene in the 1990s. Simon Fraser University School for the Contemporary Arts hosted a Visual Arts Summer Intensive course led by Mary Kelly, an influential conceptual artist, educator, and writer, on feminism and psychoanalytic theory in cultural practice. The conversation with artists from that seminar, led and edited by Kathleen Ritter and commissioned specifically for this book, addresses the importance of feminist historiography, providing an oral history of a central moment in feminist art practice in Canada. Lorna Brown, Allyson Clay, Marian Penner Bancroft, Kathy Slade, Jin-me Yoon, and Anne Ramsden discuss the feminist community of the day, how it influenced their own art practices, and the legacy that it left in Vancouver and beyond.

"From Mentorship to Collaboration: Art, Feminism, and Community in Winnipeg" also discusses strategies for building a feminist art culture, using the examples of MAWA and the Winnipeg-based community art project Crossing Communities, which grew out of MAWA. Noni Brynjolson shows how mentorship provided the basis for each of these organizations, underlining its necessity in creating intergenerational dialogue amongst women artists. This model was then used as a means to empower women-identified people in conflict with the law in the context of Crossing Communities. Brynjolson conveys the complexity of community-based art and building a feminist art community through these two detailed case studies.

Amy Fung's piece, "How to Review Art as a Feminist and Other Speculative Intents," poetically disentangles the position of engaging with the power structures of the art world, from her position as a feminist. She writes, "What does the state of art reviewing have to do with feminism? How do you enter a house that was built to

exclude you?"[34] She questions the ways in which feminism, like engagement with the arts, is often merely in the service of securing people's middle-class exclusionary values, rather than a radical project of social transformation that resists hierarchalization and marginalization.

In "How Not to Install Indigenous Art as a Feminist," cheyanne turions entangles the complex paradoxes of the National Gallery of Canada's (NGC) show *Sakahàn*, the first international Indigenous art show in Canada. As turions argues, *Sakahàn* was undermined by the explicit disavowal by the gallery of the artists' and curators' politics through disclaimers mounted at the entrance of the exhibition and next to Nadia Myre's work *For those who cannot speak: the land, the water, the animals and the future generations* (2013). The institution clearly wished to distance itself from the calls for decolonization, which at that time were still resounding loudly in the wake of the Idle No More movement. The essay analyzes this schizophrenic approach of the NGC, as turions writes "there is something profoundly unresolved between the force of *Sakahàn* and the NGC's unwillingness to accept the ways the gallery itself is implicated in the ongoing settler colonial project in Canada, both as a mechanism of cultural proliferation and as a federal institution."[35] We are left with the question, is it possible to have a *national* institution genuinely engage in the work of cultural decolonization?

In "A Speculative Manifesto for the Feminist Art Fair International: An Interview with Allyson Mitchell and Deirdre Logue of the Feminist Art Gallery," Amber Christensen, Lauren Fournier, and Daniella Sanader discuss feminist art economies, collections, and the building of feminist art communities with Mitchell and Logue. They ask, what is feminist art? And how do we deal with the practicalities of funding and payment for projects in a manner that reflects a feminist process-based inquiry? The Feminist Art Gallery is the central point of analysis, a five-year project initiated by Mitchell and Logue to propel feminist art production and develop community. The conversation itself reflects the questions and methodologies of feminist process-based modes of inquiry.

Finally, Gina Badger's timeline closes the book, providing a valuable context for ongoing research into feminist art practice. As she writes in the introduction, feminist historiography reveals "no definitive structure, only connective tissues."[36] "There Is No Feminism (A Love Letter); Or, A Working Chronology of Feminist Art Infrastructures in Canada" provides a way to see through this history, giving a sense of the breadth of activities, communities, geographies, and media that feminist artists have been concerned with since 1963. Badger's timeline shows the radical dispersion and decentralization of feminism within Canada, how its practices link up with, and dovetail from, other social justice movements, particularly trans, Indigenous, and people of colour feminisms, and how these are framed by government policy, feminist institutions, and grassroots initiatives.

This collection of essays represents some of the most compelling feminist artists practicing in Canada today, engaging pressing questions of social justice with humour, style, and grace from its writers. What the collection clearly shows is that feminism is an ongoing and plural movement, which shifts to address different questions and con-

cerns at different moments in time but remains central to undoing heteropatriarchy in a colonial context. As Alissa Firth-Eagland and Candice Hopkins write in the epigraph to this chapter, "although the impact of feminist thought and action are now a part of everyday life, the hard-won struggles on issues of representation and empowerment are increasingly normalized or deliberately unrecognized." This book clearly shows not just the strength of *contemporary* feminist art practices but also the inherited battles and multiple communities of people that have been working on feminist struggles for a long time. In our present moments, we are also reworking the past, reaping its seeded possibilities to create vibrant futures. It is my hope that this book activates such a desire for change, for continued change, toward feminist futurities.

NOTES

1 Molesworth, "How to Install Art as a Feminist," 513.

2 Ibid., 512.

3 See Braidotti, "The Untimely."

4 Steele, "Committed to Memory," 41.

5 For an excellent resource on feminist art writing in Canada, see "Women Artists in Canada Bibliography" on Les Femmes Artistes du Canada/Women Artists in Canada's website: http://www.collectionscanada.gc.ca/eppp-archive/100/205/301/ic/cdc/waic/bibliography.htm.

6 Huneault and Anderson, "A Past as Rich as Our Futures Allow," 44.

7 Ibid., 45.

8 Grosz, "Histories of the Present and Future."

9 Phelan, "The Returns of Touch," 357.

10 Tuck and Ree, "A Glossary of Haunting," 654.

11 Kelly, "Desiring Images/Imaging Desire," 26.

12 Shohat, Introduction to *Talking Visions*, 2.

13 Stiles, "Never Enough Is *Something Else*," 242.

14 Cisgender refers to people whose gendered identity corresponds to the sex they were assigned at birth.

15 Gagnon, "Work in Progress," 112.

16 See, for example, Anne Fausto-Sterling's survey of chromosomes in humans and her claim that there should be five sexes in "The Five Sexes: Why Male and Female Are Not Enough."

17 For critiques of second-wave feminism from the point of view of race, see Maracle, *I Am Woman*; hooks, *Ain't I a Woman?*; Lorde, *Sister Outsider*; Walker, "Becoming the Third Wave"; Moraga and Anzaldúa, *This Bridge Called My Back*; Hull, Scott, and Smith, *All the Women Are White, All the Blacks Are Men, But Some of Us Are Brave*; Collins, *Black Feminist Thought*; Bannerji, "Introducing Racism"; Ng, "Sexism, Racism and Canadian Nationalism"; Bristow, *We're Rooted Here and They Can't Pull Us Up*; and Dua and Robertson, *Scratching the Surface*. For books and articles that challenge the sex binary, see Spade, *Normal Life*; Stryker, *Transgender History*; Clare, *Exile and Pride: Disability, Queerness and Liberation*; Rose, "Note sur l'(auto)identification et le gender passing"; and FitzGerald and Rayter, *Queerly Canadian*.

18 For articles on feminist intersectionality and standpoint theory see Davis, *Women, Race and Class*; Minh-ha, *Woman, Native, Other*; Crenshaw, *On Intersectionality*; Harding, *The Feminist Standpoint Theory Reader*; Cho, Crenshaw, and McCall, "Toward a Field of Intersectionality Studies"; Puar, "'I Would Rather Be a Cyborg Than a Goddess'"; Zack, "Can Third Wave Feminism Be Inclusive?"

19 Fraser, "Instabili: La question du sujet," 12.

20 See Rich, "Notes toward a Politics of Location."

Nelson, Charmaine. *Representing the Black Female Subject in Western Art*. London: Routledge, 2010.

Ng, Roxana. "Sexism, Racism and Canadian Nationalism." *Socialist Studies / Études Socialistes: A Canadian Annual* 5 (1989): 12–26.

Phelan, Peggy. "The Returns of Touch: Feminist Performances, 1960–80." In *WACK! Art and the Feminist Revolution*, edited by Cornelia Butler, 346–61. Cambridge, MA: MIT Press, 2007.

Puar, Jasbir. "'I Would Rather Be a Cyborg Than a Goddess': Becoming-Intersectional in Assemblage Theory." *philoSOPHIA* 2, no.1 (2012): 49–66.

Red Man Laughing Podcast. "The ReMatriate Interview," 4 May 2015. http://www.indianandcowboy.com/episodes/rematriate.

Rich, Adrienne. "Notes toward a Politics of Location." In *Blood, Bread and Poetry*, 210–31. New York: W.W. Norton & Company, Inc., 1994.

Rose, Fabien. "Note sur l'(auto)identification et le gender passing." *No More Potlucks* 2 (2011). http://nomorepotlucks.org/site/note-sur-l'autoidentification-et-le-gender-passing/.

Shohat, Ella. Introduction to *Talking Visions: Multicultural Feminism in a Transnational Age*, edited by Ella Shohat, 1–62. Cambridge, MA: MIT Press, 1999.

Spade, Dean. *Normal Life: Administrative Violence, Critical Trans Politics, and the Limits of Law*. Durham, NC: Duke University Press, 2015.

Steele, Lisa. "Committed to Memory: Women's Video Art Production in Canada and Quebec." In *Work in Progress: Building Feminist Culture*, edited by Rhea Tregebov, 39–64. Toronto: The Women's Press, 1987.

Stiles, Kristine. "Never Enough Is *Something Else*: Feminist Performance Art, Avant-Gardes and Probity." In *Contours of the Theatrical Avant-Garde: Performance and Textuality*, edited by James M. Harding, 239–89. Ann Arbor: University of Michigan Press, 2000.

Stryker, Susan. *Transgender History*. Berkeley, CA: Seal Press, 2008.

Trudel, Marcel. *Canada's Forgotten Slaves: Two Hundred Years of Bondage*. Translated by George Tombs. Montreal: Véhicule Press, 2013.

Truth and Reconciliation Commission of Canada. *Honouring the Truth, Reconciling for the Future: Summary of the Final Report of the Truth and Reconciliation Commission of Canada*. 2015. http://www.trc.ca/websites/trcinstitution/File/2015/Honouring_the_Truth_Reconciling_for_the_Future_July_23_2015.pdf.

Tuck, Eve, and C. Ree. "A Glossary of Haunting." In *Handbook of Autoethnography*, edited by Stacey Holman Jones, Tony E. Adams, and Carolyn Ellis, 639–58. Walnut Creek, CA: Left Coast Press, 2013.

Walker, Rebecca. "Becoming the Third Wave." *Ms. Magazine* (Spring 2002): 39–41.

Wark, Jayne. *Radical Gestures: Feminism and Performance Art in North America*. Montreal and Kingston: McGill-Queen's University Press, 2006.

Wohlburg, Meagan. "The ReMatriate Movement Takes on Fashion's Indigenous Cultural Appropriation" *Vice*, May 4, 2015. http://www.vice.com/en_ca/read/rematriate-movement-takes-on-fashions-indigenous-cultural-appropriation-283.

Zack, Naomi. "Can Third Wave Feminism Be Inclusive?: Intersectionality, Its Problems, and New Directions." In *The Blackwell Guide to Feminist Philosophy*, edited by Linda Martín Alcoff and Eva Feder Kittay, 193–207. Oxford: Blackwell Publishing, 2007.

Collins, Patricia Hill. *Black Feminist Thought: Knowledge, Consciousness, and the Politics of Empowerment.* New York: Routledge, 2000.

Crenshaw, Kimberlé. *On Intersectionality: Essential Writings.* New York: New Press, 2016.

Davis, Angela. *Women, Race and Class.* New York: Vintage Books, 1983.

Dua, Enaski, and Angela Robertson. *Scratching the Surface: Canadian Anti-Racist Feminist Thought.* Toronto: Women's Press, 1999.

Fausto-Sterling, Anne. "The Five Sexes: Why Male and Female Are Not Enough." *The Sciences* (March/April 1993): 20–24.

Firth-Eagland, Alissa, and Candice Hopkins. Introduction to *The F Word*, edited by Candice Hopkins and Alissa Firth-Eagland, 5–8. Vancouver: Western Front, 2009.

FitzGerald, Maureen, and Scott Rayter. *Queerly Canadian: An Introductory Reader in Sexuality Studies.* Toronto: Canadian Scholars' Press, 2012.

Fraser, Marie. "Instabili: La question du sujet." In *Instabili: La question du sujet / The Question of the Subject*, edited by Marie Fraser and Lesley Johnstone, 12–13. Montreal: La Galerie Powerhouse (La Centrale) and Centre d'information Artexte, 1990.

Gagnon, Monika Kin. *Other Conundrums: Race, Culture and Canadian Art.* Vancouver: Arsenal Pulp Press, 2000.

– "Work in Progress: Canadian Women in the Visual Arts, 1975–1987." In *Work in Progress: Building Feminist Culture*, edited by Rhea Tregebov, 101–28. Toronto: Women's Press, 1987.

Grosz, Elizabeth. "Histories of the Present and Future: Feminism, Power, Bodies." In *Thinking the Limits of the Body*, edited by Jeffery Jerome Cohen and Gail Weiss, 13–24. Buffalo: SUNY Press, 2003.

Guerrero, M.A. Jaimes. "Savage Hegemony: From 'Endangered Species' to Feminist Indiginism." In *Talking Visions: Multicultural Feminism in a Transnational Age*, edited by Ella Shohat, 414–39. Cambridge, MA: MIT Press.

Harding, Sandra, ed. *The Feminist Standpoint Theory Reader: Intellectual and Political Controversies.* New York: Routledge, 2004.

hooks, bell. *Ain't I A Woman?: Black Women and Feminism.* Brooklyn: South End Press, 1999.

Hull, Gloria T., Patricia Bell Scott, and Barbara Smith. *All the Women Are White, All the Blacks Are Men, But Some of Us Are Brave: Black Women's Studies.* New York: Feminist Press, 1982.

Huneault, Kristina, and Janice Anderson. *Rethinking Professionalism: Women and Art in Canada, 1850–1970.* Montreal and Kingston: McGill-Queen's University Press, 2012.

Kelly, Mary. "Desiring Images/Imaging Desire." In *Instabili: La question du sujet / The Question of the Subject*, edited by Marie Fraser and Lesley Johnstone, 24–8. Montreal: La Galerie Powerhouse (La Centrale) and Centre d'information Artexte, 1990.

Lemecha, Vera. MAWA: *Culture of Community.* Winnipeg: Mentoring Artists for Women's Art, 2004.

Lorde, Audre. *Sister Outsider: Essays and Speeches.* Berkeley, CA: Crossing Press, 1984.

Maracle, Lee. *I Am Woman: A Native Perspective on Sociology and Feminism.* Vancouver: Press Gang Publishers, 1996.

Mars, Tanya, and Johanna Householder. *Caught in the Act: An Anthology of Performance Art by Canadian Women.* Toronto: YYZ Books, 2004.

Minh-ha, Trinh. *Woman, Native, Other.* Bloomington: Indiana University Press, 2009.

Molesworth, Helen. "How to Install Art as a Feminist." In *Modern Women: Women Artists at the Museum of Modern Art*, edited by Cornelia Butler and Alexandra Schwartz, 499–513. New York: Museum of Modern Art, 2010.

Moraga, Cherríe, and Gloria Anzaldúa. *This Bridge Called My Back: Writings by Radical Women of Color.* 4th ed. New York: SUNY Press, 2015.

Nelson, Charmaine. *Representing the Black Female Subject in Western Art*. London: Routledge, 2010.

Ng, Roxana. "Sexism, Racism and Canadian Nationalism." *Socialist Studies / Études Socialistes: A Canadian Annual* 5 (1989): 12–26.

Phelan, Peggy. "The Returns of Touch: Feminist Performances, 1960–80." In *WACK! Art and the Feminist Revolution*, edited by Cornelia Butler, 346–61. Cambridge, MA: MIT Press, 2007.

Puar, Jasbir. "'I Would Rather Be a Cyborg Than a Goddess': Becoming-Intersectional in Assemblage Theory." *philoSOPHIA* 2, no.1 (2012): 49–66.

Red Man Laughing Podcast. "The ReMatriate Interview," 4 May 2015. http://www.indianandcowboy.com/episodes/rematriate.

Rich, Adrienne. "Notes toward a Politics of Location." In *Blood, Bread and Poetry*, 210–31. New York: W.W. Norton & Company, Inc., 1994.

Rose, Fabien. "Note sur l'(auto)identification et le gender passing." *No More Potlucks* 2 (2011). http://nomorepotlucks.org/site/note-sur-l'autoidentification-et-le-gender-passing/.

Shohat, Ella. Introduction to *Talking Visions: Multicultural Feminism in a Transnational Age*, edited by Ella Shohat, 1–62. Cambridge, MA: MIT Press, 1999.

Spade, Dean. *Normal Life: Administrative Violence, Critical Trans Politics, and the Limits of Law*. Durham, NC: Duke University Press, 2015.

Steele, Lisa. "Committed to Memory: Women's Video Art Production in Canada and Quebec." In *Work in Progress: Building Feminist Culture*, edited by Rhea Tregebov, 39–64. Toronto: The Women's Press, 1987.

Stiles, Kristine. "Never Enough Is *Something Else*: Feminist Performance Art, Avant-Gardes and Probity." In *Contours of the Theatrical Avant-Garde: Performance and Textuality*, edited by James M. Harding, 239–89. Ann Arbor: University of Michigan Press, 2000.

Stryker, Susan. *Transgender History*. Berkeley, CA: Seal Press, 2008.

Trudel, Marcel. *Canada's Forgotten Slaves: Two Hundred Years of Bondage*. Translated by George Tombs. Montreal: Véhicule Press, 2013.

Truth and Reconciliation Commission of Canada. *Honouring the Truth, Reconciling for the Future: Summary of the Final Report of the Truth and Reconciliation Commission of Canada*. 2015. http://www.trc.ca/websites/trcinstitution/File/2015/Honouring_the_Truth_Reconciling_for_the_Future_July_23_2015.pdf.

Tuck, Eve, and C. Ree. "A Glossary of Haunting." In *Handbook of Autoethnography*, edited by Stacey Holman Jones, Tony E. Adams, and Carolyn Ellis, 639–58. Walnut Creek, CA: Left Coast Press, 2013.

Walker, Rebecca. "Becoming the Third Wave." *Ms. Magazine* (Spring 2002): 39–41.

Wark, Jayne. *Radical Gestures: Feminism and Performance Art in North America*. Montreal and Kingston: McGill-Queen's University Press, 2006.

Wohlburg, Meagan. "The ReMatriate Movement Takes on Fashion's Indigenous Cultural Appropriation" *Vice*, May 4, 2015. http://www.vice.com/en_ca/read/rematriate-movement-takes-on-fashions-indigenous-cultural-appropriation-283.

Zack, Naomi. "Can Third Wave Feminism Be Inclusive?: Intersectionality, Its Problems, and New Directions." In *The Blackwell Guide to Feminist Philosophy*, edited by Linda Martín Alcoff and Eva Feder Kittay, 193–207. Oxford: Blackwell Publishing, 2007.

cerns at different moments in time but remains central to undoing heteropatriarchy in a colonial context. As Alissa Firth-Eagland and Candice Hopkins write in the epigraph to this chapter, "although the impact of feminist thought and action are now a part of everyday life, the hard-won struggles on issues of representation and empowerment are increasingly normalized or deliberately unrecognized." This book clearly shows not just the strength of *contemporary* feminist art practices but also the inherited battles and multiple communities of people that have been working on feminist struggles for a long time. In our present moments, we are also reworking the past, reaping its seeded possibilities to create vibrant futures. It is my hope that this book activates such a desire for change, for continued change, toward feminist futurities.

NOTES

1 Molesworth, "How to Install Art as a Feminist," 513.

2 Ibid., 512.

3 See Braidotti, "The Untimely."

4 Steele, "Committed to Memory," 41.

5 For an excellent resource on feminist art writing in Canada, see "Women Artists in Canada Bibliography" on Les Femmes Artistes du Canada/Women Artists in Canada's website: http://www.collectionscanada.gc.ca/eppp-archive/100/205/301/ic/cdc/waic/bibliography.htm.

6 Huneault and Anderson, "A Past as Rich as Our Futures Allow," 44.

7 Ibid., 45.

8 Grosz, "Histories of the Present and Future."

9 Phelan, "The Returns of Touch," 357.

10 Tuck and Ree, "A Glossary of Haunting," 654.

11 Kelly, "Desiring Images/Imaging Desire," 26.

12 Shohat, Introduction to *Talking Visions*, 2.

13 Stiles, "Never Enough Is *Something Else*," 242.

14 Cisgender refers to people whose gendered identity corresponds to the sex they were assigned at birth.

15 Gagnon, "Work in Progress," 112.

16 See, for example, Anne Fausto-Sterling's survey of chromosomes in humans and her claim that there should be five sexes in "The Five Sexes: Why Male and Female Are Not Enough."

17 For critiques of second-wave feminism from the point of view of race, see Maracle, *I Am Woman*; hooks, *Ain't I a Woman?*; Lorde, *Sister Outsider*; Walker, "Becoming the Third Wave"; Moraga and Anzaldúa, *This Bridge Called My Back*; Hull, Scott, and Smith, *All the Women Are White, All the Blacks Are Men, But Some of Us Are Brave*; Collins, *Black Feminist Thought*; Bannerji, "Introducing Racism"; Ng, "Sexism, Racism and Canadian Nationalism"; Bristow, *We're Rooted Here and They Can't Pull Us Up*; and Dua and Robertson, *Scratching the Surface*. For books and articles that challenge the sex binary, see Spade, *Normal Life*; Stryker, *Transgender History*; Clare, *Exile and Pride: Disability, Queerness and Liberation*; Rose, "Note sur l'(auto)identification et le gender passing"; and FitzGerald and Rayter, *Queerly Canadian*.

18 For articles on feminist intersectionality and standpoint theory see Davis, *Women, Race and Class*; Minh-ha, *Woman, Native, Other*; Crenshaw, *On Intersectionality*; Harding, *The Feminist Standpoint Theory Reader*; Cho, Crenshaw, and McCall, "Toward a Field of Intersectionality Studies"; Puar, "'I Would Rather Be a Cyborg Than a Goddess'"; Zack, "Can Third Wave Feminism Be Inclusive?"

19 Fraser, "Instabili: La question du sujet," 12.

20 See Rich, "Notes toward a Politics of Location."

21 Braidotti, "The Untimely," 237.

22 Kristeva quoted in Wark, "Queering Abjection," 97.

23 Guerrero, "Savage Hegemony: From 'Endangered Species' to Feminist Indiginism," 430.

24 For a more sustained critique of cultural genocide and its aftermath, see *Honouring the Truth, Reconciling for the Future: Summary of the Final Report of the Truth and Reconciliation Commission of Canada.*

25 While the Immigration Act did not single out particular racial or ethnic groups explicitly, Section 38 did allow the cabinet to restrict "immigrants belonging to any race deemed unsuited to the climate or requirements of Canada." Later that year, a $200 head tax on Asian immigrants (P.C. 926) and a $25 monetary requirement for entry was passed (P.C. 924). For a timeline of the systematic exclusion of people of colour as immigrants to Canada, see Canadian Council for Refugees, "A Hundred Years of Immigration to Canada 1900–1999," May 2000, http://ccrweb.ca/en/hundred-years-immigration-canada-1900-1999.

26 See Trudel, *Canada's Forgotten Slaves.*

27 Arvin, Tuck, and Morrill, "Decolonizing Feminism," 11.

28 For more information on the ReMatriate Collective, see Wohlburg, "The ReMatriate Movement Takes on Fashion's Indigenous Cultural Appropriation"; *Red Man Laughing Podcast*, "The ReMatriate Interview."

29 Frei Njootli, "Rematriating Feminism(s)" (unpublished letter to the editor of the *Globe and Mail* on International Women's Day), personal correspondence with the author, 12 May 2016.

30 Petty, "'All That Is Canadian,'" 169.

31 Alberro, "Institutions, Critique, and Institutional Critique," 9.

32 Molesworth, "How to Install Art as a Feminist," 499.

33 401 Richmond, "Women's Art Resource Centre and WARC Gallery (Studio 122)."

34 Fung, "How to Review Art as a Feminist," 238.

35 turions, "How Not to Install Indigenous Art as a Feminist," 250.

36 Badger, "There Is No Feminism," 271.

BIBLIOGRAPHY

401 Richmond. "Women's Art Resource Centre and WARC Gallery (Studio 122)." Fall 2008. http://www.401richmond.net/tenants/warc.cfm.

Alberro, Alexander. "Institutions, Critique, and Institutional Critique." In *Institutional Critique: An Anthology of Artists' Writings*, edited by Alexander Alberro and Blake Stimson, 2–19. Cambridge, MA: MIT Press, 2009.

Arvin, Maile, Eve Tuck, and Angie Morrill. "Decolonizing Feminism: Challenging Connections between Settler Colonialism and Heteropatriarchy." *Feminist Formations* 25, no. 1 (2013): 8–34.

Bannerji, Himani. "Introducing Racism: Notes towards an Anti-Racist Feminism." *Resources for Feminist Research / Documentation sur la recherche feministe* 16, no. 1 (1987): 10–12.

Braidotti, Rosi. "The Untimely." In *The Subject of Rosi Braidotti: Politics and Concepts*, edited by Bolette Blaagaard and Iris van der Tuin, 227–50. London: Bloomsbury, 2014.

Bristow, Peggy. *We're Rooted Here and They Can't Pull Us Up: Essays in African Canadian Women's History*. Toronto: University of Toronto Press, 1999.

Butler, Margot. *Locations: Feminism, Art, Racism, Region: Writings and Art Works*. Toronto: Women's Art Resource Centre, 1989.

Cho, Sumi, Kimberlé Williams, Crenshaw, and Leslie McCall. "Toward a Field of Intersectionality Studies: Theory, Applications, and Praxis." *Signs: Journal of Women in Culture and Society* 38, no. 4 (2013): 785–810.

Clare, Eli. *Exile and Pride: Disability, Queerness and Liberation*. Durham, NC: Duke University Press, 2015.

A Past as Rich as Our Futures Allow: A Genealogy of Feminist Art in Canada

Kristina Huneault and Janice Anderson

1

There is a path that runs along the train tracks in central Montreal. A three-kilometre stretch of dirt, it wends its way through a kind of urban no-man's land – past the high walls of a disused incinerator and along the back of a recycling centre, machine shops, a lumberyard. Its heavily post-industrial character notwithstanding, the space is an oasis of sorts. Wildflowers bloom in profusion by the tracks, squirrels run riot in mature poplars, and groundhogs forage for food. Sometimes, mysteriously, there is the smell of cinnamon toast.

Since 1994, the path has been officially maintained by the city as a trail for cyclists and runners, but the spaces around it are also put to less-sanctioned uses, ranging from urban bonfires and mobile dance parties to guerrilla gardening and an off-the-books dog run. At intervals, gaps have been forged in the fence that separates the path from the railway beyond it, disrupting the boundaries between public and private land, and between authorized and unauthorized mobilities. At the time of writing, an improvised set of Neoist paintings is tied to one section of the fencing, while a quirky woollen sculpture of a bird sits on the illicit side of the boundary, just next to a knitted patchwork cozy encircling one of the massive pillars of the Rosemont/Van Horne viaduct. Graffiti and postering abound.

As often as not, such creative interventions are also acts of political and social imagination – protesting austerity, claiming alternate communities, and reappropriating urban space by altering its anticipated sensory configurations.[1] Among the issues up for debate is gender. Here, manga-inspired spray paint fantasies of nubile femininity share real estate with the yarn bombing practices that have emerged, in part, as a feminist response to the male-dominated graffiti milieu. Such unexpected irruptions of knitting in the urban jungle displace the medium's associations with domesticity and prompt consideration of women as daily users and shapers of public space, rather than as adornments for it. Yarn bombing's characteristic mix of positive messages and progressive politics is not the only mode of female insurrection on display along the path, however. On a pillar directly opposite the knitted cozy, an image of a masked, black-clad female protester by the Montreal street artist Zola speaks back to her craftivist sisters' kinder, gentler form of social advocacy, countering their feminized affects of care and comfort with intimations of violent civil unrest. Yet much like her knitting peers, Zola shares a commitment to asserting women's presence in environments that would otherwise code

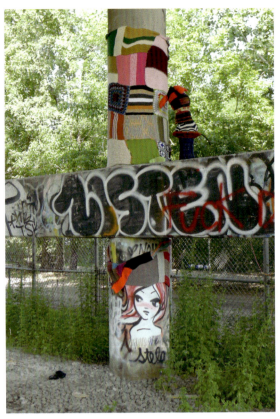

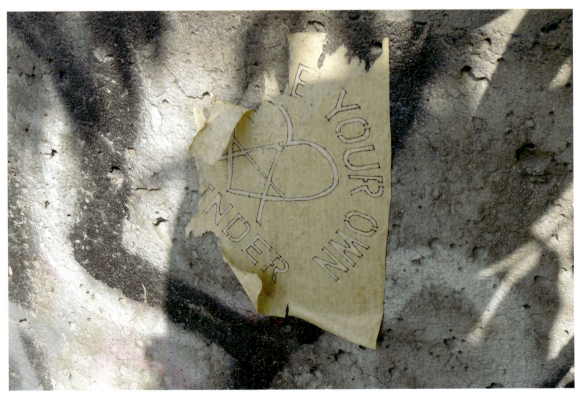

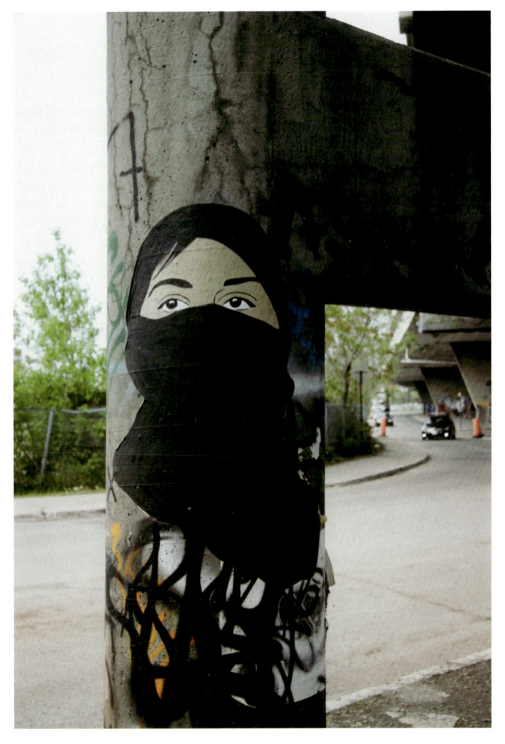

Opposite clockwise
1.1 Artwork around the Rosemont/Van Horne viaduct (entrance to train tracks).
1.2 Artwork around the Rosemont/Van Horne viaduct (knitted cozy and manga).
1.3 Artwork around the Rosemont/Van Horne viaduct ("choose your own gender" poster).

Above
1.4 Artwork around the Rosemont/Van Horne viaduct. Zola, *Untitled*, 2014.

as masculine – in her case, those of the anarchist and direct action communities. "I want to honour the girls who have participated in direct action," she observes, "because I feel like most of the time the black bloc stereotype will erase the presence of women or queer folk."[2] Further down the path, however, queer culture speaks for itself on a poster that transforms anarchism's circle-A iconography into the shape of a heart, exhorting passers-by to "choose your own gender." A neighbouring drawing of a queer superhero champions love, gender fluidity, openness, and questioning, while across a peeling gap in the paper another term appears, now somewhat distanced from the rest: *feminism*.

What, we cannot help but wonder, did this gender-bending hero once make of feminism as they rocketed beyond the gravitational pull of entrenched normativity, segregated spaces, and clearly divided identities? Did feminism appear in the guise of revered Amazonian progenitor for this intrepid renegade? Or did it find itself, rather, among the formations to be questioned – a holdover from "the days of essentialized bodies and single-issue identity politics"?[3] Such questions bear asking all along the path. Zola, for instance, grounds her work in opposition to patriarchy but also to colonialism, capitalism, racism, heterosexism, ableism, and transphobia – or as she more pithily puts it, "fuck *toute*." Yet she has also speculated that all of this opposition might still find room within an expanded understanding of feminism itself. "After all," she observes, "it is women of colour who have brought intersectionality ... into the political spectrum."[4]

The intersectionality that marks third-wave gender praxis along the tracks is also a defining characteristic of this volume, which similarly invokes the unsettling of boundaries and borders in a variety of ways: exploring female subjectivities at the nexus of race, class, and cultures; queering normative gendered identities; interrogating the established categories of art world discourse; questioning the boundaries of the human as such. Together, these essays court the destabilization of monolithic social constructions in favour of zones of indeterminacy. This is feminism's present. But what of its relation to the past? Is there, perhaps, a kind of *temporal* intersectionality to be advocated as well, running in tandem with the spatialized axes of coalitional politics and networked subjectivities? Does the blurring of boundaries extend through time, linking past, present, and future in multiple and disparate ways?

The pursuit of *herstory* is a longstanding feminist practice, though it now rarely goes by that name. Yet the generational metaphors so characteristic of feminism foster forgetting as much they do remembering. Thus, when the Montreal yarn bomber Tricot pour la paix speaks to her community, she effects a clear distinction between the gender-conscious knitters of today and their feminist forerunners: "if second-wave feminists have been historicized as women who put down their knitting, third-wave feminists may be characterized as those who have picked it back up again."[5] The pull of ancestral female tradition is strong here, but the contributions of the more recent feminist past fall away like rapidly receding objects in a rearview mirror.

As with objects in the mirror, however, our past may also be closer than it appears. Consider, for example, the obvious parallels between the craftivist yarn bombs of today and Evelyn Roth's *Videotape Car Cozy* from 1971–72, or the strikingly similar adop-

tion of the beauty queen persona in Camille Turner's ongoing *Miss Canadiana* performances (see fig. 8.2 in Sheila Petty's chapter in this volume) and Brenda Ledsham's photographic enactment of *Miss Ogyny* for Women's Perspective '83, a feminist arts festival in 1983. In 2012, Winnipeg's Plug In Institute of Contemporary Art exhibited a refurbished landmark of early feminist art in Canada – Phyllis Green's *Boob Tree* from 1975. Contemporary Canadian artists, including Allyson Mitchell and Deirdre Logue, Jess Dobkin, Maryse Larivière, Julie Lassonde, Wednesday Lupypciw, and Dayna McLeod, actively reference the feminist art practices of the 1970s, and the connections have been further noted in texts by Thérèse St-Gelais and Tamar Tembeck.[6]

Drawing on such connections, our task in this chapter is to craft a historical context for contemporary feminist art production in Canada. How does the feminist past assert its claim on the present? And how do we navigate our own claims on history? What, in short, are the historical and theoretical conditions of possibility for feminist art in Canada now? Taking our cue from the visual culture of the tracks and from the authors of this volume, our response to these questions focuses on the importance of crossing boundaries, contesting limits, and deterritorializing stratified divisions.[7] More particularly, we seek out and attend to historical manifestations of this contemporary impetus. In this vein, the first two sections of the text explore the disturbances and

1.5 Evelyn Roth, *Videotape Car Cozy*, 1971–72.

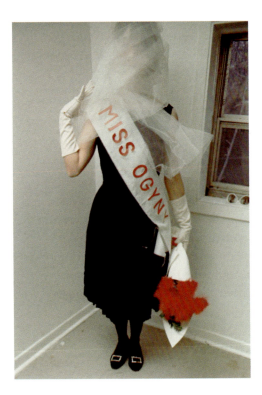

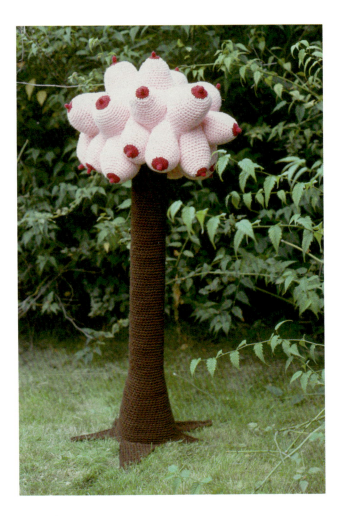

Above
1.6 Brenda Ledsham, *Miss Ogyny*, 1983.

Right
1.7 Phyllis Green, *Boob Tree*, 1975.

destabilizations wrought by the intersection of "art" and "feminism" – two discrete but overlapping milieus, each with boundaries and rules of its own – while the third and final section questions the constraints that feminist art writing has imposed on its own history. Looking to connections between then and now, second and third waves, our aim is to offer a perspective on the past that marks out history's meaning for the still-very-present-day feminist task of making a different future: one in which the burdens of expectation placed on human beings will no longer seek to limit and pin us down.

Art and Feminism: Intersecting Territories

In a lecture on women and art delivered in Montreal at the height of the Second World War, the painter Anne Savage declared that there was no gender-based discrimination in the Canadian art world. Savage was a feminist – or at least enough of a feminist to have joined the city's League for Women's Rights – but when it came to art, she was confident that such activism was no longer necessary. The women artists of 1942, she explained, "were judged strictly on merit," casually adding that "any handicap they have comes from having to devote time to such things as house-

keeping."[8] In this, Savage was typical of her generation of independent-minded women who trusted their success to the strength of their own abilities, the decency of their male colleagues, and the formal access to training and accreditation secured by the first wave of feminist activism.[9]

With the postwar retrenchment of the nuclear family, however, the housekeeping that had been – in Savage's mind – a mere afterthought to equality, returned to occupy centre stage in women's lives. In Canada, one effect of this was that women were increasingly sidelined from the expansion and professionalization of the cultural sphere that followed the tabling of the Massey Report in 1951. But as dissatisfaction with gendered social arrangements grew, women began to probe more deeply into the connection between the kinds of domestic support they were expected to provide and the way their male peers thought of them outside the home. By the time the report of the Royal Commission on the Status of Women was released in 1970, the link between gender inequality and women's disproportionate domestic burden was being widely discussed.[10] Two years later, exactly three decades after Savage's optimistic declaration of equality in the Canadian art world, the women of the Montreal art and performance group Mauve served notice that such issues affected them as well. Dressed in wedding gowns, the six women mounted the staircase of the Montreal Museum of Fine Arts and dismayed audience members by crumpling their veils into dust rags and using them to wipe the architecture of that venerable institution.[11] Their performance simultaneously deflated the happily-ever-after fantasy of marriage and critiqued the terms of women's inclusion within major cultural institutions, thus effectively bridging the social and aesthetic realms that Savage had kept apart. Second-wave feminist art in Canada was underway.

The need for such activism was increasingly apparent. In 1974, National Gallery of Canada director Jean Sutherland Boggs had declared the country to be "a haven for women in the arts," citing various instances of successful female gallery directors, dealers, art critics, and editors.[12] But Boggs's sanguine focus on individual success stories was belied by a growing body of statistical data that revealed a sizeable gap in exhibition opportunities and funding levels for male and female artists. At a time when women constituted just under half of the professional artists in the country, research by art historian Avis Lang Rosenberg and artist Jane Martin indicated that in the haven of Canada men were securing 87 percent of solo shows in commercial galleries and 96 percent of the Senior Arts Grants distributed by the Canada Council.[13]

The question of women's access to and status within the Canadian art world was cast into vivid relief by a spate of exhibitions marking the United Nations declaration of International Women's Year in 1975. Shows were held across the country, but events at the Winnipeg Art Gallery were particularly notable for the way in which they illustrated the gap between feminist ambitions and the norms of female participation in the cultural sphere.[14] Together, the gallery and its women's auxiliary planned to celebrate the UN declaration with *Images of Woman*, an exhibition of historical depictions of women made primarily by men. Objections were levelled by a hastily constituted

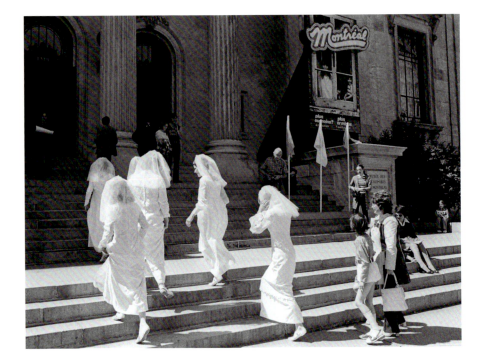

1.8 Mauve, performance at the opening of the *Montréal, plus ou moins?* exhibition at the Montreal Museum of Fine Arts, 1972.

Committee for Women Artists, whose members argued that such an exhibition could only entrench a traditional view of women's role in society.[15] But the ladies of the women's auxiliary – having arguably made the best of that role – were disinclined to substantively alter their plans, and an impasse arose. At length the gallery agreed to reserve space for a parallel show of juried work by contemporary female artists, and though it offered neither funding nor logistical support for the project, the resulting protest exhibition, *Woman as Viewer*, garnered tremendous public attention.[16]

Woman as Viewer was an explicitly "feminist, not feminine" undertaking.[17] Opening quotations by Judy Chicago and Lucy Lippard firmly situated the catalogue within the mainstream of the North American feminist art movement, as did a textual rhetoric of "consciousness," "sisterhood," and "male-identified" women (the women's auxiliary is a not-too-distant referent here). In light of subsequent reassessments of 1970s feminist art, the catalogue's deployment of a unifying vocabulary springs readily to view in its excitement over the possibility of "a new female sensibility," its talk of "the female mode of existence," and its invocation of "Woman," capitalized and singular.[18] Such language is open to criticism as reductive and falsely homogenizing. Nor were considerations of racial and ethnic diversity within the scope of the exhibition, whose artists were selected by a blind jury process.[19]

Yet in other quite significant ways, the overarching thrust of the exhibition was towards diversity. Openness of approach, flexibility, and experimentation were values espoused both explicitly, in the text, and implicitly, in the heterogeneity of the work exhibited. If it is true that an essay by sculptor Maryon Kantaroff advocated passionately for the reality of a distinctive female aesthetic – organic forms, fluid lines, life-affirming colours – the catalogue's framing text explicitly adopted a neutral position on the issue, encouraging viewers to judge for themselves. Similarly, when

organizers proclaimed that "Woman must be free to define and describe herself and the world in terms of her own needs and values," the impulse to a singular definition of womanhood was not as strong as the impassioned realization that women had for so long been defining their aesthetic beliefs and self-image according to men's expectations, that they could scarcely call their ideas their own.[20] In like fashion, the codpieces of Tanya Mars (then Rosenberg) worked more to unsettle fixed patterns of sexual expectation and response than to codify new ones.[21] Similarly, the landmark image from the show, Green's *Boob Tree*, was no serious invocation of an essential femininity, but rather a sardonic *détournement* of sexual objectification and a hyperbolically humorous insistence on female cultural presence.

Like its Quebec counterpart, *Artfemme '75*, *Woman as Viewer* stands as a paradigmatic Canadian example of the kind of independently organized, all-women exhibitions that became the earliest structural model for the conjunction of feminism and art across Europe and North America. With the advantages of hindsight, such pioneering exhibitions are easily critiqued for the simplicity with which they attempted to map political discourse onto artistic practice. Basic questions, such as the distinction between women's art and feminist art, went unanswered, often unasked. But the absence of a programmatic vision also facilitated a dynamic flexibility, and a sense of ferment and possibility. In her overview of the surge of energy and activism that events like these unleashed, art historian Jenni Sorkin has described them as feminist deterritorializations of traditional art world practice: "sporadic, disparate … transient,

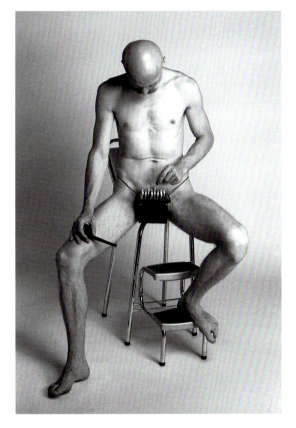

1.9 Tanya Rosenberg (Mars), *Chess Set Codpiece*, 1974.

quickly assembled, and short-lived, they were statements without fixed meanings, particular to the milieu from which they sprung."[22] In Canada, such impulses were especially strong amongst francophone women in Quebec, where dissenters disrupted a panel discussion at the Musée d'art contemporain to circulate a manifesto protesting the nature of *Artfemme '75* and calling for a still more radical feminist art practice. Gail Lauzanna, one of the curatorial team members for the show, reported, "They felt that we, as women, should not play the same rotten art game as men, should not set women against women in a competitive situation, should not box up women's creativity in traditional museum settings."[23] In keeping with this sentiment, a *salon des refusées* was organized and held at Powerhouse, the nation's first (and the continent's second) feminist art gallery, founded in 1973.

Such deterritorializing ambitions were, however, at odds with a move towards greater professionalization on the part of Canadian artists at large. In addition to being International Women's Year, for example, 1975 was also the year when Canada became the first country in the world to pay exhibition fees to artists. When the unpaid and underfunded organizers of *Woman as Viewer* pleaded their inability to meet these additional costs, the national organization of professional artists, CARFAC,[24] boycotted the show. Ultimately, a last-minute government grant resolved the matter, but the tensions between feminism's priorities and those of the art world would remain, poised on the pivot point of a professionalizing impetus that had, historically, been both friend and foe to women.[25] In her 1974 opinion piece, for example, Jean Sutherland Boggs had attributed women's successes to the fact that Canadian museums had long remained "amateur affairs," so chronically underfunded and understaffed that all hands, even female ones, were welcome on deck. For Boggs, such opportunities were steppingstones on the path to increasing women's professional achievement; by contrast, early articulations of feminism in Canada cultivated a joyous departure from the norms and standards of the art world, and were criticized in turn for their lack of professionalism.[26]

The Flaming Apron craft store, in Montreal, exemplifies this trend. Operating from November 1972 until August 1973, when a flood forced it to close its doors, the store fostered women's creative production in a collective, not-for-profit environment that was as removed as possible from the competitive norms and aesthetic conventions of commercial galleries and art schools. The collective's policy of accepting the handmade items of any woman who wished to sell her work was in line with its feminist mandate of consciousness-raising, in that it enabled many women to see their craft-based production as aesthetically valuable, often for the first time. Members of the collective also understood women's creative work as the externalization of their inner selves, and the store prided itself on offering women the opportunity to look back at their own subjectivities in object form, without fear of rejection or judgment.[27]

The encounters between feminism and art that took place at the store were not all harmonious self-affirmation and personal development, however. At times, they were more like collisions, as an incident related by one of the collective's members, Billie Jo Bruhy, makes clear:

One day a woman came into the Flaming Apron … she walked around the store, looking at everything and then, looking at some crocheted doilies which were displayed on the wall, she said, "Do you ever tell the women what to make?" I answered, "Of course not," thinking she was probably surprised at the high quality of work she was seeing … [but] she was having just the opposite reaction. "It looks like a church bazaar – all pastel colours, little doilies and doo-dads, no awareness of new design ideas or colour, very traditional, no experimentation, etc., etc." She was shaking and obviously very upset by this experience. She said that she was shocked by what she had seen and said that she was angry that the store had such poor examples of women's art. "It's no wonder that women artists aren't taken seriously!"

I wanted her to understand what the store was trying to do … I told her that women have been told what to do for too long and that we are trying to find our way back to our own creativity. I explained that we would not tell a woman what to make, or infringe on her right to work as she pleased. We had decided that in making the store we would not set ourselves up as judges of taste or quality.[28]

As feminism and art came into each other's orbit, competing ideas about the way forward for women intersected with differing understandings of culture, generating tension within and between feminist artists.

Chief among the tensions intrinsic to feminist art practice – then as now – is its constant navigation of forces of deterritorialization and reterritorialization, as women work to unsettle patriarchal cultural formations while finding sustainable ways to build rewarding artistic careers for themselves.[29] This has not been easy. Throughout the 1970s, the mainstream art press in Canada remained indifferent, if not hostile, to women's issues. Thus, the feminism that is now a much-discussed aspect of Joyce Wieland's work was largely ignored in favour of her nationalism.[30] Photographer Suzy Lake has said that she consciously stopped making overtly feminist work when its politics were not well received – a decision that accords well with Rose-Marie Arbour and Susanne Lemerise's observation that feminism, in 1975, was something that women artists were "accused of."[31] More radical feminist initiatives, such as the Flaming Apron, did not register on the nation's cultural radar at all.

But while the Flaming Apron's refusal of aesthetic norms and practices may have put it beyond the pale of the Canadian art world, the collective's ideas about quality and community engagement were very much in line with changing cultural policy at the highest levels. As the impulses generated by the social protest movements of the 1960s began to be institutionalized, the Trudeau government shifted away from the Massey-era strategy of disseminating capital-C Culture to the populace through the nation's major museums, and toward a more pluralistic and decentralized policy of "cultural democracy." The minister responsible for culture, Gérard Pelletier, moved to replace the assumption of a single standard of aesthetic quality with a recognition of

"multiple standards, each assessed with reference to its own context."[32] Local initiatives gained in priority, and as the differing needs and ambitions of disparate cultural constituencies came increasingly into account, women were among the beneficiaries.

The ins-and-outs of this moment of intersection between feminism and state cultural policy in the 1970s have been detailed by Anithe de Carvalho in her examination of Montreal artist Francine Larivée's *chef d'oeuvre* of feminist consciousness-raising: the 1976 installation-environment *La chambre nuptiale*, with its intensive, almost phantasmagorical critique of the institution of marriage.[33] First installed in a Montreal shopping centre rather than a museum, Larivée's multimedia pop-art environment was, like Judy Chicago's *Dinner Party*, a massive undertaking, involving more than 150 people and 75,000 hours of labour.[34] Unlike Chicago's apprentices, however, Larivée's workforce was remunerated by the artist, who secured the then-staggering sum of $184,000 in federal and provincial grants for the work's initial installation. Much of this was job-creation money, obtained through the federal government's Local Initiatives Program (LIP), which alleviated winter unemployment by funding privately generated projects for "community betterment."[35] Such funding was readily available at a time when memories of student strikes and FLQ bombings were still fresh in the minds of legislators seeking ways to turn disaffected protestors into productive and engaged citizens. As Carvalho notes, the sheer scale of government support for *La chambre nuptiale* indicates the extent to which the emancipatory thrust of feminist art could be encompassed within a broader agenda of social stability.

Women were underrepresented in allocations of Local Initiatives funding, but the program would nevertheless become a mainstay – albeit a short-term and seasonal one – of early feminist art in Canada.[36] In Vancouver, project grants from the LIP and the Opportunities for Youth program funded the ReelFeelings media collective (1973–77), which included artists Ardele Lister, Renée Baert, and Barbara Steinman, amongst others. The Pacific Women's Graphic Arts Cooperative and the feminist printing and publishing collective Press Gang began *Makara* (1975–78), a feminist journal of women and the arts that did not long survive the demise of LIP in 1977. LIP money also enabled Marion Barling to fund the early activities of Women in Focus, a film and video collective (and later an exhibiting space) that was an institutional centrepiece of the feminist arts community in Vancouver for almost twenty years. Feminist film production and distribution initiatives were also supported by LIP money in Quebec City, where La Femme et le Film (now Vidéo Femmes) was founded in 1973, and in Montreal, where Groupe Intervention Vidéo has been operating since 1975. LIP money partially financed the Flaming Apron and would continue to be an early source of revenue for the store's most significant offshoot, Powerhouse Gallery (later La Centrale).

With the establishment of Powerhouse as an independent, not-for-profit exhibiting space run by and for artists, feminism gained a new kind of institutional footing in the art world, taking its place as an early participant in the emerging network of parallel galleries that would so radically transform the Canadian art scene during the 1970s.[37] Driven by artists' own creative agendas, the galleries spawned a vibrant culture of experimentation that would see feminism move from the periphery of the Canadian art

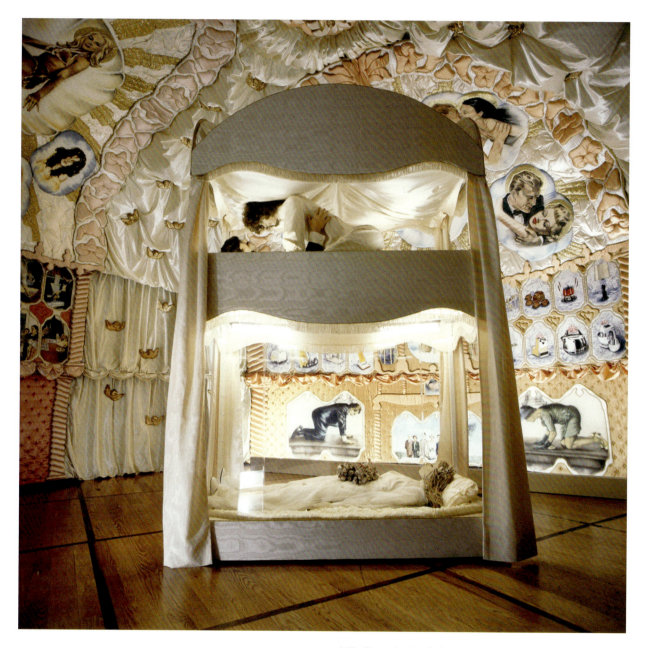

1.10 Francine Larivée and GRASAM, *La chambre nuptiale.*
Lit-tombeau et autel du couple (detail), 1976.

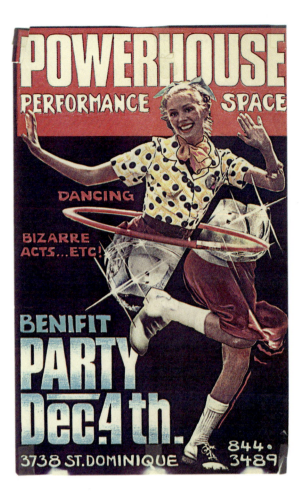

1.11 Poster promoting a benefit party for Powerhouse's performance space. Date unknown.

world to the centre of its most innovative practices. It is impossible in the space available here to fully document or even adequately convey the richness and intensity of feminist activity within the ebulliently countercultural artist-run milieu of the late 1970s and 1980s. The list of new feminist collectives, festivals, production and distribution cooperatives, performances, exhibitions, lectures, fundraisers, publications, and symposia is extraordinary. A bare-bones chronology of events in Vancouver alone, compiled by Carol Williams, runs to eleven densely packed pages.[38] A list documenting one year of women's art in Toronto makes mention of nine organizations and over twenty different events, ranging from several screening series curated by Lisa Steele and Marg Moores, to the Alter/Eros festival, an array of exhibitions and events that addressed issues surrounding female desire and sexuality.[39] The timeline that appears as an appendix in this book offers another vivid snapshot of the period.

Much of this activity, though by no means all, was connected with the parallel gallery scene. Here, insulated from the market and at arm's length from government intervention, feminism's deterritorializing politics increasingly found itself in line with art world tendencies. As Vancouver artist Laiwan has recalled of her founding of the Or Gallery, "My original intent was for artists, especially women, to take exhibition spaces into their own hands, and find locations for themselves, without the need for a board of directors, or stifling bureaucracy and hierarchy, without any need of patri-

archal acceptance … The origins of the Or was based on an extremely simple principle, one based on feminist theory of autonomy to fight patriarchal authority."[40] Michelle Nickel of Women in Focus spelled out the common interests of women's alternative art centres and the parallel galleries. Both, she observed, aimed to provide "spaces where artists can present new and experimental work and can develop ideas that may be unpopular according to entrenched social values, and censored by mainstream cultural institutions."[41] As they worked to articulate alternate visions of culture, art and feminism made common cause.

Looking back on the 1980s, the effectiveness with which women took things into their own hands is striking. Feminists did not just make art; they ran galleries, curated exhibitions, founded and edited journals, sat on juries and boards of directors, published reviews, gave lectures, and planned educational programming. Typically, they did not do just one or two of these things, but many of them. The early coordinators of Powerhouse were characteristic in this regard. During the 1980s, Tanya Mars, Linda Covit, and Nell Tenhaaf all occupied executive positions in the Association of National Non-Profit Artist Centres (ANNPAC). Mars was also editor of *Parallelogramme*, a member of the Women's Cultural Building Collective in Toronto, and a juror for multiple granting agencies; Covit was the vice-president of Véhicule gallery, and a juror for the Art Bank; Tenhaaf was a co-director of Artexte and a contributor of key feminist writings in *Fuse*, *Vanguard*, *Parachute*, *Parallelogramme*, and *C Magazine*. All were actively producing and curating feminist art. Similar characterizations might be made of dozens of other prominent feminist artists and writers across the country. To an unprecedented extent, then, the discourses and conventions that governed the artist-run scene were of women's own making. In January 1980 – with an editorial board that included the strong feminist voices of Carol Condé, Martha Fleming, Tanya Mars, and Lisa Steele – *Fuse* magazine dedicated its first issue to the subject of "Developing Feminist Resources." By 1983, ANNPAC had formally adopted a policy of gender equality; the feminist principle that gender mattered was firmly established.

It is not our intention to romanticize here. Laiwan's comments about the Or Gallery were made in the face of her later conviction that subsequent directors had abandoned its founding vision, and Nickel's account of the compatibility of feminist and artist-run visions was written in response to the realization that not all members of the parallel gallery network supported the existence of feminist art centres within it. Throughout the 1980s, women's battle for full access to the cultural infrastructure was experienced as just that: a battle. In Vancouver, hostilities that had begun in 1976 with the formation of "Women Artists Won't Kiss Ass" at the Vancouver School of Art, continued unabated in Sara Diamond's very public 1988 accusation that the institutional setting of contemporary art in the city was a tightly controlled boys' club.[42] In Halifax the trajectory was similar, with Barbara England's 1976 "Examination of Masculinism at NSCAD" being followed in 1982 with an article written by women at the college.[43] Their assessment: "Feminism is included in educational structures only in a co-opted and neutralized form. It must not threaten existing conventions, while contributing to a façade of art world progressiveness and contemporaneity."[44] Two

years later, Marusia Bociurkiw would come to the same conclusion about Toronto's artist-run community, drawing parallels between the short-term contracts and sporadic curriculum that marked the accommodation of feminism at NSCAD and the episodic festivals that then constituted the major venues for feminist art in Toronto.[45] For Bociurkiw, women's ambitious and high profile festivals appeared to proclaim that feminism had "arrived," while masking the absence of a sustaining infrastructure that would enable women to engage in the kind of ongoing critical self-examination necessary to the development of a fully realized feminist aesthetic discourse.

Money was of the essence. The 1970s policy of cultural democracy that first supported women's culture had not been lastingly integrated into federal and provincial arts funding, and with the election of the Mulroney government in 1984 Canada joined the Anglo-American turn to cultural conservatism. As cultural budgets dwindled, a wider anti-feminist backlash was experienced in the art world as growing indifference to a project for social change that was erroneously assumed to have been attained.[46] Faced with the threat of increased government intervention, the Canada Council staked out its ground on an avant-garde principle of aesthetic "excellence" – reinforcing art's separate status from politics and challenging legislators to back off from what they did not understand. But as feminist arts organizers pointed out to the council with increasing frustration, "the myth that art can be evaluated by universal, objective criteria serves to obscure the fact that what are called objective standards are only the standards of the dominant cultural grouping."[47] Arguing for a principle that had been government policy only the decade before, Lisa Steele was characteristically clear: "Cultural democracy may seem like an idealistic dream. But for women it is the only method which will make possible accurate representations of their lives and their concerns … Selection by definition involves exclusion. Many will not be allowed to run."[48] Among those who would no longer be allowed to run by the mid-1980s were London's Womanspirit Art Research and Resource Centre (1978–86) and Toronto's feminist Gallery 940 (1983–86) – neither of which was able to secure sufficient funding to continue their core activities.

In a climate of increased competition for dwindling arts funding, feminist artists and parallel galleries thus found that some kinds of aesthetic experimentation were more sanctioned than others. The borders of art were closely policed: work by Sara Diamond was refused a grant on the grounds of being "too feminist" and "not art"; the Ontario Arts Council advised feminist producers that they must focus on the aesthetic merits of their work in preference to a broader redefinition of culture; and Joyce Mason, the feminist editor of *Fuse* magazine, was advised by the Canada Council to tone down the journal's "stridency."[49] Increasingly, the fluid field of intersecting concerns intrinsic to "feminist art" was reterritorialized along clearly divided lines, and as Monika Kin Gagnon has astutely observed, the "political orientation of feminist work [was] forced to remain separate and prior to its engagement as artwork."[50] In multiple ways, then, the territorializations of the parallel gallery milieu – patriarchal and otherwise – were in constant struggle with its countercultural impulses. As we shall see, a similar process was at work within feminist art itself.

De/territorializing Feminist Discourse

What makes art "feminist"? Sheena Gourlay has persuasively theorized feminist art as a mobile coming together or articulation of two discursive fields – art and feminism – each of which is heterogeneously structured by shifting centres of power, specific to certain times and places.[51] Examining different strands of feminist thought in Quebec, Gourlay maps the subtle and often unspoken intersections that made women's art legible as "feminist" at different times. But even the more overt connections between women's art and the women's movement can be hard to assess. According to Tenhaaf, in Canada, unlike the United States, artistic links to grassroots feminist activism were always tenuous.[52] Similarly, when Bociurkiw assessed the state of feminist art in the 1980s she felt the need to advocate for stronger links to the women's movement as a whole.[53]

The ties that seemed loose in the 1980s had once been tighter, however. In the early 1970s the Flaming Apron had formally cooperated with a variety of Montreal women's centres, including the YWCA, Sororité, and the Women's Information and Referral Centre. For many years, the Women in Focus film and video collective was situated next to the offices of Vancouver Rape Relief, and the close community between the two groups is witnessed in a number of early film productions dealing with issues of violence against women.[54] The collective's archives also demonstrate connections with a wide spectrum of organizations and issues that made up the women's movement as a whole. Even in the 1980s, access-to-abortion rallies were advertised in the pages of *Fuse* magazine, and women artists participated actively in broader feminist initiatives such as *Fireweed* and the Women's Press in Toronto, *Kinesis* and the Press Gang in Vancouver, and the women's bookstores in both cities.[55] In Halifax, the performances of the Never Again Affinity Group (NAAGs) were closely connected to the women's peace movement.[56]

For artists, participation in the broader field of feminist activism presented territorializations and directives of its own to contend with. "In the women's movement itself," artist Catherine Tammaro observed, "there are so many rules about how to behave."[57] A peace activist and founder of the Women Artists' Collective at the Ontario College of Art, Tammaro also did graphics about women's reproductive health. It was here, around matters touching on sexuality, that the women's movement was at its most unruly (in the campaign for reproductive rights) *and* its most restrictive (in the campaign against pornography). Indeed, if there is one issue that divided feminist art from feminist activism more than any other it was sex, with the most vocal artists adopting an anti-censorship position that directly contravened the anti-pornography stance more common within the movement as a whole. Vancouver video artist Sara Diamond was one of the leading voices in the debate.[58] As a lesbian, Diamond had a keen appreciation of the inadequacy of normative representations of female sexuality and she made the case for artistic freedom in pursuit of an alternate visual imaginary. In this, Diamond and many of her feminist peers were allied with the gay community, which was increasingly being prosecuted for obscenity.[59] But they were also aligned

with earlier feminist artists, such as Badanna Zack, who had insisted in the pages of *Woman as Viewer* that women must claim their freedom to explore and articulate sexuality in art.[60]

It was not always an easy sell. Artists such as Tanya Mars would find that even ironic uses of female nudity were subject to censure by the broader women's movement, and Elizabeth Chitty remembers that when it came to navigating embodiment and sexuality, feminist performance artists often found it difficult to locate common ground with their political sisters.[61] "Claiming the right to own our sexual pleasure was highest on our youthful feminist agenda," Chitty recalls, but "a chill was descending, around the idea that bodies were not for display because they could not transcend the tyranny of the male gaze. Mary Kelly led the theoretical removal of women's bodies from art in the pages of *Parachute* magazine."[62] Kelly, an American artist based in the UK, also influenced the development of feminist art right across Canada, not only through her writing but through teaching stints at NSCAD in 1981 and the University of British Columbia in 1989. By mounting a psychoanalytic critique of *all* representation of the female body, Kelly effectively neutralized the anti-censorship/anti-porn debate. But while the new direction in art and criticism thus had the potential to ease a major point of tension between feminist artists and the women's movement, its heavily theorized nature erected new barriers between art and activism, as the theoretical density of art writing in the 1980s and 1990s enacted a disciplining of its own. The territorializations that structured the conjunction of "feminism" and "art" thus came from both sides of the equation.

Narrating Feminist Art

Kelly's writing has also had a significant impact on the historiography of feminist art in Canada. Typically, accounts of the movement's artistic history have been cast in terms of a developmental progression from artistic naivety to critical sophistication, in which an affirming but essentializing 1970s belief in a distinctive women's culture was a necessary "first step" that would be superseded in the 1980s by a deconstructive critique of knowledge and representation. The *Parachute* interview with Mary Kelly that Elizabeth Chitty references was the earliest articulation of this narrative to a specifically Canadian audience.[63] And certainly there is a broad swath of truth in the characterization, which conveys the impact on feminist arts practice of a nexus of phenomena including the rapid development of feminist philosophy and art history within the academy, the shift from modernist to postmodernist cultural narratives, and the massive importation of interdisciplinary theoretical discourse into the art world more broadly. But in effecting its own territorializing manoeuver on the history of feminist art, there is also much that this structuring narrative misses.

In Canada, the year 1982 emerges as a fulcrum in the developing storyline, as debate about the tenets and assumptions of feminist arts practice crystallized around three exhibitions. In Halifax, *Mirrorings: Women Artists of the Atlantic Provinces* was held at the Mount Saint Vincent University Art Gallery. In Toronto, Judy Chicago's

The Dinner Party drew record-breaking crowds at the Art Gallery of Ontario. And in Montreal, the Musée d'art contemporain coordinated its display of Chicago's work with a constellation of events known as *Art et féminisme*, including an exhibition, an extensive catalogue, two symposia, and a closely connected film festival.[64]

Mirorrings was curated by Avis Lang Rosenberg at the invitation of the gallery's director, Mary Sparling, who created numerous exhibition opportunities for the region's female artists during her tenure at Mount Saint Vincent. Following in the tradition of Sparling's own Slide Registry of Nova Scotia Women Artists (founded in 1975) *Mirrorings* was a celebratory exhibition that attempted to redress cultural exclusions by drawing public attention to the work of women.[65] Increasingly, however, feminist artists and art historians were critical of the limitations of such a "feminism of inclusion," and the exhibition was sharply criticized in the pages of *Parachute* by Vivian Cameron, Heather Dawkins, and Susan McEachern, who argued that "the fight against sexism cannot be effectively conducted by simply increasing the numerical representations of women without questioning the sources and pictorial carriers of that sexism."[66] Calling liberal feminism to account for its failure to contend with the social and psychic forces that reproduced patriarchy, they critiqued the inadequacy of Lang's curatorial attempt to counter the exclusion of women "as if it were an accidental oversight that could be corrected by increased public visibility of women's works alone."[67] As awareness of the need for a sharper critique of ideology developed, so too did a reappraisal of modernist aesthetic discourse and the means by which it determined artistic value.

These issues came to a head in the discourse and events surrounding *The Dinner Party*. Again, *Parachute* was on the attack; Chantal Pontbriand accused Chicago of *using* women by employing the posture of a feminist discourse in order to bolster her own professional status, thus reinforcing the very myth of the heroic artist-genius that had marginalized women in the first place.[68] Similar concerns were voiced in Toronto by the members of the newly founded Women's Cultural Building Collective, whose first public event was a symposium, "After the Dinner Party," where the merits and, more especially, the limitations of Chicago's work were vigorously contested.[69] Noting that admissions to *The Dinner Party* alone amounted to almost half of the Musée d'art contemporain's average yearly attendance, feminists were deeply sceptical of the work's appeal: "You can almost hear the motorized turnstiles now," commented Steele.[70]

In retrospect, what is of interest about these discussions is how little they focused on Chicago's use of the female body and the debate around an essential femininity that has subsequently been cast as central to the development of feminist art. Thus, while Steele objected in passing to Chicago's adoption of vaginal imagery to represent all women, by far the greater part of her critique focussed on the American artist's structural implication within the norms and values of the mainstream patriarchal art world, along with the class-based implications of a work that emphasized the cultural contributions of elite women. Indeed essentialism seems to have been sidestepped relatively quickly in Canada: taken up by some of the International Women's Year exhibitions

of 1975 (notably Mayo Graham's *Some Canadian Women Artists* at the National Gallery of Canada), but quickly losing its purchase on the feminist arts communities that those events helped to catalyze. True, it is possible to uncover occasional exhibitions of goddess imagery and vaginal iconography in the exhibition histories of Powerhouse and Women in Focus, but these were marginal practices.[71]

This is a point worth insisting on because of a tendency within feminist art historiography, both in Canada and internationally, to dismiss the feminist art of the 1970s as narrowly reductive and limiting. Monika Kin Gagnon, for example, writing about the development of feminist arts practice within Canada, rejected the aesthetic discourse of the 1970s as "maintaining and reinforcing sexual difference in static, immobile definitions focussing on biology."[72] For Gagnon, writing from the vantage point of 1987, such discourse was treacherously restrictive, and she tied it tightly to other key feminist strategies of the preceding decade, notably the validation of women's aesthetic traditions through the adoption of craft-based techniques, and the insistence on female experiences. Both of these she condemned as variants "of the feminist emphasis on biological difference, [which] in an equally dangerous way ghettoizes the work of women artists, by articulating a segregated definition and simultaneously reinforcing the marginal realm of the work."[73] Gagnon's argument would already have been familiar to careful readers of the Canadian art press, who could have encountered it in Kelly's 1981 *Parachute* interview (entitled "No Essential Femininity") or in Bociurkiw's 1984 *Fuse* article on "Women, Culture and Inaudibility." Significantly, both authors adopted a typology of feminist art production that had first been posed by Judith Barry and Sandy Flitterman in the UK periodical *Screen*. In their article, Barry and Flitterman had divided early feminist production into three categories: art that recovers and glorifies an inherent "feminine artistic essence"; art that valorizes the "hidden history" of women's handiwork; and art that advocates for the separateness of women. The first two categories were openly labelled as "essentialist" and all were negatively contrasted with a fourth and more up-to-date approach: art that engages with cultural texts and so gains "the power to criticize and deconstruct existing social constructs."[74] Bociurkiw's message to her feminist colleagues was clear: the 1980s were a time for Canadian artists to stop "celebrating" women and start engaging seriously with the project of critique.[75]

Critique, of course, has been essential to the internal development of feminism and to the characteristic rigour of its argumentation. Certainly the philosophical underpinnings and implications of essentialism warrant the extensive analysis they have received. But as Jayne Wark has observed, within art historical discourse, the anti-essentialist narrative also "led to the stratification of the historical trajectory of feminism along generational lines," resulting in bitter internecine disputes and a developmental narrative that does not adequately convey the complexity of the field.[76]

For one thing, such a progressivist narrative, in which a body-based 1970s essentialism is replaced by deconstructive 1980s critique, contradicts the recollections of key participants in the movement. Sharron Zenith Corne, one of the co-organizers of the 1975 *Woman as Artist* exhibition, explicitly repudiates any retrospective characteri-

zation of the show as essentializing, emphasizing instead the Marxian perspective of her fellow organizer Marian Yeo, who was committed to social, not biological, explanations of women's position.[77] The narrative also makes it hard to account for the discourse of feminist art in Quebec, where the influence of Hélène Cixous and Luce Irigaray was apparent in a continued foregrounding of the body throughout the 1980s. Irigaray had come to Montreal in 1982 to participate in one of the symposia attached to *Art et féminisme*, and the impact of her thought, like that of Cixous, is apparent in the catalogue texts of Suzanne Lamy and Diane Guay.[78] Rigorous in its methodological approach, no one could justly characterize *Art et féminisme* as being one of the naïve and purportedly essentializing "women's shows" of the 1970s, and yet as Gourlay has pointed out, the exhibition's entire premise remained firmly centred on the female body.[79] Indeed, French feminism brought together that which the Barry/Flitterman typology appeared to divide, binding the body to language, and grounding its critique of the symbolic in the very celebration of female corporeality that the new "textual turn" was supposed to eschew. In English Canada, where the need for translations created delay, French feminism's particular vein of embodied (and, many would argue, essentialist) thought would continue to fascinate artists well into the 1990s.

Another effect of the delayed adoption of the Barry/Flitterman typology in Canada is even more troubling, however: the implication that feminist art from the 1970s had been devoid of the capacity for critique. This was simply not the case, and any lingering illusions in this regard will be quickly dispelled by a viewing of Ardele Lister and ReelFeelings' 1976 short film *Where's My Prince Already?* in which an increasingly disillusioned female protagonist, clad in her wedding dress throughout, eventually dons a beret, takes up a brush, and paints "Fuck Housework" on the walls of her home. It is hard to make room for Lister in an account of 1970s feminist art that limits historical understanding by, to use Wark's elegant formulation, "construing and then dismissing an entire generation of thought and practice as monodimensional and categorically essentialist."[80] On such a telling, early feminist art could only lead to the confinement of women all the more firmly within the very boxes that they were attempting to escape.

But of course, the feminist art practices of the 1970s did not lead to this. Instead, they led directly to the feminist art of the 1980s, 1990s, and today. With the benefit of hindsight these connections are clear, and they have become clearer still in the years since *WACK! Art and the Feminist Revolution* (2007). Consider the photographic series of Suzy Lake from the early to mid-1970s, in which the artist explores her feminine identity in relation to social expectations while simultaneously calling into question the idea of a "real" or "genuine" self. In *Imitations of Myself #1* (1973) and again in *A Genuine Simulation of …* (1973–74), the artist uses cosmetics to replicate her own image on a ground of white makeup, emphasizing its artificiality. The multiple images of the grid format emphasize the process through which identity is crafted and assumed. Long before Judith Butler's concept of gender performativity had permeated artistic culture, Lake had demonstrated her clear understanding of feminine identity as constructed through self-presentation. Similarly, Lisa Steele's

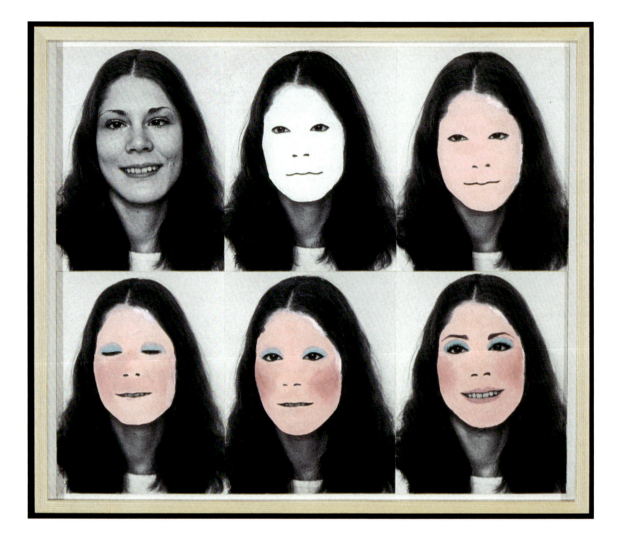

Above
1.12 Suzy Lake, *A Genuine
Simulation of ... No. 2*, 1974.

Right
1.13 Lisa Steele, *Birthday Suit with
scars and defects*, 1974.

Opposite
1.14 Mauve, *La femme et la ville*
(installation at Dupuis Frères), 1972.

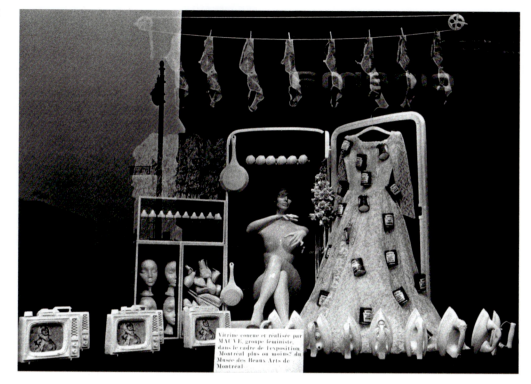

1974 treatment of her body in *Birthday Suit with scars and defects* further dissected the social and historical production of the female body. As the artist introduced each of the scars on her flesh, explaining how she had come by them, she employed formal manipulations to highlight her authorial presence, clearly signalling her control of the terms on which the audience would be allowed access to her body. First person address heightened the effect, further blurring the divide between viewer and viewed. The critical sophistication and anti-essentializing impulse of such work has been noted by Abigail Solomon-Godeau, who observes that women's early photographic self-representations rarely, if ever, conformed to the image that was later projected onto the feminist art of the 1970s.[81]

Other examples from the Canadian context bear out this conclusion more broadly. In Quebec, for example, 1970s work by Francine Larivée and the group Mauve was similarly disruptive, setting its critical sights on popular culture and received constructions of the feminine. Larivée's 1976 work *La chambre nuptiale* (see fig. 1.10) used life-sized sculptural representations of women's experiences – from childbirth and intercourse to dishwashing and applying makeup – to provoke critical consideration of the gap between Hollywood-inspired narratives of couplehood and women's lived realities within marriage. Parallel considerations governed the 1972 installation *La femme et la ville*, in which the women of Mauve took over the window of Dupuis Frères, a leading Montreal department store, with the aim of reappraising the sexualized consumption of women's bodies and laying bare the role of the bride as consumer within a capitalist society.[82] In both instances, female experience was not essentialized but rather presented as heavily mediated by representation and the discursively constructed roles that women had been trained to adopt.

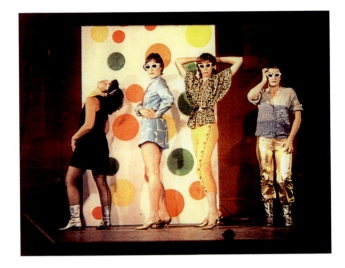

1.15 The Clichettes, *You Don't Own Me*, 1978. Performance at The Fifth Network / Cinquième Réseau National Video Conference held in September 1978 at the Masonic Temple in Toronto. The Clichettes performed for the first time in Lamont Del Monte's (David Buchan) *Fruit Cocktails*.

Opposite
1.16 Sorel Cohen, *Le rite matinal*, 1977.

Deconstruction of gendered identity was also central to the performances of The Clichettes.[83] In 1978, as they lip-synched the words to Lesley Gore's "You Don't Own Me," The Clichettes moved from camp imitation to feminist manifesto, pounding their fists on a Toronto stage while they mouthed out the song's refrain: *And don't tell me what to do / Don't tell me what to say / And please when I go out with you / Don't put me on display*. Drawing on drag traditions that have now been extensively theorized through the lens of gender performativity, The Clichettes both adopted and undermined the roles created for women by popular culture, queering femininity with their suggestion that "even women are female impersonators."[84] As they choreographed their way into and out of rigidly codified feminine appearances and behaviours, The Clichettes, like Vancouver artist Kate Craig and Toronto performance group the Hummer Sisters before them, blurred clearly defined identities in a way that no essentialist perspective could achieve. In Marni Jackson's words, they were "women engaged in the mimicry of women – gender as performance."[85] Their parodic humour cut like a knife through notions of originary femininity.

Still other feminist artworks by Canadian women working in the 1970s can be appreciated for the ways in which they bucked the restrictive tendencies now associated with essentialism. Joyce Wieland is rightly remembered as a proponent of a distinctive feminine sensibility, but her valorization of women's traditional creative techniques of quilting and embroidery did not lock her within a feminized ghetto so much as it contributed to the dismantling of art world constraints that compartmentalized and hierarchized "fine art" and "women's work." Similar deterritorializations were effected by Evelyn Roth and Sorel Cohen, who turned their female bodies, skills, and experiences to deconstructive rather than essentializing ends. In 1973, just as the first feminist organizations were forming in Vancouver, Roth recoded technology by taking recycled videotape as the medium for her recycled crocheted pieces (see fig. 1.5). As Tagny Duff has observed, Roth's unorthodox juxtaposition of crochet and videotape challenged "the traditional dichotomy of low art (craft) as women's work and high art (technology) as men's labour," further destabilizing the easy confinement of either.[86] In Montreal, Sorel Cohen took her female experience of housework as the

basis for formal aesthetic investigation, transforming her three-dimensional performance of daily household tasks into two-dimensional images that referenced both the gestural qualities of painting and the seriality of conceptualist photography. In both instances, feminist practice emerges as an intervention into and disruption of existing aesthetic vocabularies and codes.[87] Similar observations might be made of the early sculptural work of Aganetha Dyck, who, beginning in 1975, made laundry the core of her studio practice. In each case, the exploration of female experience resulted not in a delimiting restriction of women to a particular ghetto of "feminine" artistic production, but rather to a broadening of the confines and conventional demarcations of artistic practice, as women used their gendered experiences to dismantle the boundaries between art and life. Even artworks quite closely tied to the women's liberation movement expanded beyond the brief of presenting a unified view of "genuine" female subjectivity. The coloured pencil drawings of Sharron Zenith Corne, for example, do not espouse essential femininity but rather explore the concept of androgyny, melding masculine and feminine forms in surreal manipulations that now seem comfortably at home in the context of queer dismantlings and reorientations of identity.

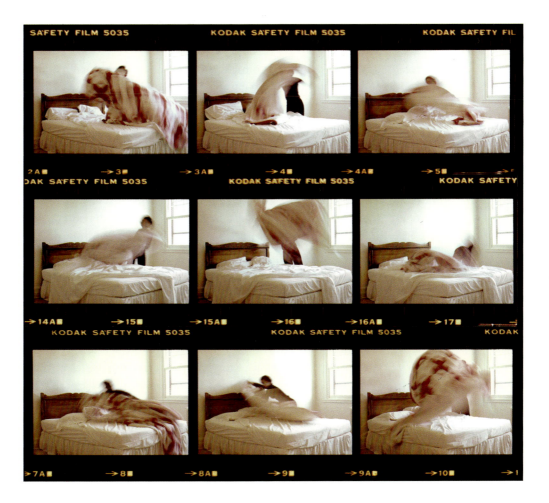

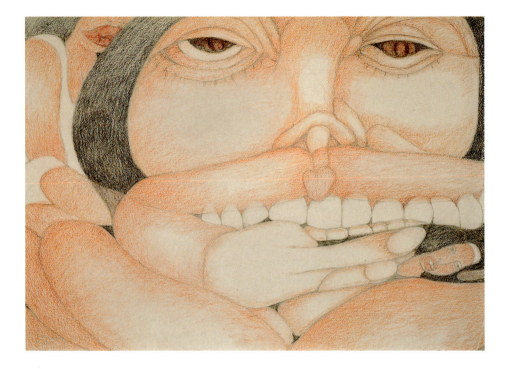

1.17 Sharron Zenith Corne, *Pink Ferocious Mouth*, 1982.

A Spare Bedroom in the Master's House?

We have chosen these examples to make an argument: that since its beginnings in the 1970s, much of the effort of feminist artists has been directed towards breaking down rigid categorizations, essential identities, and restrictive limitations. In answer to the question we posed at the beginning of this essay we would like to be clear: second-wave feminist art in Canada was not primarily an art of "essentialized bodies and single-issue gender politics." Indeed, the foundations of third-wave intersectionality were already being laid in the 1970s, by artists such as Persimmon Blackbridge and Sima Elizabeth Shefrin, whose *Bimini Quilt* (1978) honoured striking members of the Service, Office, and Retail Workers' Union of Canada – an independent, grassroots feminist labour union representing employees of Vancouver's Bimini pub.[88] The overlapping of class and gender was also Diamond's central concern when she founded the Women's Labour History Project in 1978. Were we to extend our account of second-wave feminist art into the 1980s, questions of race, ethnicity, and sexual identity would become central to the story. By the mid-1980s the creative productions of lesbians, black women, Asian women, and Indigenous women had all further deterritorialized the conjunction of feminism and art in Canada, leading Dot Tuer to wonder whether feminist artists up to that point had perhaps done little more than create "a spare bedroom in the master's house."[89] Our vision of the past is more sanguine, for one of the things we hope to have demonstrated in this essay is that the boundary-crossing, limit-contesting, non-essentializing impetus that has come to be characterized as third-wave feminism was not only a *challenge* to second-wave feminist artists (though it was that too, especially on matters of race) but also a *continuation* of the deterritorializations that were already present in their vision. As we have endeavoured

to show in the early sections of this chapter, such deterritorializations were always offset by other forces. Race-based privilege, professionalization, economic constraints, political and theoretical orthodoxies of various sorts: all these played out within and against early feminism's ludic and oppositional fervour. But the territorializations with which second-wave feminist art in Canada contended were not always those that have been projected on to it in retrospect. The image of a monolithic 1970s essentialism that limited women in the name of freeing them, and that naively celebrated their accomplishments in the place of dismantling discursive constructs and destabilizing identity, does not adequately convey the character of early feminist art practice in Canada. Perhaps more importantly still, it risks cutting contemporary practitioners off from a legacy of aesthetic and conceptual nourishment that is rightly theirs as they work to effect changes that remain to be accomplished.

Art historiography is a worrisome task, as those who have written earlier accounts of feminism and art in Canada have realized. In Carol Williams's thoughtful preface to her chronology of feminist cultural activities and events in Vancouver, she explains her decision not to write an interpretive historical essay in terms of her unwillingness to commit the exclusions that such a process would necessarily have entailed. "I recognized that my single voice was incapable of conclusively representing all the divergent characteristics and actions of feminist practitioners," she wrote. "I wished to divest myself of such singular authority."[90] Related concerns have also been voiced by Gagnon and especially by Tenhaaf, who asserted that women could not write feminist history even if they wanted to because the epistemological basis for the project was unsound. "Writing history," in Tenhaaf's view, "demands objective and value-free points of view that are, ostensibly at least, not impeded by political bias. The aim of these master discourses is to make both the subject who speaks and the subject at hand singular, authoritative and universal. So the idea of a sanctionable feminist version of history that balances the androcentric version is very problematic, if not impossible."[91]

Fortunately for us, the restrictions of a short essay on such a broad topic have relieved us of any expectation to be exhaustive or even fully representative. We are aware that we have left many important individuals, artworks, and events unmentioned – and we wish our readers to be aware of this as well.[92] But happy as we are to shelter in the refuge of "length restrictions," we consider ourselves more fortunate still in the nature of the task we were given: not to attempt a history of feminist art in Canada in the sense that Tenhaaf had in mind, but to outline an historical context for the contemporary art to follow in the pages of this book. Such a brief is in line with Joan Scott's and Drucilla Cornell's ideas that feminist history takes place in the future anterior – that the task is not to authoritatively state *what was* but to open a window to that which *will be seen to have been* from the perspective of a still uncertain future.[93] This, for instance, is the view of the 1970s that artist Ulrike Müller has advocated. In a roundtable discussion on "Feminist Time," Müller expressed her impatience with any tendency to romanticize the decade that produced the Women's Liberation Movement. "The 1970s isn't a glorious past," Müller observed, "it was a terrible time. So

the question is: what can we glean from earlier feminisms for our current moment?"[94] We agree. But together with Scott and Cornell, we would like also to insist on the importance of what is yet to come. In keeping with the theme of this book, we offer this particular version of the past not as a neutral accounting but as the active inscription of feminist desire. This, we insist, is a legitimate practice: not a wilful manipulation of history, but its reactivation for what is still to come. In drawing the outlines of historical context, we hope also to be laying out the conditions of possibility for conceivable futures.

The desire of feminism is for a future that is different from the reality we currently inhabit. For this reason, as Elizabeth Grosz has argued, the desire of the feminist historian is to enable other futures to be imagined.[95] In putting forward our historical context for contemporary feminist art in Canada, we willingly and gratefully adopt the language of the second wave, as we look to a more "liberated" future: a future where gender, ethnicity, class, and sexuality can be experienced not as restrictions but as potentials, and where the cultural edifices that we construct will not be spare bedrooms in the master's house but enriching environments in which to dwell, traversed by forces that bring to us – and draw out from us – far more than they take away.

NOTES

1 On the socio-political impact of yarn bombing see Mann, "Towards a Politics of Whimsy."
2 Zola, "Global Track Interview."
3 The phrase, though not the judgment, is Jayne Wark's in this volume, 111.
4 Zola, "Global Track Interview."
5 The quotation, given here in its original English as first written by Beth Ann Pentney, is paraphrased in French on the yarn bombing blog *Tricot pour la paix* (see "Féminisme," *Tricot pour la paix*, 19 December 2012, http://tricotpourlapaix. com/2012/12/19/feminisme/). See also Pentney, "Feminism, Activism, and Knitting."
6 St-Gelais, "Féminismes et performativité"; and Tembeck, "Re-performer le matrimoine."
7 Loosely Deleuzian in origin, our terminology here and throughout the essay reflects an understanding of lived experience as shot through with forces that coalesce into coded structurations that delimit and restrict subjectivity (territorialization) but that are also subject to an opposing process (deterritorialization) as forces move and codes are put to work differently. We would argue that gender is typically experienced as a territorialization.
8 "Distaff Side Active in Art," *The Montreal Daily Star*, 17 March 1942. See also the list of members in the archival holdings of the Archives de la Ville de Montreal, Fonds Ligue des droits de la femme, Archives de la Ville de Montreal, BM14, S1, D2.3. Savage's views were echoed by Marion Long: "Miss Marion Long, for the artists, said there was now sex equality in the art gallery and the paintings were judged on their merits, not as the product of man or woman." "Stress Women's Part in Many Professions," *Toronto Daily Star*, 24 November 1930.
9 In the Canadian art world, the readiest example is women's campaign for admission to full membership in the Royal Canadian Academy. See Davies, "Canadian Women of Brush and Chisel."
10 By 1964 Betty Friedan's *The Feminine Mystique* (1963) had engendered considerable discussion in both English and

French Canada; the author was interviewed at least three times by the CBC. The influence of those discussions is clear in the commission's conclusion that "If women are to attain equality there must be a change in the whole expectation of husband and wife. Marriage must be a partnership where each is free to pursue a career and is equally responsible for the home and family." *Report of the Royal Commission on the Status of Women in Canada*, 4.

11 Mauve consisted of Catherine Boivert, Ghislaine Boyer, Thérèse Isabelle, Céline Isabelle, Lise Landry, and Lucie Ménard. See Stratica-Mihail, "I Don't," especially 21–3.

12 Boggs, "In Canada, a Place for Women," 30.

13 The figures cited here are for 1973 and 1973–74, respectively. See Rosenberg, "Women Artists and the Canadian Artworld"; Martin, "Who Judges Whom"; and McInnes-Hayman, *Contemporary Canadian Women Artists*. Later versions of Rosenberg's study were published in *Kinesis* and *Fuse* (in March and May of 1980), and statistics gathered by Sharron Zenith Corne were presented in *Women Artists in Manitoba*, prepared for the Provincial Council of Women of Manitoba, and published by the council in 1981.

14 Examples included the *International Women's Year Exhibition of Women Artists* at the Arts and Culture Centre of St John's, NL; *Women Artists of PEI* at the Confederation Centre in Charlottetown; *Some Nova Scotia Women Artists* at the Mount Saint Vincent University Art Gallery in Halifax; *Art Femme '75* in Montreal at Powerhouse Gallery, the Musée d'art contemporain, and the Saidye Bronfman Centre; *Photography '75 / The Female Eye*, a travelling exhibition organized by the National Film Board in Ottawa, as well as *Some Canadian Women Artists* at the National Gallery of Canada; *From Women's Eyes: Women Painters in Canada* at the Agnes Etherington Art Centre in Kingston; *Images of Women* and *Woman as Viewer* at the Winnipeg Art Gallery; and the *International Women's Year Exhibition: A Selection from the Simon Fraser Collection* at the Surrey Art Gallery and Simon Fraser University Gallery.

15 The committee's "Manifesto in Defense of Women Artists" is preserved in the Winnipeg Art Gallery Archives (Correspondence re: International Women's Year Exhibitions: *Images of Woman* and *Woman as Viewer* 1975 [Roger Selby records], file A6.04, Winnipeg Art Gallery fonds). Our thanks to Andrew Kear.

16 See Corne, "Women in Exhibition"; and Earl, "Boob Tree Raises Cult."

17 Committee for Women Artists, *Woman as Viewer*, 3.

18 Ibid., 3–4.

19 In her history of Canadian feminism, Judy Rebick claims that the Canadian women's movement was unique in the world for the way in which it included Indigenous and immigrant women from the beginning (Rebick, *Ten Thousand Roses*, xii). That such diversity did not characterize the Canadian art world was the clear message of the Minquon Panchayat caucus, formed in 1992 to represent the concerns of artists of colour and First Nations artists. See Gagnon, *Other Conundrums*.

20 Committee for Women Artists, *Woman as Viewer*, 8.

21 See Rosenberg, "Codpieces: Phallic Paraphernalia."

22 Sorkin, "The Feminist Nomad," 460–1.

23 Lauzzana, "Artfemme '75," 13. The exhibition was coordinated by Powerhouse, the Musée d'art contemporain, the Saidye Bronfman Centre, and the YMCA, with exhibitions held at the first three locations.

24 CARFAC is the Canadian Artists' Representation / Le front des artistes canadiens, known almost always by its acronym.

conjunction with the self-identified feminist artists in this chapter. We would agree with the curators of WACK!, however, that the question of artistic intent cannot be the sole determinant of a work's feminist content.

86 Duff, "FFWD, RWD, and PLAY," 44.

87 Gourlay, "Feminist/Art in Quebec," 128–30.

88 Blackbridge and Shefrin, "About the Bimini Quilt," 1.

89 Tuer, "From the Father's House." Important early exhibitions addressing lesbian identity and desire were mounted in Vancouver in 1982 (*Woman to Woman* at Women in Focus) and in Toronto in 1987 (*Sight Specific: Lesbians and Representation* at A Space). Consideration of race and racism within the Canadian women's movement was the subject of a landmark issue of *Fireweed* in 1983. In the fine arts, significant events included the 1989 exhibitions *Black wimmin: when and where we enter*, organized by the Diasporic African Women's Art Collective at the Eyelevel gallery in Halifax, and *Making Ourselves Visible: Breaking Down the Barriers of Racism in the Visual Arts* at Women in Focus. Race was also a focus at the Feminism and Art Conference organized by the Women's Art Resource Centre in Toronto in 1988. For coverage of debates, see *Locations: Feminism, Art, Racism, Region*, a special WARC insert in the spring 1989 issue of *Parallelogramme*.

90 Williams, "A Working Chronology," 171.

91 Tenhaaf, "A History or a Way of Knowing," 78.

92 Perhaps most notable is our complete omission of feminist art outside of Canada's major cities.

93 Scott, *Gender and the Politics of History*; Cornell, "Rethinking the Time of Feminism."

94 Deutsche et al., "Feminist Time," 36.

95 Grosz, "Histories of the Present and Future."

BIBLIOGRAPHY

Arbour, Rose-Marie, et al. *Art et féminisme: Musée d'art contemporain, Montréal, 11 mars–2 mai 1982*. Québec: Ministère des affaires culturelles, 1982.

Arbour, Rose-Marie, and Suzanne Lemerise. "The Role of Quebec Women in the Plastic Arts of the Last Thirty Years." *Vie des arts* 20, no. 78 (1975): 65–7.

Arts and Letters Committee for the Provincial Council of Women of Manitoba. *Women Artists in Manitoba: A Report*. Winnipeg: Provincial Council of Women of Manitoba, 1981.

Bailey, Buseje, Leslie Corry, Adrienne Else, and Kim Fullerton. *Locations: Feminism, Art, Racism, Region: Writings and Artworks*, editor in chief Joyce Mason, originally published by Women's Art Resource Centre, Toronto. Special WARC insert in *Parallelogramme* (Spring 1989).

Barry, Judith, and Sandy Flitterman. "Textual Strategies: The Politics of Art Making." *Screen* 21, no. 2 (1980): 35–48.

Baxter, Danielle. "Vancouver Women in Focus Society, An Inventory of Their Papers From 1974–1983." Unpublished finding aid from the University of British Columbia's Special Collections, 1989.

Blackbridge, Persimmon, and Sima Elizabeth Shefrin. "About the Bimini Quilt." *Kinesis* 7 no. 2 (January 1978): 1.

Bociurkiw, Marusia. "Territories of the Forbidden: Lesbian Culture, Sex and Censorship." *Fuse* (March/April 1988): 27–32.

– "Women, Culture and Inaudibility." *Fuse* (Summer 1984): 47–54.

Boggs, Jean Sutherland. "In Canada, a Place for Women." *Artnews* (September 1974): 30–2.

Borsa, Joan. *Rewriting the Script: Feminism and Art in Ontario*. Videorecording. Toronto: Women's Art Resource Centre, 1988.

Bruhy, Billie Jo. "The Flaming Apron Women's Craft Store: An Experience through the Collectivity." MA thesis, Concordia University, 1974.

Burstyn, Varda. "Art and Censorship." *Fuse* (September/October 1983): 84–90.

55 See, for example, Rosemary Donegan's
contribution to *Parallellogramme*'s femi-
nist roundtable, "Fuck Yous, I'm Goin'
to Bingo!," 38.

56 Needham, *Women and Peace Resource
Book*, 41.

57 Tammaro quoted in Parker, "The Status
of Women," 38.

58 Diamond, "Of Cabbages and Kinks."
See also Bociurkiw, "Territories of the
Forbidden"; Burstyn, "Art and Censor-
ship"; and Gronau, "Censorship: Caught
in the Crossfire." *Fuse* in particular pub-
lished many pieces on the topic of cen-
sorship.

59 It was a fate that would befall feminist
art as well. In 1985 obscenity charges
were laid against Pages bookstore in
Toronto, which had made its store win-
dow available for the installation *It's a
Girl!* by the three-woman collective
Woomers. Among many objects on dis-
play, the installation included sanitary
napkins with red paint, unopened tam-
pon packets, and plaster phalluses. See
Woomers, "The Re-education of P.C.
Gordon."

60 Committee for Women Artists, *Woman
as Viewer*, 5.

61 Chitty, "You Can't Rock the Boat," 117,
128. Chitty also describes the furore over
a poster designed by Tanya Mars (then
Rosenberg) for the 1979 *Fireweed* play-
writing competition. Entitled "... but can
she write?," the poster showed Mars in
the guise of a blonde bombshell grasping
an electric typewriter in front of her
naked body.

62 Chitty, "Asserting Our Bodies," 82–3.

63 Kelly and Smith, "No Essential Feminin-
ity," 31–5.

64 Also in 1982, the *Réseau Art-Femme*
exhibitions were held in Quebec City,
Chicoutimi, Sherbrooke, and Montreal.
See Gourlay, "Feminist/Art in Quebec,"
150–75.

65 On the registry see Davis, "Visibility,"
52–3.

66 Cameron, Dawkins, and McEachern,
"Mirrorings," 33.

67 Ibid.

68 Pontbriand, "Judy Chicago," 38.

69 The papers from the symposium were
published in a special issue of *Fireweed*
(15, Winter 1982) called "After the Din-
ner Party's Over: Special Report on
Women and Writing in Canada," edited
by Rosemary Donegan and Joyce Mason.

70 Steele, "Women's Cultural Building," 4.
See also Steele, "The Judy Chicago Para-
dox," 93–5.

71 Leafing through the early issues of *Paral-
lelogramme*, for example, these tenden-
cies are apparent in exhibitions by
Corinne Kingma, Robin Barnett, and
Mary Milne.

72 Gagnon, "Work in Progress," 106.

73 Ibid., 109.

74 Barry and Flitterman, "Textual Strate-
gies," 37–44.

75 Bociurkiw, "Women, Culture and Inaudi-
bility," 51, 54.

76 Wark, *Radical Gestures*, 82.

77 Sharron Zenith Corne, personal commu-
nication, 20 July 2016.

78 Lamy, "À couleurs rompues" 15–26;
Guay, "Parler d'elles à partir d'elles-
mêmes," 27–42.

79 Gourlay, "Feminist/Art in Quebec,"
119–49.

80 Wark, *Radical Gestures*, 82.

81 Solomon-Godeau, "The Woman Who
Never Was," 337–9, 344.

82 See Stratica-Mihail, "I Don't," especially
25–6.

83 The members of the Clichettes were
Johanna Householder, Louise Garfield,
Janice Hladki, and (sometimes) Elizabeth
Chitty.

84 Jackson, "The Clichettes," 161.

85 Ibid., 162. Craig's adoption of the Lady
Brute persona, and particularly her 1975
retirement of that identity in *Skins:
Lady Brute Presents Her Leopard Skin
Wardrobe*, worked in a similar way. So
did the performances of the Hummers.
Because Craig disavowed her relation to
feminism and the Hummers considered
themselves to be postfeminists, we
have not discussed them in immediate

conjunction with the self-identified femi-
nist artists in this chapter. We would
agree with the curators of WACK!, how-
ever, that the question of artistic intent
cannot be the sole determinant of a
work's feminist content.

86 Duff, "FFWD, RWD, and PLAY," 44.
87 Gourlay, "Feminist/Art in Quebec,"
 128–30.
88 Blackbridge and Shefrin, "About the
 Bimini Quilt," 1.
89 Tuer, "From the Father's House." Impor-
 tant early exhibitions addressing lesbian
 identity and desire were mounted in Van-
 couver in 1982 (*Woman to Woman* at
 Women in Focus) and in Toronto in 1987
 (*Sight Specific: Lesbians and Representa-
 tion* at A Space). Consideration of race
 and racism within the Canadian women's
 movement was the subject of a landmark
 issue of *Fireweed* in 1983. In the fine
 arts, significant events included the 1989
 exhibitions *Black wimmin: when and
 where we enter*, organized by the Dias-
 poric African Women's Art Collective at
 the Eyelevel gallery in Halifax, and *Mak-
 ing Ourselves Visible: Breaking Down
 the Barriers of Racism in the Visual Arts*
 at Women in Focus. Race was also a
 focus at the Feminism and Art Confer-
 ence organized by the Women's Art Re-
 source Centre in Toronto in 1988. For
 coverage of debates, see *Locations: Femi-
 nism, Art, Racism, Region*, a special
 WARC insert in the spring 1989 issue of
 Parallelogramme.
90 Williams, "A Working Chronology,"
 171.
91 Tenhaaf, "A History or a Way of Know-
 ing," 78.
92 Perhaps most notable is our complete
 omission of feminist art outside of
 Canada's major cities.
93 Scott, *Gender and the Politics of History*;
 Cornell, "Rethinking the Time of Femi-
 nism."
94 Deutsche et al., "Feminist Time," 36.
95 Grosz, "Histories of the Present and
 Future."

BIBLIOGRAPHY

Arbour, Rose-Marie, et al. *Art et féminisme: Musée d'art contemporain, Montréal, 11 mars–2 mai 1982*. Québec: Ministère des affaires culturelles, 1982.
Arbour, Rose-Marie, and Suzanne Lemerise. "The Role of Quebec Women in the Plastic Arts of the Last Thirty Years." *Vie des arts* 20, no. 78 (1975): 65–7.
Arts and Letters Committee for the Provincial Council of Women of Manitoba. *Women Artists in Manitoba: A Report*. Winnipeg: Provincial Council of Women of Manitoba, 1981.
Bailey, Buseje, Leslie Corry, Adrienne Else, and Kim Fullerton. *Locations: Feminism, Art, Racism, Region: Writings and Artworks*, editor in chief Joyce Mason, originally published by Women's Art Resource Centre, Toronto. Special WARC insert in *Parallelogramme* (Spring 1989).
Barry, Judith, and Sandy Flitterman. "Textual Strategies: The Politics of Art Making." *Screen* 21, no. 2 (1980): 35–48.
Baxter, Danielle. "Vancouver Women in Focus Society, An Inventory of Their Papers From 1974–1983." Unpublished finding aid from the University of British Columbia's Special Collections, 1989.
Blackbridge, Persimmon, and Sima Elizabeth Shefrin. "About the Bimini Quilt." *Kinesis* 7 no. 2 (January 1978): 1.
Bociurkiw, Marusia. "Territories of the Forbidden: Lesbian Culture, Sex and Censorship." *Fuse* (March/April 1988): 27–32.
– "Women, Culture and Inaudibility." *Fuse* (Summer 1984): 47–54.
Boggs, Jean Sutherland. "In Canada, a Place for Women." *Artnews* (September 1974): 30–2.
Borsa, Joan. *Rewriting the Script: Feminism and Art in Ontario*. Videorecording. Toronto: Women's Art Resource Centre, 1988.
Bruhy, Billie Jo. "The Flaming Apron Women's Craft Store: An Experience through the Collectivity." MA thesis, Concordia University, 1974.
Burstyn, Varda. "Art and Censorship." *Fuse* (September/October 1983): 84–90.

French Canada; the author was interviewed at least three times by the CBC. The influence of those discussions is clear in the commission's conclusion that "If women are to attain equality there must be a change in the whole expectation of husband and wife. Marriage must be a partnership where each is free to pursue a career and is equally responsible for the home and family." *Report of the Royal Commission on the Status of Women in Canada*, 4.

11 Mauve consisted of Catherine Boivert, Ghislaine Boyer, Thérèse Isabelle, Céline Isabelle, Lise Landry, and Lucie Ménard. See Stratica-Mihail, "I Don't," especially 21–3.

12 Boggs, "In Canada, a Place for Women," 30.

13 The figures cited here are for 1973 and 1973–74, respectively. See Rosenberg, "Women Artists and the Canadian Artworld"; Martin, "Who Judges Whom"; and McInnes-Hayman, *Contemporary Canadian Women Artists*. Later versions of Rosenberg's study were published in *Kinesis* and *Fuse* (in March and May of 1980), and statistics gathered by Sharron Zenith Corne were presented in *Women Artists in Manitoba*, prepared for the Provincial Council of Women of Manitoba, and published by the council in 1981.

14 Examples included the *International Women's Year Exhibition of Women Artists* at the Arts and Culture Centre of St John's, NL; *Women Artists of PEI* at the Confederation Centre in Charlottetown; *Some Nova Scotia Women Artists* at the Mount Saint Vincent University Art Gallery in Halifax; *Art Femme '75* in Montreal at Powerhouse Gallery, the Musée d'art contemporain, and the Saidye Bronfman Centre; *Photography '75 / The Female Eye*, a travelling exhibition organized by the National Film Board in Ottawa, as well as *Some Canadian Women Artists* at the National Gallery of Canada; *From Women's Eyes:*

Women Painters in Canada at the Agnes Etherington Art Centre in Kingston; *Images of Women* and *Woman as Viewer* at the Winnipeg Art Gallery; and the *International Women's Year Exhibition: A Selection from the Simon Fraser Collection* at the Surrey Art Gallery and Simon Fraser University Gallery.

15 The committee's "Manifesto in Defense of Women Artists" is preserved in the Winnipeg Art Gallery Archives (Correspondence re: International Women's Year Exhibitions: *Images of Woman* and *Woman as Viewer* 1975 [Roger Selby records], file A6.04, Winnipeg Art Gallery fonds). Our thanks to Andrew Kear.

16 See Corne, "Women in Exhibition"; and Earl, "Boob Tree Raises Cult."

17 Committee for Women Artists, *Woman as Viewer*, 3.

18 Ibid., 3–4.

19 In her history of Canadian feminism, Judy Rebick claims that the Canadian women's movement was unique in the world for the way in which it included Indigenous and immigrant women from the beginning (Rebick, *Ten Thousand Roses*, xii). That such diversity did not characterize the Canadian art world was the clear message of the Minquon Panchayat caucus, formed in 1992 to represent the concerns of artists of colour and First Nations artists. See Gagnon, *Other Conundrums*.

20 Committee for Women Artists, *Woman as Viewer*, 8.

21 See Rosenberg, "Codpieces: Phallic Paraphernalia."

22 Sorkin, "The Feminist Nomad," 460–1.

23 Lauzzana, "Artfemme '75," 13. The exhibition was coordinated by Powerhouse, the Musée d'art contemporain, the Saidye Bronfman Centre, and the YMCA, with exhibitions held at the first three locations.

24 CARFAC is the Canadian Artists' Representation / Le front des artistes canadiens, known almost always by its acronym.

25 For an overview of the period prior to 1970, see Huneault and Anderson, *Rethinking Professionalism*. On the exhibition see Corne, "Women in Exhibition."

26 Poteet, "Powerhouse Montreal Women's Gallery," 19. The manifesto circulated to protest *ArtFemme '75* explicitly framed its objections in these terms: "*L'exposition* ART-FEMME = *rendre les femmes concurrentes autour de la notion fumeuse de 'professionalisme,' ... art professionnel = art d'homme.*" In "Exposition ART-FEMME, pourquoi-pas? pis après?," La Centrale Fonds, P128, HA1728, Concordia University Archives.

27 Bruhy, "The Flaming Apron Women's Craft Store," 38–42.

28 Ibid., 36.

29 Nell Tenhaaf makes a similar observation, in different language, in her historical account of La Centrale Galerie Powerhouse. See Tenhaaf, "A History or a Way of Knowing."

30 Neither of the two major articles on Wieland in *Artscanada* in the 1970s made any mention of feminism. See McPherson, "Wieland: An Epiphany of North," and Sitney, "There Is Only One Joyce."

31 Lake made her comments in an interview in Borsa, *Rewriting the Script*. See also Arbour and Lemerise, "The Role of Quebec Women," 66.

32 Baeker, "National Report [for] Canada," cited in Carvalho, *La chambre nuptiale de Francine Larivée*, n.p.

33 Carvalho, *La chambre nuptiale de Francine Larivée*.

34 Larivée, "La Chambre Nuptiale 'sous silence,'" 39.

35 Roy and Won, "Direct Job Creation Programs," 16.

36 Ibid.

37 On the history of Powerhouse, see Fraser and Johnstone, *Instabili*; and Stratica-Mihail, "Feminist Beginnings." "Parallel galleries" were so-designated to signify their status as alternatives that ran alongside commercial and institutional galleries. After the founding of the Association of National Non-Profit Artist Centres (ANNPAC) in 1976, they gradually became known as "artist-run centres."

38 Williams, "A Working Chronology."

39 Waugh, "Feminist Art in Toronto," 29.

40 Laiwan, letter published in *Artery*, Summer 1988, cited in Williams, "A Working Chronology," 202.

41 Nickel, "Some Perspectives," 10.

42 Diamond, "The Boys Club," 12–13.

43 England was an MFA student at the time. Her unpublished paper, which circulated widely within the college, is preserved at NSCAD University.

44 "A History of Feminism at N.S.C.A.D.," 11.

45 Bociurkiw, "Women, Culture and Inaudibility." The Toronto festivals included Women's Perspective '83 and Women Building Culture (also in 1983), Alter/Eros (in 1984), and FemFest (in 1985). For coverage, see Kwinter and Mason, "Alter Eros"; and Rubess, "Building Culture."

46 On this phenomenon, see Tenhaaf, "Trough of the Wave."

47 Gallery 940's letter to the Canada Council is quoted in Spires and Wilson, "Stopping Women's Art II," 9.

48 Steele, "Women's Cultural Building," 5.

49 See Spires and Wilson, "Stopping Women's Art II," 9; and Mason, "Celebratory Vigour," 2.

50 Gagnon, "Work in Progress," 106.

51 Gourlay, "Feminist/Art in Quebec." Other major texts dealing feminist art in Quebec are *Art et féminisme* and *Féministe toi-même*.

52 Tenhaaf, "A History or a Way of Knowing," 81.

53 Bociurkiw, "Women, Culture and Inaudibility."

54 "Vancouver Women in Focus Society fonds," University of British Columbia, Rare Books and Special Collections, RBSC-ARC-1586. The geographic proximity of the two organizations is noted by Danielle Baxter in her 1989 finding aid for the fonds.

Cameron, Vivian, Heather Dawkins, and Susan McEachern. "Mirrorings." *Parachute* 29 (December/January/February 1982–83): 33.

Carvalho, Anithe de. "*La chambre nuptiale* de Francine Larivée: Une oeuvre issue du modèle de la démocratie culturelle ou quand l'art féministe néo-avant-gardiste s'intègre à l'establishment." *Journal of Canadian Art History* 34, no. 2 (2013): n.p.

Chitty, Elizabeth. "Asserting Our Bodies." In Mars and Householder, *Caught in the Act*, 67–85.

– "You Can't Rock the Boat with Cold Feet." *Fuse* (January 1980): 117, 128.

Committee for Women Artists. *Woman as Viewer*. Winnipeg: Winnipeg Art Gallery, 1975. Exhibition catalogue.

Corne, Sharron. "Women in Exhibition: The Politics of Pioneering Feminist Art on the Prairies." *Branching Out* 5, no. 2 (1978): 7–10.

Cornell, Drucilla. "Rethinking the Time of Feminism." In *Feminist Contentions: A Philosophical Exchange*, 145–56. New York: Routledge, 1995.

Davies, Blodwen. "Canadian Women of Brush and Chisel." *Chatelaine* (June 1930): 9, 42.

Davis, Gayle R. "Visibility: The Slide Registry of Nova Scotia Women Artists." *Canadian Woman Studies* 3 (Spring 1982): 52–3.

Deutsche, Rosalyn, et al. "Feminist Time: A Conversation." *Grey Room* 31 (Spring 2008): 32–67.

Diamond, Sara. "The Boys Club." *Fuse* (September 1988): 12–13.

– "Of Cabbages and Kinks: Reality and Representation in Pornography." *Parallelogramme* (June/July/August 1983): 12–18.

Donegan, Rosemary, and Joyce Mason, eds. "After the Dinner Party's Over: Special Report on Women and Writing in Canada." Special issue, *Fireweed* 15 (Winter 1982).

Duff, Tagny. "FFWD, RWD, and PLAY: Performance Art, Video, and Reflections on Second-Wave Feminism in Vancouver 1973–1983." In Mars and Householder, *Caught in the Act*, 41–53.

Earl, Marjorie. "Boob Tree Raises Cult." *Winnipeg Tribune*, 29 November 1975.

England, Barbara. "An Examination of Masculinism at NSCAD." Unpublished paper, Nova Scotia College of Art and Design (NSCAD), 1976.

Fraser, Marie, and Lesley Johnstone, eds. *Instabili: La question du sujet/The Question of the Subject*. Montreal: La Centrale (Galerie Powerhouse) and Centre d'information Artexte, 1990.

"Fuck Yous, I'm Goin' to Bingo!" *Parallelogramme* (April/May 1983): 37–47.

Gagnon, Monika Kin. *Other Conundrums: Race, Culture and Canadian Art*. Vancouver: Arsenal Pulp Press / Artspeak / KAG, 2000.

– "Work in Progress: Canadian Women in the Visual Arts 1975–1987." In *Work in Progress: Building Feminist Culture*, edited by Rhea Tregebov, 101–27. Toronto: Women's Press, 1987.

Gourlay, Sheena. "Feminist/Art in Quebec: 1975–1992." PhD diss., Concordia University, 2002.

Gronau, Anna. "Censorship: Caught in the Crossfire." *Parallelogramme* (February/March 1984): 42–4.

Grosz, Elizabeth. "Histories of the Present and Future: Feminism, Power, Bodies." In *Thinking the Limits of the Body*, edited by Jeffrey Jerome Cohen and Gail Weiss, 13–23. Albany, NY: SUNY Press, 2003.

Guay, Diane. "Parler d'elles à partir d'elles-mêmes," In *Art et féminisme: Musée d'art contemporain, Montréal, 11 mars–2 mai 1982*, Rose-Marie Arbour et al., 27–42. Québec: Ministère des affaires culturelles, 1982.

"A History of Feminism at N.S.C.A.D." *Parallelogramme* (October/November 1982): 10–11.

Huneault, Kristina, and Janice Anderson, eds. *Rethinking Professionalism: Women and Art in Canada, 1850–1970*. Montreal and Kingston: McGill-Queen's University Press, 2012.

Jackson, Marni. "The Clichettes." In Mars and Householder, *Caught in the Act*, 160–74.

Jolicoeur, Nicole, Isabelle Bernier, and Béré-
nice Reynaud. *Féministe toi-même, fémi-
niste quand même.* Québec: La Chambre
blanche, 1986.

Kelly, Mary, and Paul Smith. "No Essential
Femininity: A Conversation between Mary
Kelly and Paul Smith." *Parachute* 26
(1982): 31–35.

Kwinter, Kerri, and Joyce Mason. "Alter
Eros: Was It Good for You?" *Fuse* (Summer
1984): 45–53.

Lamy, Suzanne. "À couleurs rompues." In
*Art et féminisme: Musée d'art contempo-
rain, Montréal, 11 mars–2 mai 1982*, Rose-
Marie Arbour et al., 15–26. Québec:
Ministère des affaires culturelles, 1982.

Larivée, Francine. "La Chambre Nuptiale
'sous silence.'" *Intervention* 7 (1980): 38–9.

Lauzzana, Gail. "Artfemme '75." *Feminist
Art Journal* 4, no. 3 (1975): 12–13.

Mann, Joanna. "Towards a Politics of
Whimsy: Yarn Bombing the City." *Area* 47,
no. 1 (2015): 65–72.

Mars, Tanya, and Johanna Householder, eds.
*Caught in the Act: An Anthology of Perfor-
mance Art by Canadian Women.* Toronto:
YYZ Books, 2004.

Martin, Jane. "Who Judges Whom: A Study
of Some Male/Female Percentages in the Art
World." *Atlantis* 5 (Fall 1979): 127–9.

Mason, Joyce. "Celebratory Vigour and Dis-
missive Buzzwords." *Fuse* (Summer 1983):
2–4.

McInnes-Hayman, Sasha. *Contemporary
Canadian Women Artists: A Survey.* Pre-
pared for Womanspirit Art Research and
Resource Centre and Status of Women
Canada. London, ON: S. McInnes-Hayman,
1981.

McPherson, Hugo. "Wieland: An Epiphany
of North." *Artscanada* (August/September
1971): 17–27.

The Montreal Daily Star. "Distaff Side Active
in Art." 17 March 1942.

Needham, Wilma, ed. *Women and Peace Re-
source Book: A Project of Voice of Women
Halifax.* Halifax: Voice of Women, 1987.

Nickel, Michelle. "Some Perspectives on
Women's Alternative Art Centres." *Parallel-
ogramme* (June/July 1982): 9–10.

Parker, Ara Rose. "The Status of Women."
Interview with Judy Erola, Susan Cole,
Anna Gronau, and Catherine Tammaro.
Impulse (Fall 1983): 37–40.

Pentney, Beth Ann. "Feminism, Activism, and
Knitting: Are the Fibre Arts a Viable Mode
for Feminist Political Action?" *Thirdspace*
8, no. 1 (2008). http://journals.sfu.ca/
thirdspace/index.php/journal/article/view
/pentney.

– "Féminisme." *Tricot pour la paix.* 19 De-
cember 2012. http://tricotpourlapaix.
com/2012/12/19/feminisme.

Pontbriand, Chantal. "Judy Chicago."
Parachute 27 (Summer 1982): 38–9.

Poteet, Susan K. "Powerhouse Montreal
Women's Gallery." *Branching Out* (Septem-
ber/October 1975): 19–21.

Rebick, Judy. *Ten Thousand Roses: The Mak-
ing of a Feminist Revolution.* Toronto: Pen-
guin, 2005.

Rosenberg, Avis Lang. "Women Artists and
the Canadian Artworld: A Survey." *Criteria*
4, no. 2 (1978): 13–18.

Rosenberg, Tanya. "Codpieces: Phallic Para-
phernalia." *Branching Out*
(February/March 1976): 13–17.

Roy, Aron S., and Ging Won. "Direct Job
Creation Programs: Evaluation Lessons."
Strategic policy document for Human Re-
sources Development Canada, 1998.
http://publications.gc.ca/collections/
collection_2013/rhdcc-hrsdc/RH64-103-
1998-eng.pdf.

Royal Commission on the Status of Women
in Canada. *Report of the Royal Commission
on the Status of Women in Canada.* Ottawa:
Information Canada, 1970.

Rubess, Banuta. "Building Culture with a
Women's Perspective." *Fuse* (September/
October 1983): 91–8.

St-Gelais, Thérèse. "Féminismes et performa-
tivité." In *Féminismes électriques: La Cen-
trale, 2000–2010*, edited by Leila Pourtavaf,
57–69. Montreal: Les Éditions du remue-
ménage, 2012.

Scott, Joan Wallach. *Gender and the Politics
of History.* New York: Columbia University
Press, 1988.

Sight Specific: Lesbians and Representation.

Toronto: A Space, 1988. Exhibition catalogue.

Sitney, P. Adams. "There Is Only One Joyce." *Artscanada*, no. 142/143 (April 1970): 43–5.

Solomon-Godeau, Abigail. "The Woman Who Never Was: Self-Representation, Photography and First Wave Feminist Art." In *WACK! Art and the Feminist Revolution*, edited by Cornelia Butler and Lisa Gabrielle Mark, 336–45. Los Angeles: Museum of Contemporary Art; Cambridge, MA: MIT Press, 2007.

Sorkin, Jenni. "The Feminist Nomad: The All-Women Group Show." In *WACK! Art and the Feminist Revolution*, edited by Cornelia Butler and Lisa Gabrielle Mark, 458–71. Los Angeles: Museum of Contemporary Art; Cambridge, MA: MIT Press, 2007.

Spires, Randi, and Pat Wilson. "Stopping Women's Art II: Ontario Women Artists' Press Conference." *Fuse* (Summer 1986): 9–10.

Steele, Lisa. "The Judy Chicago Paradox: 'After the Party's Over,'" *Fuse* (September 1983): 93–5.

– "Women's Cultural Building: Putting the Practice before the Architecture." *Fuse* (May/June 1982): 4–5.

Stratica-Mihail, Eliana. "Feminist Beginnings: An Interview with Six Founding Members of La Centrale Galerie Powerhouse." In *Impact féministe sur l'art actuel: La Centrale à 40 ans*, 43–50. Montreal: La Centrale Galerie Powerhouse, 2015.

– "I Don't: The Commodification of the Bride in Montreal Art from the 1970s." MA thesis, Concordia University, 2014.

Tembeck, Tamar. "Re-performer le matrimoine: Perspectives et témoinages sur l'héritage féministe en art actuel." *Recherches féministes* 27, no. 2 (2014): 21–37.

Tenhaaf, Nell. "A History or a Way of Knowing." In *Instabili: La question du sujet/The Question of the Subject*, edited by Marie Fraser and Lesley Johnstone, 77–84. Montreal: La Centrale (Galerie Powerhouse) and Centre d'information Artexte, 1990.

– "The Trough of the Wave: Sexism and Feminism." *Vanguard* 13, no. 7 (1984): 15–18.

Toronto Daily Star. "Stress Women's Part in Many Professions." 24 November 1930.

Tuer, Dot. "From the Father's House: Women's Video and Feminism's Struggle with Difference." *Fuse* (Winter 1987–88): 17–24.

Vancouver Women in Focus Society fonds, University of British Columbia, Rare Books and Special Collections, RBSC-ARC-1586.

Wark, Jayne. *Radical Gestures: Feminism and Performance Art in North America*. Montreal and Kingston: McGill-Queen's University Press, 2006.

Waugh, Phyllis. "Feminist Art in Toronto, 1984: A Survey." *Resources for Feminist Research/Documentation sur la recherche féministe* 13, no. 4 (1984–85): 29.

Williams, Carol. "A Working Chronology of Feminist Cultural Activities and Events in Vancouver, 1970–1990." In *The Vancouver Anthology: The Institutional Politics of Art*, edited by Stan Douglas, 170–205. Vancouver: Talon Books, 1991.

Woomers. "The Re-Education of P.C. Gordon." *Fuse* (February/March 1986): 21–3.

Zola. "Global Track Interview: Street Artist Zola Takes a Radical Approach to Her Medium." By Rhiannon Platt. *Complex*, June 28, 2014. http://ca.complex.com/style/2014/06/global-track-zola.

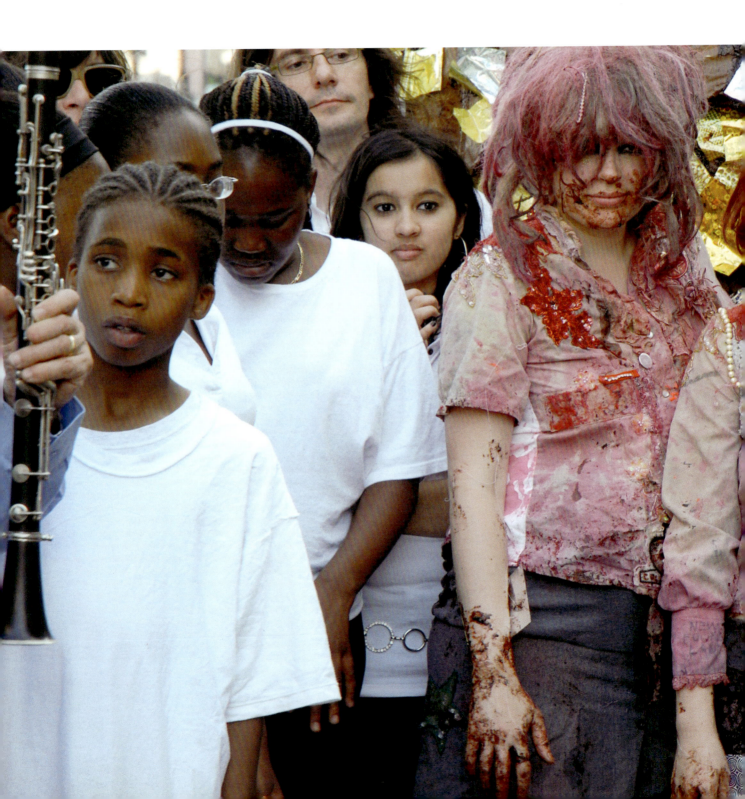

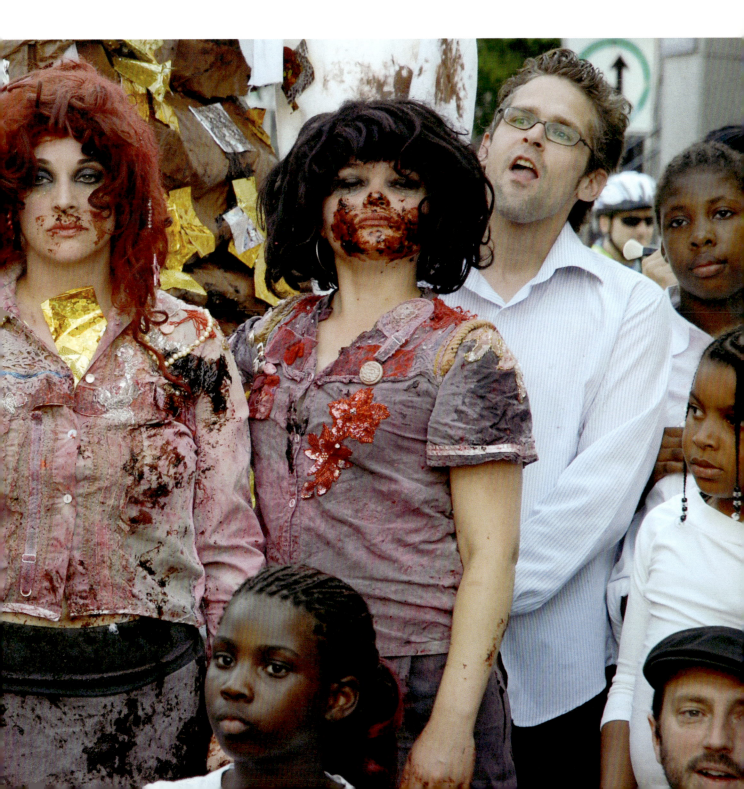

Proposition for Twenty-First-Century Feminism 1:
On Sex, Gender, and Feminism

It is impossible to write a definition of feminism because feminism is meant to address and redress the historical imposition of patriarchy, that is, the practice of oppression against women. "Women" suggests a category that seems at once self-apparent, but begins to shift and break and tear under the weight of more than half the human inhabitants of the planet. How on earth could any category account for all these people, all their lives and loves and struggles? Any articulation of feminism, then, is always partial and incomplete and necessarily located. It can only be truthful in the locatedness of a given person, a given subject, a given position or point of view. Feminism begins through the fundamental questioning of patriarchy and heteronormativity in whichever ways these manifest in people's lives, and in their articulations of collectivity and being together. The permutations of our bodies and the other systems of oppression that we all live with – although in radically divergent ways with hugely variant degrees of harm – open feminism up to this always-partial way of addressing gender, sex, and sexuality. The point is that we are not one. We are not one body, nor one gender, nor one sex, nor one race or ability or age. Feminism itself is the realization of the not-one. There is no position that can be outside of embodiment. And that body is a body that bleeds, that secretes, that has lovers and friends and ones they hold dear. That body is a body that desires and in its desire creates new worlds and new possibilities for feminism and for art.

"They Aren't a Boy or a Girl, They Are Mysterious": Finding Possible Futures in Loving Animals and Aliens

Karin Cope

2 Who has not ridden a lover like a horse, or felt desire, erotic or not, as a kind of flying? We writhe and fishtail through the atmosphere, breathing noisily, showing off, breaching and spouting. We sport feathers, leather, stones, a bit of fur, stitch fun fur to glitter and gossamer, enrapture ourselves with hope and glamour. In pursuit of love and sensuous pleasure we consume animal and mineral matter as nourishment and aphrodisiacs; we change our appearances: shave; dress up or down; bedeck ourselves; dance; parade; cover ourselves in oils, perfumes, and seductive colours; sport wigs and novel skins; don silk, satin, and whiskers. Some collect stuffed animals or imagine themselves small or large furry creatures, segments or parts of larger congeries, beasts, aliens, or new types of beings, at once both more and less than human, other than human. We invent pet names for one another and for various body parts: my little cabbage, my bunny rabbit, my furry bear, my dandelion, my aspergusto, my most beloved, my airplane, my jellyfish, my bonobo baby, my puppy, my pussy willow, my cattail, my kitten. We sing and speak and wait and dream thus, but these actions are rarely simply individual: we also speak and make and march and dance and move, reaching out, relating, and in so doing, counting, at once, as more and less than one, irrational, exuberant, unbounded, endangered, alive.

As perhaps all of us know from such common ecstatic, risky, and transitory experiences, the terms of our identities and relationships are typically too narrowly cast; they cannot begin to account for the backwards and forwards temporalities in which we live, for our varieties and admixtures of person, memory, fantasy, despair, and hope. Nothing about the language of gender, ability, race, or sexual orientation comes close to the variety of experiences of body, surface, injury, and transformation that every growing, striving, or dying being knows; nor can it plan for the sorts of in-between states and possible futures that non-conforming bodies and genders might want or need to imagine. As Audre Lorde argues so beautifully in her piece, "Poetry Is Not a Luxury," "The quality of light by which we scrutinize our lives has direct bearing upon the product which we live, and upon the changes which we hope to bring about through those lives."[1] Even so, we rarely dare to imagine or re-imagine the categories within which we live and work as fully as we might; worst of all, even the most radical of the theoretical languages we deploy in order to try to describe or reconfigure

our experiences of the world are generally profoundly impoverished in relationship to some of our most radical and daring acts of the imagination.

Indeed, many of our most treasured social and psychological assumptions and theories, the frameworks by which humanness, personhood, and appropriate expressions and relations are asserted and maintained, tend to suggest that ideas or activities that too radically mix up or trouble the boundaries of the human must be controlled; those behaviours and attitudes that get too far out of bounds speedily become a matter for disdain, ostracism, therapy, or discipline. As many of us know all too well, queer and marginal expressions of desire, being, and culture are repeatedly reined in, critiqued, hidden, demonized, rendered abject, or even destroyed by such means. As Judith Butler argues, "to find that you are fundamentally unintelligible (indeed that the laws of culture and language find you to be an impossibility) is … to find yourself speaking only and always *as if you were* human, but with the sense that you are not … that no recognition is forthcoming because the norms by which recognition takes place are not in your favor."[2] Note how, even here, in a space where she is calling for a radical reframing of the terms of cultural intelligibility and social justice, the limit against which Butler buttresses her argument is "the human." On the one hand, she will suggest that "fantasy is not the opposite of reality; it is what reality forecloses"; on the other hand, by her account the limits of fantasy's "possible in excess of the real," of its "point[ing] elsewhere," are nowhere more broadly conceived than in terms of "the human."[3]

In Butler's defense, to be sure, when you are queer, suing for inclusion in the category of the human seems difficult enough; when what is non-human – animals or aliens, say – get involved in the mix, the struggle to achieve an inclusive and adequate social imaginary might appear to be hopeless. And yet, what if we are already on that path? What if there is some shadow of truth in all of those appalling jokes and rightist fearmongering about the unlimited aspects of our unruly desires? What if thinking about enshrining civil rights for a range of queer, polyamorous, and trans acts and lives does indeed usher in some aspect of interspecies interdependence or of bestiality, by acknowledging the novel orders and combinations that inhabit our dreams, and thereby our lives? Why should we not use and celebrate these resources, the products of love, fantasy and laughter to, as Butler suggests, "imagine ourselves and others otherwise," as more and less than and not simply human; why should we not try more fully to "point elsewhere," to "embody" that elsewhere and "bring it home"?[4]

In what follows, I will argue that the arts are a space where, as artist Emily Vey Duke insists, such "difficult moments" may be not only carefully and humorously addressed, but brought on board in some way. The arts provide a space that allows for a tempering and modulating of our sense of what counts, of what should count, of what enters our imaginaries and conversations as intelligible, permissible, even desirable.[5] The arts allow us to invent heterotopic proxies and possibilities we can inhabit only discontinuously in the present – as Allyson Mitchell says of her giant neocraft nudes, the touchable fun-fur lesbian *Lady Sasquatch* "monsters": "I see the Sasquatches as a tribe … in the world doing some of the work I can't be out there to do."[6] In this vein, I propose to examine some of the practices and productions of

several younger, Canada-affiliated contemporary artists working at the intersections of feminism, queer activism, anti-racism, gender justice, and environmentalism, because I believe their work has already begun to develop a more apt, hilarious, and flexible lexicon for some of our most errant longings and utopic dreams, our animal, vegetable, or mineral embodiments and desires. The artists discussed here include Coral Short, Emily Vey Duke and Cooper Battersby, and Alvis Parsley (Alvis Choi). All of these artists tend to work collaboratively and humorously, and all draw parodically, but with utter seriousness, upon the rich resources of past imaginaries and liberatory ideals and movements. Although not all of these artists would identify as queer, all are resolutely at work in the future-oriented activist arenas that the late theorist of queer performance José Esteban Muñoz identifies in his *Cruising Utopia* as those playful, imagined zones in which "the rejection of a here and now" is bound up with "an insistence on potentiality or concrete possibility for another world."[7]

On the Importance of Cultivating Unnatural Histories: Coral Short's *Genderless Jellyfish*

Q: What did one lady sasquatch say to the
 other lady sasquatch?

A: Do you exist?

Q (*the other lady sasquatch*): Are you asking
 if I exist?

A: Yes.

Q: (*the other lady sasquatch*): Bet you can't
 resist petting me.[8]

Surely there are several reasons why fantastical, bestial, or interspecies relationships loom so large in certain future-oriented contemporary works of Canadian art, and not all of them have to do with that common misperception, at once local and global, of Canada, or at least parts of it, as a vast and unspoiled wilderness. For young genderqueer artists, producing or provoking novel combinations of found and invented materials can become an opening to critical, alternative, and necessary visions of the world. For example, in telling about what happened as she was organizing groups for two performances, *Guardians*, which is about unicorns, and *Hungry*, about a wolf pack, Coral Short observes that "many gaybies [gay babies, or young queer people] feel at home inside [the world of the performance,] once they have an animal mask on. The mask creates a transitional, transitory space for people; it allows them to relate in new ways, to build new friendships and relationships."[9] In the act of appearing as beings other than themselves, Short observes that her performers accelerate processes in which they are already engaged, of becoming other, new, or altered beings. The mask doesn't represent a temporary state, as for the players in Shakespeare's comedy *A Midsummer Night's Dream*, but a step in a journey where this art-driven shapeshifting

engages, provokes, and sustains what are already real material, physiological, emotional, and political changes taking place in individual young queers' lives and in their communities. Short goes on to make an observation about the long-range social and ecological consequences of the shifts that she is seeing in her practice: "I saw us playing with the space where people lose gender and go into the animal. I believe that soon more and more people will start to merge into animals; it will be an important way of thinking about who they are, and what they might be becoming."[10]

Working such an emergent vein, Short's disarming video, *Genderless Jellyfish* (2014), engages us in dreaming ourselves as oceanic drifters when its narrator whispers about the lessons we humans might learn from those ancient soft-bellied creatures. Short describes the visual, tactile, and communicative parameters of much of her video and craft-based work: "I [am] obsessed with giving good camp in my work with bright colours and a high-quality queer aesthetic." But lest such a camp aesthetic confuses us, Short affirms that "even in my playful work there are always serious undertones."[11] Filmed in an aquarium, and rendered in brilliantly saturated colours, Short's video is designed to look as unnatural and as seductive as possible. It features lush pink, green, blue, orange, yellow, and purple jellies undulating across the screen, accompanied by echoing deep sea sounds and a dramatically campy "natural history" voiceover: "This is the genderless jellyfish. Watch it float. Did you know that some jellyfish have male and female organs in their body? They don't give a shit about gender. They are so bad-ass! Floating around, all happy, free, swimming."[12]

2.1 Coral Short, *Uniporn*, as performed at the Edgy Women Festival, 2009.

2.2 Coral Short, still from *Genderless Jellyfish*, 2014.

In her video, Short doesn't simply "queer" or camp up jellyfish by dressing them in brilliant colours and offering them as exemplary beings from which we might learn how to stop obsessing about gender and just to be; she also deliberately takes on and recasts the nature of creatures that many of us find at once frightening and disgusting by juxtaposing elements that we might fear with elements that we might find desirable. In Short's narration, the comment that "they can sting you and then you have to pee on their sting" is followed immediately by the refrain, "They aren't a boy or girl, they are mysterious." In the oceanic world of those genderless jellyfish, there are no crises around peeing, no worries about which bathroom door to enter, no hysteria about a little bit of pain. Refusing to engage the apocalyptic tone of recent news stories about the terrors of "an empty sea" full of jellyfish blooms,[13] Short calmly reimagines ways of relating to and admiring the wondrous social world jellyfish populate: "When they move around together they are called smacks or blooms. Smacks of jellyfish are like genderless gangs. Oooh look, it's so flexible, so fluid … They are so genderless, they don't even need to touch to have babies. Nothing can stop that jellyfish!" So what if the jellies take over the world? They're badass; they're exactly our kind of gang!

Subtly, in the oceanic world of those genderless jellyfish, many of the fearsome attitudes or values of even the queer world (Are you one of us? Do you share our prejudices and attitudes? Do you fit in?) are critiqued and turned upside down. Short explains that jellyfish "have been around longer than dinosaurs. They are immortal like vampires. They don't give a shit about gender presentation or mortality. They just float around looking good!" If only we, too, could learn to be thus.

By tapping into the oceanic and the humorous, Short runs a change on abjection and marginalization. In *Genderless Jellyfish*, what was low is raised up, what was strange or even terrifying is made intelligible, and what was other, beyond the bounds of form or meaning is recast, hyperbolically, as the better part of ourselves. Short's genderless jellyfish are an underwater cabaret act, rendering everything from novel understandings of gender to stings, jelly blooms, and strange reproductive habits not simply beautiful, but fascinating, engaging, desirable. "It is important to make funny

work so that everyone can laugh," Short comments. Indeed, she sees laughter as a wedge, a way of introducing material that otherwise, might be too difficult or fractious to discuss: "Lots of people don't want to change. But then there's that moment when you're laughing and you realize your brain is going somewhere else and you just have to follow it."

Penetrating Interiorities, Missing Links, and Dystopic Tales: Emily Vey Duke and Cooper Battersby's *Animal Love*

Emily Vey Duke and Cooper Battersby are also artists of "unnatural histories." For some time they have been laughingly imagining alternate worlds in a series of videos in which animals and outlaws or marginal figures make efforts to rebuild or put to rights a world wrecked by humans. Their 2011 production, *Lesser Apes*, narrated in part by Meema the bonobo, involves a novel and deeply ironic twist, wherein a female human researcher gets involved romantically with a female ape, and the two organize a public "coming out," to much human outrage, voyeuristic fascination, and ape puzzlement. Divided into three distinct sections, each of which features a different narrator – Farrah the primatologist, Meema the bonobo, and Peter the peeping tom groundsman – the video also incorporates music, animal sounds, live action, animation, and web-sourced videos of irate junior congressmen, of fighter planes flying in formation, and of bonobos living in the Lola ya Bonobo Sanctuary in the Democratic Republic of the Congo. In a teaser text posted on Vimeo, Duke and Battersby explain that "Bonobos are the species with which humans share the most DNA, but unlike our species, they are matriarchal, live without conflict, and are unabashedly sexual."[14]

The story begins with Farrah's testimony. She admits right away that "humans aren't supposed to fall in love with animals. Everybody knows that." In a voiceover, Farrah explains "how it was with me and Meema," becoming, in the very grammar of her statement, at once subject and object. As Farrah tells how they fell in love, how she had her first orgasm, and how the two lovers learned to talk to one another – or rather, as Peter points out later, Meema learns to talk to Farrah – her story is authenticated by fuzzy web-sourced video footage documenting bonobo sex and community life, as well as bonobo and human interactions. These include bonobo antics and affectionate interchanges with a happy-seeming young woman. In fact, all of this footage has been lifted from Australian author and researcher Vanessa Woods's *Bonobo Handshake* project, a website designed with a twofold purpose: first, to engage interest in and raise funds for research and habitat protection for the endangered bonobos at the Lola ya Bonobo preserve; and, second to promote Woods's book, *Bonobo Handshake: A Memoir of Love and Adventure in the Congo*. (Spoiler alert: the love Woods talks about isn't about a sexual relationship with bonobos, but about falling in love with the man who would become her husband.)[15] Within the frame of the story that Duke and Battersby tell, however, such real footage has the effect of troubling the boundaries of their fiction; you begin to wonder just how made up their tale is; is this parody or non-fiction?

2.3 Emily Vey Duke and Cooper Battersby, still from *Lesser Apes*, 2011.

For of course, no matter how fictive, the story that *Lesser Apes* tells is also "true" in some ways – or weirder still, in a "queer world," we might wish that aspects of it were more, or less, true.[16] For example, all three narrators explicitly claim to be perverts and celebrate their perversions in different ways. "Excellent news," announces Meema as she and Farrah prepare to go to the conference where they will out themselves, while all around them, protests mount: "Apparently we're perverts. Very exciting." Not only is perversion positively weighted and pervasive among the characters in this film, it is also clearly contagious. As Meema reports in her rather innocent and upside-down way, "I can't wait to get to the Los Angeles Primates International Zoology Conference so that I can start helping the rest of the pinkies become perverts too." Worth noting is the way she talks about her trip to Los Angeles, as if all that is necessary to set change in motion is a speech act at a conference. (In this way she is perhaps not so different from many of us in the humanities and social sciences, who also hope that our talks might initiate real change – or, at the very least, go viral.) Unfortunately however, what is not really explored or spelled out in this otherwise savvy film are the ways that racist tropes, bound up with sexual innuendo, tend to play out in human–ape stories. Not only are all humans in the world of the film apparently white – Meema speaks of "pinkies" – but, as one can see quite clearly from the number of racist comments on those bonobo videos from which *Lesser Apes* was made, for many real world "pinkies" – and here I really do mean white people, not humans – photographed apes are also often figured as racialized or "underdeveloped" humans. Comments on Woods's *Bonobo Handshake* site engage every racist trope imaginable, speaking of the Lola ya Bonobo apes as "primitives," "Africans," or even endangered children, who, in the space of the reserve, must be rescued from poaching adults (read

black male) Africans and "properly civilized." In the context of Woods's website, which itself makes liberal use of colonial stereotypes and joyful "family of man" style imagery, quips like "these African kids should be wearing clothes!" are among the mildest of a range of racist comments.[17] Thus, although Duke and Battersby reframe the imagery they have lifted from Woods's site, they neither analyze nor address the racial baggage the *Bonobo Handshake* material drags with it. (Imagine the impact if their critique of racism were as acute and imaginative as their inversions of the terms of "perversion.")

Aside from this significant failure to speak to or even notice its own racialized deployments, *Lesser Apes* is artfully constructed so that bit by bit, thanks to visual cues that offer evidence about the perspectives of its narrators, and the nature of the truths they tell, we learn some crucial and attitude-changing details. Both Farrah's and Meema's stories are visually elaborated through photographic "evidence," while Peter's story is told entirely in a hand-drawn animation sequence. In the case of Farrah and Meema, we are offered visions of the world as it is seen through each of their eyes – bonobos in love and at play when Farrah speaks, while, when Meema narrates from an undisclosed North American location, we see the oddities of high tension lines in a field, the racket and speed of a city street, or a skewed view of Farrah from a spot high in a tree. We tend then, at first, to believe Farrah and Meema, and to discount Peter's testimony. After all, he's literally a creepy flat white guy, a talking head; he follows them to Los Angeles, and he admits that he "crept about behind [Farah and Meema], crouching to watch as they bathed and snogged." As he speaks, a small animated "Peter" with binoculars slips through the bushes behind a tiny interlaced Farrah and Meema. Peter tells us that he finds the political movement that the lovers have started, Perverts United (a banner with rainbow lettering goes fluttering by), objectionable. At first you think that he's simply voicing a self-blind pervert-phobic damnation of radicals of the sort that feels all too familiar, for his account begins with the assertion that he is not like them: "I'm just a nice fellow who happens to like following these two about." Quickly, however, it becomes more vitriolic. Peter insists that in the Perverts United "bunch," "there are sadists ... Loads. And roofers [date rapists] and pedophiles[18]...There are those who are excited by the prospect of maiming the powerless." One could dismiss this entire rant as false consciousness but for two significant details: (1) Peter goes on to explain that Meema is not the lesser ape, "we are." After all, she learned Farrah's tongue, but we have not bothered to learn hers. "Who is lesser then?" he asks. "The perfect pupil or the flawed professor? It's Farrah. It's us." (2) We also cannot overlook the fact that we are, like Peter, voyeurs. His position is our position as we watch all three narrators in a medium that permits us to look in on them without disclosing ourselves, without being seen. Human perversion, as Peter hints, is far stranger and more complex than the bell-clear celebration learned by Farrah's pupil, the wide-eyed peaceful loving bonobo, Meema. He, Farrah, and we viewers all share not only a militaristic culture with murderous habits, but some very peculiar secrets.

2.4 Emily Vey Duke and Cooper Battersby, still from *Lesser Apes*, 2011.

What is Farrah's secret? We can never know for sure, but there is some visual evidence in the film that Farrah engages in sadistic acts towards animals. For example, she waves dead birds about in her hands in one love-struck Meema-narrated passage. Elsewhere, we see her stuffing a live cat beneath a bell jar as she says, "It might seem fucked up. It might make people feel pushed past what's safe. Somebody I really love can't tolerate what we're doing." Both Farrah's actions and Peter's comment about "sadists … and roofers" gesture towards debates about the nature of animal consent in human–animal relationships, given that humans seem to be so bad at learning animal languages, or really grasping significant aspects of animal being.[19] Although Farrah has, as she tells us, found her way "into [Meema's], um, interiority" in one way, she will never really "get her," in the end. In the last sequence of the film, as a monarch butterfly breaks out of its chrysalis, Farrah sings to Meema, as well as to us, in both French and English (as if to say that she could at least learn more than one human language): "I want to teach you many things, but where I could learn them I don't know, no no."

In the end, perhaps the biggest and worst secret of all hinted at by this film is that humans seem nearly incapable, even when in love, of truly understanding any radical other's perspective. Although the film purports to tell Meema's story in some way, all we ever really learn is what Farrah and Peter claim; Meema, despite her TruVoice 9000 voice synthesizer, fades into caricature, a human actress in an ape costume, a peaceful loving perfect creature, a romantic parable, but notably not a reality.[20] As Duke comments, in the course of an extended interview with filmmaker Mike Hoolboom, "Animals, like children, are a repository for all our fantasies about

innocence and simplicity." The real work then, for Duke and Battersby, is human to human; indeed, the pair take the phrase "art is for empathy" as their slogan. Elsewhere in her interview with Mike Hoolboom, Duke says, "my work is about communication … The reason I make work [is] to create mutual human feeling."[21]

But seen from within the frame of Duke and Battersby's dystopic corpus, art that is for empathy might better be understood as art for testing empathy's limits. In the distorted mirror that is *Lesser Apes*, humans never appear as tolerant or open-hearted as they wish they were; it reminds us that we can be sure, in this future towards which we lean, we will stumble as we have in the past, and bruise ourselves against the multiplicity of our prejudices. Despite the wishful thinking of many commentators about what we might learn from the peaceful, matriarchal, loving, communal bonobos – those clever beasts who resolve disputes with polymorphous sexual acts instead of violence – we've already utterly failed at being like bonobos; however appealing we say they are, however much we decry their endangerment, we do not care to learn their ways; we do not care to be or to become bonobos. We cannot seem to get around our conviction that they, not we, are the "lesser apes," that we, not they, know how to speak and be and do. Are there other ways, then, of bringing us into contact with what we "do not know, no, no?"

It might make people feel pushed past what's safe.

2.5 Emily Vey Duke and Cooper Battersby, still from *Lesser Apes*, 2011.

Why Can't You Understand What I Am Saying?
Living an Alien's Life with Alvis Choi/Alvis Parsley/Captain Kernel

In the persona of Captain Kernel, a green-skinned "alien" expelled from its own world and mysteriously drawn into Earth's orbit, Hong Kong–born and –raised Alvis Choi (who also performs under the name Alvis Parsley) explores the limits of inclusion in a series of "low rent" performances at a Toronto Value Village and other marginal human haunts. Choi's "alien" performances focus not on sexual relationships per se, but on what it means to be racially or culturally excluded, not to belong, to be neither here nor there, in-between, trans, neither boy nor girl, neither human nor nonhuman, but still in need of love, in need of appropriate pronouns and in need of others' concern. "Do you ever feel weird?" a newly arrived, green-faced, white-bathrobe-wearing Captain Kernel asks startled shoppers at the Value Village on the first day of its appearance. "What do you do when you don't fit in?"[22] One of more than twenty large-scale public art projects commissioned by Art of the Danforth in Toronto in May 2014, part of the East Danforth neighbourhood's investigation of "the role of art in the community and its ability to transform the neighbourhood," Choi's *Alien in Residence* consisted of a four-day performance in the neighbourhood thrift shop.[23]

Activities each day were designed to engage Value Village customers in the earthly education of Captain Kernel. On the first day, Captain Kernel got shoppers to suggest clothing it should wear; they helped to dress it and paint its nails. Although most shoppers had no idea what was going on and were not prepared to be approached by a green-faced alien, conversations that first day were good, Choi recalls. "Most people interacted with me and offered encouraging words. They wanted to help Captain Kernel feel better about itself. One person hugged Captain Kernel; another wanted to buy a gift for Captain Kernel, and another person said, well, if god made you green, then you are fine." On the whole, Choi recalls, shoppers were accepting, indulgent, and occasionally very eager to play along. As brief video footage on Choi's website of that first day suggests, plenty of shoppers responded warmly to a performance that engaged themes of identity, belonging, and the disorientation that comes with losing one's sense of home.[24]

On the second day, Captain Kernel asked shoppers to suggest places the alien should go when it was ready to leave the store. On that day, Choi recalls, a child got into an argument with the Captain about whether it was an alien or not; the argument was resolved when together they drew a map of the universe and decided on the spot that they believed had been Captain Kernel's home. Day three was oriented around finding "superpower"-imbued objects in the store and figuring out how to use them, while day four, the Captain's last day in Value Village, was dedicated to the question, "What does home mean to you?" As Choi's artist statement for the project suggests, "in the context of Canada where a multicultural policy is official ... the question of 'Where is home?'" becomes profoundly important.[25] Who is at home here, and who is not? Who is welcome; who is recognized; who is invisible; who is alien? Who is deserving of our compassion and tenderness? Indeed, what are the terms within which

2.6 Alvis Choi/Alvis Parsley as Captain Kernel talks to Value Village patron.
From *Alien in Residence* Value Village performance, Toronto, May 2014.

a body appears to be "alien" or familiar? These are not questions of theory and social justice alone, but concrete and life-altering matters of (changeable and political) official and unofficial policy and border control.

Ironically, as Choi's performance demonstrates, by appearing hyperbolically and comically as an outcast, homeless, genderqueer, greenfaced alien that wants its nails painted, Captain Kernel was, on the whole, rather warmly embraced and cared for. Value Village shoppers even willingly engaged in "practice sessions" where they learned how to address and refer to Captain Kernel with its preferred pronoun, "it." But had the Captain appeared in other, more earthy guises, say as a lonely genderless or genderqueer Chinese newcomer, would the reception have been as warm? Would casual shoppers have been as ready to engage a performer-of-everyday-life in conversations about what they should wear, where they should go, and how they might find or make a home in this new space? Would they as readily agree to refer to such a performer with their pronoun of choice? Certainly, Choi admits, "participants in the Value Village project were much more prepared to practice interacting or using unusual pronouns with a persona than they would be in real life. But maybe, with them, I am trying to learn how we could do it."

In a subsequent cabaret performance, *Alien in Residence: Parallel Life*, Choi/Parsley, as Captain Kernel, continues to reflect upon and respond to such problems, foregrounding, in bittersweet comedy, the experience of feeling lost, alienated, and

alone. Choi's dramatic piece was part of a project entitled House of Freaks: A Queer Asian Theatrical Experience that took place at Toronto's long-running queer venue Buddies in Bad Times Theatre in August 2014.[26] In this performance, in greenface, green tights, and green gloves, a now somewhat nattily dressed green Captain Kernel sounds out, as Choi puts it in their artist statement, "the needs, desire and dreams of the socially marginalized."[27]

In the course of this achingly poignant performance, a contemporary genderqueer version of Chaplin's forlorn Little Tramp, Captain Kernel reviews its life, sings some songs, and enacts being cast out, lost, loveless, isolated, and abandoned.[28] The performance is structured by a list of five "causes of death," each of which is spelled out on a series of giant cue cards. All, we might say, tend to befall outsiders, or those who are cast out, abandoned, lost, or alienated. All are grave risks for newcomers, refugees, immigrants, and marginal, "unintelligible," or castaway beings; all are clearly among Captain Kernel's familiars. "Cause of Death #1, Longing" provides the occasion for the Captain to rehearse the story of its tumble to earth behind the Danforth Value Village, while "Cause of Death #2, Feelings," which the Captain redefines as "negative emotional attachment," sets up the story of its expulsion due to "improper relations" from its own planet. "All I want in life is a little bit of love to take the pain away," the Captain says, as the audience laughs, making it very plain that no such love is on offer.[29] In this way, an audience that is, in fact, a very enthusiastic supporter of Choi and their work, also plays its part, and participates in elaborating the bittersweet aspect of this comedy. The audience *must* laugh at such unbearable emotions because its members, too, understand them profoundly, and choose here, with Choi, to permit comedy to probe their own sorrows. Such a strategy works so long as both performer and audience, together, enact some sort of balance between deadly seriousness and humour.

Thus, a very serious Captain keeps up its end of the bargain by explaining that "Cause of Death # 3, Lack of Body Contact" really can cause death, and not simply something that feels like death. The Captain goes on to explain the phenomenon of hospitalism, the way that an infant housed in an unfamiliar environment and not touched will simply waste away. We need the touch of others, it argues, holding a stuffed animal tightly in its arms; we cannot live without them. The Captain's seriousness continues with "Cause of Death #4, Identity Crisis," which provokes an explanation of how difficult it can be to relate to others when they don't know how to relate to one's in-between or unfixed way of being. Declaring itself "neither alien nor human nor boy nor girl, but it," Captain Kernel persuades the audience to practice using its proper object pronoun. That gesture of respect established, an increasingly bent and forlorn Captain observes that "a captain steers many different ships: friendship, relationship, and kinship. But," it comments sadly, "you have to have a ship to steer." Again the audience performs its part and laughs.

Finally, after various efforts to bridge the divide between itself and others with story, song, and audience participation, the Captain arrives at "Cause of Death #5, Isolation." It explains that "everyone has their special club," their gang, with whom

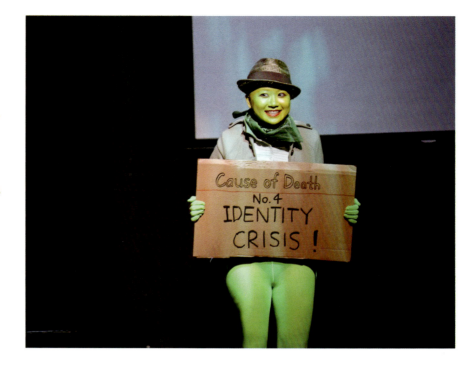

2.7 Alvis Choi/Alvis Parsley as Captain Kernel in *House of Freaks* cabaret performance, *Alien in Residence: Parallel Life*, Buddies in Bad Times Theatre, Toronto, August 2014.

they hang. But as an alien, as a being with apparently nothing in common with anyone else on earth, as a lonely longing creature, Captain Kernel confesses, "In my own special club, I was the only member."

This is dark comedy indeed. Like Chaplin's Little Tramp, ultimately utterly alone, Choi's alien takes upon itself and acts out aspects of our most interior, marginalized selves. How can it be that we are all such aliens, and yet this alien is so utterly alone? As with each of Captain Kernel's "causes of death," loneliness is the way we register the limits of ourselves as autonomous actors, as singular well bounded individuals. Despite all of our reasoned protests to the contrary, we are neither truly independent nor ever entirely "ourselves"; other beings, other objects, and other feelings routinely cast us into states where we find that we are, in a manner of speaking, "beside ourselves." As Judith Butler explains, in a burst of sensuous, poetic language,

> Let's face it. We're undone by each other. And if we're not, we're missing something. If this seems so clearly the case with grief, it is only because it was already the case with desire ... Despite one's best efforts, one is undone, in the face of the other, by the touch, by the scent, by the feel, by the prospect of the touch, by the memory of the feel. And so when we speak about *my* sexuality or *my* gender, as we do (and as we must) we mean something complicated by it. Neither of these is precisely a possession, but both are to be understood as *modes of being dispossessed*, ways of being for another or, indeed, by virtue of another.[30]

The philosophical, socio-political, and psychological consequences of this insight that both passion and grief give the lie to our myths of individual achievement and autonomy are myriad. The reason why we work so hard at expelling animals and aliens

and all of our other too familiar yet demonized others is also exactly how they get in: because we are porous, big-feeling, ruminative creatures; we chew endlessly over our own pasts and present, all the while dreaming of growing wings and taking flight. Clearly, two legs are never enough. This is also why, for those of us intent on transforming the future of what used to be called "the condition of man," building networks and collaborations are so important. For those of us inhabiting the borderlands, cobbling together our queer, non-, post-, or more-and-less-than human lives, these networks are our missing links, the hands of others that steady us on our feet.[31]

Queer and Present Networks

It is important to understand, then, that according to artist and video curator Coral Short, "our work," by which she means her own work and that of other young genderqueer or radical artists, "is a social practice."[32] Here, Short is not simply speaking about an engagement with those contemporary art practices of "relational aesthetics," "social practice," or "community-based art" aimed at or grounded in community engagement, like Choi's Value Village project, but also making a much broader claim: that the very stuff of much contemporary critical art practice is social; that it consists of contacts, networks, happenings, discussions, performances, acts of building and exchange that instantiate something other than reproduction of existing modalities or the status quo. Short wants to make clear that these networks are not virtual worlds, but real, living fields of action and interspecies recombination. A self-described queer nomad who lists more than two hundred collaborators on her cv, and who moves, in a given year, from communities on the West Coast of Canada and the United States to New York, Tennessee, Montreal, Berlin, or Glasgow, Short emphasizes the real, hands-on, situated nature of her work and that of other largely unsung artists like herself and her friends and collaborators: "I am a living piece of the internet. I'm always building real connections, strengthening the web, importing, supporting and moving a politicized culture around." According to Short, "in the utopic bubbles that we generate in these spaces, some kind of queer future is already existing. The *real* work is the communities we're creating in and through our work, the webs that we're making and building."[33]

Such are the sorts of moves that Muñoz has in mind too, when in *Cruising Utopia* he claims that "turning to the aesthetic in the case of queerness is nothing like an escape from the social realm, insofar as queer aesthetics maps future social relations."[34] In other words, in those spaces and details most marked by the sensory, the "impractical," the ornamental, the inconsequential, the non-human, the perverse, the demonized, the hilarious, one may find access to modes of "transport" or "anticipatory illumination[s]" that help "us to see the not-yet-conscious." Such art-making, for Muñoz, is always related to a political real, and "to historically situated struggles." It "may be day-dream-like, but [these] are the hopes of a collective, an emergent group, or even the solitary oddball who is the one who dreams for many." Art-making is thus a matter of working in "the realm of educated hope." Muñoz argues, as does Short,

that artists work to "perform ... astonishment in the world," and in this astonishment one may catch glimpses of something other than the darkness of the present.[35] For him, as for all of the artists and performers I have discussed here, such is the nature of "utopia" – not some futuristic fatuousness, as so many critics like to claim, nor the development of some novel singular body – but a rich, sometimes dystopic, and often hilarious resource for our political creative and social imaginations, a space where multitudes past and present, impossible and ordinary, human and non-human, embarrassing and exhilarating collide, cohabit, reorganize, and call to us, ready vehicles of intimacy, truth-telling, and transport.[36] They, and the myriad gossamer networks they build, are our future now.

NOTES

1 Lorde, "Poetry Is Not a Luxury," 36.
2 Butler, "Beside Oneself," 30. This essay was originally written for the Amnesty Lecture Series on "Sexual Rights" at Oxford in 2002, and subsequently published in *Undoing Gender*.
3 Ibid., 29.
4 Ibid.
5 Vey Duke quoted in Goodden, "19 Questions." Also see my argument about the kinds of thinking that the arts afford us in Cope, "Becoming Animal, Becoming Others."
6 Chan and Narduzzi, *Making Ladies*.
7 Muñoz, *Cruising Utopia*, 1.
8 Much thanks to Marike Finlay, my partner and frequent collaborator, who invented an entire series of Lady Sasquatch jokes to amuse me as I was writing this chapter.
9 This and all subsequent quotations of Coral Short, unless otherwise noted, are from my Skype interview with Short on 23 December 2014.
10 Childhood already gives us quite a bit of practice with unstable boundaries and what seem to be magical or disastrous not-quite-human encounters in what D.W. Winnicott calls the "transitional zone," the space of one's first efforts to negotiate me/not me encounters, the space where we learn to test and tolerate new experiences and ideas. Neither strict rationality nor propriety apply in the

transitional zone; the point, precisely, is not to have to choose between alternatives. See Winnicott, *Playing and Reality*.
11 Short in Arseneault, "Play Like a Caterpillar."
12 Short models the style of her narration on the "honey badger guy," the narrator of "The Crazy Nastyass Honey Badger," one of a series of comedic YouTube uploads that went viral in 2011. See Randall, "The Crazy Nastyass Honey Badger."
13 See, for example, the following fairly reputable sources, which are clearly using hyperbolic titles as clickbait: Elizabeth Howell, "Will Jellyfish Rule the Ocean?" and Gwynn Guilford, "Attack of the Blob: Jellyfish Are Taking Over the Sea and It Might Be Too Late to Stop Them."
14 Duke and Battersby, *Lesser Apes*.
15 Woods, *Bonobo Handshake* website. Woods made and posted a number of short videos of reserve bonobos with popular music soundtracks and catchy titles like "Do Bonobos Have More Sex than Chimpanzees?" For the full range of videos, see Woods's *Bonobo Handshake* YouTube channel: https://www.youtube.com/user/bonobohandshake.
16 We libidinize animals enormously. Not only are we attached to them – and they to us; not only does our penchant for viewing animal stories and tricks turn some fine media profits, we must also

consider, and reconcile, these several thoughts: taboos and laws against animal–human "congress" are pervasive and on the rise; so too are factory farms, mass extinctions, and varieties of animal abuse. And yet, according to some social media analysts, the most popular online stories are always about sex between people and animals. Who's looking at all of that material if not us?

17 Comment by "Ricky Ricardo" on "The Mamas of Lola ya Bonobo," *Bonobo Handshake YouTube Channel*.

18 According to the online *Urban Dictionary*, a roofier is someone who enjoys limp lifeless sex with an unconscious partner, a date rapist.

19 We know that such questions are on their minds because a 2014 installation by Duke and Battersby, *Always Popular, Never Cool (#rapeculture)*, directly addresses the issue of sexual violence and consent; in it, in a reversal of the Little Red Riding Hood story, a heroic super-girl dressed in wolf skins breaks in upon the scene of a sexual assault at a middle school party.

20 Duke and Battersby slyly cite from Nagisa Oshima's 1985 Franco-Japanese comedy, *Max, mon amour*, in which the beloved Max is played, uncredited, by British dancer and actress, Ailsa Berk, in a chimpanzee costume. See Chen, *Animacies*, for an analysis of the way the fantasy of the chimp love affair – and the chimp constume – inter-implicate colonial narratives of genitality, gender, and race.

21 Hoolboom, "Emily Vey Duke and Cooper Battersby."

22 Quotations and specific details of Alvis Choi/Alvis Parsley's *Alien in Residence* performance, unless otherwise indicated, come from an exchange of emails and a Skype interview I conducted with the artist in December 2014.

23 *Art of the Danforth* website, spring 2014, http://www.artofthedanforth.com.

24 Images of Captain Kernel may be seen on the artist's webpage: Alvis Choi, "Alien in Residence at Value Village," *Alvis Choi aka Alvis Parsley*, http://www.alvischoi.com/?p=146.

25 See Choi, "Alien in Residence at Value Village."

26 Choi, "Alien in Residence: Parallel Life," http://www.alvischoi.com/?p=365.

27 Choi, "Alien in Residence at Value Village."

28 Charlie Chaplin (1889–1977) was a comic actor and filmmaker. His "Little Tramp" was an icon of the silent film era.

29 "All I want in life is a little bit of love to take the pain away" is a line from the lyrics of "Ladies and Gentlemen We Are Floating in Space," by 1990s British space-rock band Spiritualized.

30 Butler, "Beside Oneself," 19.

31 For a useful discussion of the politics of the various languages of the non-, post-, or more-than-human, see Giffney and Hird, Introduction to *Queering the Non/Human* and Seymour's *Strange Natures*.

32 Short quoted in Schlesinger, "Coral Short Brings."

33 Author interview with Coral Short via Skype, 23 December 2014. Short's comments about how her virtual networks are matched by movements and meetings on the ground resonate with experiences that Allyson Mitchell and Alvis Choi recount, as well as with recent findings by feminist scholars about how feminist, queer, and trans people tend to use the net to build and reinforce lived networks on the ground. See, for example, Mitchell's account of how such "whirlwind" circuits work, in her "Deep Lez" talk at the Art Institutions and the Feminist Dialectic conference. See also extensive scholarly documentation by Mary Bryson, Mél Hogan, Lori MacIntosh, Tully Barnett, Alexandra Juhasz, Aristea Fotopoulou, and T.L. Cowan and other collaborators.

34 Muñoz, *Cruising Utopia*, 1.

35 Ibid., 3, 5.
36 Ibid., 189.

BIBLIOGRAPHY

Arseneault, Jordan. "Play Like a Caterpillar, Sting Like a Butterfly: Coral Short." *Edgy Women Blog*, 1 March 2013. https://edgy womenblog.com/2013/03/01/play-like-a-caterpillar-sting-like-a-butterfly-coral-short/.

Art of the Danforth website. Spring 2014. http://www.artofthedanforth.com.

Barnett, Tully. "Monstrous Agents: Cyberfeminist Media and Activism." *Ada: A Journal of Gender, New Media, and Technology* 5 (2014). http://adanewmedia.org/2014/07/issue5-barnett/.

Bryson, Mary. "When Jill Jacks In: Queer Women and the Net." *Feminist Media Studies* 4, no. 3 (2004): 239–54.

Bryson, Mary, Lori MacIntosh, Sharalyn Jordan, and Hui-ling Lin. "Virtually Queer? Homing Devices, Mobility, and Un/belongings." *Canadian Journal of Communication* 31, no. 3 (2006): 791–815.

Butler, Judith. "Beside Oneself: On the Limits of Sexual Autonomy." In *Undoing Gender*, 17–39. New York: Routledge, 2004.

Chan, Lesley Loksi, and Dilia Narduzzi. *Making Ladies: Allyson Mitchell's Ladies Sasquatch*. Video. 2010.

Chen, Mel Y. *Animacies: Biopolitics, Racial Mattering and Queer Affect*. Durham, NC: Duke University Press, 2012.

Choi, Alvis. *Alvis Choi aka Alvis Parsley*. http://www.alvischoi.com.

Cope, Karin. "Becoming Animal, Becoming Others: What We Make with Art and Literature." *Journal of American, British and Canadian Studies. (Creative Writing: New Signals, New Territories.)* 20 (June 2013): 121–38.

Cowan, T.L., Dayna McLeod, and Jasmine Rault. "Speculative Praxis Towards a Queer Feminist Digital Archive: A Collaborative Research-Creation Project. *Ada: A Journal of Gender, New Media, and Technology* 5 (2014). http://adanewmedia.org/2014/07/issue5-cowanetal/.

Drew-drew-bee. "Roofier." *Urban Dictionary*. 23 September 2009. http://www.urbandic tionary.com/define.php?term=roofier.

Duke, Emily Vey, and Cooper Battersby. *Lesser Apes*. 2011. Video. http://vimeo.com/22777196.

Fotopoulou, Aristea, and Kate O'Riordan. "Queer Feminist Media Praxis: An Introduction." *Ada: A Journal of Gender, New Media, and Technology* 5 (2014). http://adanewmedia.org/2014/07/issue5-fotopoulouoriordan/.

Giffney, Noreen, and Myra J. Hird. Introduction to *Queering the Non/Human*, edited by Noreen Giffney and Myra J. Hird, 1–12. Aldershot, UK: Ashgate, 2008.

Gooden, Sky. "19 Questions with Emily Vey Duke and Cooper Battersby: 'I Don't Know How Anyone Does It Alone.'" *Blouin Art-Info*. 15 July 2013. http://ca.blouinartinfo.com/news/story/929804/19-questions-with-emily-vey-duke-and-cooper-battersby-i-don't.

Guilford, Gwynn. "Attack of the Blob: Jellyfish Are Taking Over the Sea and It Might Be Too Late to Stop Them." *Quartz*. 15 October 2013. http://qz.com/133251/jellyfish-are-taking-over-the-seas-and-it-might-be-too-late-to-stop-them/.

Hogan, Mél, and Mary Bryson. "Queer Women and the Net Video: Interview with Mary Bryson & Mél Hogan." *Canadian Journal of Communication* 31, no. 4 (2006). http://www.cjc-online.ca/index.php/jour nal/article/view/1947.

Hoolboom, Mike. "Emily Vey Duke and Cooper Battersby." *Mike Hoolboom*. 2010. http://mikehoolboom.com/?p=35.

Howell, Elizabeth. "Will Jellyfish Rule the Ocean?" *News.Discovery.com*. 6 November 2013. http://news.discovery.com/earth/oceans/will-jellyfish-rule-the-ocean-131106.htm.

Juhasz, Alexandra. "Conclusion: It's Our Collective, Principled Making that Matters Most: Queer Feminist Media Praxis @Ada." *Ada: A Journal of Gender, New Media, and Technology* 5 (2014).

http://adanewmedia.org/2014/07/issue5-juhasz/.

Lorde, Audre. "Poetry Is Not A Luxury." In *Sister Outsider: Essays and Speeches*, 36–9. Berkeley, CA: The Crossing Press, 1984.

MacIntosh, Lori, and Mary Bryson. "Youth, MySpace, and the Interstitial Spaces of Becoming and Belonging." *Journal of LGBT Youth: The Interdisciplinary Quarterly of Research, Policy, Practice, and Theory* 5, no. 1 (2007): 133–45.

Mitchell, Allyson. "Deep Lez." Talk given at Art Institutions and the Feminist Dialectic Symposium, 4 December 2008. http://feministdialectic.ca/en/video.php?id=1.

– "Ladies Sasquatch, (2006–1010)." *Allyson Mitchell*. http://www.allysonmitchell.com/html/lady_sasquatch.html.

Muñoz, José Esteban. *Cruising Utopia: The Then and There of Queer Futurity*. New York: New York University Press, 2009.

Randall. "The Crazy Nastyass Honey Badger." *YouTube*. Uploaded 18 January 2011. https://www.youtube.com/watch?v=4r7wHMg5Yjg.

"Ricky Ricardo." Comment on "The Mamas of Lola ya Bonobo." 27 October 2009. *Bonobo Handshake YouTube Channel*. https://www.youtube.com/watch?v=Fe_N9I9Elno.

Schlesinger, Jessica. "Coral Short Brings the March Back to Dyke March." *Curve*, 29 June 2012. http://www.curvemag.com/Curve-Magazine/Web-Articles-2012/Coral-Short-Brings-the-March-Back-to-Dyke-March/.

Seymour, Nicole. *Strange Natures: Futurity, Empathy, and the Queer Ecological Imagination*. Champaign: University of Illinois Press, 2013.

Short, Coral. *Coral Short*. http://www.coralshort.com/.

– *Genderless Jellyfish*. 2014. http://www.52pickupvideos.com/HTML/Short_Week7.html.

Winnicott, D.W. *Playing and Reality*. London: Tavistock Publications, 1971.

Woods, Vanessa. *Bonobo Handshake: A Memoir of Love and Adventure in the Congo*. New York: Gotham, 2011.

– *Bonobo Handshake* website. 15 December 2009. http://www.bonobohandshake.com/.

Fashioning Race, Gender, and Desire: Cheryl Sim's *Fitting Room* and Mary Sui Yee Wong's *Yellow Apparel*

Alice Ming Wai Jim

3

In recent years, there has been a noticeable resurgence of fashionable Orientalism in visual culture and pop programming. Examples abound, from singer Gwen Stefani's Harajuku Lovers perfumes and fashion dolls to actress Kirsten Dunst in *kawaii* costume singing a cover of the Vapor's "Turning Japanese" in Takashi Murakami's music/art video *Akihabara Majokko Princess*. On the more highbrow end, the phenomenon was duly announced in a 2015 *Wall Street Journal* review of the Montreal Museum of Fine Arts' retrospective of the French Orientalist painter Jean-Joseph Benjamin-Constant, *Marvels and Mirages of Orientalism*, with the headline "Orientalist Art Makes a Surprising Comeback."[1] Technically, though, Oriental chic never went out of style – it's simply had a fair (market) share of ups and downs. Nowhere is this more obvious than in the world of fashion where the incorporation of exotic Asian styles and elements abound. From Hindu Gods and fake Chinese characters on t-shirts, baseball caps, and tattoos to Buddhist beads, Hindi bindis, Indian saris, Chinese *qipao*, and Japanese kimonos, ethnic chic can be seen on the streets as well as on the runways of Western haute couture designers.[2] Thankfully, critical discourse and scholarship on the implications of cultural appropriation in visual culture has finally caught up with the grassroots activist movements that predate Edward Said's influential 1978 book *Orientalism*, in which he defines Orientialism, "in short, [as] a Western style for dominating, restructuring, and having authority over the Orient."[3]

This chapter examines custom-designed fashion lines by two Montreal-based contemporary artists, Cheryl Sim and Mary Sui Yee Wong, to situate the conflicting desires associated with racialized and gendered representations of ethnic apparel in diasporic contexts and, more specifically, in Canada. Both projects question, in very different ways, the fashioning of race and gender in relation to authenticity, cultural appropriation, and constructions of identity. Sim's *The Fitting Room* (*La cabine d'essayage*) explores the representation of the *cheongsam* (literally "long dress" in Cantonese in reference to the form-fitting traditional Chinese gown) from the perspective of twenty women of Chinese descent from across Canada – from Vancouver, Toronto, and Montreal to Chibougamou and Saguenay in Quebec. In the process, her exhibition considers ways in which the deeply engrained visualization of Chinese femininity often invoked through the exoticism of Asian dress is related to histories of colonial desire as well as the rise of Asia's capitalist power since the 1980s.

Wong's *Yellow Apparel*, in contrast, satirically takes a jab at cultural appropriation in high fashion and the apparel industry while referencing the history of anti-Asian racism in the Americas. Eschewing gendered, exotic ethnic dress altogether, she repurposed a found fabric that depicts adorable clone preschoolers dressed in stereotypical "national dress" that loosely alludes to Inuit, Mexican, and Asian ethnicities, to shore up tensions regarding intercultural, transnational misunderstandings of the Other. This was the case when *Yellow Apparel* made its second appearance as an impromptu intervention at the ninth Encuentro – part academic conference, part performance festival – co-organized by New York University's Hemispheric Institute of Performance and Politics and Concordia University in Montreal, Quebec, in 2014. As Asian Canadian women artists, Sim's and Wong's works put into contention ethnic apparel's relationship with racialized and gendered diasporic identity constructions in the context of recent global realignment of geopolitical superpowers. Ultimately, both reflect the transnational predicament of intersectional studies regarding gender and racist "yellow (face) fashion" in the Americas.

Ethnic Chic

National dress has become folklore, with the not
impossible connotation that it can be revived as "ethnic chic."
Robert Ross, *Clothing: A Global History*

We're a culture, not a costume.
You wear the costume for *one night*. I wear the stigma for *life*.
This is *not* who I am, and this is *not* okay.
Students Teaching About Racism in Society (STARS)
poster campaign, Ohio University

What is considered ethnic in fashion, style, and dress (the three are not synonymous) varies depending on the context, sometimes dramatically from one place or time to another. The intensification of processes of globalization has also made the pursuit of the authentic Other practically impossible. This fact, however, has not forestalled the efforts of the global economies of desire to package the exotic Other for consumption not just in collusion with the fashion and apparel industries, as we shall see later on in the case of what Olivia Khoo calls the "Chinese exotic," but also in makeover culture and the self-help, self-improvement industries.[4] Today, tried-and-true techniques of self-othering, ranging from urban zen condos to *fengshui* lotion, are booming lifestyle businesses. These capitalist inroads into ethnic markets in diasporic contexts (which is not the same as infiltrating ethnic markets globally) have not gone unchallenged. As the poster campaign launched in 2011 by Ohio University's Students Teaching About Racism in Society (STARS) underscores, a particularly busy, more insidious season for the practice of "dressing up" or "going native" in offensive stereotypical

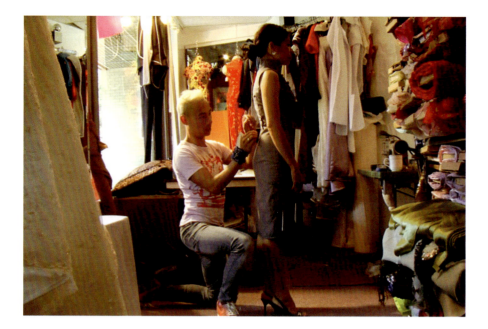

3.1 Cheryl Sim, still from
*La cabine d'essayage
(The Fitting Room)*, 2014.

costumes is during Halloween when it is somehow considered socially acceptable to perpetuate racist and sexist stereotypes through dress.[5] Ethnic chic, on the other hand, seems to be suitably fashionable all year round, except for those whose cultures are worn as mere body adornments without consideration of when or where they came from or for what purpose.

For these reasons, I use *ethnic apparel* as a critical term in this discussion in order to distinguish it from terms such as *world fashion*, *ethnic dress*, and *national dress*, with less emphasis on when it is used to qualify the word *apparel* (buttons, jewelry, handbags as well as clothing – the things one needs to pull together an "outfit" or "the look") as an undeniably de facto form of cultural industry. "Ethnic dress" only exists by virtue of being fashion's other, with fashion and Western dress long assuming a position of privilege in Eurocentric perceptions of clothing. Ethnic dress is thus not "world fashion"; the latter term, coined by American anthropologist Joanne Eicher, refers to the ubiquitous t-shirt and jeans worn by youth worldwide since the growth of the global economy in the 1980s.[6] As part of a racialized dichotomy that also implicates classist sentiments, non-Western clothing, presumed to be inferior, can only be ethnic dress or "national dress" but not fashion. In this formulation, there is no such thing as "ethnic fashion" unless it is theorized from a different perspective that expels the "West and the Rest" binary and replaces it with a transnational framework that takes into account extant multiple and alternative cultural systems, global flows, modernities, and world views continually traversing along multidirectional axes of power and registers of meta-geographical knowledge. The first project I will discuss, by Cheryl Sim, which addresses Asian dress, or more precisely, the Chinese dress, complicates precisely this formulation in its dialogue with women of Asian descent living in Canada about the cheongsam and being deeply aware of its changing fashion cachet.

The Cheongsam in *The Fitting Room*

Encountering Cheryl Sim's exhibition *The Fitting Room* on the second floor of a mall in Montreal's Chinatown might have been surprising. On closer examination, however, the multi-purpose six-storey Swatow Plaza, a commercial space rather than an art gallery, could not have been a more fitting venue to invite, as Sean Metzger writes, "spectators to reflect on their own practices of consumption … The interrelationships suggested between buying and contemplation raised questions about the value and commodification of art and everyday apparel."[7] Exploring the cheongsam, the four-part exhibition that consisted of video footage projected onto folding wood panels, a "fitting room," custom-made cheongsam, and audiotape of interviews with women of Chinese descent about the dress, was installed in front of a retail outlet that sold women's fashion. Amongst the noticeable items in the store, displayed on a high corner rack of the store, were cheongsam, the fabled traditional Chinese dress and subject of Sim's exhibition.[8] Distinguished by its high mandarin collar, side slits with sword-shape binding, and handmade flower buttons as fastenings on the diagonal placket, the formfitting one-piece cheongsam has become an internationally recognized symbol par excellence, in the collapsing of several ethnicities, of Chinese femininity. Whether sold at this mall retail shop or by high-end multinational brands, such as Shanghai Tang and Blanc de Chine, it reigns as a gender-specific signifier of quintessential modern Chinese chic.

Sim's exhibition had a decidedly retro feel to it. Displayed in the middle of the hall, practically gating the retail clothing store, was *The Chinese Screen*, a waist-height folding wood screen of four panels, each with rear-projected looped videos of different scenes. Videos of the artist being fitted for a custom-made cheongsam by Montreal designer Gary Mak in his couture atelier boutique in the nearby Holiday Inn seem to match the commercial environment perfectly, while a slideshow of old photographs of stylish women, youngsters, and calendar girls dressed in cheongsam tops and dresses evoked a waft of nostalgia to a time as far back as the 1920s when the garment was particularly popular as a fetishized commodity of the fashionable modern Chinese woman. Intermittently, clips from Wong Kar Wai's acclaimed period romantic drama *In the Mood for Love* (2000), showing the lead actress, Maggie Cheung, wearing a different cheongsam for each scene, were played. Set in the golden era of the garment's Hong Kong industry boom in the early 1960s, Wong's film about unrequited, unconsummated love serves as a reminder of how the cheongsam in the new millennium renewed its market hold as a fashionable commodity. Already by the early 1990s, the cheongsam had made a comeback through designers of Chinese descent based in the United States at high-fashion houses such as Anna Sui, Yeohlee, and Vivienne Tam.[9]

Only when visitors turned to their right did they notice the makeshift, wooden "fitting room" that provided the exhibition its title. Made of transparent plastic shower curtains, the structure was clearly not a changing room in the conventional sense of providing privacy or instituting decorum. On a hook next to the mirror inside hung a thin opaque dollar-store rain poncho that, if worn, enabled visitors to see

sequences, many humorous, from Hollywood movies in which the characters are trying on clothes, projected from above the mirror onto their flimsy makeshift screen bodies. The almost slapstick medley starkly contrasted with the melancholic, drawn out scenes from Wong's *In the Mood for Love*.

The cheongsam was not always so slim-fitting and refined. Its complex history has, in fact, long affirmed the garment as a contested site of Chineseness and femininity. For Sim, who is of mixed Chinese and Filipino heritage, there is a deliberate usage of the term *cheongsam* (長衫), which means "long dress" in Cantonese (the dialect of southern China – especially in Guangdong Province and Hong Kong), rather than *qipao* (旗袍; pronounced in Mandarin, pinyin qípáo), which refers in the Han language (distinct from Mongolian or Manchurian) to the classless and androgynous long-sleeved and ankle-length robe worn by the ruling Manchus of the Qing Empire, the last of China's imperial dynasties dating from 1644 to 1911. Living in Northeast China, the nomadic Manchu people were known as *qiren* (旗人), or Banner People, today one of China's fifty-six ethnic groups. In this region, loose and straight *qipao*, literally "banner gown," were worn by men and women. One of the first orders of business upon invading and taking over rule of China was to erase the ethnic identity of the majority of Han people through the imposition of Manchu clothing and hairstyle (e.g., long braided hair for men) on threat of execution.[10] To mitigate Han resentment, sartorial rules were relaxed where Han women's style of dress was concerned as the entrenched patriarchal system regarded women to be inferior, powerless, and thus of no consequence politically.

By most scholars' accounts, the birth of the modern cheongsam begins around this time. In her doctoral dissertation, Sim outlines some of the more controversial and inconsistent accounts of its appearance.[11] Hazel Clark's comprehensive study from a feminist perspective is the first "to diverge from the prevailing discourse that the *cheongsam* was a descendent of Manchu dress."[12] She argues that after 1800, the two-piece skirt and tunic traditionally worn by Han women and the one-piece of the Manchu increasingly began to merge, and "as a result the styles between the two groups became somewhat blurred"; with later influence from American culture, the cheongsam became an inherently hybrid garment.[13]

Ironically, however, the eventual influence of popular culture and fashion icons circulated through Hollywood film, Hong Kong print culture, and the redefinition of Chinese modernity as cosmopolitan, "would covertly transform the dress from a symbol of freedom into an instrument of constraint, both figuratively and literally."[14] Partly out of the May Thirtieth labour movement in 1925 that was characterized by anti-West demonstrations and a rise in nationalism, "by 1929 the Nationalist government officially declared the *cheongsam* the national formal dress for women."[15] As the shape of the dress became tighter and more formfitting, the slimmer, silhouetted version of the garment with a high cut reaching as high as the cheek bones heralded the Golden Age of the cheongsam in Shanghai in the late 1920s and 1930s and into the 1940s. The female body in this dominant urban fashion became China's latest export through calendar posters depicting exoticized and eroticized women to advertise

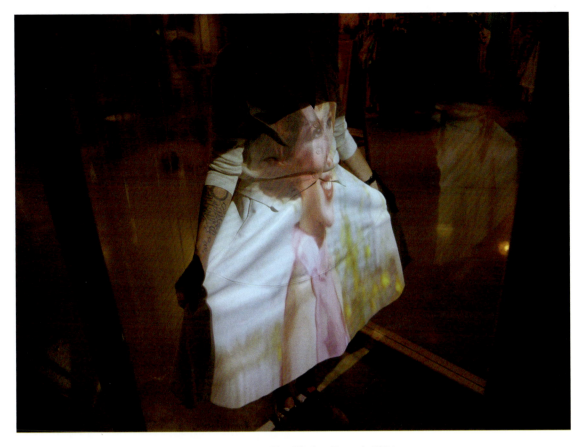

3.2 Cheryl Sim, still from *La cabine d'essayage (The Fitting Room)*, 2014.

popular brands of cigarettes, fabrics, or cosmetics, commodifying the women along with the product.[16]

The upsurge of the Chinese Communist Party in the late 1940s and 1950s, followed by the Cultural Revolution (1967–76), however, saw the Shanghai-style cheongsam outlawed as a signifier of bourgeois decadence and fall out of fashion as it was replaced by the Mao jacket and Chinese tunic suit (the "people's suit"). The cheongsam was only worn occasionally by elites mostly for exclusive foreign affairs activities and later as a kind of ceremonial dress for formal occasions such as weddings and beauty pageants, rather than as an everyday garment. "In Hong Kong, Singapore and Taiwan, however, the dress continued to be a staple in women's wardrobes."[17] At the onset of the Japanese invasion in 1937, Shanghainese emigrants and refugees, among them tailors, fled to Hong Kong, which resulted in the British colony experiencing its own golden age of the cheongsam in the 1950s and 1960s. It became the sleek, ornate, and hugely popular signifier of Hong Kong cultural identity.

Ironically, and perversely, the decade that witnessed this spurt in popularity also saw hemlines shrink to mid-calf. Richard Quines's 1960 British-American romantic hit, *The World of Suzie Wong*, propagated one of Hollywood's most persistent sartorially hypersexualized Asian female stereotypes, "Suzie Wong": the exotic, submissive, catering, and self-sacrificing prostitute in a slinky red cheongsam who can only

gain legitimacy based on a romantic relationship with a white male whose moral virtue ultimately absolves and transforms her. It is widely accepted that stereotypes of Asian women as sexual and exotic objects are historically rooted in the Western colonization of various Asian countries and intensified by war, conflict, and forced migration. The Asian female, often portrayed as being freely sexually available, is always the object of desire in colonial fantasies of power. In the case of Quines's film, set in post–Second World War Hong Kong, where British rule was resumed after the Japanese occupation ended, the classic stock Hollywood imperialist trope steadfastly constructs a fixed image of the authentic Chinese woman as fetish native-informant. Scenes centring around the American-architect-turned painter Robert Lomax's rejection of Western-style clothing on Suzie, gifts of her British expat client, and his insistence on her donning traditional Chinese dress while she pose for him, also satisfy his self-image as heroic saviour of exotic mistress-in-distress of the colonized Orient.

Sim's exhibition thus unavoidably resuscitates the durable "Suzie Wong" stereotype. This identification is heightened by sequences from *In the Mood for Love*, where the lead actress, in multiple versions of the dress, appears in various fantasy scenarios. Referring to an Orientalized imaginary no less inauthentic (most of the film was shot in Bangkok) as *The World of Suzie Wong*, the languorous scenes also suggest

3.3 Cheryl Sim, still from *La cabine d'essayage (The Fitting Room)*, 2014.

today's thriving fashion revival of Oriental chic in and outside of Asia since the 1990s. Finally, off to the side of Sim's shabby-chic fitting room was the *pièce de résistance* of the exhibition: *Robes hybrids / Hybrid Dresses* (2014), an installation of three shapely female mannequins wearing three distinct cheongsam: a red dress, a yellow dress, and a blue dress.

The store-bought, red, floral-patterned dress, titled *Sim Dynastic Dress*, with Sim's family name (沈) hand-embroidered in gold and silver thread, is the most generic of the three cheongsam. The other two dresses are custom-made. The yellow dress is fashioned from bright yellow cotton fabric with tiny white polka dots. *Banana Dress* refers to the ethnic slur "yellow on the outside, white on the inside," but unless visitors are familiar with the racist euphemism for "race traitor," they may not think to turn the dress over to see the custom print of repeated half-peeled yellow bananas on the interior lining and the dress itself as a banana skin. The most cryptic of the three dresses is the blue DNA *Dress*, on which is embroidered vertical bars of the same colour resembling Morse code but which are actual visualizations of Sim's genetic code. Similarly discrete, the inner lining of the DNA *Dress* revealed a digital textile print of repeated portraits of Sim's paternal grandparents, who were originally from Swatow in southern China.

The Chinese Exotic

The cheongsam eventually made its way to Canada through flows of Chinese immigration and brought its tumultuous past as it entered into an uncertain future. As a result, I argue, this dress is fraught with deep ambivalence for Canadian-born women of Chinese heritage today.
Cheryl Sim, "The Fitting Room: The *Cheongsam* and Canadian-Born Women of Chinese Heritage in Installation."

For the installation, Sim also conducted qualitative interviews in English and French with twenty ethnic Chinese (including Filipino, Singaporean, Malaysian, Vietnamese, Taiwanese, and Trinidadian) women, asking each of them to candidly share their reflections on what the cheongsam meant to them growing up. Visitors could listen on headphones to these audio recordings, which contrasted the rest of the exhibition in form and voice. The women's responses spoke most poignantly to the diasporic conditions of becoming Chinese through various wearing practices of cheongsam informed by the garment's history. Collectively, their voices articulate an insistent diasporic belonging in the Canadian context that not only aesthetically manifests in the customized design on the fabrics of the three cheongsam, but also signals a generational transformation.

While the cheongsam was embraced in Canada after its arrival in the early 1930s, the younger generation's attitudes toward the dress are more ambivalent. In the interviews, they spoke of their desire for assimilation and integration, and of being born and growing up as nth generation Asian Canadian women and as a visible minority in North America. Many of the interviewees understood the cheongsam as a kind of formal dress worn for special family occasions, while some reflected on its more contested meanings, past and present, in the media, gender politics, and the entertainment and fashion industries: "It's probably closer to fashion now – but twenty years ago it might have been separate … If you're going to a dress up party and you want to dress as a Chinese girl then it's a costume. If you're going to a multicultural show it's an ethnic garment. If you're going to a wedding, or a social event, it's fashion." Despite cynicism about cultural authenticity and appropriation, many interviewees expressed interest in obtaining permission to wear the traditional dress of other cultures and giving oneself the permission to wear one's own dress. Yet the majority of the interviewees spoke to the discomfort, cultural anxieties, and expectations around wearing cheongsam as ethnic apparel: "I wouldn't wear it because I wouldn't want to look too Chinese … because I wouldn't live up to the expectation of being Chinese." As one of the interviewees, I expressed my sentiments in this way: "Right now, I would say I'd be happy to wear it whenever I want to wear it; when I'd be unhappy is when I am *expected* to wear it … I'm not going to wear it if they want me to be a China doll. For me it is not about reminding me about my Chineseness. We don't live in a society that will let us forget that. So when we want to wear ethnically marked clothing, we have to do it out of our own choice." These responses reinforce how, as Ross puts it, "In many cases, and within certain limits, people decide for themselves what clothes they will wear, which is why wearing clothes (and certainly not wearing them) is almost invariably a political act."[18] However, in the same way that an earlier generation would tend to flashback to the negative images associated with the dress from *The World of Suzie Wong*, Sim's interviewees' more familiar reference point for the cheongsam are the positive images celebrated in *In the Mood for Love* – images that, in fact, "incite desire to wear the cheongsam as well as the desire to embody the fantasy of stylish, Chinese femininity that Cheung so magnificently presents."[19]

Another interviewee in her mid-thirties, a second-generation, ethnic Chinese Vietnamese Montrealer, in one of the few explicitly feminist statements made to Sim, addressed the gendering and beauty ideals involved in wearing a cheongsam.

C'est une robe qui est tellement serré – quand tu n'as pas la forme pour le porter – je suis aussi féministe – donc je peux voir la robe comme associé à la femme chinoise (idéal) donc je le mets en questionne (comme la mini-jupe, les talons haut) donc la robe aussi … Comment c'était utilisé pour vendre des choses – je vois le côté patriarcal. Clairement c'est un symbole très lourd pour la féminité. C'est n'est pas confortable mais elle modifie notre corps, la féminité … dans la culture chinoise les sexes sont très éloigné … Ça nous rend plus obéissante. Je vois la discipline, la docilité … Il faut aussi porter un regard critique sur l'idée

du corps qui pourrait porter cette robe. Ça implante une idée monolithique de quoi est une femme asiatique. Les femmes ne sont pas uniforme.[20]

This last entry is particularly telling for contemporary understandings of Asian femininity. Since the 1990s, diasporic women are all too cognizant of a new mode of representation for femininity associated with ethnic apparel that is constantly in a tug-of-war with nostalgic, cliché, and colonialist ideas of the cheongsam while also beginning to express a growing sense of agency through ethnic apparel. Olivia Khoo calls this recent "product of the emergent diasporic Chinese modernities in the Asia-Pacific ... the Chinese exotic," which "can be distinguished from earlier representations in that it is self-consciously connected to the capitalist success of the region."[21] Khoo's formulation of the cosmopolitan, mobile, and modern Chinese exotic is particularly useful to grasp the circulation of the cheongsam as a signifier of China/Asia in the contemporary moment. Khoo writes, "The Chinese exotic is also differentiated from colonialist or imperialist exoticism in that it conceived of women and femininity, not as the oppressed, but as forming part of the new visibility of Asia, connected with the region's economic rise and emergent modernities. What is exotic now is no longer the old (primitive) China with Asia, but the idea of a new Asia (Asian the cosmopolitan, the rich, the modern, and the technological) ... The Chinese exotic shifts between perspectives to displace the 'self' and 'other' binaries assumed in orientalist understandings of the exotic."[22] While new representations can be sites of new agential power, "although exotic discourses now appear in new, updated forms, their orientalist underpinnings haven't entirely disappeared. What *have* appeared are sources of potential empowerment, or agency, in these representations, which are a product of their modernity."[23]

It is from this perspective of potential agency that Sim's *The Fitting Room* can enter into a different kind of conversation at the intersection of cultural analysis, fashion history, and gender criticism, one that includes a consideration of what an Asian Canadian feminist reading of this project might be. Interrogated from a feminist perspective, Sim contends "the cheongsam is a 'cultural-political complex,' made up of a tight network of linked relationships that inform its quality as a 'technology' shaped by governments, patriarchal discourses, popular media and the fashion industry, to affect the current perception and wearing practices of this garment by Canadian women of Chinese heritage."[24] The installation is constructed as a "feminine" space, one claimed by the exotic that necessarily "travels in a form that is feminised."[25] In the case of the Chinese exotic, it travels "as a fold – a trope of movement that can potentialise a shift from object to subject positions within diasporic contexts in the West."[26] As Carla Jones and Ann Marie Leshkowich write, "The extent to which Asian dress is reorienting fashion versus re-Orientalizing Asia rests fundamentally on the factors of who is performing, with what intentions, under what circumstances, and before what audience."[27]

While the cheongsam was peaking in Shanghai fashion houses in the 1920s and 1930s, the Chinese diasporas in North America were dealing with racist immigration

policies. The Canadian government has only recently recognized the historical legacy of racist immigration polices against Asians and the struggle these policies caused for raising the next generation.[28] In a fit of neo–Yellow Peril (anti-Asian xenophobia) and fear mongering, Canadian media has continued to single out Asian students, for example, for supposedly taking the places of white students; these media makes no distinction between international students and Canadian-born Asian students.[29] The archetypal Asian (Canadian) woman has shifted from being ridiculed, tragic, and poor to being hypersexualized and over-domineering, making Sim's *The Fitting Room* and its array of diverse voices that counter the stereotypes imprinted on ethnic apparel all the more resonant.

Rearranging Desires

Wouldn't it be nice if we were all equal,
If no one were green with envy,
And we all wore yellow...
Yellow Shoes ad campaign, reproduced as vinyl wall
text for the exhibition *Rearranging Desires*, FOFA Gallery,
Concordia, 2008[30]

Hong Kong–born, Montreal-based multidisciplinary artist Mary Sui Yee Wong presented *Yellow Apparel* as part of a 2008 exhibition I curated at Concordia University's Faculty of Fine Arts (FOFA) Gallery called *Rearranging Desires: Curating the "Other" Within*. Inspired by postcolonial theorist Gayatri Spivak, the exhibition featured contemporary artworks by four Montreal artists of Asian descent as an attempt to "rearrange desires" concerning the presentation, reading, and interpretation of culturally specific work in a postcolonial context.[31] Confronting cultural expectations of what work by artists of Asian descent should look like, the core objective was to consider the implications of these desires for diasporic formations and their representations – to register intonations and contradictions, pitch and silence, rather than set down shared aesthetics and politics. From the onset, Wong's *Yellow Apparel* sought to examine representation and cultural consumption in relation to the persistence of fashionable Orientalism, or what Hiroshi Narumi refers to as "fashion orientalism," which "defines Euro-American aestheticism as the standard and represents other cultures as exotic."[32] Wong provides several examples of fashion Orientalism: "the recent trends towards the use of Asian calligraphy and symbols in clothing, the popularization of feng shui in architecture, Hollywood's attempt to cash in on kung fu movies, and the flooding of contemporary Asian art in the international art market."[33] As it unfolded into a global economics of desire through the designs of a single rolled bolt of fabric, *Yellow Apparel* unravelled other constructions of difference at the same time.

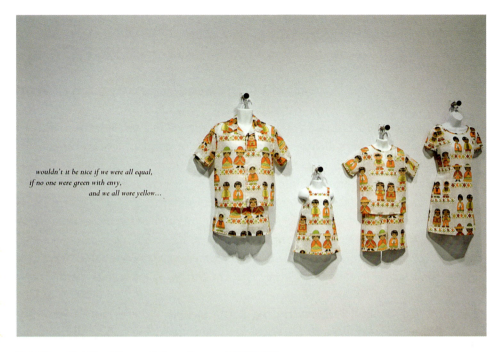

wouldn't it be nice if we were all equal,
if no one were green with envy,
and we all wore yellow...

3.4 Mary Sui Yee Wong, *Yellow Apparel*, 2001–08.

The telltale sign of the focus on fashion of Wong's clothing line is revealed in its title, which is also its brand name: *Yellow Apparel*. As much as it plays on the racist anti-Asian epithet *Yellow Peril*, the title also humorously makes a bid on the hugely successful L.A.–based manufacturer, distributor, and retail company American Apparel. *Yellow Apparel*, however, clearly places emphasis on the colour yellow as being opposite to American identity but also rooted in Quebec where Yellow is the name of a popular shoe store franchise. Rebecca Duclos observes, "Wong's found fabric is in strange sync with Johann Friedrich Blumenbach's pervasive and pejorative 'five colour typology of humans' (white, black, yellow, red, and brown) that was developed by the Göttingen scientist in the early 1800s, [which] isn't represented by the skin colour of the happy figures … Rather, the diverse chromatic array arrives in the form of the clothing that each of these figures is seen to wear."[34]

Unlike Sim's approach, which focused on the Chinese dress, Wong's fashion line addressed ethnic apparel as a whole by revealing its designs not through the meticulous silhouetted cut of the cloth proper (Wong's were quite plain and basic wearable tunics, pants, and dresses[35]) but by re-appropriating stereotypical representations of other cultures already found in the pattern of a pre-existing bolt of fabric that she came upon years ago: paper-doll-like representations of children dressed in stereotypical "celebratory clothing" or "national dress" in brownish, yellowish, reddish tones only loosely associated with the colour of their skin. With no shortage of irony, the most recognizable ethnicities were Inuit (coat with fur-lined hood), Mexican (sombrero),

and Asian (slanted eyes and robes). Clearly, the fashion world's and garment and textile industry's embrace of diversity or ethnicity does little to challenge or confront widespread systemic racism in all different shapes and sizes.

Global Village Syndrome: It's a Small World after All

"There's so much that we share that it's time we're aware / It's a small world after all," goes the Sherman Brothers' song, written especially for and made famous by the Disney theme park attraction that debuted at the 1964 New York World's Fair. In little boats on "the happiest cruise that ever sailed," visitors were carried past animatronic dolls of children frolicking in miniature sets of different lands and dressed in traditional local costumes, each singing, in their native language, arguably the most translated (and irritating) piece of music on Earth today. It came of no surprise, then, to have choristers of Montreal's all-women Choeur Maha/Maha Choir sing "It's a Small World" in English, French, and Chinese (Cantonese) during the opening performance of Wong's *Yellow Apparel* for the *Rearranging Desires* exhibition, on cue once all the models (including the artist's teenage daughter) strutted down the corridor in the cheeky doll-faced faux fashion line to requisite techno catwalk music.

What was unpredictable was how, nearly six years later, in the summer of 2014, a second fashion show of *Yellow Apparel* would take place in the building across the street, this time as an impromptu intervention at the ninth Encuentro of NYU's Hemispheric Institute of Performance and Politics. With the theme "MANIFEST! Choreographing Social Movements in the Americas," the 2014 Encuentro in Montreal featured a full eight days of workgroups, workshops, performances, and exhibitions, as well as innumerable ad hoc meetings, in different venues around the city with its base at Concordia University. The six performers in this case were members of the Performing Asian/Americas: Converging Movements workgroup, the first permanent work group focusing on Asian diasporic presence and creative activity in the Americas.[36]

The intervention was a response to the premiere of a controversial performance on the third day of the program, *Juana la Larga*, by celebrated Mexican theatre artist and activist Jesusa Rodríguez (b. 1955) and Argentinian composer, pianist, and singer Liliana Felipe (b. 1954). The feature performance contained a brief but looming projected image of the notorious Fu Manchu, the popular fictional Asian master criminal appearing in 1913 in the first of a series of novels by British author Sax Rohmer about the evil genius doctor who has discovered a secret elixir that prolongs his lifespan and is tirelessly dogged by two outstanding members of the local law-enforcement agency. Fu Manchu would later make his American debut portrayed as a crazed Asian demon with pointed ears, a Dracula-looking widow's peak, and long fingernails in the early 1929 Paramount talkie film *The Mysterious Dr. Fu Manchu*, starring Warner Oland. In countless revivals and versions over the decades, the character of Fu Manchu has been chastised and protested against as a racist and offensive stereotype associated with the genre of Yellow Peril thrillers that remain popular.

Yellowface and the Ethics of Humour

First appearing in the 1950s, the term *yellowface* refers to Asian stereotypes associated with early Hollywood mainstream films of the twentieth century, when white actors wearing makeup played intentionally pejorative visible minority character roles such as Fu Manchu or Charlie Chan. According to Krystyn R. Moon, "Tied to blackface and the portrayal of African Americans on the stage by whites in the nineteenth century, the term *yellowface* ... describe[d] the continuation in film of having white actors playing major Asian and Asian American roles and the grouping together of all makeup technologies used to make one look 'Asian.'"[37] Whether cast in big or small roles, visible minority characters in general were typically characterized in *yellowface* as immoral, criminal simpletons, assuming exaggerated accents and movements and used as comedic contrasts to their white protagonists, thereby degrading the ethnicities being represented. The phenomenon of yellowface performances, however, has been around in the United States for over two hundred years, since Arthur Murphy's English adaptation of Voltaire's play *The Orphan in China* (1755) opened at Philadelphia's Southwark Theater in 1767.[38] Yellowface also references stylized behaviours used to portray Asians, including "mincing steps, tittering behind fans, excessive bowing, evil characterizations," as well as mimicking accents and language abilities of English-as-second-language speakers.[39]

Some would say not much has changed over half a century later. Jeff Yang writes, "Ching Chong" – "the spectre of Yunioshi" and one of the most persistent icons of ingrained ethnic stereotypes harking back to Second World War–era anti-Japanese propaganda cartoons – "continues to haunt Hollywood and Asian America today."[40] As activists have pointed out, "Racially stereotypical images are problematic even when presented as progressive satire, because many who see them won't understand the context and will laugh for the 'wrong reasons.' And even when laughed at for the right reasons, they're problematic."[41] Humour, especially ethnic humour, brings critically engaged, knowledgeable people together, except when people don't think it's funny. One of the most remarkable things was the denial of the existence of yellowface discourses in Mexico by the *Juana la Larga* creators, Rodríguez and Felipe, a pair well-known for their use of parody, political satire, and cabaret.

Juana la Larga was based on recently revealed archival research about an actual case of an intersex person named Juana Aguilar, who faced the Spanish Inquisition in Guatemala in 1803.[42] The projected image of the doctor, who was Japanese – a fact recorded in the archives – appeared during the staging of the surgical procedure ordered by the Inquisition to remove Aguilar's female sexual organs. Serious in subject matter – clitoral mutilation – but humorous in delivery, the doctor who executes the surgery was performed in yellowface by Rodríguez, and further alluded to through the projection of a large stereotypical image of the character of Fu Manchu (who technically is not Japanese but Manchurian).[43] In lieu of the program originally planned for the *Transnocheo* at the Phi Centre in Old Montreal, Rodríguez and Hemi director

Diana Taylor decided to replace it with an ad hoc Town Hall meeting in order to address the growing discontent and anger concerning transphobia and anti-Asian racist imagery in the performance. A second meeting was needed to continue addressing what had by then become heated debates with too many competing agendas.

The following day, a second meeting took place at the Library of Performing Rights installed in the Leonard and Ellen Bina Art Gallery as one of the experiments facilitated by Lois Weaver's Long Table – part round-robin table talk, part participatory performance. Discussions resumed under the theme of "Representing Bodies and Experiences."[44] The Long Table appropriated the dinner table conversation format as a public forum, complete with a list of accepted behaviours and etiquette to ensure structural, equitable airtime by stakeholders, including the injunctive that only those seated around the table could voice their thoughts. The atmosphere of the exchanges (which felt at times rather exclusive as speakers were reluctant to give up their seat at the table after they spoke their peace) were no less charged, turning the dialogue into a public spectacle rather than an intimate sharing of voices. The majority of the time was devoted to the problematic, abusive way in which "the representation of transgendered or intersex bodies, specifically through inanimate objects, predominantly a medical mannequin," were enacted by the cis-gendered artists of *Juana la Larga*. Not giving up their seats even once during the eighty-two minutes, Rodríguez and Felipe were inevitably subject to verbal attacks and expected to respond.

It was only upon the intervention halfway through by the Performing Asian/Americas: Converging Movements workgroup, whose members re-staged Wong's *Yellow Apparel* fashion show using the long table as a runway, that the discussion turned finally to the issue of yellowface. Initially, Rodríguez refused outright to take responsibility for the racist representation of the Japanese doctor not only via the Fu Manchu image but also on stage through stereotypical gestures, slanted eyes, and buckteeth, arguing for equal-opportunity re-performance of racialized roles and conventions. In Mexico, she responded, these kinds of images are everywhere and no one has any problem with them; if others find evidence to the contrary, then they should create and produce their own performance to answer for the historical amnesia.

While the responsible use of ethnic humour to elucidate social injustices (as opposed to racist humour intended to maim) was a sustained critical intervention, a great deal of time and effort was devoted by members of the Performing Asian/Americas workgroup to educating their peers about the historical legacies of anti-Asian discourses and movements up, down, and across the Americas. Yellowface, as a manifestation of Yellow Peril, has been around for a very long time in the commercial, public, and private cultural realms. Although the topic may not often reach the mainstream press, there is certainly a very vocal and articulate criticism of it in the field of Asian diasporic studies in the Americas.

The most effective, and brave, intervention was by a young Chinese-Mexican historian, Itzayana Gutiérrez Arillo, who tearfully recounted the history of Mexico's racism towards Asians. As a result of anti-Asian violence, no archives exist attesting to the historical presence of Asians in Mexico who emigrated in the late 1800s to gain

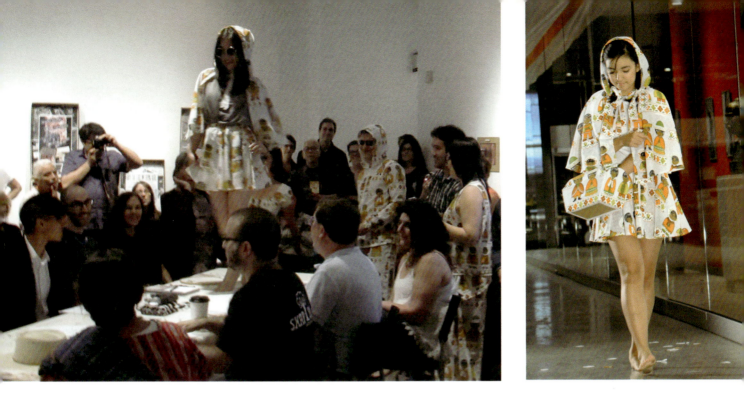

Left
3.5 Restaging of Mary Sui Yee Wong's *Yellow Apparel* during Lois Weaver/The Library of Performing Rights' *Long Table: Representing Bodies and Experiences,* at the Leonard and Ellen Bina Art Gallery, Hemispheric Institute Encuentro, Concordia University, Montreal. 2014.

Right
3.6 Mary Sui Yee Wong, *Yellow Apparel*, 2001–08.

entry into the United States in search of employment opportunities. Some people stayed in Mexico, as, in part, a consequence of the US Chinese Exclusion Act of 1882, and earned their living as tradesmen, barbers, and shopkeepers. Chinese constituted Mexico's second-largest foreign ethnic community in the late nineteenth and early twentieth centuries.[45] In 1899, the Mexican government also signed a treaty with China to recruit Chinese to work in agriculture in the northern border areas. At the beginning of the Mexican Revolution in 1910, Maderista forces, sympathizers of revolutionary leader Francisco Madero, entered Torreón, Coahuila, in northern Mexico on 13 May 1911, targeting the homes and businesses owned by the small Chinese community of six hundred residents and killing half the Chinese population. They were blamed for becoming rich at the expense of humble Mexicans in what remains the worst act of violence committed against any Chinese diaspora of the Americas during the twentieth century. The proceedings of the Long Table deteriorated after this retelling of history into first-world feminists attacking third-world women. Towards the end of the Long Table session, Rodríguez acquiesced that it was always her goal to better understand the ethics of humour and "how to offend the right people, the oppressors, not the ones who've already been victimized or marginalized." Wong's *Yellow Apparel* was a fitting intervention by the Performing Asian/Americas workgroup at its first Encuentro in Montreal. Encuentro 2014 was only the second time the Hemi event had taken place

in a so-called first-world country (the first being New York in 2003). This episode illustrates how profoundly charged the representation of ethnic and other marginalized identities can be in fashion and other forms of visual culture.

Conclusion

Ethnic apparel encompasses the critical awareness of ways in which race, gender, and desire are refashioned through artistic interventions. It also underscores how this critical awareness needs to extend to questions of cultural appropriation and mimesis, through stereotypical makeup, behaviours, and accents that risk essentializing in denigrating ways the ethnicity and gender that one chooses to take on. Ethnic apparel has a way of uncovering the entangled power relations of visual culture in local and global, national and international, universal and particular representations. Accordingly, it is not only the visual quality of ethnic apparel as material culture that matters but also the discourses, ideas, desires, and practices vital to its very existence. Established meanings and modes of representation in ethnic apparel reflect and inform desires – colonial desire, desires of belonging, politico-economic desire, and desiring bodies, as well as expectations, memories, and ways of being in the world. Ethnic apparel and orientalist fashion are fundamental bedfellows in processes of subjectification and identity in the twenty-first century. Fashioning desires around race and gender are paradoxically confirmed and controlled as well as contested and rejected by the scopic regimes in vogue. This accounts for the innumerable cyclical episodes of iconoclasm, appropriation, remixing, and other sartorial negotiations of fashion orientalism through feminist and critical race theory, practice, and art history. Ultimately, Cheryl Sim's *The Fitting Room* and Mary Sui Yee Wong's *Yellow Apparel* bring forward the vexed negotiation of expressions of desire, fear, and identity embodied in cultural practices involving ethnic apparel as it becomes increasingly absorbed as part of a global alterity industry while at the same time intertwined between often little-known or neglected, deeply layered dark micro-histories and the political agendas of those who would confront them to redefine what is fashionable.

NOTES

1 Marcus, "Orientalist Art Makes a Surprising Comeback."

2 Directed by Sonya Mehta and Sheng Wang, the documentary *Yellow Apparel: When the Coolie Becomes Cool* (2000) explores appropriation of Asian culture in Western society, asking why products once ridiculed in the past are now coveted global commodities.

3 Said, *Orientalism*, 166.

4 Broadly speaking, in postcolonial thought, the term *exotic Other* refers to subjects and cultures perceived, represented, and commodified as strikingly different from the colonizer's normalized perspective.

5 The awareness poster campaign pairs individual students with photos or backdrop images of typical racial and ethnic stereotypes associated with their ethnicities impersonated by white people, such as the donkey-riding Mexican, "black gangster," Japanese geisha, Oriental femme fatale, Asian model minority, a "Muslim terrorist," and an "Indian"

couple in Native American regalia. See the STARS website: http://www.ohio.edu/orgs/stars/Home.html.

6 Eicher, "Introduction: Dress as Expression of Ethnic Identity," 1–5.

7 Metzger, "*La cabine d'essayage* (The Fitting Room): Cheryl Sim," 214.

8 "Access to store-bought cheongsam in Canada is still limited to boutiques in Chinatowns in any city. These dresses are made primarily in China by the mainstream fashion industry, that has embraced many changes to make the dress more economical to make and easier to wear." Sim, "The Fitting Room," 139.

9 Ibid., 95. Today, most cheongsam manufacturing has moved to mainland China. But despite being referred to as a sunset industry, the classic dress is still popular for weddings and beauty pageants, and is the favoured outfit of Chinese actresses. Wong, "Sexy, Skintight, Sophisticated."

10 Wu, *Chinese Fashion*, 104.

11 Hamilton, Ontario–born media artist Sim is associate curator at DHC/ART Foundation for Contemporary Art. She obtained her doctorate in the Études et pratiques des arts program at l'Université du Québec à Montréal in 2015.

12 Clark, *The Cheongsam*, 8.

13 Ibid., 4.

14 Sim, "The Fitting Room," 70.

15 Ibid., 74.

16 Clark, "The Cheung Sam," 155–65.

17 Sim, "The Fitting Room," 79.

18 Ross, *Clothing*, 169, 171.

19 Sim, "The Fitting Room," 134.

20 "It's an extremely tight fitting dress when you don't have the body to wear it. I am also a feminist; I can see how the dress is associated with the ideal Chinese woman, which, like the mini-skirt, high heels and the cheongsam, I put into question ... How it was used to sell things, I see the patriarchal side. Obviously it's a symbol that weighs heavily for femininity. It's not comfortable but it modifies our bodies; in Chinese culture, there is a huge gap between the sexes. I see discipline, docility ... It's also necessary to

take a critical look at the idea of the bodies who can wear this dress. This implants a monolithic idea of what an Asian woman is. Women are not all the same" (author's translation).

21 Khoo, *The Chinese Exotic*, 2.

22 Ibid., 12.

23 Ibid., 2.

24 Sim, "The Fitting Room," 63.

25 Khoo, *The Chinese Exotic*, 3.

26 Khoo explains, "Exoticism mythologizes and reifies the more positive and successful, enviable and utopic, aspects of Other societies. Exoticism is imbricated in the condition of modernity, and is constituted by it." Ibid., 69.

27 Jones and Leshkowich, "Introduction," 8.

28 Eight years after the Canadian government apologized to Chinese Canadians for the head tax, the provincial government of BC made their apology on 15 May 2014. During the years of the Chinese Head Tax policies and Chinese Exclusion Acts (in Canada, 1923–1947 and in the United States, 1882–1943), which restricted immigration of Chinese, early Chinese communities in North America were constituted primarily of bachelor societies.

29 See, for example, controversies surrounding "Campus Giveaway," an episode of CTV's newsmagazine program *W5* that aired on 30 September 1979; Kohler and Findlay, "Too Asian"; and Hutchinson, "Vancouver Being Transformed."

30 Yellow shoes conjure up quite a number of associations, ranging from Nike's neon yellow (actually the colour is called volt) sneakers, popularized during the 2012 Olympics, to Disney's Yellow Shoes Creative Group, the in-house advertising agency that designs all the marketing campaigns for the Walt Disney Company. In the case of Wong's *Yellow Apparel*, the reference is drawn verbatim from an ad campaign by Yellow Shoes (established 1916), "Quebec's largest and most respected family footwear retail companies, named after the yellow sample tags affixed to the factory room samples

[founder Samuel Avrith] used to buy from the various factories in Quebec and sell direct to the client. Yellow, as it is now called, is the oldest shoe retailers in the province with three generations of the same family at the helm of the Company." Accessed 1 August 2015, http://www.yellowshoes.com/History-en-14.

31 For curatorial essay, see Jim, *Rearranging Desires: Curating the "Other" Within.* Wong's *Yellow Apparel* was developed during the 2004 Intra-Nations thematic residency at the Banff Centre, Banff, AB.

32 Khoo, *The Chinese Exotic*, 58.

33 Wong, "Yellow Apparel." Wong is a faculty member at Goddard College, Plainfield, VT, and the Department of Studio Arts at Concordia University, Montreal.

34 Duclos, "Mary Wong and the Burden of Semiotics," 39.

35 The style of Wong's line is deliberately of a more conservative period in the 1960s, when this fabric pattern might have been much more popular.

36 For the Hemispheric Institute of Performance and Politics website and the Performing Asian/Americas workgroup description and participant list, see http://hemisphericinstitute.org/hemi/en/enc14-work-groups/item/2531-enc14-workgroups-asianamericas. Lok Siu, a fellow co-organizer of the working group, has also written on this Encuentro experience, though her essay focuses our discussions leading up to the performance. See Siu, "Hemispheric Raciality."

37 Moon, *Yellowface*, 164.

38 Ito, "'A Certain Slant.'"

39 Erin Quill quoted in Chow, "Roundtable.'"

40 Yang, "The Mickey Rooney Role."

41 Ibid.

42 *Juana La Larga* was performed at Concordia University's DB Clark Theatre, 23 June 2014. Edited documentation is available on the Hemispheric Institute website, http://hemisphericinstitute.org/hemi/en/enc14-performances/item/2330-enc14-performances-rodriguez-

felipe-juana. *Juana La Larga* was a well-known 1896 novel by Spanish realist author Juan Valera (1824–1905); the novel is about a young girl's affair with a wealthy, much older widower. It was made into a television movie series in 1982. Latin American audiences would have been familiar with the narrative.

43 Gina Marchetti argues that "Hollywood used Asians, Asian Americans, and Pacific Islanders as signifiers of racial otherness to avoid the far more immediate racial tensions between blacks and whites or the ambivalent mixture of guilt and enduring hatred toward Native American and Hispanics." *Romance and the "Yellow Peril,"* 6. Postwar politics had it that national distinctions when it came to Asians were flattened out, a conflation that plagues the appropriation of Asian culture in general.

44 Complete video documentation of this "manifestation" is available on the Hemispheric Institute's website: http://hemisphericinstitute.org/hemi/en/enc14-manifestos/item/2596-longtable-representing-bodies-and-experiences.

45 Romera, *The Chinese in Mexico*. Chinese migration to Mexico dates back to the 1600s when Spanish trading ships sailed between Mexico and the Philippines. Small numbers of Chinese immigrants entered colonial Mexico as personal servants of Spanish merchants.

BIBLIOGRAPHY

Chow, Kat. "Roundtable: The Past and Present of 'Yellowface.'" *Code Switch: Frontiers of Race, Culture and Ethnicity* (blog), 14 August 2014. http://www.npr.org/blogs/codeswitch/2014/08/14/339559520/roundtable-the-past-and-present-of-yellowface.

Clark, Hazel. *The Cheongsam.* Oxford: Oxford University Press, 2000.

– "The Cheung Sam: Issues of Fashion and Cultural Identity." In *China Chic: East Meets West*, edited by Valerie Steele and John S. Major, 155–65. New Haven, CT: Yale University Press, 1999.

Duclos, Rebecca. "Mary Wong and the Burden of Semiotics." In Jim, *Rearranging Desires*, 38–43.

Eicher, Joanne B. "Introduction: Dress as Expression of Ethnic Identity." In *Dress and Ethnicity: Change across Space and Time*, edited by Joanne B. Eicher, 1–5. Washington, DC: Berg, 1999.

Hutchinson, Brian. "Vancouver Being Transformed by New Wave of Brash, Rich Asians Looking for Safe Place to 'Park Their Cash.'" *The National Post*, 12 December 2015. http://news.nationalpost.com/news /canada/vancouver-being-transformed-by-new-wave-of-brash-rich-asians-looking-for-safe-place-to-park-their-cash.

Ito, Robert B. "'A Certain Slant': A Brief History of Hollywood Yellowface." *Bright Lights Film Journal* (blog), 2 May 2014. http://brightlightsfilm.com/certain-slant-brief-history-hollywood-yellowface/#. VWuuWc9VhBc.

Jim, Alice Ming Wai, ed. *Rearranging Desires: Curating the "Other" Within*. Montreal: Gail & Stephen A. Jarislowsky Institute for Studies in Canadian Art and Concordia FOFA Gallery, 2008. Exhibition catalogue.

Jones, Carla, and Ann Marie Leshkowich. "Introduction: The Globalization of Asian Dress: Re-orienting Fashion or Re-orientalizing Asia?" In *Re-orienting Fashion: The Globalization of Asian Dress*, edited by Sandra Niessen, Ann Marie Leshkowich, and Carla Jones, 7–48. Oxford: Berg Publishers, 2003.

Khoo, Olivia. *The Chinese Exotic: Modern Diasporic Femininity*. Hong Kong: Hong Kong University Press, 2007.

Kohler, Nicholas, and Stephanie Findlay. "Too Asian: Some Frosh Don't Want to Study at an Asian University." *Maclean's Guide to Canadian Universities 2010 edition*. Toronto: Rogers, 2010. http://www2. macleans.ca/2010/11/10/too-asian/.

Marchetti, Gina. *Romance and the "Yellow Peril": Race, Sex, and Discursive Strategies in Hollywood Fiction*. Berkeley: University of California Press, 1993.

Marcus, J.S. "Orientalist Art Makes a Surprising Comeback." *Wall Street Journal*, 17 April 2015. http://www.wsj.com/articles /orientalist-art-makes-a-surprising-come back-1429305221.

Metzger, Sean. "*La cabine d'essayage* (The Fitting Room): Cheryl Sim." *Asian Diasporic Visual Cultures and the Americas* 1, nos. 1–2 (2015): 214–18.

Moon, Krystyn R. *Yellowface: Creating the Chinese in American Popular Music and Performance, 1850–1920s*. New Brunswick, NJ: Rutgers University Press, 2005.

Romera, Robert. *The Chinese in Mexico, 1882–1940*. Tuscon: University of Arizona Press, 2010.

Ross, Robert. *Clothing: A Global History*. Cambridge, UK: Polity Press, 2008.

Said, Edward. *Orientalism*. London: Penguin Books, 1991.

Sim, Cheryl. "The Fitting Room: The *Cheongsam* and Canadian-Born Women of Chinese Heritage in Installation." PhD diss., Université du Québec à Montréal, Montreal, 2015.

Siu, Lok C.D. "Hemispheric Raciality: Yellowface and the Challenge of Transnational Critique." *Asian Diasporic Visual Cultures and the Americas* 2, nos. 1–2 (2015): 163–79.

Wong, Hiufu. "Sexy, Skintight, Sophisticated: How China's Iconic Dress Has Survived a Century." *CNN News*, 20 March 2014. http://www.cnn.com/2014/02/26/travel/ cheongsam-exhibition-hk/.

Wong, Mary Sui Yee. "Yellow Apparel." *fibreQUARTERLY* 4, no. 4 (2008). http:// www.velvethighway.com/joomla/index.php? option=com_content&task=view&id=103 &Itemid=86.

Wu, Juanjuan. *Chinese Fashion: From Mao to Now*. New York: Berg, 2009.

Yang, Jeff. "The Mickey Rooney Role Nobody Wants to Talk Much About." *Wall Street Journal* (blog), 8 April 2014. http:// blogs.wsj.com/speakeasy/2014/04/08/the-mickey-rooney-role-nobody-wants-to-talk-about/.

Queering Abjection: A Lesbian, Feminist, and Canadian Perspective

Jayne Wark

4

The Intersection of Abjection and Queerness

Envision a gargantuan hairy goddess slapped together with fun fur and hot glue, a pair of lesbians masquerading as rangers at a world-famous national park, a video diary documenting a day in the life of a bull dyke, and blown-up Polaroids of a former lover's face with eyes obliterated by black strips recalling sordid 1960s detective novels. All these are artworks made by four Canadian artists to be discussed in this chapter, respectively, Allyson Mitchell, Shawna Dempsey and Lorri Millan, and Rosalie Favell.

These works confound the conventional expectation of art to be beautiful, pleasurable, and to carry a sense of uplifting idealism. This expectation has been contested throughout the history of twentieth-century modern art, but the term *abject art* entered the art world lexicon in the early 1990s to denote a specific type of work preoccupied with taboo, transgression, and disruption in both subject matter and form. While these characteristics may not seem applicable to the work of Favell, Dempsey and Millan, and Mitchell *tout court*, I will argue that the pieces discussed here do arouse the connotations of abjection through their irruption of queerness – specifically lesbian queerness – within social spaces. As Judith Butler wrote in her book *Bodies That Matter*, queerness is relegated to the "domain of abjection" because it constitutes a threatening spectre to the normative identification of the sexed subject. Yet Butler's further observation that such irruptions may have the positive value of making us think differently about "the workings of heterosexual hegemony" accords with how I wish to investigate the role of abjection in these artists' work.[1]

Before delving into the relation between contemporary lesbian art and abjection, it is first necessary to uncouple the concept of abjection from *abject art*. This term was coined for the 1993 exhibition at the Whitney Museum of American Art titled *Abject Art: Repulsion and Desire in American Art*.[2] This exhibition brought together previously inchoate tendencies in contemporary American art under this nomenclature with the goal of making a counterattack into the so-called culture wars of that era. The culture wars were defined by rancourous antagonism between right-wing and progressive factions at broad cultural and political levels, but had especially dire consequences for arts funding policies at the National Endowment for the Arts (NEA).[3] But

while the disruptive and provocative objective of the Whitney's *Abject Art* exhibition is understandable within its original American context, its interpretation of abject art and its subsequent prominence within art world discourse not only cannot be applied in a country like Canada, where state support for the arts has never been subjected to this kind of political interference, but has also resulted in a skewing of the meaning of abjection that has closed off other possible understandings of the relation between abjection and art.

I propose to open up some of those other understandings through historical and theoretical analyses that shed light on the role and meaning of abjection in the work of Favell, Dempsey and Millan, and Mitchell. I will first take up the theoretical context for the Whitney's exhibition to consider the implications and consequences of how and why it drew upon the two foundational texts on abjection by Julia Kristeva and Georges Bataille. I will then delve more deeply into Kristeva's text to reconsider it in light of Judith Butler's argument for abjection as central to queer theory and practice. I propose that this role of abjection serves as a basis for a simultaneously critical and productive strategy in the work of Favell, Dempsey and Millan, and Mitchell. My goal is both to challenge received understandings of abject art as determined by the American context of the Whitney exhibition and to consider how these artists' work constitutes what Butler called a "reworking of abjection into political agency" from a lesbian, feminist, queer, and Canadian perspective.[4]

From Theory to Art: The American Culture Wars

The theoretical touchstone for any discussion of abjection is French feminist philosopher Julia Kristeva's 1980 book, *Pouvoirs de l'horreur: Essai sur l'abjection*, published in English in 1982 as *Powers of Horror: An Essay on Abjection*. In it she identifies abjection both as a state of degradation and as a social position or domain that "disturbs identity, system [and] order" because it refuses to "respect borders, positions [and] rules." Kristeva classifies abjection as repulsion and/or horror at the breakdown of meaning caused by the disintegration of distinctions between subject and object, self and other. Her examples include filth, waste or dung, food and, most famously, the skin that forms on the surface of milk, which can induce spasms and vomiting.[5]

Kristeva's concept of abjection was evident in the Whitney's 1993 *Abject Art* show, which included artists such as Robert Gober, Andres Serrano, Kiki Smith, and Cindy Sherman, whose work incorporates disturbing bodily aberrations, grotesque materials, messy forms, and taboo social acts and relations. In her excellent undergraduate paper, "Abjection: The Theory and the Moment," Amy Zurek posited this exhibition as the historical moment when an interest in abjection coalesced within the art world for two main reasons.[6] First, it was a crucial retaliatory salvo in the culture wars then raging in the United States. Second, it coincided with and articulated a growing body of scholarly and critical thinking about the idea of abjection in relation to art. This convergence of theoretical articulations of abjection and art practice became the basis for the retaliatory nature of the *Abject Art* show. By identifying the connection between

these theoretical and historical factors more precisely, it is possible to establish the grounds for differentiating between the Whitney show's approach to abjection and art and the one I wish to develop here in relation to the work of Favell, Dempsey and Millan, and Mitchell.

At the time of the *Abject Art* show there was renewed interest in the literary and theoretical writings of the French intellectual Georges Bataille. Bataille was a dissident Surrealist who countered André Breton's idealist conception of Surrealism as rising and "phallic" with a materialist preference for art that was base, "anal," and *informe* (literally unformed or formless), and thus both psychically and aesthetically abject.[7] In her 1985 book, *The Originality of the Avant-Garde and Other Modernist Myths*, historian Rosalind Krauss revived Bataille from obscurity in her analysis of Alberto Giacometti's sculpture.[8] That same year, Krauss collaborated with Jane Livingston on the exhibition and publication *L'Amour fou: Photography and Surrealism*, which manoeuvred photography from the margins to the centre of Surrealism, and positioned Bataille's work as central to this reframing.[9] Krauss's interest in Bataille and the *informe* was subsequently passed on to her doctoral student, Hal Foster, who completed his dissertation on Surrealism in 1990 at the City University of New York.

A direct link can then be traced from Foster to the *Abject Art* show. Foster was director of the Whitney's Curatorial and Critical Studies program from 1987 to 1991, the same program in which the three student curators of the show – Craig Houser, Leslie C. Jones, and Simon Taylor – were enrolled in 1992–93. Given this link, as well as the prominence of Krauss and Foster as editors of *October* magazine, it seems quite reasonable to assume that the renewed interest in Bataille on the part of Krauss and Foster was influential for these student curators. It is understandable, therefore, that their curatorial premise would augment Kristeva's theory of abjection with Bataille's less well-known formulation as articulated in his 1934 essay, "L'Abjection et les forms misérables."[10]

Bataille's essay on abjection differed significantly from Kristeva's by taking a sociological rather than psychoanalytic approach.[11] Written a year after the Nazis came to power in neighbouring Germany, and had completed the building of Dachau to imprison their political enemies (communists and labour leaders), Bataille's essay described how the oppressors ("*oppresseurs*") subordinate the oppressed ("*opprimés*") through mechanisms of exclusion and degradation that consigned them to the realm of abjection. For Bataille, therefore, abjection could only have the negative connotations of exclusion: "Les choses abjectes peuvent être définies … négativement – comme objets de l'acte impératif d'exclusion."[12]

Bataille's conception of abjection as social exclusion suited the curators' agenda for the *Abject Art* exhibition, which was to hit back against the repressive politics of their conservative opponents in the culture wars. As the curators stated in the introduction to the show's accompanying catalogue, "our goal is to talk dirty in the institution and degrade its atmosphere of purity and prudery by foregrounding issues of gender and sexuality in the art exhibited."[13] Their strategy was to adopt Bataille's negative conception of abjection as their conceptual framework and then illustrate this with

artworks that manifest the improper and unclean phenomena that Kristeva had described as causing the psychic repulsion and horror of abjection.

This conjoining of Bataille's negative sociological view of abjection to artworks evoking the psychically disgusting and repulsive elements that Kristeva spoke about was strategically useful at that moment in the American culture wars. By encompassing burgeoning tendencies in art under the newly invented nomenclature "abject art," the show succeeded in defining and legitimizing it both as a category and an aesthetic, one that would become so pervasive in the 1990s that it even led Hal Foster to describe it as "the shit movement."[14] As I see it, however, although the version of abjection promulgated by the Whitney show was specific to its American culture-war context, its prominence has occluded other interpretations of the role of abjection in art. In order to open up other possible readings that can be brought to bear on the artworks, it is necessary to take a closer look at Kristeva's theory of abjection.

Revisiting Kristeva

Kristeva's *Powers of Horror* is a critical reworking of Jacques Lacan's psychoanalytic theory of the process of individuation. In Kristeva's view, we first experience abjection when we separate from the intimacy of the mother-child dyad, a pre-Oedipal realm she calls the "semiotic."[15] In Samantha Pentony's words, the child's entry into the Symbolic Order, or law of the father, causes a "revolt against that which gave us our own existence," which is the maternal body and everything associated with it.[16] Kristeva argues that we relive the trauma of this revolt whenever we encounter bodily fluids, waste, or matter out of place.[17] Such things fill us with revulsion and we regard them as abject because they threaten us with the disintegration of the orderly borders we presume to exist between self and other, identity and non-identity, human and non-human. As Christine Ross puts it, "the abject never ceases to haunt the borders of identity; it constantly threatens to dissolve the unity of the subject."[18] The abject is therefore what we strive to disavow or cast out. In Kristeva words, "The abject has only one quality of the object – that of being opposed to I."[19]

Although we are repelled by the otherness of the abject, Kristeva says we are simultaneously drawn to it through *jouissance*: "One does not know it, one does not desire it, one joys in it (*on enjouit*)."[20] This duality is fascinating to Kristeva and indeed is central to her theory of how abjection pertains to art and culture. On the one hand, she says, abjection is "perverse" because it refuses to accept prohibitions, rules, or laws, and instead "turns them aside, misleads, corrupts; uses them, takes advantage of them, the better to deny them." On the other hand, abjection can be "purified" through catharsis, beginning with "the history of religions, and end[ing] up with that catharsis par excellence called art."[21] Abjection is thus valuable to art for two reasons: it signifies the disruption of rules and prohibitions, and can also be a positive force for cultural intervention and social change.

Kristeva explores these positive aesthetic aspects of abjection exclusively in relation to literature, which may account for why art-based discussions of her theory have

largely ignored them, including the *Abject Art* show. Kristeva concurs with Lacan that the acquisition of language is intrinsic to a subject's passage into the Symbolic and entails the repression of the pre-Oedipal or semiotic realm. For Kristeva, however, literature is a form of cultural creativity that can resist that repression by reaching back into the past, into what she calls the maternal *chora*.[22] The "aesthetic task," she says, is to retrace "the fragile limits of the speaking being, closest to its dawn," to a place where "'subject' and 'object' push each other away, confront each other, collapse, and start again – inseparable, contaminated, condemned, at the boundary of what is assimilable, thinkable: abject. Great modern literature unfolds over that terrain: Dostoyevsky, Lautreamont, Proust, Artaud, Kafka, Céline."[23] Kristeva regards such literature as redemptive because it propounds "a sublimation of abjection." This sublimation is the counterpart to abjection's value as the place where prohibitions are refused and boundaries are broken. As a result of this duality, "abjection is eminently productive of culture. Its symptom is the rejection and reconstruction of languages."[24]

If we transpose Kristeva's views on abjection from literature to art, they offer a way of thinking about abjection that differs from the *Abject Art* exhibition, which, as I have argued, was preoccupied with Bataille's negative conception of abjection as a socially exclusionary force and limited in its incorporation of Kristeva's theory to a handful of concrete examples of abjection's visceral and embodied repulsiveness that she provides in her essay. In doing so, we can move beyond the American-centric version of abject art portrayed in that exhibition and consider other possible approaches to the idea of abjection and its role in art.

Canadian and Queer: A Distinct Nexus

I stress the need to move beyond the conception of abjection promoted by the Whitney's *Abject Art* show in order to develop a more nuanced understanding of its relevance to the work of the artists I wish to discuss here: Rosalie Favell, Shawna Dempsey and Lorri Millan, and Allyson Mitchell. While their art has some similarities with work included in the *Abject Art* exhibition, there are also three crucial differences that pertain both to its distinctively feminist-lesbian-queer orientation and its Canadian context.

First and foremost, these Canadian artists' work, spanning the period from 1990 to 2015, was produced in a very different socio-political context. In the American culture wars, the right-wing forces took particular aim at the increasingly visible presence of gays and lesbians in art and culture. They deployed a "family values" agenda that exploited the AIDS crisis to target homosexuals as immoral deviants and to thus justify cutting off publicly funded arts grants to them and their supporting institutions.[25] While Canada has not been immune to right-wing demands for the censorship of cultural displays of homosexuality, going back, for example, to the repeated attacks in the 1970s and 1980s against Toronto's gay magazine, *The Body Politic*, these have been local skirmishes rather than national campaigns. Canada's national arts funding body, the Canada Council for the Arts, has retained its core principle of peer-reviewed, arm's-length adjudication both for individual artists and arts institutions, and has

never been subjected to the kind of ideologically motivated political interference that reared up furiously in the United States in the 1990s and continues today.[26] In short, the culture wars conflict that provoked the *Abject Art* exhibition simply has no parallel in Canada.[27]

Second, by exploring lesbian, feminist, and queer subjectivities that range from private and intimate experiences to demands for the legitimate presence of homosexuals and queers within the public sphere, the work of Favell, Dempsey and Millan, and Mitchell addresses something of the *redemptive* potential of abjection proposed by Kristeva, as opposed to the *Abject Art* exhibition's aim to "talk dirty in the institution and degrade its atmosphere of purity and prudery."[28]

Third, although these artists make work about their experiences as lesbians, neither they nor I treat lesbianism as a fixed identity category because there is no attempt to stabilize it as an essential subjectivity in the way advocated by radical lesbian feminists such as Mary Daly, Adrienne Rich, or Sheila Jeffreys.[29] Since their work instead addresses the politics of how lesbianism is socially positioned as an effect of homophobia, I see it aligned with the queer practice and theory that emerged to combat the homophobia that was really at the heart of the culture wars.[30]

The term *queer* surfaced on the streets in the 1980s to indicate resistance to normative epistemological and social practices that equate heterosexuality with human nature. It then passed into academic usage in the 1990s as a critique of identity-based "lesbian and gay studies."[31] While Teresa de Lauretis was the first to pair the term *queer* with *theory* for the title of a conference at the University of California, Santa Cruz, in 1990, the two texts regarded as foundational to its premises, Eve Kosofsky Sedgwick's *Epistomology of the Closet* and Judith Butler's *Gender Trouble* (both 1990), had already been written.[32]

Of these two, Butler's *Gender Trouble* is most pertinent to the consideration of the role of abjection in relation to the queer subjectivities in the work of Favell, Dempsey and Millan, and Mitchell. While Butler did not use the term *abjection* in reference to queer experience in *Gender Trouble*, she did so in its sequel, *Bodies That Matter* (1993), which aimed to address the confusion and critical backlash *Gender Trouble* had caused.[33] *Gender Trouble* had dealt a body blow to prevailing notions of identity politics through its central argument that gender identity is founded not on biological sex but is instead "constructed" through "performative acts" that appear to produce gender as a natural effect of biological sex.[34] In clarifying her theory of gender performativity in *Bodies That Matter* and elaborating on how it could be performed differently to resist its normative heterosexual imperatives, Butler proposed an understanding of abjection that echoed the negative and positive duality of the concept that Kristeva had also articulated.

On the one hand, Butler wrote that heterosexual imperatives consign people who do not conform to the norms – that is, queers – to the realm of abjection: "This exclusionary matrix by which subjects are formed thus requires the simultaneous production of a domain of abject beings, those who are not yet 'subjects,' but who form the constitutive outside to the domain of the subject."[35] These abject beings are relegated to

"unlivable" or "uninhabitable" zones of social life, but they are necessary because they "circumscribe the domain of the subject" by producing that subject's "abjected outside, which is, after all, 'inside' the subject as its own founding repudiation."[36] On the other hand, Butler proposed that, despite this bleak prognosis for abject (queer) beings, abjection might constitute a positive form of political agency able to resist and challenge the heterosexual matrix: "I suggest that the contentious practices of 'queerness' might be understood not only as an example of citational politics, but as a specific reworking of abjection into political agency ... The public assertion of 'queerness' enacts performativity as citationality for the purposes of resignifying the abjection of homosexuality into defiance and legitimacy ... This is the politicization of abjection in the effort to rewrite the history of the term, and to force it into a demanding resignification."[37]

Butler's call for a reworking of abjection as a creative and disruptive force for political agency and resignification, one that embraces the brash, bold, and sometimes disgusting aspects of queer life, resonates with Kristeva's opinion that "abjection is eminently productive of culture. Its symptom is the rejection and reconstruction of languages."[38] It must be noted, however, that although Butler never discusses Kristeva's essay on abjection, she harshly criticizes the theory on which it rests – namely, that the maternal semiotic realm can serve "as a perpetual source of subversion within the Symbolic."[39] Her core argument is that Kristeva is an essentialist because she accepts the maternal body and our relationship to it as prior to culture and discourse.

These disagreements notwithstanding, there is concurrence between Kristeva and Butler on three points that are central to the analysis I will develop here of the works of Favell, Dempsey and Millan, and Mitchell. First, culture is ruled by the paternal laws of the Symbolic and "is predicated upon a repudiation of women's bodies." Second, subversion of the paternal laws is possible and necessary in order to attain "an open future of cultural possibilities."[40] Third, since "abjection is eminently productive of culture," it can be reworked "into political agency."[41] This concurrence provides the theoretical basis for the following discussion of the role of abjection in these artists' works. It allows us to move away from the negative connotations of abjection conveyed by the Whitney's *Abject Art* exhibition and focus instead on its potential as a means to resignify the psychic and social complexities of queerness as a force for political change.

Rosalie Favell: Queer and Indigenous

The psychic and social complexities that simultaneously denote abjection and signify its resistance abound in the work of Rosalie Favell. Favell is a Métis artist from Winnipeg, Manitoba. *Métis* is a specifically Canadian term, derived from the Old French word meaning mixed race, which refers to the offspring of European settlers and Indigenous women from the Cree, Objiwa, and Salteaux Nations in western Canada. They are "a post-Contact Indigenous people with roots in the historic Red River community."[42] The term has always denoted the supposed contamination of miscegenation and the accompanying exclusion that designates abject social status, as articulated

by Bataille. But although this "mixed race" designation historically excluded the Métis from recognition under Canada's 1876 Indian Act, they have always considered themselves a distinct group among Canada's Indigenous peoples, now officially recognized as the Métis Nation. The Métis Nation was formalized in Section 35.2 of the 1982 Canadian Constitution Act, but its members' much more important *legal* rights were ascertained only in 2003 with the Supreme Court of Canada's decision on the *R. v. Powley* case, which hinged on access to hunting and lands rights for Métis people.[43]

Favell emerged as a professional artist in that period of political and social transition between the official recognition of the Métis and the attainment of legal rights. Her early work probed the uncertainty and invisibility of her Métis identity by culling and repurposing photographs of her maternal ancestors found in family albums. This repository of photographs testifies to the strong matrilocal geneology and identity among Métis families. While the work is shaped by a desire to know more about a cultural heritage that has been systematically oppressed and devastated by policies of cultural and racial genocide, apartheid, and assimilation, the images of her family members must also be seen as an intervention into the vast photographic archive of unnamed Indigenous women produced as documents of colonizing practices in Canada.[44] Favell's work, therefore, is no mere nostalgic or essentialist longing for a lost past, but rather engages in the complicated entanglements of family history with government surveillance and eugenics and can therefore be read as an act of political resistance to Canada's deplorable colonial history.

Favell's 1994 work, *Living Evidence*, makes this point even sharper. It consists of a series of thirty Polaroid photographs taken by Favell either of her lesbian partner, also an Indigenous woman, or "selfies" of the two of them together. By shifting the focus from historical representations of Indigenous women to Favell's own experiences as a contemporary woman, *Living Evidence* was groundbreaking because it was one of the first acts of self-representation by an Indigenous Canadian artist. *Living Evidence*'s audaciousness was further heightened by Favell's outing of herself as lesbian. This isn't explicit in the snapshots themselves, but is made clear by the superimposed handwritten texts from Favell's diary declaring her love for her partner and her despair and pain over their breakup. The trauma of the loss of her lover is also manifest visually by masking out the lover's eyes with black tape, producing a violent erasure of her identity and a jarring contrast to the photographic documents of happier times.

When *Living Evidence* was first exhibited in 1994 at the Dunlop Art Gallery in Regina, Saskatchewan, curator Ingrid Jenkner remarked on the difference between the private context in which the photographs were made and their display in the gallery. She noted, for instance, that despite having been greatly enlarged (61 x 51 cm each), they are mounted with black photo corners of the sort used in family albums. But instead of the usual smiling family souvenirs one finds in such albums, Favell's photographs and diary excerpts reveal the unorthodox (and troubled) relationship between the women. Yet as much as Favell exposes, she also holds back by concealing her lover's identity with the black tape. As Jenkner wrote, "with the shift from private memento to public exhibition, homophobia enters the picture, and Favell makes

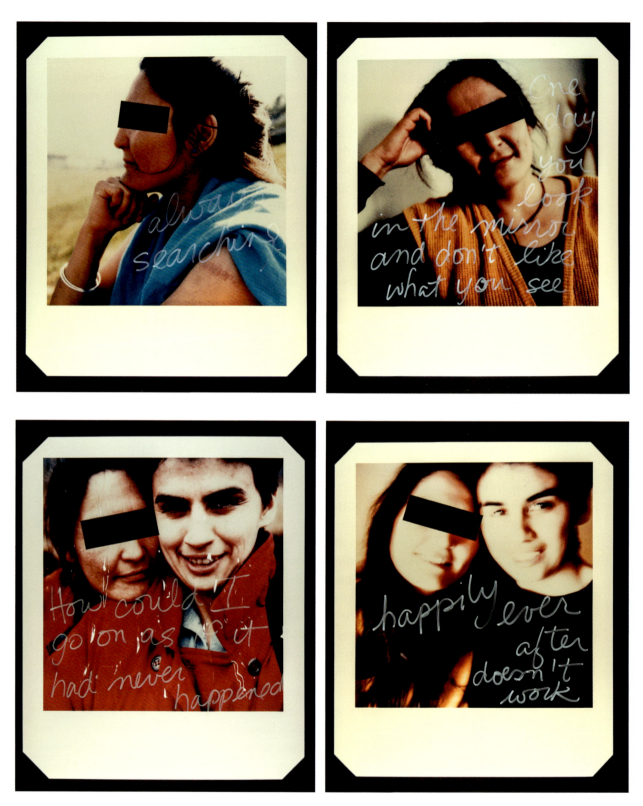

4.1 to 4.4 Rosalie Favell, *Living Evidence*, 1994. Four of a series of thirty colour photographs.
Clockwise from top left: "Always searching"; "One day"; "Happily ever after doesn't work";
"How could I go on..."

it visible, like a disfiguring scar. She must anticipate that her decisions will affect the social well-being of both subjects in her pictures."[45]

By making homophobia visible in *Living Evidence*, Favell draws attention to the strictures that consign her lesbian relationship to what Butler called the "abjected outside" of normative heterosexual subjectivity and sociality. Yet this act of placing the work in the public space of an art gallery, especially in 1994 when the representation and presence of homosexuality in art and culture was such a charged social issue, can also be read as an instance of Butler's "citational politics," whereby the abjection of queerness can be reworked into political agency.[46] Further, by bringing herself and her lover into view as queer *and* Indigenous, Favell reveals how experiences of abjection can collide, intersect, and overlap in multiple ways.

Shawna Dempsey and Lorri Millan: Lesbians Go Public!

The work of Shawna Dempsey and Lorri Millan also instantiates the "citational politics" of gender performativity, but in their case this takes the explicit form of performance art. The difference between these two terms is important regarding the applicability to their work of Butler's theory of performativity and abjection's potential to resignify queerness. In *Gender Trouble* Butler defined performativity as the *unconscious* and repeated iteration of "performative acts," saying there is no preexisting subject who acts consciously, no "doer behind the deed."[47] She underscored this point in *Bodies That Matter*, stating that "performance as bounded 'act' is distinguished from performativity insofar as the latter ... cannot be taken as the fabrication of the performer's 'will' or 'choice.'"[48] This statement might seem to disqualify cultural performance acts like those of Dempsey and Millan from having the potential to subvert and/or reimagine gender norms. Some feminist scholars in theatre and performance studies have indeed challenged it on these grounds, arguing that it excludes the possibility that cultural forms of performance can be sites of both theoretical and real resistance.[49] Yet Butler does in fact allow for the possibility of queering gender by performing it differently by means of conscious agency, not only through such cultural forms as drag and gender parody, but also the "politicization *of* theatricality," which includes cross-dressing, drag balls, AIDS benefits, "the convergence of theatrical work with theatrical activism," and "performing excessive lesbian sexuality and iconography that effectively counters the desexualization of the lesbian."[50] While Butler doesn't mention visual art per se, it seems clear that her theory of queer performativity as a "reworking of abjection into political agency" is relevant to performative artworks like those of Shawna Dempsey and Lorri Millan.[51]

Shawna Dempsey and Lorri Millan have collaborated since 1989. Like Favell, they live in Winnipeg, which they call "The Lesbian Capital of the Universe."[52] In contrast to Favell's painful revelations of her lesbian identity, however, Dempsey and Millan flaunt theirs with unruly gusto, which is perhaps easier for them to do as white women. Their performances, videos, films, and public art projects combine preposterous skits, costumes, and monologues with a wry humour that simultaneously

disarms hostility to homosexuality and affirms lesbian identification. As Paulina Palmer has argued, the lesbian has been relegated to the abject domain because she embodies Kristeva's definition of that which disturbs identity, system, and order by threatening the regulation of heterosexual femininity within the Symbolic Order.[53] Dempsey and Millan upend this abject relegation and turn it into cause for celebration.

The humourous charge of their performative work is hard to convey in words. It often consists of pseudo-vaudevillian skits such as *We're Talking Vulva* (1990), featuring Dempsey in an anatomically correct, full-body costume doing a song-and-dance tribute to female genitalia: "The vulva's something that men have feared. It looks innocent enough, a bit like a beard. On the outside it's fuzzy, it's fluffy, it's hairy – open it up, it gets pretty scary. Yippers! It gives us pleasure, it makes us feel good, we can touch ourselves better than lots of men could. Many don't want to, we remind them of mother, that we all come from here, this hole and none other."[54]

As I have written elsewhere, nothing is sacrosanct in Dempsey and Millan's comedic inversions of what is officially designated as "normal" or "deviant."[55] In *Growing Up Suite* (1996), for instance, Dempsey dons her mother's 1960s-era "industrial strength" foundation garments while recounting how the women who modelled such lingerie in mail order catalogues awakened her adolescent lesbian desire for those "unimaginable body parts so powerful they needed architecture to keep them in place."[56] This performative and parodic outing of "illicit" lesbian desire both elicits and gratifies lesbian identification and creates what Cheryl Kader has called a "community of spectators."[57] As Dempsey and Millan put it, their performative strategies enhance this community connection: "It is our hope that by existing simultaneously in space with our audience, there is the potential for dialogue, for movement, for the creation of individual and hence political change."[58]

But while it is paramount for Dempsey and Millan to speak *to* the lesbian community within its traditionally intimate and underground enclaves, they also speak *for* this community through wider public means and events, thus countering its social invisibility.[59] Some works, like *What Does a Lesbian Look Like?* (1994), a short video that exposes every myth about lesbians (and reveals they're all true!), have the semblance of public service announcements. Others, such as *A Day in the Life of a Bull Dyke* (1995), which follows the ups and downs of a bulldagger in a mockumentary style pillorying the crude sensationalism of journalism, are full-on confrontations with the social opprobrium leveled at butch dykes who are perceived as monstrous aberrations.[60]

Such performances would most likely have been excoriated and/or denied public funding in the context of the American culture wars, but Dempsey and Millan have received active support from various quarters. *What Does a Lesbian Look Like?* was co-produced with Much Music and aired on rotation in 1994–95; *We're Talking Vulva* was created for the National Film Board of Canada's *Feminist Minutes* series; and *A Day in the Life* was the recipient of multiple international awards. This receptiveness to the explicit lesbian and queer content of their work stands in sharp contrast to the contemporaneous American one where, as Catherine Lord has argued, the "family values" basis for attacks on homosexuals had the effect of making "'the public' a club

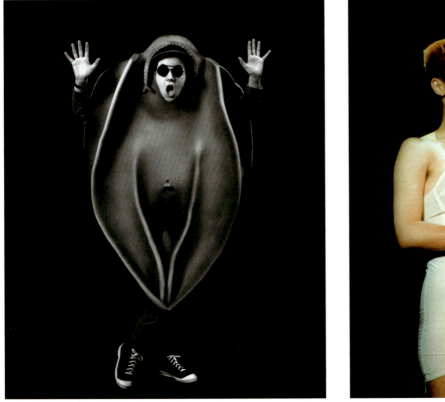 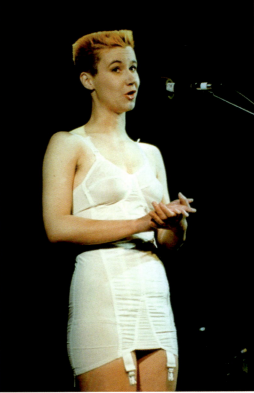

Left
4.5 Shawna Dempsey, Lorri Millan, and Tracy Traeger, *We're Talking Vulva*, 1990.
Based on the 1986 performance piece by Dempsey.

Right
4.6 Shawna Dempsey and Lorri Millan, *Growing Up Suite*, The Banff Centre, 1996.

with a limited membership."[61] The comparatively open atmosphere in Canada, which is reflected in its still intact principle of arm's-length, peer-reviewed funding for the arts at national, provincial, and municipal levels, is a major factor in the difference between how such work was supported in one country and denigrated in the other. This also accounts for why Canadian artists like Dempsey and Millan, unlike their American counterparts in the Whitney exhibition, were able to use humour as a queer strategy for resisting and sublimating abjection.

This humourous strategy is brilliantly revealed in Dempsey's and Millan's best-known work, *Lesbian National Parks and Services*. This work began in 1997 as an artist-in-residency project funded by multi-level public grants at Banff National Park and is ongoing in various permutations. Located in the Rocky Mountains of Western Canada, Banff is surrounded by a spectacular landscape and is a tourist mecca. Dempsey and Millan's gambit was "to insert a lesbian presence into the landscape."[62] Wearing classic ranger attire, they blended seamlessly into the milieu. Only a close investigation would reveal that the crests on their caps identified them as Lesbian Park Rangers. Some of their activities documented in the accompanying video include

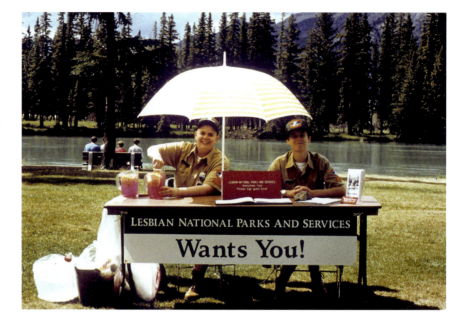

4.7 Shawna Dempsey and Lorri Millan, *Lesbian National Parks and Services*, The Banff Centre, 1997–ongoing.

patrolling the parklands, researching the flora and fauna, giving directions to lost tourists, and holding a recruitment drive. At this event, the friendly Rangers are seated at an outdoor table with a big banner reading "Lesbian National Parks and Services Wants You!" At one point, several groups of children come bounding up for free lemonade, oblivious to the ironic hilarity of their lesbian "recruitment."

This absurd scene perfectly captures Dempsey's and Millan's strategies for resisting abjection. Their playful humour enables them to bring a visible homosexual presence into spaces that are ostensibly public, but are in practice designated as heterosexual family spaces. These public interactions aim "to help people learn about the fascinating and fragile lesbian ecosystem" so as to help make "the world a happier, safer place for lesbians."[63] Ultimately, they renounce abjection by demonstrating that lesbians are not social deviants, or if they are, this is not undesirable.

Allyson Mitchell: Deep Lez

Allyson Mitchell is a Toronto-based artist who shares strategies of humour to resignify both what Butler denoted as "the abjection of homosexuality" and what Kristeva referred to as its tactile, visceral, and embodied aspects of "the unclean/improper."[64] Her approach is to meld feminism and popular culture to investigate both from a lesbian perspective. Mitchell is part of the 1990s generation of women who split into third-wave and postfeminist camps, with the former critiquing but extending feminist politics into a new era and the latter abandoning feminism as passé and irrelevant.[65] Mitchell renounces postfeminist depoliticization and seeks instead to build bridges over feminism's generational waves.

Mitchell's practice is diverse, encompassing sculpture, performance, installation, film, and handcrafted multiples. Representations of or reflections on the body and sexuality feature prominently throughout her repertoire, and are treated with a joyous, irreverent, and downright bawdy humour. *The Fluff Stands Alone* (2003), for example, is a series of images lampooning *Playboy* magazine's 1970s heyday by recasting its "dirty joke" cartoons in wall hangings made of bedspreads and garish fun fur. Revelling in their campy splendor, these racially diverse and corpulently sexy mammas thwart the crudely chauvinistic one-liners of the original cartoons. Mitchell further lacerated *Playboy's* ideal of femininity with *Big Trubs* (2004), a hybrid of the Playboy Bunny, the Venus of Willendorf, and Roman war victory statues. Standing ten feet high and measuring over seven feet in girth, *Big Trubs* is a fun-fur goddess come to Earth to celebrate "excess and pleasure" and "fight fat phobia."[66]

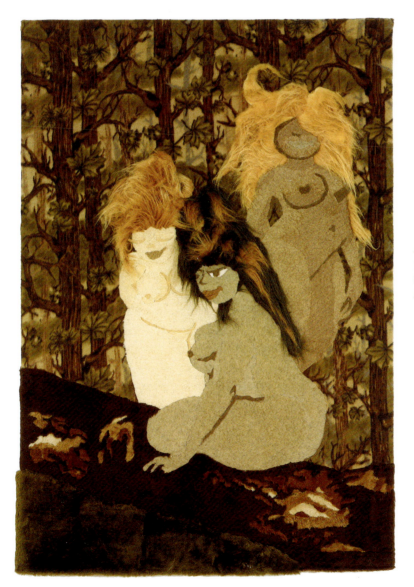

4.8 Allyson Mitchell, *The Michigan Three*, 2003. From the series *The Fluff Stands Alone*.

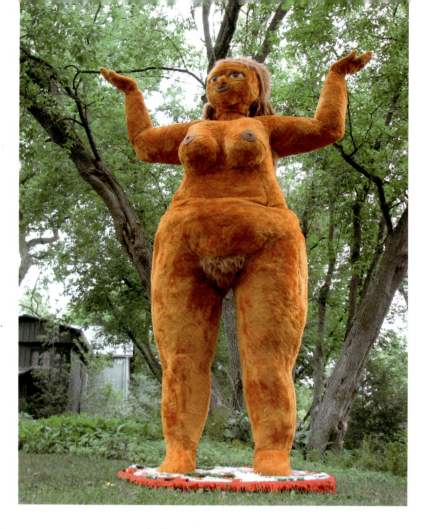

4.9 Allyson Mitchell, *Big Trubs*, 2004.

While fat activism is important in Mitchell's work, her broader concern is to redress the ongoing degradation of women, especially lesbian women, who can't or won't meet the persistently oppressive ideals of commodified femininity. Mitchell's use of materials and techniques associated with femininity is a key strategy in this respect, as seen with *The Fluff Stands Alone* (bedspreads and thrift shop fabrics) and *Big Trubs* (fun fur and a glue gun). Such materials and techniques are popular with amateur crafters (who are overwhelmingly women), and thus disdained within the world of professional craft. Or so it was until the term "sloppy craft" began to gain traction among professional craftspeople after it surfaced in 2007 at the international Neo-Craft conference, held at the Nova Scotia College of Art and Design in Halifax, Canada, and was subsequently discussed in Glenn Adamson's *Crafts* magazine article, "When Craft Gets Sloppy." Adamson describes it as the "calculated sloppiness" embraced by "post-disciplinary" craft education, and aligned it with early feminist reclamations of domestic craft, the fascination with low or "abject" art forms in the 1990s, and the growing popularity of the DIY movement today.[67]

Mitchell's work appears to share some of the sloppy craft characteristics Adamson outlines, but these resemblances are superficial. While sloppy crafters abandon the hallmarks of expertise that have traditionally distinguished professional craft by embracing lowly and unaesthetic (and thus abject) forms and techniques, they do so within a

discourse that is purely aesthetic because the goal is to assert such work as an ironically knowing variation of professional craft. Mitchell's work, by contrast, counters such aesthetic conceits by foregrounding critical and political goals. It not only encompasses fat activism, but also revitalizes feminist politics for a new generation by bridging the gap that opened up between feminists and lesbians in the early 1980s over charges of heterosexism.[68] Mitchell's strategy has been shaped and informed not only by a desire to build bridges over feminism's waves, but also by an awareness of how the concept and aesthetic of "abject art," which her generation of artists inherited from its 1990s formulation, can be deployed differently as a critical and political tactic to recuperate its otherwise aesthetically and socially degenerate associations.

Mitchell's Deep Lez project is central to these critical and political goals. Deep Lez is a broad enterprise bringing together artists, academics, and activists seeking to make a return to the "radical lesbian politics" and "herstories" of second-wave feminism and redefine their relevance for the present.[69] In her book *Time Binds: Queer Temporalities, Queer Histories*, Elizabeth Freeman refers to this kind of return as "temporal drag," a term implying "retrogression, delay, and the pull of the past on the present." Freeman is critical of how the popularization of *queer* theory and politics has resulted in casting the *lesbian* who remains committed to feminism as "the big drag," an anachronistic relic from the days of essentialized bodies and single-issue identity politics. Freeman's concern is that the prioritizing of the future-oriented transformative potential advocated by queer theorists like Butler might also have had the deleterious effect of devaluing anything that generates continuity with the past, including feminism and "political history itself." Freeman thus proposes the notion of "temporal drag" as a way to return to the history of feminism and its hoped-for collective politics. She regards Mitchell's Deep Lez project, with its "temporal binding of past and present lesbian cultures," as constitutive of this political goal.[70]

As Freeman recounts from a 2004 interview with Mitchell, Deep Lez originated with a trip to a thrift shop during which Mitchell and a gay male friend found an old macramé wall-hanging in the shape of an owl and decorated with wooden beads and dried nuts. "Oh my god," said Mitchell's friend, "That's so deep lez."[71] This discarded handicraft from a bygone era struck Mitchell as a metaphor or omen of the past lurking in the present. It unleashed the creation not only of *Big Trubs*, but also the giant *Lady Sasquatches* (2006–10), lesbian versions of an ancient Indigenous mythological figure who valorize "cellulite, dirty fingernails, tattoos, big butts, fangs, collectivity and collaboration."[72] As Freeman observes, the *Lady Sasquatches* "reanimate all kinds of cultural dinosaurs: the legend of Sasquatch, the sexually excessive racial primitive, the hairy radical feminist, the Wiccan icon, the home arts."[73]

The home arts aspect of Deep Lez is directly invoked in Mitchell's *Fat Craft* project (2004–07), a series of needlepoint, crochet, and pompom samplers embroidered with slogans such as "Fat Forever," "Sedentary Lifestyle," "No Cookie for Fattie," etc. Despite any superficial resemblances to sloppy craft, Mitchell's *Fat Craft* is not an ironic parody of amateur craft, but rather stems from a genuine admiration and emulation of "wimmin's" craft history. It thus invokes early feminist projects like Judy

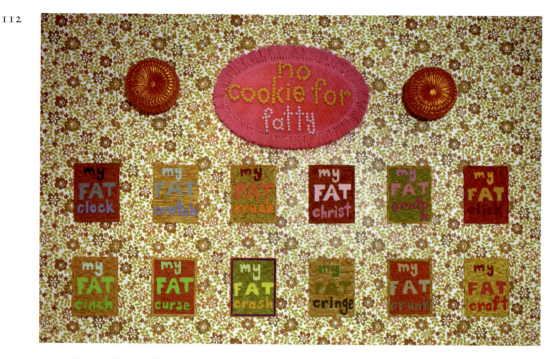

4.10 Allyson Mitchell, *Fat Craft*, 2004–07.

Chicago's famous *Dinner Party*, and recycles them through "temporal drag" into a contemporary lesbian assertion of interracial and queer body politics. Mitchell's fat activism reminds us, says Freeman, "that the stigmatic histories of *female* fatness and lesbianism interlock on a single body": the "fat dyke." As she further contends, this linkage has been largely overlooked within contemporary queer theory, which "has generally treated lesbian stigma as if it were coded primarily by transgender embodiment," thus ignoring the actual social coding of lesbian bodies, unlike those of gay men, "as a problem of sizable bodily proportions."[74]

I concur with Freeman's assessment of how Mitchell's work reanimates supposedly obsolete and unfashionable feminisms in order both to redress "white feminism's failed concatenation with antiracist organizing" and bring the lesbian back into the feminist history of "the shared culture making we call 'movements.'"[75] To this assessment I would add that Mitchell's art and activism both instantiates and sublimates the psychic and social reverberations of abjection in multiple ways. These range from inserting fat female and explicitly eroticized lesbian bodies into the spheres of art and public spaces; making the alliance with discarded feminist histories and collectivist politics; refusing postfemininism's commercialized and depoliticized individualism; and retrieving the dowdy, dusty, outmoded (or never in mode), and abandoned forms of women's domestic craft.

These bodies, identities, political movements, and crafts have been deemed undesirable, deviant, passé, and crudely amateurish: in a word, abject. Yet Mitchell renounces their abject designation and instead calls upon us to embrace their value as signifiers and agencies of creative and enfranchised political change. Hers is a reclamation project, analogous to the recuperation of the word queer from its pejorative

meaning to one of positive defiance against social conformity and prohibitions. It is, therefore, the "reworking of abjection into political agency" that Butler calls for, a "resignifying [of] the abjection of homosexuality into defiance and legitimacy."[76]

Conclusion

The value of a different approach to abjection, beyond the acrimonious and retaliatory one defined by the Whitney's *Abject Art* exhibition, lies in strategies for creating progressive social change, not merely confrontational antagonism. The works by Favell, Dempsey and Millan, and Mitchell certainly acknowledge the social realities of oppression and discrimination of homosexuals – especially non-gender conforming lesbians – to the realm of abjection, but they also supersede its negative connotations by invoking Kristeva's and Butler's conceptions of its potential for psychic and social transformation. This is manifested in Favell's courageousness in coming out as a lesbian and also being one of the first Canadian Indigenous artists to assert the right to self-representation. Dempsey and Millan, meanwhile, have used humour to bring lesbian discourse and practice out from its "hidden" community of bars and clubs in an effort to dislodge homophobia in the public realm. For her part, Mitchell has salvaged discarded feminist histories, denigrated female bodies and amateur crafts in a campaign for constructive community activism and political movement-making. While this ability to engage constructively rather than combatively with queer abjection in cultural and broader social spheres may be facilitated by the relatively tolerant and liberal Canadian milieu, the struggle against homophobia, sexism, the legacy of colonial oppression and other forms of social abjection is far from over. Fight on!

NOTES

1 Butler, *Bodies That Matter*, 3, xii.

2 The type of work shown in the Whitney's *Abject Art* exhibition first surfaced in three other exhibitions, all in 1990: *Just Pathetic* at the Rosamund Felson Gallery in Los Angeles, *Work in Progress? Work?* at Andrea Rosen Gallery, and *Stuttering* at Stux Gallery, both in New York. Similar work was shown in the *True Stories* exhibition at the Institute of Contemporary Art in London in 1992, but its designation as "abject art" came about with the Whitney exhibition. For an overview of these exhibitions, see Wilson, "Michael Wilson on Sore Winners."

3 As James Davison Hunter explains in *Culture Wars: The Struggle to Define America*, the American culture wars began with the rise of the conservative right in in the 1970s and 1980s. Their eruption in the arts sector was triggered in June 1989 with Rev. Donald Wildmon, founder of the American Family Association, publically denouncing the NEA for funding the "anti-Christian bigotry" of Andres Serrano's *Piss Christ*. Republican politicians Jesse Helms, Alfonse D'Amato, and Dick Armey immediately led sustained attacks on NEA funding of many other artists, including Karin Finley, Holly Hughes, and Robert Mapplethorpe, which famously resulted in the decision later that month by the Corcoran Gallery of Art in Washington to cancel its exhibition of Mapplethorpe's homoerotic photographs. Throughout 1989 and 1990 the US Congress debated reducing NEA funding levels and banning grants to artists or

institutions deemed to be producing or disseminating obscene or indecent materials. For discussions of how these efforts were met with protests and anti-censorship campaigns across the arts sectors, see Dubin, *Arresting Images*, Quigley, "The Mapplethorpe Censorship Controversy," and Steiner, *The Scandal of Pleasure*, 11. The NEA was attacked again in 1995–97 when Republican House Speaker Newt Gingrich pushed to eliminate it altogether. While the NEA survives today, its budget has been reduced by 49 percent since 1992 and grants to individual artists no longer exist; see Stubbs, "Public Funding for the Arts: 2012 Update."

4 Butler, *Bodies That Matter*, 21.
5 Kristeva, *Powers of Horror*, 4, 2.
6 Zurek, "Abjection," 3.
7 Spector, *Surrealist Art and Writing*, 84.
8 Krauss, *The Originality of the Avant-Garde*, 52–5.
9 Krauss and Livingston, *L'Amour fou: Photography and Surrealism*, 57, 64–5.
10 Bataille, "L'Abjection et les formes misérables," 217–22.
11 Zurek, "Abjection," 6–8.
12 "Abject things can be defined ... negatively – as objects of the imperative act of exclusion" (author's translation). Bataille, "L'Abjection et les formes misérables," 217, 220.
13 Ben-Levi et al., Introduction, 7.
14 Foster, "Obscene, Abject, Traumatic," 118.
15 Kristeva, *Powers of Horror*, 71.
16 Pentony, "How Kristeva's Theory of Abjection Works."
17 Kristeva, *Powers of Horror*, 13.
18 Ross, "Redefinitions of Abjection," 149.
19 Kristeva, *Powers of Horror*, 1.
20 Ibid., 9.
21 Ibid., 15, 17.
22 Ibid., 13–14.
23 Ibid., 18.
24 Ibid., 26, 45.
25 Lord, "Inside the Body Politic," see especially 32, 37–8.
26 Evidence of these ongoing attacks include the removal in 2010 of David Wojnarowicz's video on gay love, *A Fire in My Belly* (1986–87), from the National Portrait Gallery due to pressure from the Catholic League; see Gopnik, "National Portrait Gallery Bows to Censors," and Thomson, *Culture Wars and Enduring American Dilemmas*.

27 As journalist Anthony Furey has reported, even when conservative parties have been in government in Canada, the citizenry has supported centrist and progressive social policies; see his "Canadians Are Centrist Except in the Voting Booth." Daniel Béland has noted how this centrist tendency has much annoyed American conservatives in his entry on "Canada" in *Culture Wars in America: An Encyclopedia of Issues, Viewpoints and Voices*. Moreover, despite the drift to the right in Canada while the Conservative Party under Stephen Harper was in power from 2006 to 2016, socially and fiscally conservative positions and policies in Canada favour traditional views of family structures, but are not explicitly homophobic; see Ibbitson, "How Harper Created a More Conservative Canada."
28 Ben-Levi et al., Introduction, 7.
29 See, for example, Daly, *Gyn/Ecology: The Metaethics of Radical Feminism*; Rich, "Compulsory Heterosexuality and Lesbian Existence"; and Jeffreys, *Unpacking Queer Politics*.
30 Katz, "'The Senators Were Revolted,'" 245.
31 See Cunningham, "Queer Theory," and Lord, "Inside the Body Politic," 30.
32 Halperin, "The Normalization of Queer Theory," 339–41.
33 Sara Salih's book *Judith Butler* provides a good summary of some of the main criticisms of *Gender Trouble* (59–60). These include philosopher Seyla Benhabib's claim that Butler's reliance on the Nietzschean "death of the subject" thesis leads to self-incoherence; questions by sociologists John Hood Williams and Wendy Cealy Harrison as to whether her critique of the ontological status of gender is founded on an equally foundation-

alist conception of gender performativity; feminist Toril Moi's similar objection that the concept of one essential subject (stable, coherently sexed and gendered) has merely been replaced by another (unstable, performative, contingent); and theorist Jay Prosser's concern about the consequences of some inaccuracies in Butler's reading of Freud.

34 Butler, *Gender Trouble*, 9–10, 25, 173–80.

35 Butler, *Bodies That Matter*, 3.

36 Ibid., 3.

37 Ibid., 21.

38 Kristeva, *Powers of Horror*, 45.

39 Butler, *Gender Trouble*, 101–2.

40 Ibid., 118–19.

41 Kristeva, *Powers of Horror*, 45; Butler, *Bodies That Matter*, 21.

42 For an excellent analysis of how Métis identity is constituted, see *âpihtawiko-sisân: Law, Language, Life: A Plains Cree Speaking Métis Woman in Montreal* (blog), "Who Are the Métis?" 10 May 2016, http://apihtawikosisan.com/2016/05/who-are-the-metis/.

43 For the *R. v. Powley* case, see Indigenous Foundations, "Powley Case," http://indigenousfoundations.arts.ubc.ca/home/land-rights/powley-case.html. For historical and contemporary information on the Métis Nation, see the Métis National Council website at http://www.metisnation.ca/.

44 Carla Taunton, personal communication, 25 September 2013.

45 Jenkner, *Rosalie Favell*, n.p.

46 Butler, *Bodies That Matter*, 3, 21.

47 Butler, *Gender Trouble*, 25.

48 Butler, *Bodies That Matter*, 234.

49 See, for example, Diamond, *Unmaking Mimesis*, 46–7 and Harris, *Staging Femininities*, 174–5. As Sara Salih has noted, although these views misinterpret Butler's meaning, Butler must take some responsibility for this since she has created confusion by sometimes eliding and waffling on performance and performativity (56).

50 Butler, *Gender Trouble*, 137; *Bodies That Matter*, 233.

51 Butler, *Bodies That Matter*, 21.

52 Dempsey and Millan, "Public Warning!," 57.

53 Palmer, "Queer Transformations."

54 Dempsey and Millan, *We're Talking Vulva*. Video clip available at artists' website, http://fingerinthedyke.ca/were_talking_vulva_mov.html.

55 Wark, *Radical Gestures*, 202.

56 Dempsey and Millan, *A Live Decade*.

57 Kader, "Kate Clinton: The Production and Reception of Feminist Humor," cited in Auslander, *From Acting to Performance*, 112.

58 Dempsey and Millan, "Shawna Dempsey and Lorri Millan," 69.

59 See Lord, "Inside the Body Politic," 31.

60 Dempsey and Millan, "Public Warning!," 66–7.

61 Lord, "Inside the Body Politic," 38.

62 Dempsey and Millan, description of *Lesbian National Parks and Services*, artists' website, http://www.shawnadempsey andlorrimillan.net/#/alps.

63 Dempsey and Millan, *Handbook of the Junior Lesbian Ranger*, 4.

64 Butler, *Bodies That Matter*, 21; Kristeva, *Powers of Horror*, 2–3.

65 See McRobbie, "Postfeminism and Popular Culture," and Pinterics, "Riding the Feminist Waves?"

66 Allyson Mitchell, description of *Big Trubs*, artist's website, http://www.allysonmitchell.com/html/big_trubs.html.

67 Adamson, "When Craft Gets Sloppy," 36, 39.

68 See Lord, "Inside the Body Politic," 34–5.

69 Mitchell, "Deep Lez."

70 Freeman, *Time Binds*, 62–3, 65, 85.

71 Ibid., 85.

72 Mitchell, description of *Ladies Sasquatch*, artist's website, http://www.allysonmitchell.com/html/lady_sasquatch.html.

73 Freeman, *Time Binds*, 89.

74 Ibid., 91.

75 Ibid., 91, 93.

76 Butler, *Bodies That Matter*, 21.

BIBLIOGRAPHY

Adamson, Glenn. "When Craft Gets Sloppy." *Crafts* 211 (March/April 2008): 36–41.

Auslander, Philip. *From Acting to Performance: Essays in Modernism and Postmodernism.* New York: Routledge, 1997.

Bataille, Georges. "L'Abjection et les forms misérable." In *Écrits posthumes, 1922–1940*, vol. 2, *Oeuvres complètes*, edited by Denis Hollier, 217–22. Paris: Gallimard, 1970.

Béland, Daniel. "Canada." In *Culture Wars in America: An Encyclopedia of Issues, Viewpoints and Voices*, 2nd ed., edited by Roger Chapman and James Ciment, 92–3. New York: Routledge, 2015.

Ben-Levi, Jack, Lesley C. Jones, Simon Taylor and Craig Houser. Introduction to *Abject Art: Repulsion and Desire in American Art*, edited by Craig Houser, Lesley C. Jones, and Simon Taylor, 7–15. New York: Whitney Museum of American Art, 1993. Exhibition catalogue.

Butler, Judith. *Bodies That Matter: On the Discursive Limits of Sex.* New York: Routledge, 1993.

– *Gender Trouble: Feminism and the Subversion of Identity.* New York: Routledge, 1990.

Cunningham, Kimberly Jasper. "Queer Theory." In *The Concise Encyclopedia of Sociology*, edited by George Ritzer and J. Michael Ryan, 485–6. Oxford: Blackwell Publishing, 2011.

Daly, Mary. *Gyn/Ecology: The Metaethics of Radical Feminism.* Boston: Beacon Press, 1978.

Dempsey, Shawna, and Lorri Millan. *Handbook of the Junior Lesbian Ranger.* Winnipeg: Finger in the Dyke Productions, 2001.

– *A Live Decade: 1989–1999.* Winnipeg: Finger in the Dyke Productions, 1999. Video compilation.

– "Shawna Dempsey and Lorri Millan." In *The Feminist Reconstruction of Space*, edited by Louise W. May, 66–83. St Norbert, MB: St Norbert Arts and Cultural Centre, 1996.

– *We're Talking Vulva.* Co-produced and directed with Tracey Traeger. Colour film, 1990. www.shawnadempseyandlorrimillan.net/#/were-talking-vulva/.

Dempsey, Shawna, Lorri Millan, Lynne Bell, and Janice Williamson. "Public Warning! Sexing the Public Spheres: A Conversation with Shawna Dempsey and Lorri Millan." *Tessera* 25 (Winter–Spring 1998–99): 57–77.

Diamond, Elin. *Unmaking Mimesis: Essays on Feminism and Theatre.* New York: Routledge, 1997.

Dubin, Steven C. *Arresting Images: Impolitic Art and Uncivil Actions.* New York: Routledge, 1992.

Foster, Hal. "Obscene, Abject, Traumatic." *October* 78 (Autumn 1996): 106–24.

Freeman, Elizabeth. *Time Binds: Queer Temporalities, Queer Histories.* Durham, NC: Duke University Press, 2010.

Furey, Anthony. "Canadians Are Centrist Except in the Voting Booth." *Toronto Sun*, 8 March 2013. http://www.torontosun.com/2013/03/08/canadians-are-centrist-except-in-the-voting-booth.

Gopnik, Blake. "National Portrait Gallery Bows to Censors, Withdraws Wojnarowicz Video on Gay Love." *Washington Post*, 30 November 2010. http://www.washingtonpost.com/wp-dyn/content/article/2010/11/30/AR2010113006911.html.

Halperin, David. "The Normalization of Queer Theory." *Journal of Homosexuality* 45, nos. 2/3/4 (2003): 339–41.

Harris, Geraldine. *Staging Femininities: Performance and Performativity.* Manchester: Manchester University Press, 1999.

Hunter, James Davison. *Culture Wars: The Struggle to Define America.* New York: Basic Books, 1991.

Ibbitson, John. "How Harper Created a More Conservative Canada." *Globe and Mail*, 6 February 2015. http://spon.ca/how-harper-created-a-more-conservative-canada/2015/02/10/.

Jeffreys, Sheila. *Unpacking Queer Politics: A Lesbian Feminist Perspective.* Cambridge: Polity Press, 2003.

Jenkner, Ingrid. *Rosalie Favell: Living Evidence.* Regina, SK: Dunlop Art Gallery, 1994. Exhibition catalogue.

Kader, Cheryl. "Kate Clinton: The Production and Reception of Feminist Humor." In *Sexual Politics and Popular Culture*, edited by Diane Raymond, 42–55. Bowling Green, OH: Popular Press, 1990.

Katz, Jonathan D. "'The Senators Were Revolted': Homophobia and the Culture Wars." In *A Companion to Contemporary Art since 1945*, edited by Amelia Jones, 231–46. Oxford: Blackwell Publishing, 2006.

Krauss, Rosalind. *The Originality of the Avant-Garde and Other Modernist Myths*. Cambridge, MA: MIT Press, 1985.

Krauss, Rosalind, and Jane Livingston, eds. *L'Amour fou: Photography and Surrealism*. Washington: Corcoran Gallery; New York: Abbeville Press, 1985.

Kristeva, Julia. *Powers of Horror: An Essay on Abjection*. Translated by Leon S. Roudiez. New York: Columbia University Press, 1982.

Lord, Catherine. "Inside the Body Politic: 1980–Present." In *Queer Art and Culture*, edited by Catherine Lord and Richard Meyer, 29–45. London: Phaidon, 2013.

McRobbie, Angela. "Postfeminism and Popular Culture." In *Interrogating Postfeminism: Gender and the Politics of Popular Culture*, edited by Yvonne Tasker and Diane Negra, 1–39. Durham, NC: Duke University Press, 2007.

Mitchell, Allyson. "Deep Lez." *Feminine Moments: Fine Art Made by Lesbian, Bisexual and Queer Women Artists Worldwide* (blog), 15 September 2009. http://www.femininemoments.dk/blog/deep-lez/.

Palmer, Paulina. "Queer Transformations: Renegotiating the Abject in Contemporary Anglo-American Lesbian Fiction." In *The Abject of Desire: The Aestheticization of the Unaesthetic in Contemporary Literature and Culture*, edited by Konstanze Kutzbach and Monika Mueller, 49–67. Amsterdam and New York: Rodopi, 2007.

Pentony, Samantha. "How Kristeva's Theory of Abjection Works in Relation to the Fairy Tale and Post Colonial Novel: Angela Carter's *The Bloody Chamber*, and Keri Hulme's *The Bone People*," *Deep South* 2, no. 3 (1996). http://www.otago.ac.nz/deep south/vol2no3/pentony.html.

Pinterics, Natasha. "Riding the Feminist Waves: In with the Third?" *Canadian Woman Studies* 21, no. 4 (2001): 15–21.

Quigley, Margaret. "The Mapplethorpe Censorship Controversy." *Political Research Associates*, 1 May 1991. http://www.politicalresearch.org/1991/05/01/the-mapplethorpe-censorship-controversy/#sthash.34FNgBBA.dpbs.

Rich, Adrienne. "Compulsory Heterosexuality and Lesbian Existence." *Signs: Journal of Women in Culture and Society* 5, no. 4 (1980): 631–60.

Ross, Christine. "Redefinitions of Abjection in Contemporary Performances of the Female Body." *Res* 31 (Spring 1997): 149–56.

Salih, Sara. *Judith Butler*. New York and London: Routledge, 2002.

Spector, Jack. *Surrealist Art and Writing, 1919–39: The Gold of Time*. Cambridge: Cambridge University Press, 1997.

Steiner, Wendy. *The Scandal of Pleasure: Art in an Age of Fundamentalism*. Chicago: University of Chicago Press, 1997.

Stubbs, Ryan. "Public Funding for the Arts: 2012 Update." *Grantmakers in the Arts* 23, no. 3 (2012). http://www.giarts.org/article/public-funding-arts-2012-update.

Thomson, Irene Taviss. *Culture Wars and Enduring American Dilemmas*. Ann Arbor: University of Michigan Press, 2010.

Wark, Jayne. *Radical Gestures: Feminism and Performance Art in North America*. Montreal and Kingston: McGill-Queen's University Press, 2006.

Wilson, Michael. "Michael Wilson on Sore Winners." Review of the exhibition *Just Pathetic*, curated by Ralph Rugoff at the Rosamund Felsen Gallery, Los Angeles, 1990. *Artforum* 43, no. 2 (2004): 117–18.

Zurek, Amy. "Abjection: The Theory and the Moment." Bachelor's senior project paper, University of Pennsylvania, 2011.

The Appearance of Desire

Thérèse St-Gelais
Translated by Sue Stewart

5 This chapter essentially presents a feminist reflection on how desire has been constructed and questioned by artists who are engaged in critical representations of the norms that shape desire, in the context of feminist art in Quebec. While desire is represented in the work of many artists, it is also frustrated or thwarted in certain productions by Quebec's women artists. In their work, we do not see the denial of a *representable* desire but rather the need to present an appearance of desire that is at times deceptive and at others completely fabricated.

First I will examine three pieces by Olivia Boudreau – *Jupe* (Skirt) (2004); *Le mur* (The wall) (2010); and *L'étuve* (The steamroom) (2011) – in which desire would appear to have its place in a slow procession of images but nonetheless remains unsatisfied. This slow pace is accompanied by the absence of a narrative climax, which thwarts the anticipated desire. Elsewhere, the desirable icon harbours a provocation that overturns expectations of the programmed "male gaze."[1] This device is operative in Christine Major's *La dépense* (Spending) (2010); in implicitly sexual images conveyed with chromatic virtuosity, it questions the apparently natural connections between art and a sensual representation of desire. A far cry from the notable excess of Major's work, but revealing a sexuality rendered invisible by representations of woman as the mother whose desiring body we do not recognize, Myriam Jacob-Allard's *Un coin du ciel* (A corner of heaven) (2014) is driven by the determination to lift the veil hiding the face of a figure combining the *maternal* with the *beloved* that has been constructed by the *guardians of the home*. Also on a domestic theme, we will discuss an *oeuvre sans titre* (untitled work) (2011) and *Carnaval* (2008) by Les Fermières Obsédées. They borrow from the Cercles de Fermières québécoises to help put desire to the test with a permissive non-conformity, permitting the assertion that norms can no longer claim the validity of truth. Their work features images of artists and women that fail to meet the criteria for *desired femininity*, instead coming closer to a deviant and therefore unseemly sexuality.

The pieces featured in this essay were chosen according to the principle that we grant the art in question a power to produce change, a power residing in spaces in the work that are at first glance hard to detect and interpret. In this connection, we repeat the question posed by Rosi Braidotti as she expresses the difficulty of putting absences

in words: "What language is appropriate for expressing silences and missing voices?"[2] Similarly, I share Braidotti's perception of the activity of thinking, which I will apply to creating or producing a work of art: "Thinking is the activity that aims to invent new images of what thinking means. Thought is life experienced to the *n*th power, creative and critical."[3] Further, it is true that opening up possibilities of meaning, challenging the real by measuring it against the fiction whose appearance it adopts, and questioning the spaces that separate them is, in a way, the province of art. Following Jacques Rancière, I lean towards the position that "there is no reality *per se*, but only configurations of what is given to us as our reality, as the object of our perceptions, thoughts and actions. Reality is always the object of a fiction, that is, a construction of the space in which what can be seen, said and done come together."[4]

In Quebec as elsewhere, the theme of the body and its many moods, including that of desire and its manifestations, is not only still current but has become the subject of lively debate. For example, under the editorship of Isabelle Boisclair and Catherine Dussault Frenette, a writers' collective has addressed the theme of *Femmes désirantes* (Women who desire).[5] Regarding bodies, subjects, and desires, many schools of thought have been established, but they have not reached, and perhaps have no intention to reach, a consensus. In a situation of desire, whether explicit or not, the bodies that give, sell, or display themselves in pornographic poses – considered immoral or pernicious for some, legitimate and even profitable for others – now appear to be so many platforms for establishing values and ideologies.

While not overtly positioned in the feminist camp, Christine Major's work is examined here owing to a strangely worrying, even disturbing dimension in its central representation of a female figure. In apparent contrast to the other works included, Myriam Jacob-Allard's work deals with the invisibility of the desiring body of supposedly asexual women. This proposition is in some ways overturned by the work of Les Fermières Obsédées; the pieces being examined here are considered provocative and categorized under political protest, while they come closer to denaturalizing the norms. In part, therefore, my aim is to address these bodies whose sensuality, and the desire it would arouse, are set aside or held back by various strategies that play upon the gaze's expectations. In this spirit, my discussion begins with the production of Olivia Boudreau, in which we can see that time is a key factor, not to say of the essence.

Unslaked

The plot of Olivia Boudreau's work,[6] steeped in sensuality, is sometimes carried on the breeze. This is the case in *Le mur* (2010), in which a white curtain floating in front of a wall leads us to feel that, sooner or later, we will see what is to be found behind this flimsy surface. We believe that in time, an image, figure, scene, even some form of pleasure awaits us. For a brief moment, the immaculate curtain lifts and allows us to see the wall it conceals, but this reveals nothing to hold our gaze. That's because it is not a matter of seeing, but of waiting. In Boudreau's work, time is real and is actualized

5.1 Olivia Boudreau, still from *Le mur*, 2010.

through space, objects, the material and the immaterial, letting desire take shape. An expectation related to what triggers desire also has a place in *Jupe* (2004), in a more explicit way; in a restrained rhythm, we see a tartan skirt moving up and down, revealing and then covering milky-white thighs. This protracted action continues with slight variations for some nine minutes, without anything else taking place. The sensuality that may reside in draped figures in the paintings – and even sculptures – produced by male artists from previous eras[7] apparently resides in a sheet in Boudreau's work, which nonetheless reveals nothing more than the *underside* of an expectation, without consummation.

The video piece *L'étuve* (2011) has a longer running time and draws all its poetic and formal power from water vapour that fills the space of a sauna and then dissipates. Within this sauna, one to five women appear and fade away under the captivating effects of this volatile, fluctuating material, in which visibility, or invisibility, becomes crucial. Given the women's presence in a place that is their preserve, we might think that the piece, in keeping with this device, will unveil a space in which desire is only waiting for an opportunity to manifest itself. This evokes the many representations of "bathing women" we have inherited from the nineteenth century and the golden age of Orientalist painting, which could also be termed *deliberately Orientalizing*.[8] However, this twenty-minute piece does not capture our gaze with a voluptuous element it might harbour. Rather, in my opinion, it holds the gaze in order to free it of the weight of the dominant structural model, which is represented by the languorous deployment of female bodies in a relatively intimate situation. It is as if the piece "denatures" the implicit sensual content that would celebrate a conventional heteronormative sexuality.

5.2 Olivia Boudreau, still from *Jupe*, 2004 (detail).

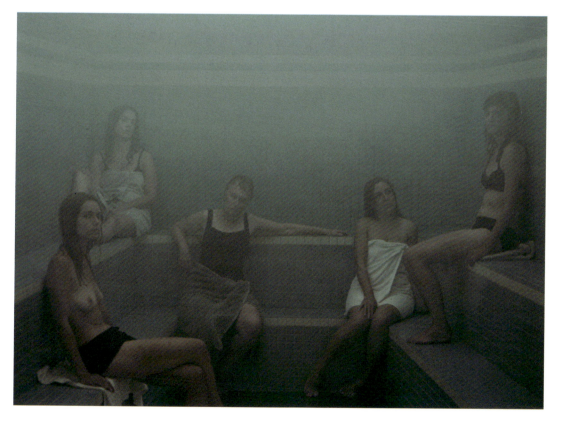

5.3 Olivia Boudreau, still from *L'étuve*, 2011.

When looking at an image, whatever it is, we are often able to check off which elements belong to a sexual identity or desire controlled by codes or convention. The same is true of spaces in which we recognize particular features regulated by institutions or by defined functions. The sauna space is an example. And yet, what we say about a space could also be applied to time, insofar as it plays a role in constructing and deploying desire and the identities that experience it. As it is used in Boudreau's work, time does not produce the normative or "natural" effect described and challenged by Judith (Jack) Halberstam: "These formulaic responses to time and temporal logics produce emotional and even physical responses to different kinds of time: thus people feel guilty about leisure, frustrated by waiting, satisfied by punctuality, and so on. These emotional responses add to our sense of time as 'natural.'"[9] In line with a non-normative concept, time, as signified in Boudreau's work, and more specifically that time required to consummate desire, remains suspended. It leaves us in a state of indecision, but also one of openness to possibilities that can neither be measured nor evaluated by time construed as "productive," to borrow the term used by Elizabeth Freeman in *Time Binds:* "Emotional, domestic, and biological tempos are, though culturally constructed, somewhat less amenable to the speeding up and micromanagement that increasingly characterized U.S. industrialization,"[10] and also, we believe, the dominant world of neoliberal thinking.

With Boudreau there is no linear narrative nor any outcome to what seems to present itself as a scenario in which desire plays a role. Neither is there an ending. The artist short-circuits desire and its expected consummation, and takes a fresh look at the effects, here paradoxical, of objectifying the body: making it seen but showing nothing. These pieces foil objectification by unveiling a desire that is frustrated in its deployment.

Hijacked

Christine Major is a painter. In 2010, she produced *La dépense*, which was shown in an exhibition titled *La nymphe moderne* (The modern nymph). This piece features a woman sitting on the floor of what looks like a space connected with consumption or a storage room for food and cooking containers.[11] She is sitting with her legs deliberately open, exposing a red mass that spreads across the floor. She rests her elbows on her knees, bringing a cigarette to her mouth with her left hand. Her posture, combined with the pumps encasing her feet, gives her a strange air of assurance, considering the space in which she is seen. Sitting at floor-level, on a surface that is red like her skirt and crotch, she nonetheless seems to be on standby in a world that is controlled by standards and ordered by uses and practices reflected in the alignment of the containers and products. She meets this order with a perturbed space and a zone of resistance that inevitably clashes with the decorum expected of a woman called the "mistress of the house."

Through the title of the exhibition in which this piece was shown, with its reference to feminine grace (*La nymphe moderne*), the woman's determined posture, the uniformly red field, and the contrast it sets up to the colours around it, the piece proposes the representation of a female figure whose self-assurance seems to be out of sync with her surroundings. It must be noted that Major's work features a sexual dimension – it is an easy semantic leap from nymph to nymphomania – that offers itself to the gaze through the indecency of the open legs and the colour red determinedly occupying a space that is now sexualized. And yet, while red could also symbolically evoke a wound, in this case it is subjectively redirected towards an assertion, addressing the power of a figure that is paradoxically in a posture of authority. In a way, Major is short-circuiting our initial reading of this image and offering the representation of what comes across as a retrenching, a retrenching that nevertheless manifests itself as calming, even "rehabilitating." As if out of the domestic routine of running errands and making meals, which seems to doom emancipation to failure, there has

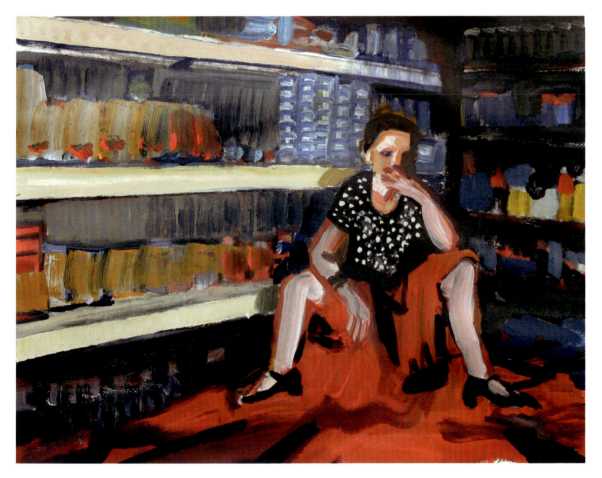

5.4 Christine Major, *La dépense*, 2010.

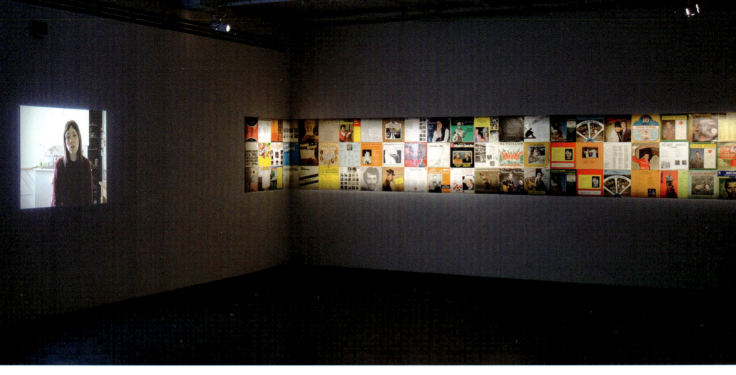

5.5 Myriam Jacob-Allard, view of the exhibition *Un coin du ciel* at La Galerie de l'UQAM, Montreal, 2014.

come a sudden U-turn into jubilation and salvation. Beyond its straightforward representation of a woman in a pantry this painting casts a critical eye on the associated good behaviour and focuses on a chromatic power that strengthens the female figure's determination. Thus, what first appears to be an image of imprisonment instead suggests an assertion that again recalls a statement by Halberstam: "We can also recognize failure as a way of refusing to acquiesce to dominant logics of power and discipline and as a form of critique."[12] With Major, as often occurs in her productions, there is a disturbing strangeness whose implicit links to what is familiar are manifested in unfamiliar ways.

Through her methods of disturbing the sexual space in this representation, by playing on convention and impropriety, Major renders visible and possible unexpected reversals of archetypal situations that allow us to rethink representations of the female. Her work calls domestication into question, justifiably, while we must defuse *natural* tendencies to limit what might be seen in a different light.

Invalidated

Myriam Jacob-Allard also presents her female figures in a domestic space. While far from containing the kind of sexual ambiguity expressed in the work of Christine Major, her piece *Un coin du ciel* is no less disarming about what is concealed. In this piece, the artist had members of her family – her mother and grandmother, among others – perform the eponymous country song that, since the 1950s, has gently rocked

many Quebec homes with an apparently comforting air. Filmed in their kitchen, these women convey the lyrics of love and fidelity corresponding to the heteronormative desires typical of this so-called popular culture. The video screening is accompanied by country-and-western vinyl albums from the artist's family archives, which have been hung on the walls of the exhibition space. These recordings feature songs lauding the "good mother" who is conciliatory, selfless, and generous, who we want to forget is first and foremost a woman, and who radically sets aside the complex structure of her identity. Obviously, *Un coin du ciel* appears to be more conservative than Major's work, but that is in fact because it presents an image of a woman without a desiring body that might prove to be unseemly and even indecent in its representation. In this case, the body is seen only in its virtuous aspect, which is for the pleasure and well-being of the family unit. In fact, this piece reproduces the image of the Québécoise mother from the era that preceded and ushered in the Quiet Revolution, showing a woman who respects the image she is expected to project. This woman therefore fits into the context Lori Saint-Martin described in *Le nom de la mère* (The name of the mother): "The religious discourse that was widely disseminated in Quebec into the 1960s and beyond presents her as asexual, smiling through her tears and selfless; the psychoanalytical discourse informs us that she wants to have children to compensate for the narcissistic wound of castration, such that motherhood is the sign of an ontological lack; the scientific discourse speaks to us of maternal instinct and hormonal determinism."[13]

And yet, the piece also brings out the mother–daughter relationship, when the artist (the daughter) herself does a kitchen rendition of the song that is popularly associated with "the mother," possibly in a spirit of understanding her better or more effectively detaching herself from her. For, again in the words of Saint-Martin, when that relationship is foregrounded, "it is for or against the mother, to escape her or to find her again and avenge her, that the daughter writes,"[14] and, we might add, that she creates.[15] In fact this relationship is eminently present in Jacob-Allard's work, in which the country folk music, equally omnipresent, is used to convey the artist's roots in representing female figures from her family. Thus, the deferential representation of the woman overshadowed by that of the mother is taken up in that of the daughter, who is playing the role of *that* mother, whose abnegation by definition involves the desiring body's erasure. Like a *mise en abyme*, *Un coin du ciel* launches an accusation at the constructed, even theatricalized, aspect of the woman-mother whose "nature" would obviate physical pleasure.

Denaturalized

The artistic collective Les Fermières Obsédées, which has been active since 2001, has made similar references to tradition, having borrowed its name in part from Les Cercles de Fermières du Québec (CFQ). The CFQ is a Quebec association of women that celebrated its one hundredth anniversary in 2015 and whose aim is to "promote

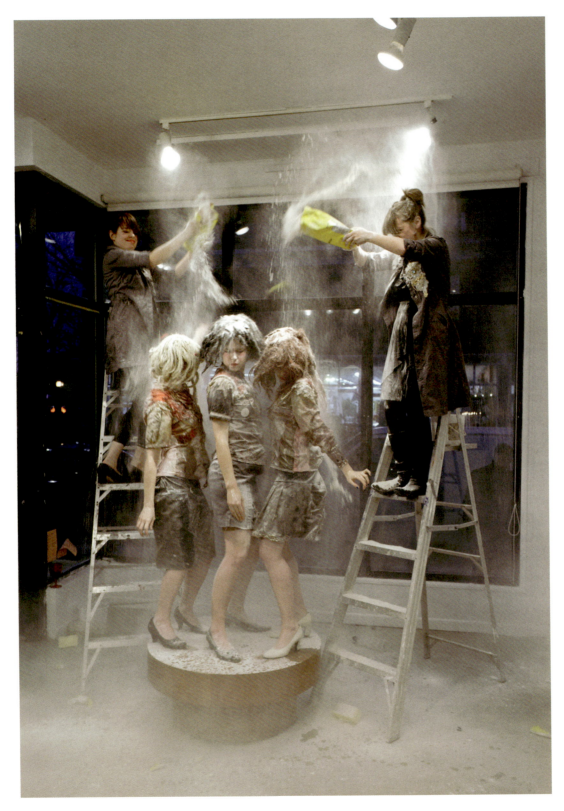

5.6 Les Fermières Obsédées, *Untitled*, performance at
La Centrale Galerie Powerhouse, Montreal, 2011.

women's development and fulfillment."[16] However, the collective, Les Fermières Obsédées, soon threw any such references into question. Appropriating the street as well as exhibition spaces to present an excess that literally contradicts the good manners women are expected to display, the collective overturns social norms and conventions to illustrate a dislocation that is in some respects beneficial.[17] Since the early days, when the members wore mini-skirts, corsets, high-heeled shoes, and wigs that became increasingly sullied from show to show, the collective has shown itself to be reliably irreverent, acting out in ways that bear little similarity to normalized gender expectations. Elements of their performance, including dirty clothes, bodies, or faces, improper and even gross actions, disjointed and sometimes wild rhythms, consistently provoke dismay.

The collective is no longer made up of the same artists, and in recent interventions, the performers have chosen to wear flesh-coloured underwear from the 1950s, as in *Le marché du zombie* (The zombie market) (2014), performed during Quebec City's 7th Manif d'art à Québec. Nonetheless, the group remains *obsessed* by delinquency, chaos, disrespect, and all of their possible permutations. In 2011, the members had three other women wear their *classic* uniform as part of a performance to celebrate the launch of the collective's first monograph.[18] Standing on a plinth, in an arrangement strangely reminiscent of the china couple atop a wedding cake, the trio found itself being gradually splattered with the ingredients of a cake – flour, eggs, and so on – and the party decorations to match, such as confetti and streamers, as the aroma of a freshly baked cake filled the space. While embodying a symbol associated with the institution of marriage, these women found themselves challenging and dishonouring its value in their messy state. Borrowing the image of what represents a conventional aim of the loving couple, with its related splendour and happiness, the performance made fun of the customs and norms surrounding an event perceived to be the consecration of a happy life. And yet, in this case, while using humour to achieve their ends, Les Fermières Obsédées did much more than "trifle with love." They played up theatrics to undermine respect for proper conventional behaviour. They de-assigned the roles and functions of bodily objects and subjects by inverting the status they should be granted, and in doing so exposed a dimension that is artificial and even entirely constructed.

Returning again to Halberstam, this time on the aesthetic concept of turbulence, might allow us to grasp, in a peripheral way, the Fermières' process: "I want to claim for the images that I examine [here] an aesthetic of turbulence that inscribes abrupt shifts in time and space directly onto the gender-ambiguous body, and then offers that body to the gaze as a site of critical reinvention."[19] In fact, the bodies of the collective's members occupy spaces of thought and action that have not been assigned to them, not because they are off-limits, but rather because the artists denaturalize them. According to Arthur Danto, "in disturbational art, the artist is not taking refuge behind the conventions: he [sic] is opening a space which the conventions are designed to keep closed."[20] Danto had previously defined one objective of the art of turbulence:

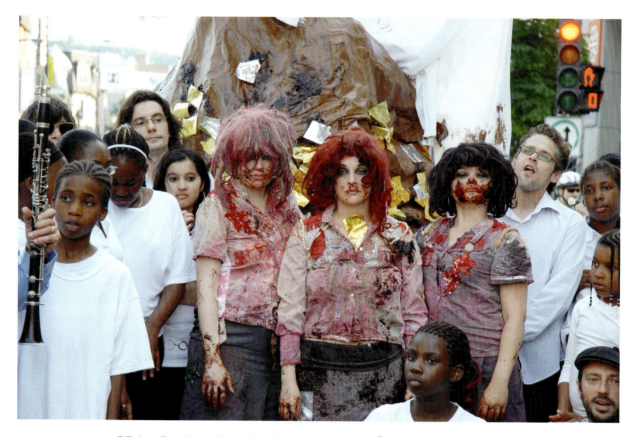

5.7 Les Fermières Obsédées, *Carnaval*, Paysages Éphémères, Montreal, 2008.

"in a way this models what the art of disturbation seeks to achieve, to produce an existential spasm through the intervention of images into life."[21] As "abrupt shifts in time and space" or "existential spasm," whether defined by Halberstam or Danto, turbulence translates into deliberate reversals for Les Fermières Obsédées, who invalidate behavioural norms for women.

With *Carnaval* (2008), Les Fermières Obsédées marched through the streets of Montreal accompanied by a convertible car, a group of young women, an Italian marching band, and a sculpture whose shape and colour suggested a heap of either chocolate or shit. Decked out in their usual clothes – schoolgirl-style blouses and skirts that had obviously already suffered through previous performances – they waved to passersby, most of whom had no acquaintance with these girls with fake smiles whose appearance was far from that of the very *feminine* class of duchesses and queens in the traditional Quebec City carnival. Altogether, Les Fermières Obsédées disown a form of belonging that is indisputably associated with an identity based on gender, sex, or desire, and in this respect they *de-domesticate* the thinking that would limit them to normative representations, thus aiming for disidentification.

As Braidotti maintains, "Disidentification implies lucidity, deliberately abandoning structures and habits of thought, representation and, also, life that are part of our individual and cultural identity."[22] She continues, "Disidentification is not a betrayal of primordial affects, but rather a kind of epistemological disobedience that encourages the systematic pursuit of a radical or relative non-belonging as the subject's principal positioning."[23]

Performances by Les Fermières Obsédées are certainly feminist, and they also align with the ideas of Judith Butler, in whose case we can see that a tangible, beneficial detachment from norms identifies her with the queer movement: "Indeed, it may be precisely through practices which underscore disidentification with those regulatory norms by which sexual difference is materialized that both feminist and queer politics are mobilized."[24] Thus, in the words of José Esteban Muñoz, "Disidentification is about cultural, material, and psychic survival. It is a response to state and global power apparatuses that employ systems of racial, sexual, and national subjugation. These routinized protocols of subjugation are brutal and painful. Disidentification is about managing and negotiating historical trauma and systemic violence."[25] And yet, what is demonstrated by Les Fermières Obsédées is a deviation from norms grounded in scenarios that are "too" conspicuous. This revulsion experienced by some fails to consider the violence that may come from heteronormative structures of gendered identity. Les Fermières Obsédées works belong to the art of turbulence: "These pieces disturbate in the direction of life," just as they sometimes "disturbate in the direction of art."[26]

Conclusion

Unslaked, hijacked, invalidated, denaturalized – desire and its normative manifestations meet opposition in the works we have treated here. The pieces all display affinities regarding the issues raised by desire's representation or evident invisibility. At the same time, although they set out to criticize the very idea of adopting models, including that of deploying desire, they appropriate existing representations to debunk foundational notions. The foreign (or false) zones of intimacy within which the bodies are presented are part of a deliberate choice of scenography that challenges the works' reception and what the gaze, more specifically the heteronormative gaze, would have seen or wanted to see. Thus, the critical impact of this work with bodies, which allows for greater openness regarding art's roles and functions, must be recognized. To paraphrase Braidotti, we must see what producing a work of art means when confronting concepts that are not always shared about what is a good or bad use of identity.

Queers of Color and the Performance of Politics. Minneapolis: University of Minnesota Press, 1999.

Rancière, Jacques. *Le spectateur émancipé*. Paris: La Fabrique éditions, 2008.

Said, Edward W. *Orientalism*. New York: Vintage Books, 1979.

Saint-Martin, Lori. *Le nom de la mère: Mères, filles et écriture dans la littérature québécoise au féminin*. Québec : Éditions Nota Bene, 1999.

Taraud, Christelle. "Painting the Erotic and Exotic Oriental Feminine in Quiescence." In *Benjamin-Constant: Marvels and Mirages of Orientalism*, edited by Nathalie Bondil, 213–23. Montreal: Montreal Museum of Fine Arts and Musée des Augustins de Toulouse, 2014.

Thériault, Michèle, ed. *Olivia Boudreau: Oscillations of the Visible / L'oscillation du visible*. Montréal: Leonard & Bina Ellen Art Gallery, 2014. Exhibition catalogue.

As Braidotti maintains, "Disidentification implies lucidity, deliberately abandoning structures and habits of thought, representation and, also, life that are part of our individual and cultural identity."[22] She continues, "Disidentification is not a betrayal of primordial affects, but rather a kind of epistemological disobedience that encourages the systematic pursuit of a radical or relative non-belonging as the subject's principal positioning."[23]

Performances by Les Fermières Obsédées are certainly feminist, and they also align with the ideas of Judith Butler, in whose case we can see that a tangible, beneficial detachment from norms identifies her with the queer movement: "Indeed, it may be precisely through practices which underscore disidentification with those regulatory norms by which sexual difference is materialized that both feminist and queer politics are mobilized."[24] Thus, in the words of José Esteban Muñoz, "Disidentification is about cultural, material, and psychic survival. It is a response to state and global power apparatuses that employ systems of racial, sexual, and national subjugation. These routinized protocols of subjugation are brutal and painful. Disidentification is about managing and negotiating historical trauma and systemic violence."[25] And yet, what is demonstrated by Les Fermières Obsédées is a deviation from norms grounded in scenarios that are "too" conspicuous. This revulsion experienced by some fails to consider the violence that may come from heteronormative structures of gendered identity. Les Fermières Obsédées works belong to the art of turbulence: "These pieces disturbate in the direction of life," just as they sometimes "disturbate in the direction of art."[26]

Conclusion

Unslaked, hijacked, invalidated, denaturalized – desire and its normative manifestations meet opposition in the works we have treated here. The pieces all display affinities regarding the issues raised by desire's representation or evident invisibility. At the same time, although they set out to criticize the very idea of adopting models, including that of deploying desire, they appropriate existing representations to debunk foundational notions. The foreign (or false) zones of intimacy within which the bodies are presented are part of a deliberate choice of scenography that challenges the works' reception and what the gaze, more specifically the heteronormative gaze, would have seen or wanted to see. Thus, the critical impact of this work with bodies, which allows for greater openness regarding art's roles and functions, must be recognized. To paraphrase Braidotti, we must see what producing a work of art means when confronting concepts that are not always shared about what is a good or bad use of identity.

NOTES

1 Mulvey, "Visual Pleasure."
2 Braidotti, *La philosophie*, 16. All translations by Sue Stewart unless otherwise noted.
3 Ibid., 190.
4 Rancière, *Le spectateur émancipé*, 83–4.
5 Boisclair and Frenette, *Femmes désirantes*.
6 See Thériault, *Olivia Boudreau*.
7 The masculine gender is used deliberately here, in the context of conventional art history.
8 Here I am referring to Edward W. Said's canonical work *Orientalism*, published in 1978, and Christelle Taraud's more contemporary article "Painting the Erotic and Exotic Oriental Feminine in Quiescence," in which the author makes a thorough, critical commentary on the representation of women in harems.
9 Halberstam, *In a Queer Time and Place*, 7.
10 Freeman, *Time Binds*, 7.
11 In Quebec, *dépense* (expense) can also refer to a pantry.
12 Halberstam, *The Queer Art of Failure*, 88.
13 Saint-Martin, *Le nom de la mère*, 13.
14 Ibid., 16.
15 It would be relevant to look at Myriam Jacob-Allard's work in the context of the many works of recognized historical import, especially from Quebec, concerning the theme of female lineage. I am thinking primarily of the Lori Saint-Martin's *Le nom de la mère* and Evelyne Ledoux-Beaugrand's *Imaginaires de la filiation*. In the latter, the author made the observation that "since the 1990s, feminism has produced numerous narratives and writings that put new stock in genealogy's vertical axis" (18).
16 See the website of the Cercles de Fermières du Québec at http://cfq.qc.ca/a-propos/mission-et-objectifs/.
17 For more on the collective's body of work, see Caillet et al., *Les Fermières Obsédées*.
18 Caillet et al., *Les Fermières Obsédées*. The performance took place at La Centrale Galerie Powerhouse on 25 March 2011.
19 Halberstam, *In a Queer Time and Place*, 107.
20 Danto, *The Philosophical Disenfranchisement of Art*, 125.
21 Ibid., 119.
22 Braidotti, *La philosophie*, 127.
23 Ibid., 129.
24 Butler, *Bodies That Matter*, 4.
25 Muñoz, *Disidentifications*, 161.
26 Danto, *The Philosophical Disenfranchisement of Art*, 124.

BIBLIOGRAPHY

Boisclair, Isabelle, and Catherine Dusseault Frenette, eds. *Femmes désirantes: Art, littérature, représentations*. Montréal: Éditions du remue-ménage, 2013.

Braidotti, Rosi. *La philosophie … là où on ne l'attend pas*. Paris: Larousse, 2009.

Butler, Judith. *Bodies That Matter: On The Discursive Limits of "Sex."* New York and London: Routledge, 1993.

Caillet, Aline, Marie-Ève Charron, Guy Sioui Durand, André-Louis Paré, and Thérèse St-Gelais. *Les Fermières Obsédées*. Trois-Rivières: Éditions d'art Le Sabord, 2010.

Danto, Arthur. *The Philosophical Disenfranchisement of Art*. New York: Columbia University Press, 1986.

Freeman, Elizabeth. *Time Binds: Queer Temporalities, Queer Histories*. Durham and London: Duke University Press, 2010.

Halberstam, Judith. *In a Queer Time and Place: Transgender Bodies, Subcultural Lives*. New York and London: New York University Press, 2005.

– *The Queer Art of Failure*. Durham, NC: Duke University Press, 2011.

Ledoux-Beaugrand, Evelyne. *Imaginaires de la filiation: Héritage et mélancolie dans la littérature contemporaine des femmes*. Montréal: Les Éditions XYZ, 2013.

Mulvey, Laura. "Visual Pleasure and Narrative Cinema." *Screen* 16, no. 3 (1975): 6–18.

Muñoz, Jose Esteban. *Disidentifications:*

Proposition 2: On Colonial Patriarchy and Matriarchal Decolonization

To think about feminism and feminist art in Canada necessitates a consideration of decolonization. We are bound together through the ongoing violence of settler colonialism. Settlers continue to benefit, structurally, from genocide and accumulation through dispossession of Indigenous peoples. Art practices alone cannot adequately address everything that needs to change in relation to these ongoing realities, but they can provide means of imagining otherwise and outside of colonial frameworks, creating spaces of self-representation. They can provide modes of critique, of resistance, of brilliant propositions, and ingenious models of relationality. Through decolonial (self-)love and rematriation, art can create avenues for Indigenous women and trans people to be the holders of their multiple and diverse identities. And settler allies can use their privileged access as platforms for Indigenous voices to be amplified, to begin to affect and infect the colonial structures of the nation-state, to slowly, but ever so surely, shift those structures towards modes of Indigenous-led governance and imaginaries.

Resistance as Resilience
in the Work of Rebecca Belmore

Ellyn Walker

In the summer of 2013, I was fortunate enough to take part in an interdisciplinary residency around the theme of Art and Resistance in Chiapas, Mexico, organized by the Hemispheric Institute of Performance and Politics. Consisting of a small yet diverse group of scholars, curators, artists, and graduate students from across the Americas, we were joined by senior performance artists for our final week together, one of whom was Rebecca Belmore. Upon this occasion, Belmore performed a chilling example of the ways in which colonization in Canada and across the Americas is a project of ongoing violence and, thus, political urgency.[1]

Standing in front of us in LA FOMMA, an Indigenous women's theatre centre based in the colonial town of San Cristóbal de Las Casas, Belmore began with no introduction, as her work would soon speak for itself. Outstretching her arms, she started to sing Canada's national anthem – what is today a familiar song around the world. While doing so, she took the scarf she was wearing as part of her outfit and extended it outwards horizontally, as if wings were unfurling from her back. She swiftly wrapped the scarf around her neck in a loop, as is often stylistically worn, though she did so in a way that featured a tighter loop than usual. She continued to pull tighter and tighter on the scarf and, consequently, her neck – her voice straining in reaction to the increasingly suffocating tautness.

Upon completion of the song in English, Belmore switched to French – to reflect Canada's official bilingualism – all the while, the audience was captivated by her vocal endurance, physical capacity, and personal vulnerability. Line after line of the song, her voice began to waver, crack, and eventually fade as she was deprived of oxygen, and her face transformed from red to purple to blue before our eyes. Her eyes swelled and her fingers twitched, as we were all witness to the somatic deprivation Belmore suffered in demonstrating Canadian nationalism to her Chiapan and international audience. The performance ended, as if not soon enough, and Belmore ran off to what we could only hope were comforting arms, quenching water, and reparative breathing space. This painful performance – both for Belmore to withstand and for the audience to watch – was a metaphor for the violence of colonization, both on bodies and on the land.

American performance scholar Judith Butler and social anthropologist Athena Athanasiou write that "the predicament of being moved by what one sees, feels, and

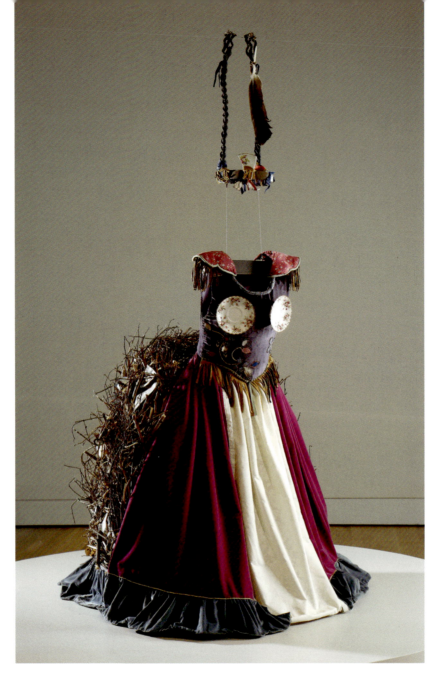

6.1 Rebecca Belmore, *Rising to the Occasion*, 1987–91.

comes to know is always one in which one finds oneself transported elsewhere ... into a social world in which one is not the center."[2] That afternoon together we witnessed and felt some of the invisible traumas Canadian colonialism wreaks as Belmore's violent struggle to voice endured and enacted a different kind of story than Canadian nationalism upholds. Not surprisingly, Belmore's thirty-year career has always proposed contestations to official histories and dominant narratives, beginning with her first public work in 1987, *Rising to the Occasion*. In it, Belmore donned an opulent dress that both combined and perverted colonial and Indigenous tropes, such as the

Victorian corset or braids of Pocahontas or the "Indian princess." This work effectively introduced what would become the signature characterization of her practice: thoughtful and poetic defiance. While Belmore's artistic accomplishments exceed the space afforded by this chapter, I'd like to focus on three specific works – *Fountain* (2005), *Ayum-ee-aawach Oomama-mowan: Speaking to Their Mother* (1991), and *One thousand One hundred & eighty One* (2014) – that hold continued potency as conversations around Indigenous justice and sovereignty gain momentum across Canada, and that intersect with critical questions of Indigenous women's oppression around the globe.

The 2015 report released by the Truth and Reconciliation Commission of Canada has increased national awareness of historic and contemporary colonial violences experienced by Indigenous peoples and the ways in which these traumas endure intergenerationally. However, Belmore reminds us that there still remains great work to be done – as she returns again and again to the subject of missing and murdered Indigenous women and ongoing genocidal practices as urgent sites for conciliation.[3] Likewise, the Idle No More movement, emergent in 2013, successfully amplified the visibility of Indigenous activism and solidarity work, and did so in ways that called for continued long-term action and resistance to the settler–colonial project that constructs the land now known as Canada.[4] Along these lines, Belmore's iconic artworks sound an unrelenting and immutable call for (inter)national decolonization.[5]

Fountain

Fountain, presented as part of the 51st Venice Biennale in 2005, is a celebrated artwork for many reasons. As is emblematic in almost all of her art, Belmore uses her body as a proxy for the thousands and thousands of Indigenous women that colonial practices have attempted to silence, oppress, and extinguish. Here, her very existence – her bodily presence – insists on Indigenous survival and resilience, demonstrating the undeniable ways in which the colonial project (despite its ongoing reality) has ultimately failed to complete its genocidal mission.

Fountain consists of a video installation that portrays Belmore from a panoramic view amid an overcast and ominous oceanic environ that is projected onto large screens that feature a continuously flowing stream of water.[6] The waters from which her projection emerges act as a consistent sightline within the piece and maintain a steady horizon for what will soon become a chaotic scene. Upon looking closely, the viewer realizes that the bay itself is industrial, suggestive of contemporary realities rather than referencing a bucolic past. In it, Belmore struggles to carry a heavy bucket of water from the turbulent ocean, reflective of the ongoing burden of colonial struggle and resistance that Indigenous women have to endure. Suddenly, a dramatic fire erupts on the shoreline, though Belmore persists onwards towards the beach and, correspondingly, the camera. With intensity, Belmore throws the bucket of water at the camera and, thus, the viewer, where the water abruptly transforms to blood and drips down the screen, representative of the immense violence inherent in histories of colonization and related processes of occupation. The blood begins to slowly drip down

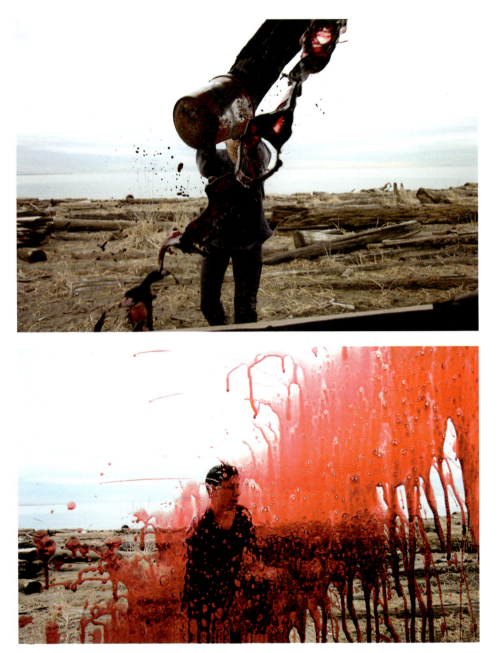

6.2 & 6.3
Rebecca Belmore,
Fountain, 2005.

the screen, eventually revealing Belmore's insistent gaze that works to assert Indigenous survival and resistance as an Anishnaabe woman.

Tuscarora scholar and curator Jolene Rickard wrote in her curatorial essay for the biennale artwork that Belmore's "role as the artistic voice of Canada" was one that uniquely called for the "reworking of a 'post' to 'neo' colonial, theoretical and aesthetic frame."[7] As the first Indigenous woman to represent Canada at this internationally renowned event, Belmore references the colonial histories and realities of Canada, but, also, of nations around the world. This intra/extra-national connection is extremely pertinent, as the biennale was founded as a nationalistic project, beginning

in 1895 within the context of the World's Fair.[8] This involved large-scale expositions that showcased creative and technological innovations of various countries to a global audience, where displays of national accomplishments and technological "progress" were meant to be demonstrated. Belmore is critically aware of this history, which makes her work all the more poignant and subversive – as she directs her focus on the symbol of the fountain as a particularly potent site of nationalistic spectacle.

Water, the foremost "material" within a fountain, holds diverse yet specific references that further complicate the work. Within Indigenous cultures across Turtle Island and beyond, water represents an epistemological relation that is the life source of all humanity, in addition to being a necessity for physical survival.[9] Water is also what brought diverse bodies to foreign lands through such transnational processes as slavery, indentured labour, immigration, and the movements of refugees. As such, water signifies a complex relationship to bodies, transporting them across vast geographies and collapsing distinctions of "home" and, relatedly, "belonging" in doing so. Water, furthermore, refers to the increasing scarcity of natural resources that are of great colonial and capital value, as more and more places around the world continue to contaminate and deplete this irreplaceable resource.

Despite all of this, water is still what continues to connect us to (and divide us from) each other and other places, such as how in the work, two faraway port cities, Vancouver and Venice, are made analogous – one the site of presentation, the other of production.[10] Curator Lee-Ann Martin explains that both "cities share a seeming abundance of water that defines the[ir] distinctive identity" and that enables their "sustenance, pleasure and commercial exchange. As busy ports, Venice and Vancouver are linked in the self-perpetuating cycle of global commerce. Iona Beach, south of Vancouver, where the city's sewage is released into the ocean, is where *Fountain* was performed by Belmore."[11] It is within the interstices of these two disparate yet similarly gentrified and colonized spaces that Belmore's artwork takes shape, waters that appear and function similarly, yet span vastly different geographies.

Ayum-ee-aawach Oomama-mowan: Speaking to Their Mother

The canonical work *Ayum-ee-aawach Oomama-mowan: Speaking to Their Mother* also takes up the importance of water – beginning as a giant megaphone to address the land and, more recently, the water. Of course, Belmore has worked intermittently with both the symbol and material of water throughout her career. In the installation *Paradise*, for example, created for the 11th Biennale of Sydney in 1998, she encased various photographs of water, stones, clouds, and sky in glass.[12] In the 1996 work *Temple*, she poignantly presented a water-based installation at The Power Plant in Toronto that addressed the "perceived abundance, sources and quality of drinking water [in which] she collected 3,500 litres of water from various sources, including Lake Ontario, the polluted Great Lakes basin upon whose shoreline The Power Plant is located."[13] In the summer of 2014, as part of her solo exhibition *KWE: Photography, Sculpture, Video and Performance by Rebecca Belmore* at the Justina M. Barnicke

Gallery,[14] curator Wanda Nanibush and Belmore organized a public gathering on the Toronto Islands that included interaction with the iconic megaphone. "Reminiscent of birch-bark cones used for moose calling in northern Ontario," such as in Upsala, Ontario, where Belmore grew up, the megaphone "empowered aboriginal people to speak to 'all of [their] relations' as well as the living cosmos" that surround wherever the megaphone is situated.[15] On that hot summer afternoon in August, we travelled and gathered together at Gibralter Point – an important site for Indigenous peoples long before European contact – to share intimate stories with each other and with the water that carried us to the islands that day.

Originally created in response to the 1990 stand-off at Kanehsatà:ke (also known as the Oka Crisis), *Ayum-ee-aawach Oomama-mowan* continues to gain significance as Indigenous–settler relations remain contested throughout Turtle Island and beyond. Having toured different First Nations communities, galleries, and museums over its twenty-five-year existence, the work's diverse mobility attests to its astute relevance to people all across this land. Originally actualized in a meadow in Banff National Park where people's voices reverberated back nine times upon speaking, each location is carefully selected. For example, during the sculpture's tour in the 1990s, various Indigenous communities where land claims were being actively asserted against the Canadian state were chosen as the site to animate the artwork. The megaphone's sonic effect is dependent on each of its locations, highlighting the ways in which this work

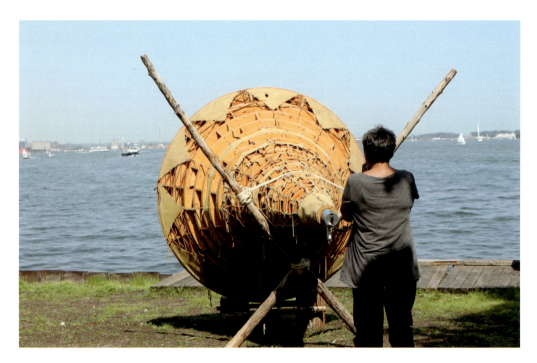

6.4 Rebecca Belmore, *Ayum-ee-aawach Oomama-mowan*, event at Gibraltar Point, Toronto Island, 9 August 2014. Part of the exhibition *KWE: Photography, Sculpture, Video and Performance by Rebecca Belmore* at the Justina M. Barnicke Gallery, 15 May–9 August 2014.

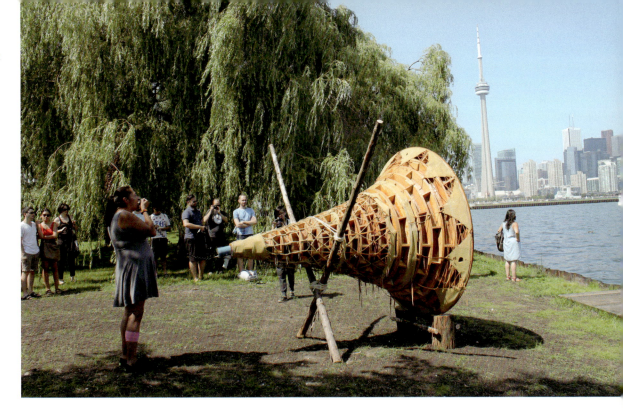

6.5 Rebecca Belmore, *Ayum-ee-aawach Oomama-mowan*, event at Gibraltar Point, Toronto Island, 9 August 2014.

is always in relation to and dependent upon the land and the people who activate it. Similarly, in the very process of using it, an immeasurable shift in sovereignty occurs between the state and the individual, when each person can be heard speaking in whatever language they choose to their original mother, Earth.[16]

Part of the brilliance of *Ayum-ee-aawach Oomama-mowan* is its duality – functioning as both a conceptual artwork and a practical, performative object. It is not just something to be viewed, but also something to be actively used. Described by Rickard as "one of the most significant expressions of sovereignty beyond political boundaries," the megaphone originally exemplified a unique act of self-determination at a particular time in Canadian history in which the country needed to listen. It continues to fill this role. As Rickard argues, "to bring a thought to life through the spoken word is one of the most powerful acts of reinserting aboriginal knowledge or epistemes into aboriginal and Canadian cultures,"[17] a point that is highlighted through the bilingual title of the work, which references the Indigenous counter-story to the Canadian narrative. It simultaneously leaves room for the interstices between Indigenous–settler positions to be negotiated not necessarily as binaries, but as mutually constitutive relations and histories.[18] Belmore remarks on the work's complex meaning in a more recent interview with ongoing collaborator Nanibush, describing it as "politics as poetic action." It is "poetic because we were speaking directly to the land [and] political because of the long history of others working to silence the sound of our voice echoing off of this land."[19] In this way, the megaphone offers a space for resistance and reconnection, making audible the return of voices to the territory they

once resounded in. While the land represents our Mother within Indigenous world views, it is equally the water that represents our lifeblood and that maintains our continued existence on Mother Earth. For this reason, the increasing degradation of our environment due to climate change, capitalism, and gentrification poses urgent questions for our future, ones we must attend to if we want to see our grandchildren outlive us one day.

On that summer day at Gibralter Point, we were speaking directly to the water as something that is important to us all – Indigenous and settlers alike. Though the stories shared through the megaphone are not mine to tell, they reflect the different concerns and experiences specific to each person and their history, and did so in ways that unified us through the process of careful, deep listening. Through these acts of speaking and listening, *Ayum-ee-aawach Oomama-mowan* teaches us many things – foremost, to care for our environment in the same way that we should for each other.

One thousand One hundred & eighty One

This sentiment of care is echoed again in the work *One thousand One hundred & eighty One*, a site-specific artwork performed as part of the same exhibition, KWE. Gathering outside of the gallery, which is located downtown as part of the University of Toronto campus, a crowd watched Belmore's performance as the sun slowly set over the city. Dressed in a neon orange construction vest, her body became hypervisible. This attire was thoughtfully chosen so as to counteract the erasure of Indigenous women who continue to disappear across this land at an alarming rate. Belmore began to hammer nails into a log that rested on top of a table in the centre of the crowd, where over and over again, we watched her hammer into it and tire as her laborious actions continued. At some point she began to yell the number 1,181 louder and louder as she continued to hammer – her screeching voice insisted on our collective listening, as anyone within proximity would undeniably hear the repeated number and were thus forced to consider its significance. This number was already of consequence to me, as I had been closely following Canadian news coverage of missing and murdered Indigenous women: it was the latest statistic to be released by a national report put out by the RCMP in 2013. The report documents "1,017 Aboriginal female homicide victims between 1980 and 2012, and 164 Aboriginal women currently considered missing. Of these, there are 225 unsolved cases of either missing or murdered Aboriginal women."[20] These statistics are not only heartbreaking but are astounding – one wonders why other cultural groups aren't targeted in these same ways, especially since Indigenous peoples currently make up approximately 10 percent of the Canadian population.[21] The answer is, unfortunately, easy. Colonialism continues to desecrate bodies, families, and communities, and it is Indigenous women who are unquestionably at the forefront of this violence.

Since the early European colonizers arrived on this land, they have treated Indigenous women as their property for the taking – raping and assaulting their bodies, which is akin to the violence of stealing land that was not theirs. If men can so unjustly

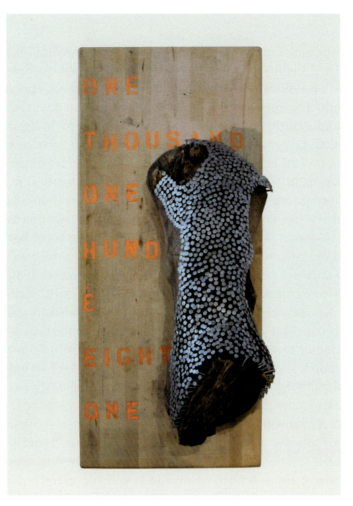

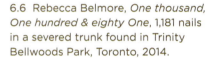

6.6 Rebecca Belmore, *One thousand, One hundred & eighty One*, 1,181 nails in a severed trunk found in Trinity Bellwoods Park, Toronto, 2014.

appropriate Mother Earth, imagine what they feel entitled to do to the bodies of its women. These acts – of stealing and occupying Indigenous land and bodies – are equally destructive in the project of colonization. However, settler colonialism and ongoing white supremacy construct these disappearances and violences in particular ways. The representation of missing and murdered Indigenous women is still inadequate, as it is most often Indigenous women who appear "white" who receive notable national attention.[22] Likewise, murderers and aggressors of white women statistically get longer prison sentences than perpetrators of Indigenous women.[23] The fact that we do not care the same way about Indigenous women as we do all other women in this country – especially white women – is appalling. Belmore reminds us of this with *One thousand One hundred & eighty One*, giving specificity to the overwhelming figure that obscures the individuality of each woman. Using her bodily force, in particular, her hands – signifiers of maternal care and healing referenced throughout classical art history – Belmore grapples with the open wound of past and present colonization and the multifaceted violence these processes imply, most violently asserted on the bodies of Indigenous women.

Rethinking the means of both "countability" and "accountability," Belmore allows the nails to protrude slightly, though, distinctly from the log as a reminder of the countless families who still wait up each night for their mothers, daughters, nieces, cousins, and friends. The visibility of these nails also insists on a type of critical consciousness that importantly counteracts the state's efforts of Indigenous erasure, assimilation, and cultural genocide and that rejects any claim to ignorance – an awareness that Belmore invited others to feel by way of example, as she and Nanibush slowly rubbed their hands along the protuberant nails. When others from the audience gradually joined in, taking their turn to wait for the others to finish before them, they both felt and saw the nails as the collective weight of the missing and murdered women – the nails hammered into the subtle shape of a female body. Both poetic and political, the cold, metallic touch of the nails left a lasting impression: a call to the work we must all undertake to restore safety to Indigenous women in this country.[24] By inviting others to participate in the experience of "being with" the women, Belmore invoked Butler and Athanasiou's critical question of "what [might it] mean to take part by not being exactly a part and yet by being tied to the lives and actions of others?"[25] This kind of complex relationality allowed for "multiple forms of doing, undoing, being undone, becoming, ... of giving and giving up" to occur[26] – all of which are undoubtedly important processes to any potentiality of sustained Indigenous–settler conciliation.

However, there remain limits and perils to particular kinds of recognition projects that uphold colonialism and deter real processes of conciliation from taking place, as outlined in the works of Indigenous scholars such as Audra Simpson, Glen Coulthard, and curator cheyanne turions. Both Simpson and Coulthard offer a politics of refusal in which to reject the neoliberal apparatus of cultural recognition that works to elide real questions of social change, Indigenous sovereignty, and Indigenous–settler conciliation.[27] Like these scholars' turn towards self-recognition, turions's also reframes sovereign embodiment from site of the nation to the self,[28] which necessitates specific ethical considerations such as "articulations of acknowledgment, witnessing, responsiveness, responsibility," accountability, and agency.[29] With *One thousand One hundred & eighty One*, Belmore refuses to accept, obscure, and forget such injustices practiced by the Canadian state, and thus rejects the naturalization of colonial violence on the Indigenous female body – the nailed image standing in for the thousands and thousands of women counted within and outside the RCMP report. Representative of tools for construction, but also of objects that can inflict violence and pain (such as with the biblical crucifixion of Christ), nails are re-imagined within the performance as an instrument of refusal. Through the act of witnessing Belmore's creation and the opportunity to feel it for themselves, the work implicates viewers in the epidemic, reminding us that settler colonialism is a project that should be acknowledged and resisted by everyone who wants to see a more socially just future for Indigenous women on this land.

Belmore's Legacy

The immense body of work Belmore has produced over the span of her career has created a lasting legacy both within and outside of Canada. Indeed, "legacy" is an interesting concept to consider when thinking through her work, as it can be related to the idea of "ancestry," which is of incredible importance to conversations around Indigeneity, as it works to tie Indigenous peoples to their clans and territories. As colonization has been practiced on this land for over 450 years, there remains great work to be done in understanding its long-term processes and lasting affects so as to resist its current naturalization and future continuance. Today, more and more emerging Indigenous artists are taking cue from Belmore's practice, such as can be found in the works of Meryl McMaster, Nigit'stil Norbert, Vanessa Dion Fletcher, Jeneen Frei Njootli, and others who grapple with the representation of Indigenous women, the body, and related experiences of gendered, colonial violence, and its resistance.

McMaster's photographic series *In-Between Worlds*, for example, features the artist as subject documented in various outdoor environs. The series calls attention to landscape as an important site of identity representation; her staged self-portraits make undeniably clear Indigenous peoples' intrinsic relationship with the land. Being of Plains Cree, British, Dutch, and Scottish ancestry, McMaster embodies the confluence of *many* rather than one identity,[30] and thus negotiates this complexity through the use of embellished costumes and sculptural elements that recall Indigenous and settler tropes alike. Reminiscent of Belmore's early work *Rising to the Occasion*, in which she uses her body as an interpolator and negotiator of Indigenous–settler symbolism, here, McMaster appropriates and embodies similar cross-cultural tropes in order to question their relevance but also their interrelationship – as Indigenous–settler histories remain entangled and contested across this land. One of the series' photographs, *Aphoristic Currents* (2013), shows McMaster donning an extravagant, oversized ruff reminiscent of an Elizabethan frill, where her visibly whitened face calls attention to McMaster's European heritage, while also highlighting the ways in which "whiteness has been imposed on Indigenous bodies and their cultures,"[31] including her own Indigenous ancestors. Like Belmore, McMaster makes the point that "Indigenous peoples have survived and succeeded in spite" of Canada's history of colonialism, emphasizing the fact that those of Indigenous ancestry embody important histories of struggle and resistance but also of courage and resilience.[32]

Other more senior Indigenous artists such as Skeena Reece, Tanya Lukin Linklater, Christi Belcourt, Nadia Myre, and Shelley Niro also draw attention to the epidemic of missing and murdered Indigenous women in their works. Like Belmore, they call for a multiplicity of responses: acknowledgment, awareness, education, affinity, alliance, action, and, ultimately, justice. Like Belmore's continued gesture of acknowledging each one of the women affected, as seen in her works *One thousand One hundred & eighty One, Vigil* (2002), *The Named and Unnamed* (2002), and in her 2015 installation *Trace* for the Canadian Museum of Human Rights, Belcourt's touring community-based exhibition project *Walking with Our Sisters* presents a site-specific installation

of handmade moccasins for the 1,181 sisters who have disappeared. Through the iconic Indigenous footwear, individually beaded and created, Belcourt gives nuance to the unique lives of each of the women otherwise obscured through cold statistics.[33] In approaching works like these that speak to the missing and murdered women's individuality as well as their collectivity, we are tasked with thinking about our own relationship to the one and the many.

Indigenous peoples in this country have never been idle, despite Idle No More's catchy moniker, as they have miraculously, though not unsurprisingly, survived thousands of years on this land through extreme environments and centuries of settler occupation and colonial violence, which continues today through ongoing systems of white supremacy, capitalism, and patriarchy. Thus, it is up to us all – Indigenous and settler alike – to ensure a future of Indigenous justice on this land for all life to come. Belmore shows us that such a future is not possible without critical processes of truth and remembrance, which, when combined, reveal incredible examples of resistance and thus resilience in spite of colonialism and its many faces.

NOTES

1 Colonization refers to the act of establishing control of a sovereign area away from one's own.

2 Butler and Athanasiou, *Dispossession*, xi.

3 Scholar, curator, and artist David Garneau defines conciliation as "the action of bringing into harmony" (7) whereas "*re*-conciliation refers to the repair of a previously existing harmonious relationship" (7), which is a fiction in the Canadian context and thus "a continuation of the settlement narrative" (8). Garneau explains that "conciliation is established as a living agreement, a relationship that does not compromise each other's core spaces. Conciliation is not the erasure of difference or sovereignty. Conciliation is not assimilation. [Rather, it is the] thinking, making, collaborating and exhibiting within sites of perpetual conciliation [that] has the potential to transform rather than contain" Indigenous–settler relations on this land (3). Garneau, "Imaginary Spaces of Conciliation and Reconciliation."

4 See *The Winter We Danced*, edited by the Kino-nda-niimi Collective.

5 Decolonization refers to both short- and long-term acts that counter the ways in which colonization constructs contemporary individual and social life. Cherokee scholar Jeff Corntassel describes decolonization as ongoing and "everyday acts of resurgence" that regenerate Indigenous knowledges, epistemologies, and ways of being where one can "embrace a daily existence conditioned by place-based cultural practices" that centre on Indigenous land, sovereignty, and ways of thinking. "Re-Envisioning Resurgence," 89.

6 Shot on video by renowned filmmaker Noam Gonick.

7 Rickard, "Rebecca Belmore," 1.

8 Di Martini, *The History of the Venice Biennale*, 8.

9 Turtle Island refers to the lands now known as North America and its origins within many Indigenous creation stories.

10 At that time, Vancouver was also the city in which Belmore lived.

11 Martin, "The Waters of Venice," 48.

12 Ibid., 49.

13 Ibid.

14 Now called the Art Museum at the University of Toronto.

15 Rickard, "Rebecca Belmore," 2.

16 Nanibush, "Love and Other Resistances," 175.

17 Ibid.

18 Ibid.

19 Nanibush, "An Interview with Rebecca Belmore," 214.

20 RCMP, *Missing and Murdered Aboriginal Women*, 7.

21 Racialized bodies are also subject to state and colonial violence in Canada, and even more acutely within the context of the United States, where African-Americans and Latinos undergo extreme brutality throughout their day-to-day lives.

22 The case for Loretta Saunders, the twenty-six-year-old blonde, blue-eyed Inuk woman murdered in Halifax in 2013, received an overwhelming amount of attention compared to other disappeared and murdered Indigenous women across the country.

23 Consider the prison sentences of iconic Canadian serial killers Robert Pickton versus Paul Bernardo. Pickton murdered more than fifty women, most of them street-involved Indigenous women who lived and worked in Vancouver's downtown lower eastside. He was charged with the second-degree murder of six of those women, and is now serving life in prison with no possibility of parole for twenty-five years. Paul Bernardo, who worked in partnership with his wife Karla Homolka, raped and murdered three young white women, including Homolka's own sister, in Toronto's east Scarborough area. He was charged with two counts of first-degree murder and aggravated sexual assault, and continues to serve life in prison with no possibility of parole for twenty-five years.

24 Walker, "Rebecca Belmore: 1187," 16.

25 Butler and Athanasiou, *Dispossession*, 155.

26 Ibid., 193.

27 See Simpson, *Mohawk Interruptus*, and Coulthard's *Red Skin, White Masks*.

28 See turions, "A Table for Negotiation, Mediation, Discussion, Difference."

29 Butler and Athanasiou, *Dispossession*, 92.

30 Walker, "Identity as Contingency," 27.

31 Walker, "Representing the Self through Ancestry," 16.

32 Ibid., 17.

33 The RCMP are widely suspected of being major perpetrators of violence against Indigenous women in Canada. See Dhillon's "Indigenous Girls and the Violence of Settler Colonial Policing."

BIBLIOGRAPHY

Butler, Judith, and Athena Athanasiou. *Dispossession: The Performative in the Political*. Malden: Polity Press, 2013.

Corntassel, Jeff. "Re-Envisioning Resurgence: Indigenous Pathways to Decolonization and Sustainable Self-Determination," *Decolonization: Indigeneity, Education & Society* 1, no. 1 (2012): 86–101.

Coulthard, Glen. *Red Skin, White Masks: Rejecting the Colonial Politics of Recognition*. Minneapolis: University of Minnesota, 2014.

Dhillon, Jaskiran K. "Indigenous Girls and the Violence of Settler Colonial Policing." *Decolonization: Indigeneity, Education & Society Journal* 4, no. 2 (2015): 1–31.

Di Martini, Enzo. *The History of the Venice Biennale: 1895–2005*. Venezia: Papiro Arte, 2005.

Garneau, David. "Imaginary Spaces of Conciliation and Reconciliation: Art, Curation and Healing," *West Coast Line* 28 (Summer 2012): 28–38.

The Kino-nda-niimi Collective. *The Winter We Danced*. Winnipeg: ARP Books, 2014.

Kulchyski, Peter. *Aboriginal Rights Are Not Human Rights: In Defence of Indigenous Struggles*. Winnipeg: ARP Books, 2013.

Martin, Lee-Ann. "The Waters of Venice: Rebecca Belmore at the 51st Biennale." *Canadian Art* 22, no. 2 (2005): 48–53.

Nanibush, Wanda. "An Interview with Rebecca Belmore" *Decolonization: Indigeneity, Education & Society* 3, no. 1 (2014): 213–17.

– "Love and Other Resistances: Responding to Kanehsatà:ke through Artistic Practice." In *This Is an Honour Song: Twenty Years*

since the Blockades, edited by Leanne Simpson and Kiera L. Ladner, 165–74. Winnipeg: Arbeiter Ring Publishing, 2010.

Rickard, Jolene. "Rebecca Belmore: Performing Power." In *Rebecca Belmore: Fountain*, 1–5. Venice Biennale Catalogue, 2005.

Royal Mounted Canadian Police (RCMP). *Missing and Murdered Aboriginal Women: A National Operational Overview*. 2013. http://www.rcmp-grc.gc.ca/en/missing-and-murdered-aboriginal-women-national-operational-overview.

Simpson, Audra. *Mohawk Interruptus: Political Life Across the Borders of Settler States*. Durham: Duke University Press, 2014.

turions, cheyanne. "A Table for Negotiation, Mediation, Discussion, Difference." *Curatorial Research Blog*, March 24, 2014. https://cheyanneturions.wordpress.com/2014/03/21/a-table-for-negotiation-mediation-discussion-difference/.

Walker, Ellyn. "Identity as Contingency: Exploring Positionality in Meryl McMaster's In-Between Worlds." *BlackFlash Magazine* (August 2015): 26–31.

– "Rebecca Belmore: 1187." *Carbon Paper* 3 (Fall 2014): 16.

– "Representing the Self through Ancestry: Meryl McMaster's *Ancestral* Portraits." *Reconstruction Journal* 15, no. 1 (2015): 13–17.

Desirous Kinds of Indigenous Futurity: On the Possibilities of Memorialization

Tanya Lukin Linklater

It is from a place of incomplete engagement, a place that prioritizes the poetic over the prescriptive, and a place of marginality as radical possibility, that I write my encounter with the works of filmmaker Lisa Jackson, artist Peter Morin, and the collaborative artistic team of Peter Morin, Ayumi Goto, and Leah Decter. Their videos and performances investigate the bodies of Indigenous women and children in relation to systems and histories that disrupt settler colonialism through embodiment on the land (where Indigenous ways of knowing are found), and reckon with decolonization while enacting a radical reconciliation.[1] I assert my own partial awareness, my limited understanding in relation to what Métis artist and writer David Garneau contextualizes as a colonial attitude that is acted within academia and "characterized by a drive to see, to traverse, to know, to translate (to make equivalent), to own, and to exploit."[2] This drive is "based on the belief that everything should be accessible, is ultimately comprehensible, and a potential commodity or resource, or at least something that can be recorded or otherwise saved."[3] Garneau further asserts that "Primary sites of resistance … [are] the perpetual, active, refusal of complete engagement."[4] This is a significant strategy that asserts sovereign spaces for Indigenous peoples and communities and refuses to centre whiteness, a colonial desire to consume Indigenous pain, or a demand for reconciliation. Instead, Garneau speaks to sovereign spaces that place our experiences within a context of ethical concern for our peoples and communities at the centre and the choice of when and how to engage beyond this resistance.

I begin with an understanding borrowed from Roger I. Simon that "practices of remembrance understood as specific ways of enacting public history, while obviously concerned with the past, always contain implications for what is yet to come."[5] Certainly, a desire for social justice frames these works. I witness or share a hope embedded in the work for real, on-the-ground change – change that emphasizes a futurity that will create better conditions for Indigenous communities, children, and peoples. This future orientation will include the re-emergence of Indigenous knowledges and epistemologies through repatriation of our lands and re-centring of our cultural selves. Futurity can be seen, as Claire Bishop has argued, through social practices that will a kind of intended outcome of social change.[6] The works that I discuss here certainly embody this will for social change oriented towards the future, but with a

recognition that "Colonialism is not a singular historical event but an ongoing legacy – the colonizer has not left."[7]

This essay begins with a brief discussion of the legacy of Indian residential schools and the formation of the Truth and Reconciliation Commission of Canada. I draw on the work of scholars, Elders, artists, and community leaders equally that align with Indigenous feminist perspectives on land, sovereignty, futurity, and decolonization. The inclusion of many voices in this section of the essay is important as I want to be clear that these ideas are shared. I also draw on the work of Eve Tuck and C. Ree, who call for desire as an antidote to damage narratives told about Indigenous peoples. This call for desire asks me as the writer to thoughtfully consider artistic works that engage with these histories in ways that do not re-victimize Indigenous viewers but are implicated ethically in relation to these difficult histories and are grappling with our current circumstances. Tuck and Ree's call helps me to decide what to include in this essay as I look and listen – for films, sculptures, and performances that speak to me through their care and courage. This looking and listening, in conversation with artists and experiencing their works through documentation and online viewing, frame my discussion of Lisa Jackson's short film, *Savage*, followed by a description of Peter Morin's investigation of the legacy of Indian residential schools in his body-based performance and sculpture practices. In my analysis of *Savage* and Morin's practice, I place these works within specific histories of real and felt consequences for Indigenous peoples. The essay ends with a discussion of the work, *Performing Canada*, a collaboration between Leah Decter, Ayumi Goto, and Peter Morin. The conclusion of the essay is a collaborative text written by Decter, Goto, and Morin that addresses their approaches toward and experiences of radical reconciliation in the project *Performing Canada* as a way to ask how artists are ethically engaging with the legacy of Indian residential schools. The work is a body-based, collaborative performance that memorializes as well as enacts the complexities of what the artists call radical reconciliation. This collaborative text is a kind of potentiality and a call for further conversation.

Reconciliation and Settler Colonialism

Alex Janvier (Dene Suline and Saulteux) reflects on his experiences as an Indian residential school survivor and artist, recognizing in his encounters with peoples internationally that "they've been victimized, sometime, somewhere along their history and they're survivors and I said, 'Oh other peoples who have survived the crush of another body of minds.'"[8] Janvier's recognition of surviving the "crush of another body of minds" aligns with educational theorist Marie Battiste's (Mi'kmaw) discussion of continued cognitive imperialism in the public education system, which was most overtly pronounced in the Indian residential school system. She writes, "Cognitive imperialism relies on colonial dominance as a foundation of thought, language, values, and frames of reference ... As a result of cognitive imperialism in education, cultural minorities

in Canada have been led to believe that their poverty and powerlessness are the result of their cultural and racial origins rather than the power relations that create inequality in a capitalist economy."[9] We live with the legacy of Indian residential schools and the intergenerational trauma that was systemized and orchestrated by the Indian residential school system – including cognitive imperialism – that has been, in many cases, internalized by survivors and subsequent generations of Indigenous families and communities, to the detriment of Indigenous peoples' well-being in Canada. The legacy of Indian residential schools is embodied in real, lived ways in the everyday-ness of Indigenous peoples' experiences within their families and communities.[10]

However, I am cautioned when considering narratives of the Indian residential school survivors. Thousands of survivors' narratives have been documented by the Truth and Reconciliation Commission in statement-gathering events in hundreds of local and seven national hearings across Canada. Scholar Melanie Laing explains that "truth and reconciliation commissions are established after mass violence or atrocity plagues a society and the traditional legal system is either unwilling or unable to deliver justice in any complete sort of way."[11] *Honouring the Truth, Reconciling for the Future: Summary of the Final Report of the Truth and Reconciliation Commission of Canada*[12] outlines that the Commission's mandate[13] includes truth-sharing for survivors to speak about "violations of life and dignity," or trauma, that was enacted by governmental legislation, churches, and society at large in the Indian residential schools.[14] Participating in truth-sharing through public testimony may be one way in which survivors heal from the traumas inflicted at residential school. Healing is specific to individuals, families, and communities; it takes time, and includes diverse processes. Often, survivors reclaim cultural or ceremonial processes to support their healing. This action of reclaiming Indigenous cultural processes, which are often land-based, may have the effects of reversing cognitive imperialism by centring survivors' cultural selves in relation to families, land, and community.

Education scholar Rebecca Sockbeson (Waponahki) problematizes truth-sharing as a means of reconciliation, asserting that "For too long the responsibility has been on the survivors telling their stories" within the reconciliation process.[15] She argues that because the violence the Indian residential schools enacted was systemic and structured, it is not the responsibility of individuals to right these violences. Rather, it is the role of governments and educational institutions to initiate systemic change.[16]

Further, these narratives of violence and dispossession may be appropriated for the colonizers' gain, as bell hooks asserts: "No need to hear your voice when I can talk about you better than you can speak about yourself. No need to hear your voice. Only tell me about your pain. I want to know your story. And then I will tell it back to you in a new way. Tell it back to you in such a way that it has become mine, my own. Rewriting you I write myself anew. I am still author, authority. I am still colonizer the speaking subject and you are now at the center of my talk."[17] By holding on to the dominant frame, colonizers are able to use the pain of the colonized to assuage their sense of self while incorporating colonized subjectivity. Scholars Eve Tuck (Unangan)

and C. Ree build on hooks's analysis by investigating the relationship of damage narratives to Indigenous histories as a kind of containment and positing desire as a means to refuse this containment. They write,

> I am invited to speak, but only when I speak my pain ... Instead I speak of desire. Desire is a refusal to trade in damage; desire is an antidote, a medicine to damage narratives ... It is a recognition of suffering, the costs of settler colonialism and capitalism, and how we still thrive in the face of loss anyway; the parts of us that won't be destroyed. When I write or speak about desire, I am trying to get out from underneath the ways that my communities and I are always depicted ... Desire is what we know about ourselves, and damage is what is attributed to us by those who wish to contain us. Desire is complex and complicated. Desire, in its making and remaking, bounds out into the past as it stretches into the future. It is productive, it makes itself, and in making itself, it makes reality.[18]

Through the concept of desire, Tuck and Ree emphasize futurity. Damage narratives are detrimental to Indigenous peoples, lands, and communities when they frame, tell and re-tell Indigenous experiences as only historical (vanishing) and always already oppressed, containing their pain and sublimating their desire. Tuck more fully investigates the notion of futurity in collaboration with scholars Maile Arvin (Native Hawaiian) and Angie Morrill (Modoc) in their description of the "intellectual and political contributions of [Native feminist theories'] activism and scholarship,"[19] including the concepts of "land, sovereignty, and futurity and decolonization" central to Native feminist theories, and to my engagement with the works of Jackson, Morin, Decter, and Goto.[20]

Arvin, Tuck, and Morrill explain that "land is knowing and knowledge,"[21] which echoes cultural teacher John Crier's (Plains Cree) assertion, "I want my land back. I don't want to be homeless in my home. The land actually grew us. We are from the land. When we talk about the knowledge, epistemology, we need that land for the people. The land contains many memories of our ancestors, not just the reserves."[22] Former National Chief Ovide Mercredi (Cree) elaborates on this idea when he asserts that even worse than the Indian residential school system and its ongoing legacy is "the dispossession of land and displacement of people,"[23] which Native feminist theorists name settler colonialism. Arvin, Tuck, and Morrill define settler colonialism as "a persistent social and political formation in which newcomers/colonizers/settlers come to a place, claim it as their own, and do whatever it takes to disappear the Indigenous peoples that are there."[24] "Settler colonialism and patriarchy are structures, not events" and are "not contained in a period of time."[25]

Native feminist theories also address sovereignty as central to Indigenous futurity. Garneau describes the anaesthetization of sovereignty within reconciliation,[26] emphasizing that the Indian residential schools were part of a larger colonial project to

remove Indigenous peoples from their lands.[27] According to Garneau, in the concil-
iatory framework, Indigenous pre-contact sovereignty is erased, privileging the set-
tler colonial relationship to land as property in the nation-state. Tuck and Yang assert
that "decolonization in the settler colonial context must involve the repatriation of
land simultaneous to the recognition of how land and relations to land have always
already been differently understood and enacted."[28]

These critical conversations lead me to consider the ways in which land functions
in the work of Jackson, Morin, Goto, and Decter. These artists' recognition of the re-
moval of Indigenous peoples from the land may disrupt the settler colonial relation-
ship to land. Their embodied actions on the land orient their works to Native feminist
theories of futurity. I am compelled by Indigenous and non-Indigenous bodies' rela-
tionships to land, structures, and objects in these works. The artists' strategies for sit-
uating their work in relation to reconciliation raises questions for me regarding the
possibilities and limitations found within the idea of reconciliation. I am also deeply
moved by these works that I experience through my computer – I can view *Savage*
and documentation of the Morin performance online. I experience *Performing Canada*
by Decter, Goto, and Morin only in a few photos of a canoe dressed in red ripped
cloth on an icy riverbank, or in snapshots of bodies in sand, and in the stories told to
me by the artists about the project, but mostly I experience *Performing Canada* in my
mind. As Coast Salish Elder, Florence James explains, "knowledge is limited, to know
something is limited, but the imagination is powerful. To process and create using our
own imagination – it is huge, limitless."[29]

Savage

Lisa Jackson's *Savage* was commissioned in 2009 for the imagineNATIVE Film Festival's
Embargo Collective project, and is described by the filmmaker as a residential school
musical.[30] Seven international Indigenous filmmakers were challenged to make a short
film within certain parameters: the theme of the project was patience, and no English
was allowed.[31] The film that resulted relies on visual imagery, the body, and music to
drive an unresolved narrative. *Savage* was brought to my attention by Glen Lowry, a
professor at Emily Carr who visited northern Ontario for a talk about his co-edited col-
lection, *Speaking My Truth*. During his visit, he told me about *Savage*, describing its
peculiar imagery, as he'd seen it installed in the exhibition, *Witnesses: Art and Canada's
Indian Residential Schools*, curated by a team including Geoffrey Carr, Dana Claxton
(Lakota), Tarah Hogue (Métis), Shelley Rosenblum, Charlotte Townsend-Gault, Keith
Wallace, and Scott Watson at the request of Chief Robert Joseph for the Morris and
Helen Belkin Art Gallery at the University of British Columbia. The exhibition coin-
cided with the Truth and Reconciliation Commission's national event in Vancouver in
September 2013. His description led me to seek out the six-minute video that tells of
a mother's loss and a child's transformation. The video parallels truth-telling and wit-
nessing in the TRC's hearings, yet there's a profound silence in the video – no one speaks.

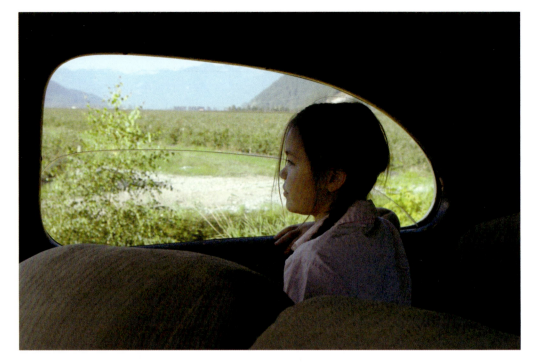

7.1 Lisa Jackson, still from *Savage*, 2009.

The mother character communicates through song with lyrics in Cree language (accompanied by English subtitles). The girl communicates through her body to land, objects, and structures.

The film opens with a car traversing mountains at dawn, passing through evergreen trees and bush interrupted by out-of-focus agricultural land. We see a child, a healthy, braided girl in the back seat. She looks out the window, riding across a beautifully shot landscape, her eyes transfixed by the sun. She appears to be unafraid in the car driven by an out-of-focus man, his hand on the steering wheel. This is the first movement: to consider the relationship of the girl's body to object, to car, and to the land she sees while moving across it. This first sequence references the ongoing removal of Indigenous peoples from their lands through the Indian residential schools and other government actions.

When the girl arrives, we see a hand open the door, and a presumably female figure walks the girl away from the car. In the next close-up shot, the girl is undressed, washed in a bathtub, and her hair is cut – again by disembodied hands. We never see the face of the perpetrators responsible for her removal from her family, her community, and her homelands. The individuals who perpetrate these acts in Jackson's short video are not as important as the structures that the individuals enact and embody, and which the children come to embody.

In the next shot, the girl stands with short hair, in a uniform, facing the camera, at the bottom of stairs. The camera and the viewer's eye are focused on the relationship of the girl's body to a classroom and the objects inside of the classroom – desk, paper, pencil, scratchy uniforms. Her body has been transformed most obviously by the face-

less, nameless hands cutting her long braids. But her body is transformed beyond that. She becomes, alongside the rest of the children in her classroom, white-faced with sunken eyes, appearing apparition-like. From healthy braided girl to an erasure of her individual identity within a classroom of identically uniformed, pale children, she scrapes numbers and letters into paper.

In my encounter with the short video, I come to see that the girl and her classmates resemble what appear to be zombies. Zombies are infected by an imaginary, fictitious virus that forces them to consume human beings, effectively eradicating the human race. In a sense, we can consider that the child zombies in *Savage* have been infected by and are embodying colonization within the context of the Indian residential school system where the goal was to eradicate Indigenous peoples. In this way, we may also consider the zombies' function within *Savage* as a way for the viewer to recognize the bodies of Indigenous children "infected" by cognitive imperialism or colonization. Colonization has very real impacts on the physical bodies of Indigenous peoples but lasting impacts are also invisible and exist within the minds of survivors of trauma.

The idea of zombies is reinforced when the teacher exits the classroom, and the children begin a stilted, awkward, yet nonetheless identifiable dance that reminds me of

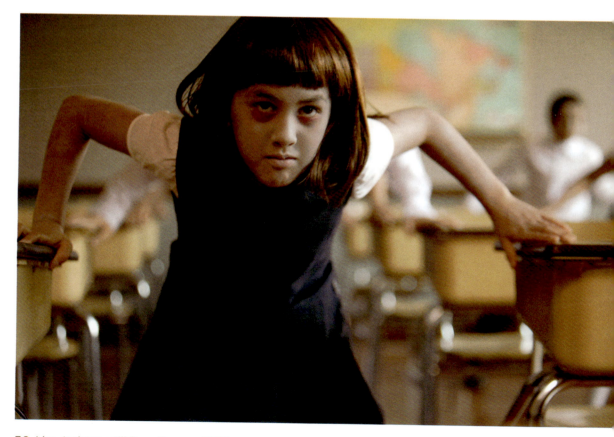

7.2 Lisa Jackson, still from *Savage*, 2009.

Michael Jackson's *Thriller*. This made me consider how dance functions in *Thriller* and in *Savage*. In *Thriller* dance is a form of chasing, as Michael Jackson's monstrous zombie character chases his co-star with a pack of zombie dancers moving in unison, initially waking from the dead in the cemetery, circling the couple until Jackson turns on her and leads the chase. The children in *Savage* dance in lines, in relation to the desks. They are constrained by the boundaries of the lines of the desks and their bodies cannot leave those structures. Yet their dance subverts a colonial history as the children's bodies act out in unexpected ways – they are not only victims of abuse but express a kind of kinesthetic agency even in the midst of the colonial structure that acts upon their bodies. The dance that the children assert within the residential school setting creates a physical agency that subverts the colonial damage narrative of Indigenous peoples as always already oppressed. This liberatory agency could be described as the hope for cognitive justice and uncontainable desire. Marlene Brant Castellano (Mohawk) tells us that "Interwoven with collective memories of painful events are shared stories of resistance and survival that demonstrate resilience, the human capacity to achieve a good life outcome in the face of adversity."[32] While the film is left unresolved, we are left with the possibility of hope for the girl and for all the children.

A parallel narrative occurs simultaneously within the film. This is the story of a mother's grief expressed in lullaby, in the domestic space of a 1940s or 1950s kitchen. Portrayed by Skeena Reece, I notice the use of Cree language within song to structure grief. As a viewer, we don't know if the mother is a residential school survivor, if this is the first generation from her family to be taken to residential school, or if she is the girl in the parallel narrative of the film. In this way, *Savage* is a humanizing, intimate testimony of historical grief and the intergenerational impacts of residential school – while the daughter is transformed, the mother is as well.

Jackson's examination of the experience of Indigenous women as mothers during the residential school era and her engagement with grief through Indigenous song, within home and community, rather than at a TRC public event with hundreds or thousands of survivors and witnesses, offers a different kind of witnessing for the viewer. This is a witnessing that is structured by family, community, and Indigenous ways of grieving. Jackson tells a specific story, rather than a totalizing story of abuse. She tells a story of a woman turning to her song as a way to find comfort and strength in the midst of grief. This specificity humanizes the Indigenous woman as we feel compassion for her. This humanizing of Indigenous women and motherhood is an incredibly potent strategy on the part of Jackson, as Indigenous women in Canada are often vilified within the media as negligent, and generations of Indigenous peoples have been labelled as incapable of parenting due to the legacy of Indian residential schools.[33] When a perception of Indigenous women on the whole takes hold *that we are not good mothers, that we are incapable of mothering, or make poor mothering choices*, this belief can be devastating. Cindy Blackstock (Gitxsan), attorney and advocate for First Nations children in care, explains "that First Nations children were drastically overrepresented in the child welfare system at every point of intervention despite the fact that they were not overly represented for reports of sexual abuse,

7.3 Peter Morin, *lost moccasin tongues*, 2009. Hand-printed moccasins on the wall. The artist worked with high school students to re-make/re-dream the moccasins that were never made for the children forced to go to residential school. In part two of the performance, the wall was washed with English linen.

physical abuse, emotional abuse, and exposure to domestic violence ... The only type of child maltreatment for which First Nations are overrepresented is neglect, fuelled by poverty, poor housing, and caregiver substance misuse."[34] Blackstock asserts that the overrepresentation of First Nations children in the child welfare system is attributed to structural issues of underfunding in First Nations communities and the intergenerational impacts of the Indian residential schools. What has occurred en masse is a child welfare system that removes First Nations children from their families in Canada in continuously growing numbers.

Peter Morin and Reconsidering Reconciliation

Tahltan artist Peter Morin has engaged with the history of Indian residential schools and reconciliation in projects over several years.[35] The catalyst for his arts research and practice is his work with Indigenous children in the child welfare system. He explains, "They are removed from their home communities. There is the violence of removal, or the violence before in the home. They are put into a white person's house with no information about their community and no reflection of their life or lives. I was thinking and saying, '*The foster care system continues to be the residential school*' and I was taken aside by my boss – '*you're not allowed to say that*.'"[36] This context of working with Indigenous children in the child welfare system propelled Morin's investigation of the histories of Indian residential schools, including his family's experience:

7.4 Peter Morin, *the picking up the pieces drums*, installed with hair drawings, 2013.

"I needed to understand it better – their situation which was informed by the residential school, my situation informed by the residential school and day school, so that I could tell them my truth about it. I wanted to be able to speak to our kids about it with deep meaning, resonance. I needed to know so that I could tell these kids and maybe this situation, that this residential school situation, would never happen again."[37] The investigation broadened as Morin "entered into a body dialogue with this history."[38] Morin told me stories about his practice and investigation of reconciliation, and in this telling, he opened a space between us. Through his telling I was brought into an understanding of his process and his deep commitment to Indigenous children, youth, and communities. He told me, "The performances are so fraught with edges; the dialogue is fraught with edges, but it's people like you and me who need to be negotiating those edges and reflecting that learning back to our communities."[39] I also began to understand that Morin uses a methodology that I describe as engaging with cognitive justice through the body. His practice is an intimate investigation of materials and objects in relation to the body, in relation to story, and in relation to the land.

As an invited artist to the *Reconsidering Reconciliation* residency and exhibition at Thompson Rivers University in 2013, Morin, over several days, drew what he imagined to be the hair of the children who attended residential school in a meditative, repetitive drawing practice. He drew for at least an hour each day, repeating the physical action of the drawing of each strand of hair. He drew the hair that was cut in residential school, the hair that was cast away once it was shorn. I imagine the physical

action of the drawing, and the physical memory of the hair for the children who lost it. There is a strong kinesthetic relationship between Morin's drawing, storying performance, and sculptural practice in this project.

Morin also built five drums during the residency, from pieces of hide that he sewed together and stretched across circular wooden frames. Typically, a drum is constructed from one seamless piece of hide stretched across a wooden frame. Morin chose instead to sew pieces of hide together, to exhibit the seams. The drums were then installed on the gallery wall in front of the hair drawings, eliciting a connection between the past and present. He describes the drums as "made up of two different parts of two different animals – some have elk and deer, or deer hides from three different deer – they are called *the picking up the pieces drums* … what happens after residential school? We pick up the pieces, we carry on."[40] He also describes *the picking up the pieces drums* as "portals" to communicate across time and space.[41] This project was a part of a larger ongoing body-based engagement with the history of residential schools. He developed a series of performances, with and without audiences, to investigate these histories, alone and in collaboration with other artists.

In 2015 Morin performed at Queen's University in response to the two hundredth birthday of Canada's first prime minister, John A. MacDonald, who "authorized the creation of Indian Residential Schools in the west" in 1883.[42] For this performance, Morin constructed a copper sculptural object: a radio antenna to transmit truth to his ancestors. In this intimate performance, curator Erin Sutherland (Métis) describes Morin telling his truth quietly to the copper pipe antenna, so that only the ancestors hear his words.[43] Morin's performances are complex in that he offers space for Indigenous peoples to tell their truths to the ancestors through portals across time and space, which builds on Indigenous epistemologies, but he also facilitates spaces for settler Canadians to engage with the history of Indian residential schools.

During the 2013 performance at the Reconsidering Reconciliation residency, Morin asked Indigenous and non-Indigenous artists to sing, speak, or make sound to the drums that he explained were portals for communication, while he performed Martin Luther King Jr's "I Have a Dream" speech into a drum. The residue of the performance included the installation of the drums that held the resonance of song and the reverberations of Peter's voice/MLK's words calling for equality, as well as the video documentation of the performance archived on the course website. In this instance, Morin frames reconciliation as a social justice project emphasizing the US Civil rights movement, which saw black and white allies demonstrating against segregation, for black voting rights, and to end the social, political, and economic inequalities of racial oppression through non-violent protest. While Morin's invocation of civil rights may be criticized by Native feminist theorists who assert that "Indigenous communities' concerns are often not about achieving formal equality or civil rights within a nation-state, but instead achieving substantial independence from a Western nation-state,"[44] Morin is calling for settler Canadians to take collective responsibility for the shared legacy of Indian residential schools and to engage with these histories for a fair and just future.

Reconciliation, in these performances, is defined by Morin as engaging with history through the body: "reconciliation is about the body – how and who and when and what this body can do and how colonization has done everything in its power to limit the physical, spiritual, creative agency of our bodies. Nation to nation dialogue – how do we enable and support the agency and knowledge of bodies and knowledge systems – that's real."[45] He utilizes Indigenous frameworks of storytelling, drawing practice, and sculptural processes, including drum-making, to engage with land-based Indigenous epistemologies that he embodies in performance. He speaks of ancestors, of a continuum of time into the past and future. Morin feels a deep responsibility to children and youth and to Indigenous futurity, and these commitments guide his work.

Performing Canada

In 2014, Peter Morin, Leah Decter, and Ayumi Goto collaborated on a work called *Performing Canada*. While the performance was durational, took place over seasons, and included the trio travelling together across great distances, I want to bring attention to the beginnings of the performance, including the sites of the Red River, the section performed at Art Gallery of Algoma University, which was formerly a residential school, and the Shingwauk Residential Schools Centre.

In Shingwauk, the performance involved nearly three thousand handmade paper canoes. Some of the paper canoes were released into the water near the former residential school as a poetic gesture for Indigenous children who never returned home. This gesture with the river and handmade canoes implicates the artists' bodies in the

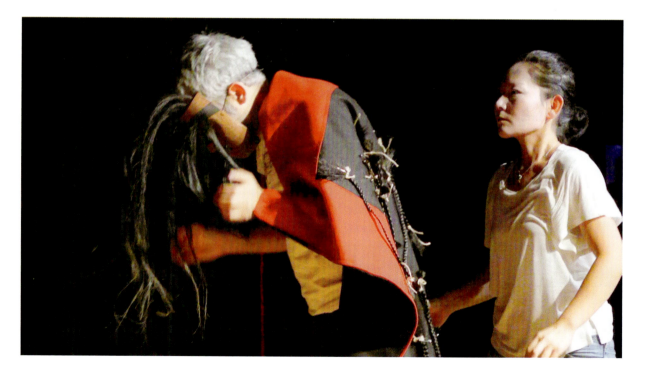

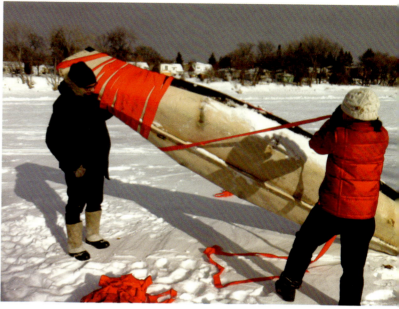

7.6 & 7.7 Leah Decter, Ayumi Goto, and Peter Morin, *Performing Canada*, 2014.

Opposite
7.5 Peter Morin, *This is what happens when we perform the memory of the land*, 2013. Regalia made by the artist to refer to the residential schools. In the performance, Peter Morin and Ayumi Goto became ancestors witnessing the truth of residential school survivors.

history of residential schools and ritualizes a memorializing of the children. The act of releasing one thousand handmade paper canoes into the river on the sites of Algoma University and the Shingwauk Residential Schools Centre made me consider the waterways of Canada, waterways that Indigenous peoples knew and understood deeply as they travelled for trade, to make fish camp, and to arrive at hunting grounds. But the waterways and the image of the canoe, present in the first iteration of the collaborative performance, are also deeply embedded in a collective idea of the formation of the Canadian nation-state. The canoe allowed fur trappers and traders to traverse the land with the express intent of removing resources and later, the dispossession of land from Indigenous peoples.

In Manitoba, the performance was photographically documented as a single canoe lying on the frozen Red River, with red strips of cloth wrapped around it. The stark image of the canoe in winter when the water is immobile at the surface renders the canoe static. Yet the ritual wrapping of the canoe in red cloth points to its significance as an object in relation to the transformation of land into the nation-state through exploration, land claims, and the enactment of property to the detriment of Indigenous life and ways of being on the land. Because of its proximity to the Red River, the image also brings to mind the murder of Tina Fontaine, a fifteen-year-old Indigenous girl in the child welfare system in Winnipeg whose body was found in the river in August

2014 in a condition that can only be described as the result of an apparent homicide that included sexual violence. Within months of Fontaine's murder, Rinelle Harper, a sixteen-year-old Indigenous girl living in Winnipeg, was assaulted by two men and left for dead in the Assiniboine River in November 2014. She crawled out of the frigid water only to be assaulted again. Rinelle Harper's survival of sexual violence and aggravated assault coupled with Fontaine's death months apart in Winnipeg reignited continued calls for a national inquiry into missing and murdered Indigenous women in Canada – estimated by the RCMP at well over one thousand Indigenous women between 1980 and 2012.[46] The histories of displacement of peoples, dispossession of land, and continued violence against Indigenous women and children are connected in my reading of the photographic image.

Performing Canada speaks to the nation-state itself as a performance. The performativity of the nation-state allows the space for us to understand that it is not natural or fixed but is a process of continual (dis)investment. Indeed, the performativity of the Canadian nation-state allows us to recognize that other sovereignties exist within its borders. The artists further disrupt the nation-state by considering deeply the relationship of their bodies – as Indigenous peoples and settler Canadians – to the land, as they traverse the nation-state and memorialize the children who did not survive residential school. This memorialization is a form of decolonization as it "involves an interruption of the settler colonial nation-state, and of settler relations to land."[47]

The action of memorializing necessitates bodies in relation to the land, in a specific time. Monuments are built and installed on the land as a physical marker of the nation-state's dominant narrative of settler colonialism. But Decter, Goto, and Morin embody and enact memorialization that interrupts the settler colonial nation-state because their action doesn't allow the nation-state to forget the history of removal and genocide. Their performance acts as a gentle remembering of the lives lost while expressing the desire to make a Canada that no longer denies its history but recognizes settler colonialism and the resilience of Indigenous peoples. In this way, *Performing Canada* is a form of radical reconciliation that is "beyond nationhood."

beyond nationhood: a collaborative text by Leah Decter, Ayumi Goto, and Peter Morin (2015)

performing canada brought our individual practices, lineages, and ontologies into a state of potent inter/change. how to carry, honour, and disperse burdens, to activate embodied re-membering and at the same time, release grief to reverberate into the past, the now and the futures not yet envisioned? how to inter/act as historicized bodies in ways that drive new meaning, values, actions, relations; resist binaries, questioning positionalities? how that third perspective – whoever might take that turn – could somehow cleave the multiply imposed binary between settler and Indigenous, a binary that has come to oversimplify considerations of past, current, and future socio-political relations on this land. collective history and this thing called canada need to be negotiated, dissected; subtleties seen and acknowledged.

this collaboration began as a conversation, an opening into risk and trust. it grew into an immersion, in process and in transit. contemplating how we per-form, and how we might de-form canada, in order to re-envision what this land and relations on and to it might be. the earliest conversations reflected on the body of the canoe being much like the body of a bird, motivation by migrations or desire

three in the car
the canoe lashed to the top
hovering over
we name the resultant wind resistance as canoe singing
we can't escape it
the breath is present
body is present

embodied memory inherent in muscle and bone, skin and hair, the place where land meets body. carrying our ancestors in traversing the land.

my body is in relationship to ancestors in relationship to the land in relationship to global ancestors in relationship to global land. this research intention/research path/research journey leads to much deeper investigations of ancestry/our respective ancestors' ability to collaborate/the contributions of our ancestors to canada/the unnamed and unacknowledgment of canada towards the linages that thread our acts.

new pathways into the internal landscape of my body
these new pathways are new canoe routes
inside my body feels like a northern river
the body is alive with knowledge
there are no replacements required

three bodies shadowed by a fourth; an icon, an appropriation, a foundational con-
veyance itself now conveyed, inverted, not worthy of its intent. repurposed to en-
able in(tro)spection, rehearsal, performance, enaction, doing, making and being.
multiplied by the thousands in the complexity of ornate pattern, correspondence
imprinted with sustenance, and the plain brown wrapping of utility. the training of
muscle memory in the repetition of each other's making and doing and being. multi-
ple transgressions of with/against, away/towards, yes/no thinking are coextensive
with the proliferation of possible and enacted actions that surpass one's solitary
imagination. in the daily tedium of driving together, eating together, shopping to-
gether, folding 2,900 paper canoes together, trying to find a place to break together,
sleeping within a few feet of each other, performing together. performance that vi-
brates through our pores, into the air, whirls down our legs, into the ground,
through the water, rippling into distant spaces, to attach sonorously and kinetically
the here and there. and surrounded in the timelessness of falling in love with
the land.

because of our bodies together, the land feels different, invites us as a whole,
some kind of post-individual reconfiguration of energies performing canada, and
petayulea, this moniker, a recombination of our individual names, histories, cultural
affiliations, a sing-song performance of the estrangement from our respective senses
of a priori definitive selves. land views the three entities as a different kind of pres-
ence, necessitates at critical moments to take a few steps away in order to reflect,
only to return to witness all that has transformed, ever motile, and then ready
to start again. coming to know is a long-simmering relationship with the shape-
shifting nature of the self, others, the amalgamation of histories that are re-storied
and revised in terms of respect, creative actions, the overwhelming possibilities
of new intimacies and engagements.

embodied, responsive and un/determined, this stretches through and beyond worlds
of contemporary art and theoretical conjecture; past performative gesture and acts
of reconciliation. opened ritual, culture and history to ... the body is present in all
of our performance research/knowledge production.

we can't escape it

NOTES

1 Eve Tuck and K. Wayne Yang assert that
"Reconciliation is about rescuing settler
normalcy, about rescuing a settler future.
Reconciliation is concerned with ques-
tions of what will decolonization look
like? What will happen after abolition?
What will be the consequences of decolo-
nization for the settler? ... We want to
say, first, that decolonization is not ac-
countable to settlers, or settler futurity.
Decolonization is accountable to Indige-
nous sovereignty and futurity." "Decolo-
nization Is Not a Metaphor," 35. Tuck
and Yang assert that decolonization
centralizes the concerns of Indigenous

peoples over the settler concerns found within reconciliation. However, Morin, Goto, and Decter framed their performance collaboration as "radical reconciliation" in an interview conducted with the author on 14 December 2015.

2 Garneau, "Imaginary Spaces," 29.

3 Ibid.

4 Garneau explains incomplete engagement is "to speak with one's own in one's own way; to refuse translation and full explanations; to create trade goods that imitate core culture without violating it; to not be the Native informant." Ibid.

5 Simon, "The Terrible Gift," 188.

6 Bishop, "The Social Turn," 68.

7 Garneau, "Imaginary Spaces," 38.

8 Janvier quoted in Dewar, "Alex Janvier," 17.

9 Battiste, *Decolonizing Education*, 161.

10 As Battiste asserts, "Past and present education systems that have attempted to forcibly assimilate Indigenous peoples to colonial modes have generated new, multi-generational oppression and traumas ... Evidence of the effects of forced education of Indigenous peoples in residential schools and other institutions are well known to be a substantial contributor to the current high level of suicide, substance abuse, incarcerations, children in care, and family violence." *Decolonizing Education*, 136.

11 Laing, "An Analysis of Canada's Indian Residential Schools Truth and Reconciliation Commission," 5.

12 The Truth and Reconciliation Commission of Canada (TRC) was established in June 2008, the same month as the federal government's apology to Aboriginal peoples for its part in the Indian residential schools system. The TRC and apology were the result of more than two decades of ongoing negotiations and government responses, including, as Henderson and Wakeham write in the introduction to *Reconciling Canada*, "the Royal Commission on Aboriginal Peoples; the establishment of the Aboriginal Healing Foundation; the development of the Alternative Dispute Resolution process; and the signing of the 2007 Indian Residential Schools Settlement Agreement" (4). The Truth and Reconciliation Commission of Canada's website, prior to the changes to the website with the TRC's closing, stated that its mandate was threefold: to "Tell Canadians what happened in the Indian Residential Schools; Create a permanent record of what happened in the Indian Residential Schools; Foster healing and reconciliation within Canada." While this document online no longer exists, it has been replaced with the Truth and Reconciliation Commission of Canada's more formal mandate document found here: http://www.trc.ca/websites/trcinstitution/File/pdfs/SCHEDULE_N_EN.pdf.

13 *Honouring the Truth, Reconciling for the Future* furthers that the TRC was mandated to "reveal to Canadians the complex truth about the history and the ongoing legacy of the church-run residential schools, in a manner that fully documents the individual and collective harms perpetrated against Aboriginal peoples, and honours the resilience and courage of former students, their families and communities" and to "guide and inspire a process of truth and healing, leading toward reconciliation within Aboriginal families, and between Aboriginal peoples and non-Aboriginal communities, churches, governments, and Canadians generally. The process was to work to renew relationships on a basis of inclusion, mutual understanding and respect" (27).

14 Castellano, "A Holistic Approach to Reconciliation," 392. Statements continued to be gathered from survivors and anyone who wanted to give a statement about the legacy of Indian residential schools until the closing of the Truth and Reconciliation Commission of Canada. In some cases testimony is shared in private interview sessions, but most often we think of TRC events featuring public testimony and witnessing. In *Honouring*

the Truth, Reconciling for the Future, the TRC notes that, as of 2015, it had gathered nearly 6,750 statements (29). As the National Centre for Truth and Reconciliation's website explains, the centre is continuing to take statements: "The NCTR will continue to invite former students, their family and others whose lives have been impacted by the schools to share their experiences in a safe and secure setting. Over time, we will also encourage community members to share their experiences of other policies of aggressive assimilation in Canada, encouraging dialogue on topics such as land claims, water, education, poverty, and missing and murdered Aboriginal women." The website also notes that statements can take any form, including "written, audio/video, poetry, art, music," and explains that the centre provides support during the process. See http://nctr.ca/about.php.

15 Sockbeson, "Indigenous Peoples Education Panel."

16 Ibid.

17 hooks, "Marginality as a Site of Resistance," 243.

18 Tuck and Ree, "A Glossary of Haunting," 647–8.

19 Arvin, Tuck, and Morrill, "Decolonizing Feminism," 18.

20 Ibid., 21.

21 Ibid.

22 Crier, "Living Reconciliation."

23 Mercredi, "Natural Resource Extraction."

24 Tuck, Arvin, and Morrill, "Decolonizing Feminism," 12.

25 Ibid., 13.

26 While there is sentiment among survivors, their families, and scholars that healing still needs to occur before communities focus on reconciliation, scholar Marlene Brant Castellano sees the benefits of survivors "taking steps to reconcile" as this action "reasserts agency, the capacity to act, and potentially make a difference in spite of uncertainty and risk." "A Holistic Approach to Reconcil-

iation," 396. Castellano defines reconciliation as "accepting one another following injurious acts or periods of conflict and developing mutual trust. Reconciliation involves perpetrators asking for and victims offering forgiveness, as they acknowledge and accept the past and recognize the humanity of one another." Ibid., 383. However, she cautions that "multiple violations of the human dignity of Aboriginal peoples over generations and their relative powerlessness in the face of public institutions have created distrust that public dialogue can bring about change." Ibid., 384. Castellano's cautious stance in 2008 is echoed by a growing critique of Canada's attempts at reconciliation.

27 Garneau states that "re-conciliation refers to the repair of a previously existing harmonious relationship. This word choice imposes the fiction that equanimity is the status quo between Aboriginal people and Canada. Initial conciliation was tragically disrupted and will be painfully restored through the current process. In this context, the imaginary word describes is limited to post-contact narratives. This construction anaesthetizes knowledge of the existence of pre-contact Aboriginal sovereignty. It narrates halcyon moments of co-operation before things went wrong as the seamless source of harmonious origin. And it sees the residential school era, for example, as an unfortunate deviation rather than just one aspect of the perpetual colonial struggle to contain and control Aboriginal people, territories, and resources." "Imaginary Spaces of Conciliation and Reconciliation," 35.

28 Tuck and Yang, "Decolonization Is Not a Metaphor," 7.

29 James, "The Land."

30 Jackson, *Savage*, video, 2009, http://lisajackson.ca/Savage.

31 Jackson, "Lisa Jackson," 43.

32 Castellano, "A Holistic Approach to Reconciliation," 388.

33 Certainly, families and communities were

and continue to be deeply impacted by this history and the intergenerational effects of Indian residential schools. The Summer Institute Nindibaajimomin – Digital Storytelling on the Inter-generational Experiences of Residential Schools at the Oral History Centre, University of Manitoba is an ongoing project to document and tell visual, poetic, intimate stories of the intergenerational effects of residential schools through the medium of digital storytelling. These stories will continue to be told and witnessed. See http://nindibaajimomin.com.

34 Blackstock, "Reconciliation Means Not Saying Sorry Twice," 167.

35 The Truth and Reconciliation Commission and Aboriginal Healing Foundation supported art projects that engaged with healing from the legacy of Indian Residential Schools and reconciliation. Dewar and Goto provide an overview of the relationship between art and reconciliation in "Reconcile This!," a special issue of West Coast Line, including the history of artist calls sent out by the TRC and a description of the projects and practices outlined in the special issue.

36 Morin, interview with the author, 4 December 2014.

37 Ibid.

38 Ibid.

39 Ibid.

40 Ibid.

41 Ibid.

42 Legacy of Hope Foundation, Hope and Healing.

43 Sutherland, conversation with the author, 26 April 2015.

44 Arvin, Tuck, and Morrill, "Decolonizing Feminism," 10.

45 Morin, interview with the author, 4 December 2014.

46 Amnesty International Canada, "Missing and Murdered Indigenous Women and Girls."

47 Tuck and Ree, "Decolonization Is Not a Metaphor," 647.

BIBLIOGRAPHY

Amnesty International Canada. "Missing and Murdered Indigenous Women and Girls: Understanding the Numbers." Human Rights Now: Amnesty Canada Blog. Accessed 24 November 2016. http://www.amnesty.ca/blog/missing-and-murdered-indigenous-women-and-girls-understanding-the-numbers.

Arvin, Maile, Eve Tuck, and Angie Morrill. "Decolonizing Feminism: Challenging Connections between Settler Colonialism and Heteropatriarchy." Feminist Formations 25, no. 1 (2013): 8–34.

Battiste, Marie. Decolonizing Education: Nourishing the Learning Spirit. Saskatoon: Purich Publishing, 2013.

Bishop, Claire. "The Social Turn: Collaboration and Its Discontents." In Right about Now: Art & Theory since the 1990s, edited by Rakier Schavemaker, 59–68. Amsterdam: Valiz Publishers, 2007.

Blackstock, Cindy. "Reconciliation Means Not Saying Sorry Twice: Lessons from Child Welfare in Canada." In From Truth to Reconciliation: Transforming the Legacy of Residential Schools, edited by Linda Archibald, Marlene Brant Castellano, and Mike DeGagné, 165–78. Ottawa: Aboriginal Healing Foundation, 2008. http://www.ahf.ca/downloads/from-truth-to-reconciliation-transforming-the-legacy-of-residential-schools.pdf.

Castellano, Marlene Brant. "A Holistic Approach to Reconciliation: Insights from Research of the Aboriginal Healing Foundation." In From Truth to Reconciliation: Transforming the Legacy of Residential Schools, edited by Linda Archibald, Marlene Brant Castellano, and Mike DeGagné, 383–97. Ottawa: Aboriginal Healing Foundation, 2008. http://www.ahf.ca/downloads/from-truth-to-reconciliation-transforming-the-legacy-of-residential-schools.pdf.

Crier, John. "Living Reconciliation: Ancient Foundations in Our Contemporary Indigenous Worlds." Presentation at Revisioning Reconciliation: Mobilizing Indigenous Epistemologies, University of Alberta, Edmonton, AB, 27 March 2015.

Decter, Leah, Ayumi Goto, and Peter Morin. Interview with author, 14 December 2014.

Dewar, Jonathan. "Alex Janvier: Reflections (Remarks and Interview)." In "Reconcile This!" Special issue, *West Coast Line* 74 (Summer 2012): 17–21.

Dewar, Jonathan, and Ayumi Goto. Introduction to "Reconcile This!" Special issue, *West Coast Line* 74 (Summer 2012): 4–11.

Garneau, David. "Imaginary Spaces of Conciliation and Reconciliation." In "Reconcile This!" Special issue, *West Coast Line* 74 (Summer 2012): 28–38.

Henderson, Jennifer, and Pauline Wakeham. Introduction to *Reconciling Canada: Critical Perspectives on the Culture of Redress*, edited by Jennifer Henderson and Pauline Wakeham, 3–27. Toronto: University of Toronto Press, 2013.

hooks, bell. "Marginality as a Site of Resistance." In *Out There: Marginalization and Contemporary Cultures*, edited by Russell Ferguson, Martha Gever, Trinh T. Minh-ha, and Cornel West, 241–3. Cambridge, MA: MIT Press, 1990.

Jackson, Lisa. "Lisa Jackson." In *Witnesses: Art and Canada's Indian Residential Schools*, edited by Scott Watson, Keith Wallace, and Jana Tryner, 43. Vancouver: Morris and Helen Belkin Art Gallery, 2013.

– *Savage*. Video, 2009. http://lisajackson.ca/Savage.

James, Florence. "The Land: Its Language, Its Sounds, and Its Stories." Presentation at Canada-Mexico Indigenous Roundtable, Vancouver Island University, Nanaimo, BC, 16 June 2015.

Laing, Melanie. "An Analysis of Canada's Indian Residential Schools Truth and Reconciliation Commission." *Undergraduate Transitional Justice Review* 4, no. 1 (2013): 34–50.

Legacy of Hope Foundation. *Hope and Healing: The Legacy of the Indian Residential School System*. Ottawa: Legacy of Hope Foundation, March 2014. http://staging.legacyofhope.ca/wp-content/uploads/2016/03/Hope-Healing-2014_web.pdf.

Mercredi, Ovide. "Natural Resource Extraction." Presentation at Canada–Mexico Indigenous Roundtable. Vancouver Island University, Nanaimo, BC, 15 June 2015.

Morin, Peter. Interview with author. 4 December 2014.

Simon, Roger I. "The Terrible Gift: Museums and the Possibility of Hope without Consolation." *Museum Management and Curatorship* 21 (2006): 187–204.

Sockbeson, Rebecca. "Indigenous Peoples Education Panel." Presentation at Revisioning Reconciliation: Mobilizing Indigenous Epistemologies, University of Alberta, Edmonton, AB, 27 March 2015.

Sutherland, Erin. Conversation with author. 26 April 2015.

Truth and Reconciliation Commission of Canada. *Honouring the Truth, Reconciling for the Future: Summary of the Final Report of the Truth and Reconciliation Commission of Canada*. 2015. http://www.trc.ca/websites/trcinstitution/File/2015/Findings/Exec_Summary_2015_05_31_web_0.pdf.

Tuck, Eve, and C. Ree. "A Glossary of Haunting." In *Handbook of Autoethnography*, edited by Holman Jones and Ellis Adams, 639–58. Walnut Creek, CA: Left Coast Press, 2013.

Tuck, Eve, and K. Wayne Yang. "Decolonization Is Not a Metaphor." *Decolonization: Indigeneity, Education & Society* 1, no. 1 (2012): 1–40.

"All That Is Canadian": Identity and Belonging in the Video and Performance Artwork of Camille Turner

Sheila Petty

8

In a globalized cultural milieu, it appears as if identity has become a concept that threatens to self-implode under the pressures of mobile peoples, ideas, and economic imperatives. Moreover, as ideas of identity, and racial identity in particular, oscillate between disintegrating borders and retrenched concepts of nation, they smack of outdated concerns. Yet to accept this proposition is to raise another, even more urgent question: If racial identity as a construct is a dead end, then what avenue replaces it? Moreover, how can we uncover the "critical perspectives" that "might nurture the ability and the desire to live with difference on an increasingly divided but also convergent planet?"[1]

Race has never simply been about bodies in the first place but is instead anchored in the more tangential, even ephemeral, intersections of race, gender, politics, economics, and the discourses of nationhood, and, as such, is socially constructed and ever-shifting, rather than static or transhistorical. For the peoples of the black diaspora, there have already been centuries of struggle to bring forward their voices, and over the course of its many complex histories, the black diaspora has generated a wide range of ideas concerning the interrelationship between race and identity. The black/African diaspora, and specifically the Black Atlantic, encompasses the world created by the post-Columbus African slave trade and by other population displacements among people of African descent. The black diaspora is often described as a space in movement between cultures, nations, races, origins, destinations, and journeys. Media and performance artists of the black diaspora exploit the interactivity of this space, with its histories of hybridizing global flows of black thought. Paul Gilroy, for example, argues that in the black diaspora, "the concept of space is itself transformed when it is seen less through outmoded notions of fixity and place and more in terms of the ex-centric communicative circuitry that has enabled dispersed populations to converse, interact and even synchronise."[2] Furthermore, narrative and aesthetic concepts, arising in Africa, have circulated through the hands of black diasporic theorists and artists, and redefined the ways in which black cultures and histories intersect in this globalized era.

The ways in which artists of the African diaspora account for, and engage "the multiplicity of the pathways and trajectories of change" inherent in global black histories, makes their work especially useful for exploding notions of fixity.[3] In particular,

performance genres of the black diaspora often draw on what Catherine M. Cole has described as "fluid spatial dynamics" in indigenous African performance genres in which performers at festivals or other gatherings move through towns "with audiences constantly converging and dispersing as they go." These dynamics are truly Black Atlantic–inspired, forged psychically long before the colonial imposition of European-style proscenium arch theatre with its distinct separation of performers on stage and seated audiences.[4] This latter type of bicameral staging actually unwittingly reproduces the oppressor versus oppressed binarism antithetical to diaspora aesthetics which involve a "telling with" rather than "telling to" structure, borrowed from African oral tradition and remediated accordingly through histories, journeys, and experiences. The diasporic gaze, forged through the crisscrossing movements of black people across the Atlantic to various locales is also not Manichean, but is fixed simultaneously on Africa as source and the Black Atlantic as diaspora, creating new interstitial spaces for identity construction.

The journeys taken by black diasporic peoples create whole cloth out of the warp and weft of experiences that cross borders, cultures, and histories. They are, in the most basic sense, global identities that are often as different as the specific circumstances underpinning them. The work of Toronto-based African Canadian media and performance artist Camille Turner is important in this context because Turner, throughout the course of her artistic career, takes up the challenge of what it means to be black, female, and Canadian. This essay will examine a selection of Turner's performance artworks beginning with early (but still ongoing) work such as *Miss Canadiana*, which explores racial myths encountered by a young black Canadian woman. I will also look at *The Final Frontier*, an ongoing Afrofuturist performance in which African astronauts, descendants of the West African Dogon people visit Earth ten thousand years in the future to save the planet. I am interested in uncovering how Turner complicates preconceived notions of Canadian national identity and multiculturalism and draws on the transnational, the globalized African diaspora, and the Afrofuturistic, repudiating linear, static constructions of identity, home, and belonging.

Bojana Videkanic has written that "creating art in the 'Canadian' context means challenging the ideas of multiculturalism, national identity and social identity" as well as borders and all means of "inclusions/exclusions."[5] The production of art in Canada has also often focused on the question of representation and who has the right to speak in which (Canadian) context. This is a perfectly justifiable concern given the pervasiveness of Eurocentric standards in determining the meaning and significance of artworks. Paul Gilroy has argued that this "constitutes a significant battleground because aesthetic issues are especially close to the surface of individual judgements and, above all, because the majority of its critics are bound by the belief that good art is universally recognizable and cultural background is not a factor either in its production or its appreciation."[6] Gilroy's comment underscores the tension between the cultural contexts of artists and their artworks and the subject positioning of viewers. Art production necessitates a gaze, which in turn demands a point of view that is presented "to the viewer as the embodiment of a certain ideological request."[7] The

"gaze," long considered a cornerstone construct in feminist art and media produc-
tion, is about much more than gender and sexuality for many female artists of colour:
it is also about otherness and belonging/not belonging. It is about layered histories of
oppression where history and historiography are a constant mediator.

I first encountered Camille Turner's performance and video art in 2002 when I
began to explore the impact of digital technology on culture and plan an exhibition
titled *Racing the Cultural Interface: African Diasporic Identities in the Digital Age* for
Soil Digital Media Suite – Neutral Ground, Regina, and Mount Saint Vincent Uni-
versity Art Gallery, Halifax, 2004–05. At the time, there seemed to be a lot of new
and exciting work out there on how digital narratives were changing the ways in
which we think about ourselves and the world. Initially, I was intrigued by Lev
Manovich's suggestion that "we are no longer interfacing to a computer but to culture
encoded in digital form." As I began to look deeper into digital theory, however, I
began to uncover what was to be a disturbing trend. In the rush to theorize the "*cul-
tural interface*" the focus seemed to be squarely centred on Eurocentric origins of
digital technology.[8] This raised a contentious and critical question for me: How is
"self" constructed in digital theory outside Eurocentrism? Turner, who I then met in
Toronto at Terms of Address: A Symposium on the Pedagogy of Film and Video Exhi-
bition in March 2003, was asking the same question, but from personal and lived
experience. Born in Jamaica, Turner immigrated with her family to Canada when she
was nine. Her youth was spent in Hamilton, Ontario, where she experienced alien-
ation, un-belonging, and racism, declaring to have always "felt like an outsider in
Canada."[9] This sentiment echoes that of Stuart Hall who famously declared in the
John Akomfrah documentary, *The Stuart Hall Project*, "Britain is my home, but I'm
not English."[10] Turner claims that much of her work is about belonging and home
because she has always felt like she has been in-between places: Jamaica, Hamilton,
Toronto. Thus, Turner's performance work tends toward site-specific or place-based
exploration that requires journeys to places to investigate and uncover erased histo-
ries. McKittrick and Woods have argued in their edited volume *Black Geographies
and the Politics of Place* that "all displaced persons from Africa to Africville have dif-
ferent desires for home. They want to build new homes in places that have barred
their entry. They also want to explore and reimagine the politics of place." Through
her artistic practice, Turner effects what McKittrick and Woods would term "black
performance practice," a black geographic practice that joins in and contributes to
the network of expressive African diaspora cultures.[11]

Turner created her alter-ego, the iconic persona "Miss Canadiana," in 2002 and
appeared in full beauty queen regalia on Parliament Hill on Canada Day. Turner de-
scribes the environment as "surreal" that day as "the sea of red and white patriots parted
as I walked by and people whispered or vocalized comments. I posed for the camera with
mounties and curious onlookers who wanted to 'commemorate' the event."[12] She then
took her persona to international venues such as Frankfurt and Dakar before returning
to Canadian venues like Regina, Toronto, and Halifax. Turner claims the title "Miss
Canadiana" is a parody on "missing the mark of being Canadian." Using satire and

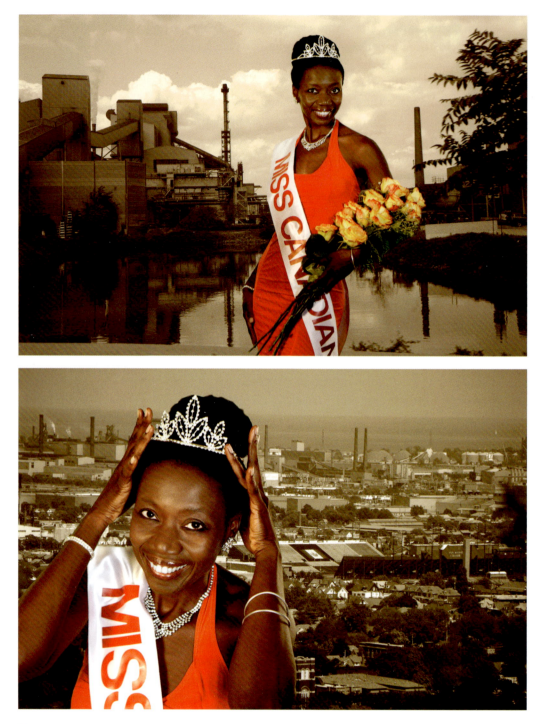

Top
8.1 Camille Turner, *Hometown Queen*, 2011.

Bottom
8.2 Camille Turner, *Fair Dominion*, 2011. From the series *Hometown Queen*.

parody, which are familiar conventions of "Canadian" cultural heritage, she explodes stereotypes of Canadian identity and creates ironic commentaries on the constructed nature of all Canadian identities. She wants people to interact and consider their personal responses to her image as "all that is Canadian" – "a representation of Canadianess."[13] Some credulous people have mistaken her for "Miss Canada," the queen of a beauty pageant that ended in the 1980s. Others, such as the RCMP in Regina, welcomed her and invited her to stay for their graduation ceremonies in October 2004. She only dispels the myth if people ask, "Is this for real?" Turner has mused that she finds it fascinating that one can wear or put on an identity without people challenging or questioning it. In Dakar, Senegal, "a white French woman said to her, 'When you are Miss Canadiana, I don't even notice you're black,'" foregrounding whiteness as the always assumed neutral and presupposed category, which serves to reinforce difference rather than engaging with it.[14] The French woman's comment is also, however, highly reminiscent of the colonial gaze described by Frantz Fanon where black subjectivity is constructed in relation to whiteness: "not only must the black man be black; he must be black in relation to the white man."[15] The French woman articulates the assumption that to be Canadian means to be white (and implicitly, to be a person is to be a white person). Black folks are thus objectified through "a gaze of difference, a gaze of differentiation" and relegated to the category of sub-human.[16] As Coco Fusco has elegantly put it, "black people's entry into the symbolic order of Western culture hinged on the theft of their bodies, the severing of will from their bodies, the reduction of their bodies to things, and the transformation of their sexuality into an expression of otherness" via slavery and colonization. As a consequence, black bodies are read as other within Eurocentric cultural frameworks and the persistence of legacies of slavery and colonialism propel African diasporic digital artists to interrogate how "new technologies elaborate and diversify these strategies of domination."[17]

Turner refuses the use of victimization imagery and instead chooses strategies of resistance and empowerment. She does this by staging her performances, complete with a celebrity-style entourage and mock press coverage, such as the following announcement made by the Mount Saint Vincent University Art Gallery in Halifax: "Miss Canadiana makes a special appearance in the 'Canadian Kitsch Museum,' Mezzanine Gallery, on Thursday, January 6th, 2005 at noon. Media will be present and fans of the 'All-Canadian girl' will have the opportunity to be photographed with her on this single stop in a Canada-wide tour." In essence, Turner is appropriating and restyling Canada, seeking to right the erasure of black Canadian experience. In Regina, members of the Daughters of Africa group felt that Turner was taking their "image of black Canadian identity into the mainstream."[18] They felt a sense of empowered representation through Turner's intervention, a rewriting of Canadian history that acknowledges the continued presence and contribution of African-descended peoples, despite George Elliott Clarke's pessimistic observation that African Canadians "can never escape the situation of our blackness (whatever our adherence to potent, transnational Afrocentrisms) within the Canadian contexts of regional, ethnic, and linguistic balkanization and the perpetual erasure of our cultures from the public sphere."[19]

An integral part of the *Miss Canadiana* site-specific interventions is the Canadiana kitsch that Turner dispenses or displays, depending on the presentation context. In Regina and Halifax, she decked out a small room within the gallery space in a veritable plethora of Canadian memorabilia such as flags, postcards, ornaments, and other tourist kitsch and served tea and maple-leaf-shaped cookies while video footage of her appearances played in the background. The public became active participants in the project through their inclusion in the live performances and the video documentation, adding to the illusion of verisimilitude. In addition to her celebrity appearances, Turner created a web archive of her *Miss Canadiana* work, including photos, video stills, and a fifteen-second video titled "Miss Canadiana Competition," in which she is crowned in a fictional pageant. The video was screened for three weeks on a video billboard in downtown Toronto during *Transmedia 2002: 15 seconds of Fame*.[20] In the video, Turner is crowned queen and thus the winner of the beauty pageant by a white woman. A medium shot of Turner and two other contestants, including a woman of East Indian ancestry and a woman of European ancestry, all wearing the *Miss Canadiana* sash, depicts the women in exaggerated mock excitement as Turner is crowned. The video ends with a medium shot of Turner, in full regalia, flanked by two Mounties in front of Parliament Hill. On the surface, this would seem to be the ultimate endorsement of Canadianness: a fictional icon framed by these icons of Canadian folklore. However, her work portrays something more complicated. Far from being an endorsement of Canadian multiculturalism and assimilation where whiteness is the standard or reference point of departure, *Miss Canadiana* blurs the line between a fictional world and reality and draws attention to how "African Canadians possess, then, not merely a double consciousness but also a poly consciousness," based on histories of black migration and immigration, exile, and long-established black communities that date back further than Canada's birth as a nation.[21] Against this complicated backdrop of identity construction, Turner also investigates notions of blackness as place and blackness as journey within the Canadian landscape and abroad. Turner, as a diasporic subject, explores identity as the ever-unfinished journey as she expands the corpus of her artwork beyond her *Miss Canadiana* persona to probe issues of belonging in a world of migrants and travelling.[22] Foregrounding blackness and the artist's body as a site of social/historical/racial investigation, Turner joins the ranks of other black Canadian female performance and literary artists working in transnational or diasporic contexts such as Marlene Nourbese Philip, d'bi young, and Dionne Brand.

In the black flows of thought, composed through the Black Atlantic, art practice often, importantly, involves participation to offer and express a globalized diasporic black self. In so doing, Turner broadens the debate of polyvalent black Canadian identities while deterritorializing outmoded either/or authenticities. Both Turner and Philip work to diffuse static notions of what the African diasporic self is, putting significant emphasis on its potential.[23] Their performance and literary work create activated spaces in which viewers must interact and engage with the performer and her art. Themes of alienation, home, and belonging abound in their work, which is diasporic

in tone and context.[24] For example, Philip's 2008 innovative interaction-performance poem titled *Zong!* at *b current* in Toronto on 16 April 2012 involved a collective reading, during seven hours, of the text in its entirety, from beginning to end by the audience and Philip. Repetition of fragments of songs, chants, memories, verses, in a counterpoint repetitive structure ensures that formerly forgotten African slaves will be honoured and remembered. The text itself is composed of the transcript of an eighteenth-century British court case concerning the casting overboard and murder of 150 African slaves during the slave ship *Zong*'s voyage to Jamaica from West Africa. To demonstrate solidarity with this interaction-performance, a collective reading was also organized in South Africa, and performances of the work are ongoing in various locations, highlighting the importance of transcontinental blackness, tied together through a diasporic identity that is the result of slavery. Philip maintains that her texts are constructed in a way that they must tell themselves through active audience participation rather than "be told" by the artist to the audience.[25] This practice of collaborative input of real audiences is also a cornerstone of Turner's performance work. For example, in her *Miss Canadiana Heritage and Culture Walking Tour* she performs as Miss Canadiana, a tour guide shepherding groups of tourists around Toronto's Grange neighbourhood with the goal of exposing the hidden histories of black Canada. The groups act as classes with Turner as their teacher as they wander for an hour and a half, maps in hand, reacting to the discoveries they make and interacting with each other as well as interested passersby.[26] These performances are very reminiscent of African community-based theatre with its pedagogical aims and audience participation. I would argue that active involvement, through which participants' experiences become part of the artwork, is a key element of diaspora aesthetics, necessitating a diasporic gaze forged out of a confluence of experiences and histories. Homi Bhabha would allude to this process as "insurgent act[s] of cultural translation."[27]

Édouard Glissant's theory of "tout-monde" is useful for mapping the aesthetic complexities of diasporic artworks that combine historical, political, geographic, ideological, and cultural discourses in relation to the aesthetic concerns of the artists. Glissant's work is foundational for the African diaspora because it visualizes culture and art production as an unfolding process, subject to both internal and external cultural contacts where the "synthesis/genesis" of identity and aesthetics are continually evolving.[28] The theory of *tout-monde* is grounded in the philosophy that the world is globalized, *métissé*, and creolized. Glissant would often repeat, "Agis dans ton lieu, pense avec le monde" (act in your location, think with the world.)[29] *Tout-mondisme* therefore foregrounds a decentring of hegemonic and Eurocentric points of view and promotes interdisciplinarity. It is in Glissant's refusal of static or universalist moorings for identity that Turner finds an approach suitable for coping with the "complexity" of "the fractious African-Canadian identity." Describing this state as "*African Canadianité*, a condition that involves a constant self-questioning of the grounds of identity," Clarke argues that "African Canada replicates a Caribbean-like diversity" and hence resists static definitions of experience and culture.[30] Clarke shares with Glissant the position that "relation is not made up of things that are

foreign but of shared knowledge" encompassing contemporary issues of African Diasporic migration and exile.[31]

In some of Camille Turner's more recent work she effects an innovative blend of Glissantian theory, postcolonial melancholia, Afrofuturism, and journey. Drawing on her sense of otherness and alien(ation) as a Caribbean-born but Ontario-raised youth, Turner began to conceive of such works as *The Final Frontier* in 2008, which follows the journeys of African Astronauts who have returned to planet Earth ten thousand years from now with the goal of saving it. Like *Miss Canadiana*, the work is a combination of ongoing performance and installation. The African Astronauts, or "Afronauts,"[32] are descendents of the Dogon people of Mali. The image the viewer clicks on to enter the two-minute trailer of the video is a long shot of a vista landscape with four Afronauts standing in a straight line facing the camera slightly centre-left. Behind the Afronauts we see prairie grasses, part of a river, and rolling hills. In the upper screen left, coulees or v-shaped valleys appear along the opposite side of the river. Coulees, a result of the last ice age, are common in southern Alberta, and Turner drew on this iconic landscape after a trip to Lethbridge in 2005 when she became fascinated with the melancholic beauty of the combination of steep-sided v-shaped valleys and grasslands. The otherworldly or "extraterrestrial" feel of the area, along with its confluences of histories of oppression, including First Nations battles with Northwest Mounted Police in the nineteenth century and a nearby former Second World War Japanese Canadian internment camp, was intriguing to Turner as a backdrop for her video and performances.[33] In the opening shot, the coulees bear a striking resemblance to the roofs of Dogon huts, found around the Bandiagara cliffs in the central region of Mali, West Africa. The Dogon fled to this area to escape the penetration of Islam in West Africa centuries ago. Their strategic positioning along the cliffs and their proximity to the Niger River are evoked in the video's opening setting, and the Afronauts' costumes are a curious blend of past/present/future Dogon hunter (complete with walking sticks that resemble flintlock rifles used by the Dogon) and space travel garb.

The narrative of *The Final Frontier* is structured as a kind of historical story, but unlike Eurocentric histories, time and events are not arranged in a linear fashion. Fragmented events from past, present, and future circulate throughout the narrative, bridged by Turner's voiceover as one of the Afronauts. The trailer opens with a white title on a black background: "The AfroFuture." The title is followed by extreme close-ups of Turner walking as she solemnly faces the camera, eyes hidden by futuristic-looking sunglasses, her voiceover declaring, "I'm Camille Turner ... I was born in Jamaica and left the land of the sea and the sun for the great white north when I was nine years old. Canada prides itself on being a multicultural country that welcomes everyone, but when I step outside my Toronto home I feel like an alien." The close-up shots of Turner are followed by long and medium shots of the four Afronauts walking toward the camera, wind turbines spinning and humming in the background. Her voiceover continues, "So I decided to travel across Canada with some other aliens to see how people respond." The image fades to black as the soundtrack emits futuristic beeps. The next sequence depicts Turner and one of the other Afronauts sitting at

8.3 Camille Turner, *The Final Frontier* (Afronauts in spaceship), 2007.

spaceship consoles, followed by the four, with their backs to the camera, psychedelic colours pulsing, watching their approach to Earth through the spaceship window. Suddenly, they appear on the grassy, rolling hills in front of the river and coulees. The image fades to black and then they are walking down the street of Vulcan, Alberta, which Turner chose because of its proximity to Lethbridge and also because of its "sci-fi name."[34]

Interestingly, although *The Final Frontier*'s mood could be considered melancholic, Turner refuses the state of paralysis or stalemate described by Paul Gilroy as "post-colonial melancholia" whereby a longing for a lost empire among ex-colonial powers undermines any attempt at establishing a more convivial approach to racial difference.[35] One of the most deleterious effects of postcolonial melancholia is the entrenchment of hostility towards immigrants, and although armed with a desire for convivial coexistence, such immigrants discover that even after establishing multigenerational stakes in dominant cultures, they are still considered "aliens" or outsiders. There is an almost understated sense of play at work in the video; irony and parody undergird townspeoples' reactions to the Afronauts as they exclaim, "We're curious and drawn to them; their skin colour is different; I think my child should experience different things; Do they need money or something?; It was very earthy." As

in her *Miss Canadiana* performances, Turner (along with the other Afronauts) hands out kitschy trinkets, performing what has been described elsewhere as a "Canadian-style circus."[36] In the trailer's final sequence, townspeople and Afronauts work the land together as Turner's voiceover intones, "*The Final Frontier* is a journey that bridges Canada's geographic and cultural divide. We travel across the country to encounter the 'other' and find ourselves … Come along on the journey and see Canada like you've never seen it before!"

The Final Frontier is essentially an Afrofuturist revisionist narrative combining elements of science fiction, fantasy, historical fact, and fiction with the underlying goal of rereading Canada's multicultural past and envisioning a future in which African Canadians are not deemed alien but rather an integral part of Canada's national utopian future. Turner creates what Kodwo Eshun describes as "temporal complications and anachronistic episodes that disturb the linear time of progress … [and] adjust the temporal logics that condemned black subjects to prehistory."[37] By openly staking out her own social subjectivity within the video, Turner transforms an act of personal remembrance into national history. I would further argue that her central

8.4 Camille Turner, *The Final Frontier*, at the Kamloops Art Gallery, 2010.

role as filmmaker and subject/participant places her in the metaphorical position of "griot," the historian/storyteller in West African (and Dogon) cultures. As a filmmaker, she both organizes the descriptive elements of the text and adds to its overall evocation by inclusion of her own personal experiences, blurring all boundaries between self and history.

Camille Turner's performance and video work raises questions that persist beyond the final frames of the videos or the final scenes of the performances, in short, beyond the "final frontier." They offer the opportunity to consider what Gilroy has described as "the paradox of discrepant ontologies" lurking beneath the surface of postcolonial melancholia.[38] As with all her work, which depends significantly on the collaborative participation of real audiences and their willingness to momentarily suspend disbelief and uncover real histories through fictional narratives, Turner creates the possibility of ongoing debate and active participation so germane to the diasporic aesthetic and gaze. In short, the African diasporic "imaginations of the self" that derive from the continent "are born out of disparate but often intersecting practices, the goal of which is not only to settle factual and moral disputes about the world but also to open the way for *self-styling*."[39] Given this context, Turner's performance and media artworks offer fertile ground for better understanding global flows of history and culture. In reply to her question, "when will I ever be Canadian?" – she is *all* that is Canadian but also much more because, through parody and playfulness, she merges and even exceeds identities through a confluence of global forces. It is this playfulness of becoming-alien or posing as a beauty queen that actually questions the imposition of identity or nationality as a fixed marker to begin with.

NOTES

1 Gilroy, *Postcolonial Melancholia*, 3.
2 Gilroy, "Route Work," 22.
3 Mbembe and Nuttall, "Writing the World," 349.
4 Cole, "When Is African Theater 'Black'?," 43–5.
5 Videkanic, "You Pretend to Be a Canadian," 32.
6 Gilroy, *Small Acts*, 77.
7 McEvilley, "Exhibition Strategies," 55.
8 Manovich, *The Language of New Media*, 69–70.
9 Turner, "Miss Canadiana Confronts," 53.
10 Akomfrah, *The Stuart Hall Project*.
11 McKittrick and Woods, *Black Geographies*, 5–6, 10.
12 Turner, personal communication (email), 28 November 2003.
13 Grant, "All Bow to Miss Canadiana," 21; Turner, personal communication (email), 28 November 2003.
14 Barnard, "Here She Comes," D4.
15 Fanon, *Black Skin*, 110.
16 Oyewumi, *The Invention of Women*, 2.
17 Fusco, *The Bodies That Were Not Ours*, 5.
18 Barnard, "Here She Comes," D4.
19 Clarke, "Contesting a Model Blackness," 2.
20 The video can be viewed at the *Transmedia 2002: 15 Seconds of Fame* website: http://www.year01.com/archive/trans media2002/transmedia2002_flash.html.
21 Clarke, "Contesting a Model Blackness," 17.
22 This is reminiscent of some of the performance and digital media work of other African diasporic women artists such as

Mother Me

Jenny Western

9 In 2012 I gave birth to my first child and I spent 2013 trying to figure out what had happened. For the past ten years I had worked at being and becoming a curator: grad school, institutional positions, independent roles, publications, public talks, exhibition after exhibition after exhibition. The role helped to define me. My curatorial projects often assisted me in sorting out ideas and concepts that usually came out of experiences in my daily life. As a mom to a newborn, I had no time to read anything of substance, and my foggy, sleep deprived brain was suddenly struggling to retain any relevant information other than to track the minutiae of the baby's daily routine. This was a humbling time. All I had to reflect on and speak about, it seemed, was motherhood. It was a topic that did not hold much weight in the art world. Years earlier during a studio visit, Winnipeg-based artist Gaëtanne Sylvester had been the first to talk openly with me about the frustrations of addressing motherhood as a subject in art. Sylvester, a mother and now grandmother whose ceramic work has included explorations of the pregnant body among other things, indicated a certain taboo around motherhood as a chosen artistic topic. It is perceived as far too personal, nostalgic, and sentimental to present in a critical, contemporary art forum, so artists (and artist-moms in particular) usually just don't.

For my own part, I had been interested in investigating certain parts of motherhood even before becoming a mom. In 2008 I curated a group exhibition called *Mother's Mother's Mother* that travelled from Urban Shaman Gallery and Ace Art Inc. in Winnipeg to the Art Gallery of Southwestern Manitoba in Brandon, Manitoba. The show was an exploration of generational relationships among Indigenous female artists in Canada and highlighted the work of Hannah Claus, Rosalie Favell, Maria Hupfield, Shelley Niro, Daphne Odjig, and Tania Willard. The pieces in the exhibition did not necessarily address motherhood specifically but constituted my attempt at drawing out instances of exchange, inheritance, influence, and resistance within the kinship of our contemporary Aboriginal art community. Furthermore, I was motivated to explore my own matrilineal Oneida/Stockbridge-Munsee/Brothertown heritage through this project in an attempt to get closer to the overlooked knowledge of the female forebearers in my own family. Yet any deliberate mention of pregnancy, labour, or mothering was kept subtle and unobtrusive. My actions followed what Sylvester had suggested to me long ago. I didn't want the exhibition to be written off. Motherhood

Wing. Ann Arbor: University of Michigan Press, 1997.

Grant, Shauntay. "All Bow to Miss Canadiana." *The Daily News* (Halifax), 6 January 2005: 21.

Manovich, Lev. *The Language of New Media.* Cambridge, MA: MIT Press, 2001.

Mbembe, Achille. "African Modes of Self-Writing." Translated by Steven Rendall. *Public Culture* 14, no. 1 (2002): 239–73.

Mbembe, Achille, and Sarah Nuttall. "Writing the World from an African Metropolis." *Public Culture* 16, no. 3 (2004) 347–72.

McEvilley, Thomas. "Exhibition Strategies in the Postcolonial Era." In *Contemporary Art in Asia: Traditions, Tensions*, 54–9. New York: Asia Society Galleries, 1996. Exhibition catalogue.

McKittrick, Katherine, and Clyde Woods, eds. *Black Geographies and the Politics of Place.* Toronto: Between the Lines; Cambridge, MA: South End Press, 2007.

Oyewumi, Oyeronke. *The Invention of Women: Making an African Sense of Western Gender Discourses.* Minneapolis: University of Minnesota Press, 1997.

Turner, Camille. "Miss Canadiana Confronts the Mythologies of Nationhood and the Im/possibility of African Diasporic Memory in Toronto." *Caribbean InTransit Arts Journal: Location and Caribbeanness* 1, no. 2 (2012): 52–60.

– Personal communication (email). 28 November 2003.

Videkanic, Bojana. "You Pretend to Be a Canadian: Exploring the Work of Kinga Araya and Camille Turner." *Women and Environments* (Fall/Winter 2006): 32–5.

Wah, Fred. "Reading M. NourbeSe Philip's 'Zong!'" *Jacket 2: North of Invention.* Edited by Sarah Dowling. 29 March 2013. http://jacket2.org/article/reading-m-nourbese-philips-zong.

Jenny Western

9

In 2012 I gave birth to my first child and I spent 2013 trying to figure out what had happened. For the past ten years I had worked at being and becoming a curator: grad school, institutional positions, independent roles, publications, public talks, exhibition after exhibition after exhibition. The role helped to define me. My curatorial projects often assisted me in sorting out ideas and concepts that usually came out of experiences in my daily life. As a mom to a newborn, I had no time to read anything of substance, and my foggy, sleep deprived brain was suddenly struggling to retain any relevant information other than to track the minutiae of the baby's daily routine. This was a humbling time. All I had to reflect on and speak about, it seemed, was motherhood. It was a topic that did not hold much weight in the art world. Years earlier during a studio visit, Winnipeg-based artist Gaëtanne Sylvester had been the first to talk openly with me about the frustrations of addressing motherhood as a subject in art. Sylvester, a mother and now grandmother whose ceramic work has included explorations of the pregnant body among other things, indicated a certain taboo around motherhood as a chosen artistic topic. It is perceived as far too personal, nostalgic, and sentimental to present in a critical, contemporary art forum, so artists (and artist-moms in particular) usually just don't.

For my own part, I had been interested in investigating certain parts of motherhood even before becoming a mom. In 2008 I curated a group exhibition called *Mother's Mother's Mother* that travelled from Urban Shaman Gallery and Ace Art Inc. in Winnipeg to the Art Gallery of Southwestern Manitoba in Brandon, Manitoba. The show was an exploration of generational relationships among Indigenous female artists in Canada and highlighted the work of Hannah Claus, Rosalie Favell, Maria Hupfield, Shelley Niro, Daphne Odjig, and Tania Willard. The pieces in the exhibition did not necessarily address motherhood specifically but constituted my attempt at drawing out instances of exchange, inheritance, influence, and resistance within the kinship of our contemporary Aboriginal art community. Furthermore, I was motivated to explore my own matrilineal Oneida/Stockbridge-Munsee/Brothertown heritage through this project in an attempt to get closer to the overlooked knowledge of the female forebearers in my own family. Yet any deliberate mention of pregnancy, labour, or mothering was kept subtle and unobtrusive. My actions followed what Sylvester had suggested to me long ago. I didn't want the exhibition to be written off. Motherhood

role as filmmaker and subject/participant places her in the metaphorical position of "griot," the historian/storyteller in West African (and Dogon) cultures. As a filmmaker, she both organizes the descriptive elements of the text and adds to its overall evocation by inclusion of her own personal experiences, blurring all boundaries between self and history.

Camille Turner's performance and video work raises questions that persist beyond the final frames of the videos or the final scenes of the performances, in short, beyond the "final frontier." They offer the opportunity to consider what Gilroy has described as "the paradox of discrepant ontologies" lurking beneath the surface of postcolonial melancholia.[38] As with all her work, which depends significantly on the collaborative participation of real audiences and their willingness to momentarily suspend disbelief and uncover real histories through fictional narratives, Turner creates the possibility of ongoing debate and active participation so germane to the diasporic aesthetic and gaze. In short, the African diasporic "imaginations of the self" that derive from the continent "are born out of disparate but often intersecting practices, the goal of which is not only to settle factual and moral disputes about the world but also to open the way for *self-styling*."[39] Given this context, Turner's performance and media artworks offer fertile ground for better understanding global flows of history and culture. In reply to her question, "when will I ever be Canadian?" – she is *all* that is Canadian but also much more because, through parody and playfulness, she merges and even exceeds identities through a confluence of global forces. It is this playfulness of becoming-alien or posing as a beauty queen that actually questions the imposition of identity or nationality as a fixed marker to begin with.

NOTES

1 Gilroy, *Postcolonial Melancholia*, 3.
2 Gilroy, "Route Work," 22.
3 Mbembe and Nuttall, "Writing the World," 349.
4 Cole, "When Is African Theater 'Black'?," 43–5.
5 Videkanic, "You Pretend to Be a Canadian," 32.
6 Gilroy, *Small Acts*, 77.
7 McEvilley, "Exhibition Strategies," 55.
8 Manovich, *The Language of New Media*, 69–70.
9 Turner, "Miss Canadiana Confronts," 53.
10 Akomfrah, *The Stuart Hall Project*.
11 McKittrick and Woods, *Black Geographies*, 5–6, 10.
12 Turner, personal communication (email), 28 November 2003.

13 Grant, "All Bow to Miss Canadiana," 21; Turner, personal communication (email), 28 November 2003.
14 Barnard, "Here She Comes," D4.
15 Fanon, *Black Skin*, 110.
16 Oyewumi, *The Invention of Women*, 2.
17 Fusco, *The Bodies That Were Not Ours*, 5.
18 Barnard, "Here She Comes," D4.
19 Clarke, "Contesting a Model Blackness," 2.
20 The video can be viewed at the *Transmedia 2002: 15 Seconds of Fame* website: http://www.year01.com/archive/transmedia2002/transmedia2002_flash.html.
21 Clarke, "Contesting a Model Blackness," 17.
22 This is reminiscent of some of the performance and digital media work of other African diasporic women artists such as

Berni Searle, *Home and Away* (2003), and Ingrid Mwangi/Robert Hutter, *Cryptic: A Traveler's Diary* (2007).

23 Philip was born in Tobago, emigrated to Trinidad when she was eight, and then moved to Ontario to do graduate work when she was twenty-one. A specialist in immigration and family law, Philip eventually gave up her practice to write prose, plays, and poetry and is renowned for writing creole in Canada.

24 Casas, *Multimodality*, 39, 43.

25 Wah, "Reading M. NourbeSe Philip's 'Zong!'"

26 The video documentation can be viewed on Turner's website: http://camilleturner.com/project/miss-canadianas-heritage-and-culture-walking-tour/.

27 Bhabha, *The Location of Culture*, 7.

28 Glissant, *Poetics of Relation.*

29 Glissant, *Philosophie de la relation*, 87.

30 Clarke, "Contesting a Model Blackness," 25, 26.

31 Glissant, *Poetics of Relation*, 8.

32 The term *Afronauts* is generally attributed to George Clinton.

33 Cheetham, "Alienated Cosmopolitans."

34 Ibid.

35 Gilroy, *Postcolonial Melancholia*, 91–6.

36 This term was used by *Globe and Mail* reporter Campbell Clark to describe New Democratic Party aides handing out cold Camembert outside the Ottawa Courthouse on the first day of the Mike Duffy trial. Clark, "The Alpha and the Omega of the Duffy Trial," A4.

37 Eshun, "Further Considerations," 297.

38 Gilroy, *Postcolonial Melancholia*, 8.

39 Mbembe, "African Modes," 242.

BIBLIOGRAPHY

Akomfrah, John. *The Stuart Hall Project* (film). Smoking Dogs Films. United Kingdom, 2013.

Barnard, Elissa. "Here She Comes, Miss Canadiana: Artist Uses Persona to Make Challenging Points." *Halifax Herald Limited*, 7 January 2005: D4.

Bhabha, Homi. *The Location of Culture.* London: Routledge, 1994.

Casas, Maria Caridad. *Multimodality in Canadian Black Feminist Writing: Orality and the Body in the Work of Harris, Philip, Allen, and Brand.* Amsterdam: Editions Rodopi B.V., 2009.

Cheetham, Mark. "Alienated Cosmopolitans: Can We Be World Citizens Yet Still Retain a Sense of Place?" *The Walrus*, May 2007. http://thewalrus.ca/2007-05-national-magazine-award-gold-medal/.

Clark, Campbell. "The Alpha and the Omega of the Duffy Trial." *Globe and Mail*, 8 April 2015: A4.

Clarke, George Elliott. "Contesting a Model Blackness: A Meditation on African-Canadian African Americanism, or the Structure of African Canadianité." *Essays on Canadian Writing* 63 (Spring 1998): 1–55.

Cole, Catherine M. "When Is African Theater 'Black'?" In *Black Cultural Traffic: Crossroads in Global Performance and Popular Culture*, edited by Harry J. Elam Jr and Kennell Jackson, 43–58. Ann Arbor: University of Michigan Press, 2005.

Eshun, Kodwo. "Further Considerations on Afrofuturism." CR: *The New Centennial Review* 3, no. 2 (2003): 287–302.

Fanon, Frantz. *Black Skin, White Masks.* Translated by Charles Lam Markmann. New York: Grove Press, 1967.

Fusco, Coco. *The Bodies That Were Not Ours, and Other Writings.* New York: Routledge, 2001.

Gilroy, Paul. *Postcolonial Melancholia.* New York: Columbia University Press, 2005.

– "Route Work: The Black Atlantic and the Politics of Exile." In *The Post-Colonial Question: Common Skies, Divided Highways*, edited by Iain Chambers and Lidia Curti, 17–29. London: Routledge, 1996.

– *Small Acts: Thoughts on the Politics of Black Cultures.* London: Serpent's Tail, 1993.

Glissant, Édouard. *Philosophie de la relation.* Paris: Gallimard, 2009.

– *Poetics of Relation.* Translated by Betsy

felt too risky as it seemed possible to too easily slip into personal, sentimental, and uncritical representations. And yet, even a casual observer will notice that art history textbooks and museums of the Western canonical variety are teeming with images of the Madonna and Child. But, due to the patriarchal nature of art historiography, these dynamic complexities of motherhood are very rarely delved into with any seriousness through these artworks.

How can this subject matter, which is so common to each of us, be so challenging? As Adrienne Rich points out in her influential 1976 text, *Of Woman Born: Motherhood as Experience and Institution*, "All human life on the planet is born of woman. The one unifying, incontrovertible experience shared by all women and men is that months-long period we spent unfolding inside a woman's body."[1] True, each of us has certain concepts of motherhood coloured by our own experiences with the maternal, extending from someone's uterus to some version of a caring parent. But beyond this, the range of what motherhood looks like is vast and varied. Suffice it to say that the human waiting outside of the uterus to provide care for a baby is in all likelihood a person with a strong constitution, or who will necessarily develop a strong constitution through mothering. In my brief experience as a mom, being too personal, nostalgic, and sentimental will only get you so far with a newborn human. Caring for babies, kids, and even adult children is hard work. Motherhood then seems like it would be prime fodder for artistic investigation and critical production. The lack of critical and artistic engagement with motherhood is perhaps imposed because the topic is not easy to navigate and the majority of artists who have attempted to do so tend to come up short. But why?

Rich argues that the problem stems from a patriarchal vision of motherhood. She writes that "The ancient, continuing envy, awe, and dread of the male for the female capacity to create life has repeatedly taken the form of hatred for every other female aspect of creativity."[2] She goes on to say that women's intellectual and aesthetic creations have been labelled inappropriate, inconsequential, as attempting to be like men, and ultimately take away from the focus on marriage and childbearing as the goals of womanhood. Other scholars concur, such as Andrea Liss in her text *Feminist Art and the Maternal*, where she writes that a patriarchal representation of motherhood remains blatant in an area somewhere between "an ever-present 'natural' space, another based in an insipid invisibility where 'too specific' really means 'too personal,' and one in which a feminist woman herself labels and thus devalues the status of motherhood."[3] Rich, writing from a second-wave feminist perspective, precedes Liss and other feminist authors who are writing from their position in the time of the third wave, and it is important to note these distinctions when considering feminist motherhood.

Beginning in the 1950s and 1960s, second-wave feminism emerged as a critique of, among other things, patriarchy and the roles of women as wives and mothers.[4] Betty Friedan's 1963 text *The Feminine Mystique* is often cited as a crucial moment in second-wave feminism for its identification of the "problem with no name" that plagued middle-class women who were limited to the roles of wives and mothers

rather than engaging in the possibilities of paid labour in the public sphere. Through the collective consciousness of the feminist movement that came out of the second wave, women were able to challenge gender relations, assume positions of power in the workforce, and view women's roles in society as more than wives and mothers. Third-wave feminism arrived in the 1990s and was, in part, a response to second-wave feminism.[5] Rather than eschew the role of the wife and mother, third-wave feminists point to the private realm of the family and home as important sites for feminist dialogue and action.[6] Some scholars suggest that family is to third-wave feminism what the workplace was to the second wave,[7] and professor of feminist legal theory Bridget J. Crawford writes, "In third-wave feminist hands, feminism is a framework that permits simultaneous critique and embrace of motherhood."[8] The reason for second wave feminist activists to put space between themselves and motherhood, Liss explains, was a resistance to a patriarchal view of motherhood that had been culturally codified as passive, weak, and irrational. Once motherhood was no longer situated apart from feminism in the third wave, opportunities open up for feminist motherhood through a "rethinking [of] the representation of motherhood as more than a sign of codified femininity or as a muted allegory."[9] It becomes possible that a feminist take on motherhood in the twenty-first century can offer new perspectives then, subverting the assumed patriarchal order of gender and power that second-wave feminism fought against, while even using the tenants of the third wave in reclaiming motherhood's possible sentimentality from cultural embarrassment as a real feeling of deep and loving emotion.[10]

Given my new role as a mom and curator, I longed to find examples of artwork that addressed motherhood in ways that were substantive and inspiring. Examining art and curatorial practice through a lens of feminist motherhood suggested a way forward that was not completely bogged down by patriarchal expectations of mothering. But my own background as an Indigenous curator also demanded certain considerations. For Indigenous women the issue extends beyond questions of feminist motherhood and patriarchy. As D. Memee Lavell-Harvard and Kim Anderson, editors of *Mothers of the Nations: Indigenous Mothering as Global Resistance, Reclaiming and Recovery*, write, "generations of resistance and resilience means those Indigenous women do not necessarily face the same dilemmas [as other women] as we work instead to reclaim and revitalize the more empowering cultural beliefs, traditions, and practices of our ancestors."[11] I was reminded of the importance of considering my own family and heritage when I began my research for *Mother's Mother's Mother* exhibition. I was fresh off an MA in art history and trained to approach my work in a formal discipline. It took effort to allow myself to consider my mother as a site of primary source material. She held an archive that I had always leaned heavily upon but that I had not given much professional credence to. Once I allowed myself to see her as a serious contributor to my research, my whole practice opened up, and I began to open up with it as I not only turned to feminist sources to inform my professional practice but also sought out other ways of reclaiming the cultural beliefs, traditions, practices, and knowledge of the women and mothers within my family.

Women's stories, particularly those of Indigenous women, often speak of a quiet subversive resistance. Lavell-Harvard and Anderson write that "Generations of strong women have provided the foundation for such resistance, for, as Anderson explains, the 'guidance that women receive from their mothers, aunts, and grandmothers, shapes the way they learn to understand themselves and their positions in the world.'"[12] Having learned how to resist subjugation and how to survive under the weight of oppression, previous generations of Indigenous mothers have maintained a definition of womanhood and mothering premised upon strength and capability that was distinctly different from the negative images and subservient female role offered by mainstream society."[13] Work by Indigenous artists on issues of motherhood brings an additional element to considerations of feminist motherhood, one that resists the taboos and stereotypes of motherhood imposed by patriarchy while presenting thoughtful reflections on the maternal experience outside of mainstream vision. Three works in particular will be examined here: Faye HeavyShield's landscape-inspired installation, *Body of Land*; Danis Goulet's short film, *Barefoot*, about teenaged motherhood in northern Saskatchewan; and Kenneth Lavallee's mural, *Mother and Son*, which recounts family mythology. These three works suggest images of motherhood in connection to nature, community, family, and personal experience in a way that goes beyond the tired notions of patriarchal motherhood, offering a way past the taboo.

Faye HeavyShield

Faye HeavyShield is an artist from southern Alberta who was born on the Blood Reserve and is a member of the Kainai (Blood) Nation. As a teenager, HeavyShield attended a residential school that took her forty miles away from her home. She later attended the Alberta College of Art + Design and the University of Calgary, eventually receiving her BFA. Her cosmology and outlook have been informed by a Roman Catholic education, but she has also maintained strong ties to her Blood heritage. Through her artwork, HeavyShield explores her family's history, her personal memories, her relationship to community, and her life experiences as a contemporary Indigenous woman.[14] In tandem with its content, HeavyShield's work takes a simple and straightforward approach to materials, often using or referencing natural elements such as bone, grass, and water. As outlined in HeavyShield's biography, she keeps her visual aesthetic minimal since she does not want to "dress a memory, because that would just weigh it down."[15] Her artwork demonstrates a quiet strength. When it comes to motherhood, she is equally as direct. In a written piece titled "Traditional," HeavyShield weaves a tale around maternal relationships through a short segment on her matrilineal ancestry: "This is Marley whose mother is Hali whose mother is Faye whose mother is Issitaki whose mother-in-law is Kate. Marley dances in the girl's traditional category, meaning that her dress and dance take after the way the older women dance, in soft, graceful steps. She was born seven years after Issitaki passed and 40 years past Kate. When this girl dances we see all over again how much the old lady enjoyed dance and we tell Marley that she is making the old grandmas happy."[16]

HeavyShield's artwork generally is a poetic yet unflinching account of things, and her large-scale installation *Body of Land* is no exception. Constructed over several years, *Body of Land* is a landscape comprised of portraits. Using several hundred close-up photographs of skin, HeavyShield further abstracts these images by rolling them into cones and pining them to the wall. The result is a subtly immersive space that speaks to stories of family, language, narrative, knowledge, and personal histories.[17] Recalling the undulating hills of southern Alberta after returning home, HeavyShield has mused of this landscape, "It's soft, just like a body or a mother."[18] The coulees and wind of this region are never far from HeavyShield's artistic practice, and *Body of Land* is not exempt. While composed of photographs of the skin of friends, family, and acquaintances, *Body of Land* is also a meditation on the nature of home. The relationship between home(land) and mother(land) are not new terrain and yet HeavyShield's strategic abstraction of her source material allows the work to sidestep the pitfalls of didactic nostalgia by asking her audience to intuitively grasp the sensations and emotions associated with this piece. The warm fleshy tones of the piece suggest an intimacy that is evocative of the physical closeness between a mother and her child, whether through gestation or the labour process or in other maternal relationships throughout life. This intimacy is a link to something much greater, the way that the mother is a conduit to generations and generations of people, memory, and experiences, preceding and proceeding as a lineage unfolds. The multiplicity and repetition of forms in HeavyShield's *Body of Land* suggests this as well, that a sense of community and kinship is made up of individual yet connected forms. In the aforementioned written piece "Traditional," HeavyShield states, "Histories are created, added to and evolving through experience and experiment. Our art conveys in different ways the stories we hear about grandparents and great-grandparents …Tradition is not complete; what is given to us and what we will, in turn, pass on is not the end of the line. It is exciting and energetic."[19]

Body of Land alludes to motherhood through its abstracted representations of the land as mother and emphasis on family and community relationships. Anishnaabe Elder Betty McKenna has said that traditional women's wisdom was passed down in their community from "mother to daughter to granddaughter, aunty to niece," and she goes on to emphasize the cyclical connections that women have with the earth: "We are a product of Mother Earth, we come from her, we go back to her … As women, we are, in a sense, a smaller version of Mother Earth; we give life, we work, and protect."[20] HeavyShield's artwork can transform the patriarchal concept of motherhood by celebrating those connections to the land, family, and community in a way that asks viewers to look deeper and consider the relationships and representations of motherhood as something much larger than as merely the reproduction of the nuclear family.

Danis Goulet

Danis Goulet is a Toronto-based filmmaker who uses the cinematic form to interrogate motherhood in her piece *Barefoot*. Goulet originally hails from the northern prairie town of La Ronge, Saskatchewan. She is Cree/Métis and has often tackled issues around contemporary Indigenous identity in Canada through her films. In 2012 Goulet created a short film called *Barefoot*, which relays the experiences of a teenaged girl in a northern Saskatchewan community. It is a story with a surprising twist. The film's protagonist, Alyssa, is shown shopping, running laps during gym glass, doing things typical of teenaged girls. The notable difference is that each of Alyssa's friends seems to be pregnant or to have a small child. While teenaged pregnancy might be disapproved of in other circles, in Alyssa's town it is seen as the norm. Alyssa watches as her friends pick out baby clothes and predict their unborn children's gender. Soon enough she is experiencing morning sickness and her community begins to form a

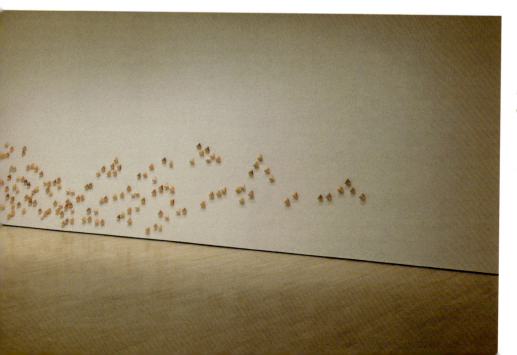

9.1 Faye HeavyShield, *Body of Land*, 2002–ongoing.

circle of support around her. Her grandmother gives her a beaded moss bag passed down through her family. The baby's father, a teenaged gas station attendant, drops by her home with a gift for the baby causing Alyssa's aloof demeanour to soften as she leans in to kiss him. There is a sweetness in the ways that this new life is welcomed into being. After a friend mentions to Alyssa how small her baby bump is, audiences are let in on her secret: at home and alone Alyssa lifts her shirt to adjust the pillow she has stuffed in her pants to mimic a pregnant belly. This imaginary baby is wanted, not only by the community, but by Alyssa as well. Things really start to become complicated when Alyssa's baby-daddy announces that he is dropping out of high school in order to support her and their child. Alyssa's cool exterior remains unchanged for much of the film yet the panic of her situation is palpable when, at the story's end, Alyssa walks away from him, letting it slide that the baby is not his. Audiences are left wondering where she will go and what she will do next.

Goulet has crafted a dynamic tale of real life as observed in her home community. As she explains, "All of my little cousins growing up in the north and in Saskatchewan are for the most part having kids before they're 20. I just found that very interesting. I'm not trying to judge that choice. It's really more of a different cultural context that is outside the value system of mainstream Canada."[21] And in truth, Goulet's treatment of the storyline is heartfelt, honest, at times funny, and occasionally gut wrenching. By casting local and amateur actors, Goulet is able to capture a tone that resists pandering to the cautionary tales of after-school specials on teenaged pregnancy and instead focuses on relaying the experience of a young female protagonist who is sympathetic and sure of herself rather than tragic or victimized. As a creative offering, *Barefoot* presents a unique vision of motherhood that is too often moralized and invalidated. The film does so with great care, unfolding a storyline that is sophisticated and considered in its intent and choices. Even the film's title, which presumably references the old figure of speech "Barefoot and pregnant in the kitchen," makes us second-guess its inferred meaning. The phrase is transformed by the practices and values of a community where extended families live together and motherhood at a young age is commonplace. As Mary Anderson writes, "The ideas and representations surrounding Aboriginal mothers in Canada have long been stereotypical and unjust. Colonial narratives have helped shape notions of the 'un-fit' Aboriginal mother and the negative stereotypes have served to trap many women in a certain framework that sustains their marginalization."[22] At a time when 55 percent of Aboriginal mothers in Canada are under twenty-five years old,[23] Goulet tells a story of motherhood that is honest and clear-eyed without getting tripped up by negative stereotypes. As with HeavyShield's *Body of Land*, *Barefoot* presents an artistic exploration of motherhood that involves community and personal experience in a way that challenges the perceived notions of mainstream motherhood.

Opposite
9.2 & 9.3 Danis Goulet, stills from *Barefoot*, 2012.

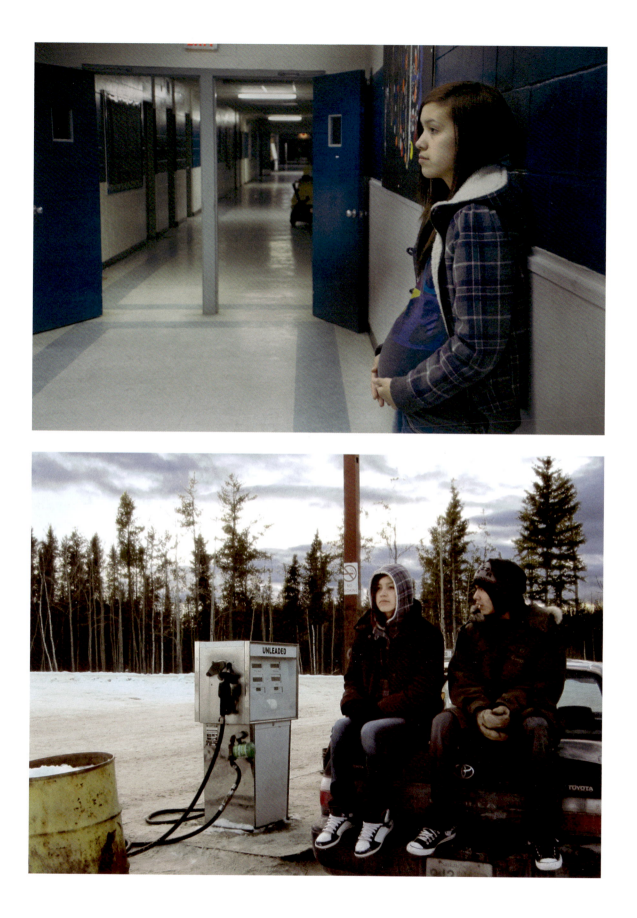

Kenneth Lavallee

Kenneth Lavallee, an artist who lives and works primarily in Winnipeg, has spent significant time going back and forth to his mother's community of St Laurent, Manitoba. This relationship to his mother's home has left an impact on his artistic practice in notable ways, highlighting a son's observation of his own mother's life experience. St Laurent is a small community located on the shores of Lake Manitoba with a sizeable Métis population. Raised by a single mom, Lavallee spent time in St Laurent with his grandparents and extended family throughout his formative years. Here he lay out under the stars looking for UFOs, played near the woods with his cousins, and swam at the beach. In Winnipeg, Lavallee passed by the mural *Peace and Harmony* on Selkirk Avenue by famed Woodlands-style painter Jackson Beardy everyday on his way to school. Lavallee draws from these diverse memories to inform his artistic practice today. His recollection of watching the night's sky has become a painting called *Milky Way* about his grandmother's admonition not to whistle around the Northern Lights. Playing with cousins near the woods is explored in the piece *The Bush*, where Lavallee depicts a memory of two threatening wolves that appeared at the tree line of the family's yard. And *Twin Lakes* takes its name from the nearby St Laurent beach area. Beardy's influence on Lavallee's work is there too, as Lavallee recognizes, in the latter's use of colour and form. In this, as in many aspects of Lavallee's practice, the artist cites his mother as influence, explaining that she had once worked at the office for the Assembly of Manitoba Chiefs and frequently collected works from artists she encountered there whose styles were similar to that of Beardy and his colleagues in the Professional Native Indian Artists Incorporation (also known as the Indian Group of Seven of which Daphne Odjig, Alex Janvier, and Norval Morrisseau were also members). Having these examples of artwork around him during his early years left its mark on Lavallee, who recalls being encouraged to create from a young age. Lavallee also recalls his mother leading by example, once taking shoe polish as her medium to paint a mural on the side of Lavallee's grandmother's garage in St Laurent.

Today Lavallee's practice focuses mainly on painting and printmaking, but demonstrates a certain affinity for large-scale mural work with examples existing across Winnipeg and beyond. His first large-scale outdoor work was painted on the side of a shed that sits on his grandmother's property in St Laurent. It is a simple painting executed in shades of blue and white, but the message of motherly care is evident even in its light-handed treatment. Titled *Mother and Son*, the mural was inspired by an event that occurred when the family was camping one summer. As Lavallee's mother returned from the outhouse she spotted a black bear and immediately moved to protect her son. Lavallee recalls the moment well, citing it as a pivotal moment. "It was probably the realest mother moment we've had,"[24] and became the impetus to create the painting. Aside from the obvious mirroring of his mother's St Laurent garage painting, his selection of a shed as canvas for his artwork is also very poignant. As a single mom raising her son and struggling with finances, Lavallee's mother had to move

home to St Laurent for a time while Lavallee stayed in Winnipeg with his aunt. The shed was built to house all of her possessions in temporary storage. Lavallee's artistic exploration of this subject expresses a reciprocal loving relationship.

The mural is painted in a manner reminiscent of classic Madonna and Child paintings. In *Mother and Son*, the mother sits with her arm around the child, pulling him close to her while looking behind them. The child, although not sitting, is situated near her lap. The act of guarding and love is clear. The mother and son are joined together by their physical proximity but also by Lavallee's choice to depict their heads together in a large halo-like circle. Formally, the circle gives weight to this seemingly simple composition but it also invokes a reference to the haloed mother and child of classic Madonna portraiture. While perhaps unintentional, Lavallee is leaning on a certain tradition and reassigning it in a meaningful way to his home, his family, and his community. As Rachel Epp Buller explains, "Psychologist Shari Thurer ... argues that the veneration of the Virgin Mary, particularly in medieval and Renaissance Europe, set the stage for a model of submissive, chaste, and sacrificial motherhood promoted for centuries to come. In advancing this narrow and essentialist construction of motherhood, historical visual representations of mothers have contributed to hegemonic constructions of maternity, allowing until recently little room for artists to picture the diversities of maternal experience."[25] Lavallee's mural subverts this classic representation of mother and child because it suggests intersubjectivity in its content. Liss

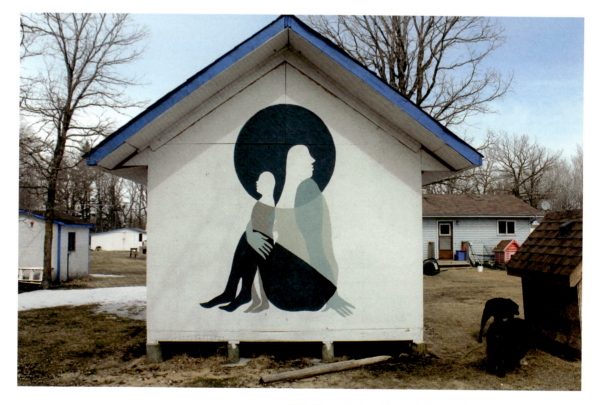

9.4 Kenneth Lavallee, *Mother and Son*, 2012.

points to intersubjectivity as key to allowing for deeper meaning in motherhood be-yond its traditional representations: "The concept of intersubjectivity not only gives the mother her own sense of agency, it also allows for infinite forms and textures of relationship between mother and child."[26] Through his choice to represent himself and his mother as the subjects of his painting, as well as recalling his mother's previ-ous artwork through his creation of a mural on the side of his grandmother's shed in his mother's home community, Lavallee seems to invoke his mother as a kind of artis-tic collaborator by exploring the intersubjectivity possible within representations of motherhood, from the point of view of the male child. Lavallee's treatment of the sub-ject, while drawn from memory and emotion, resists sentimentalizing his mother's role in his life. She may be a muse to his work but she comes across as a dynamic, fully formed woman rather than a one-dimensional caregiver.

HeavyShield, Goulet, and Lavallee, each take a very personal approach to their artistic practice and while doing so open up ways to rethink the category of mother by incorporating strategies compatible with feminist motherhood and Indigenous per-spectives. Weaving in elements of identity, community, and tradition, each artist pres-ents a glimpse of motherhood in their own way while subverting the patriarchal representations of motherhood so often found in the mainstream. While the stories they tell through their work often rely on elements of memory and experience, *Body of Land*, *Barefoot*, and *Mother and Son* resist being overly nostalgic or sentimentally trite in their approach and instead present an image of motherhood far more repre-sentative of the nuances and complexities of lived motherhood. As Liss explains, "Art and theory are sites for imagining new ways of being and beckoning previously unar-ticulated possibilities."[27] The three artworks explored here suggest to me possibilities for moving forward as a curator and mother in ways that reject the supposed taboo of motherhood in art and instead embrace new ways of operating. These three art-works lead me to believe that motherhood and a full creative life are not mutually ex-clusive, but that rather, "Sometimes these desires merge: passion for one's baby or one's child(ren) opens up new perspectives and forms of being and living, oftentimes the mother's desires collide with her artist self."[28]

NOTES

1 Rich, *Of Woman Born*, 11.
2 Ibid., 40.
3 Liss, *Feminist Art and the Maternal*, xv.
4 Rampton, "Four Waves of Feminism."
5 Iannello, "Women's Leadership and Third-Wave Feminism," 71.
6 Ibid., 74.
7 Ibid., 75.
8 Crawford, "Third-Wave Feminism," 238.
9 Ibid., xvi.
10 Ibid., 152.
11 Lavell-Harvard and Anderson, *Mothers of the Nations*, 5.
12 Ibid.
13 Ibid.
14 Hopkins and Swanson, "Artists: Faye HeavyShield (1953–)," 54.
15 Ibid., 54.
16 HeavyShield, "Traditional," 136.
17 HeavyShield, "Body of Land," 2.
18 HeavyShield, "National Gallery of Canada Artist Interview."

19 HeavyShield, "Traditional," 136.
20 McKenna et al., "Voices from Moon Lodge," 234–5.
21 CBC News, "Barefoot Explores Teen Pregnancy in Northern Sask."
22 Anderson, "Camera, a Collective, and a Critical Concern," 147.
23 Stout, "Healthy Living and Aboriginal Women," 82.
24 Personal correspondence, 24 July 2014.
25 Buller, *Reconciling Art and Mothering*, 1.
26 Liss, *Feminist Art and the Maternal*, 24.
27 Ibid., xx.
28 Ibid., xvii.

BIBLIOGRAPHY

Anderson, Mary. "Camera, a Collective, and a Critical Concern: Feminist Research Aimed at Capturing New Images of Aboriginal Motherhood." In *Mothers of the Nations: Indigenous Mothering as Global Resistance, Reclaiming and Recovery*, edited by D. Memee Lavell-Harvard and Kim Anderson, 147–59. Bradford, ON: Demeter Press, 2014.

Buller, Rachel Epp, ed. *Reconciling Art and Mothering*. Surrey: Ashgate Publishing Limited, 2012.

CBC News. "Barefoot Explores Teen Pregnancy in Northern Sask." 11 September 2012. http://www.cbc.ca/news/entertainment/barefoot-explores-teen-pregnancy-in-northern-sask-1.1230022.

Crawford, Bridget J. "Third-Wave Feminism, Motherhood and the Future of Feminist Legal Theory." In *Gender, Sexualities and Law*, edited by Jackie Jones, Anna Grear, Rachel Anne Fenton, and Kim Stevenson, 227–40. New York: Routledge, 2011.

HeavyShield, Faye. "Body of Land." *MAWA Newsletter* (Sept./Oct. 2005): 2.

– "National Gallery of Canada Artist Interview: Faye HeavyShield." National Gallery of Canada Media video, 3 January 2013. https://www.youtube.com/watch?v=vfyLIaaL6tA.

– "Traditional." In *Honouring Tradition: Reframing Native Art*, edited by Beth Carter, Quyen Hoang, Gerald T. Conaty, and Federick R. McDonald, 136–7. Calgary: The Glenbow Museum, 2008. Exhibition catalogue.

Hopkins, Candice, and Kerry Swanson. "Artists: Faye HeavyShield (1953–)." In *Shapeshifters, Time Travellers and Storytellers*, edited by Candice Hopkins and Kerry Swanson, 54. Toronto: Royal Ontario Museum, 2008. Exhibition catalogue.

Ianello, Kathleen. "Women's Leadership and Third-Wave Feminism." In *Gender and Women's Leadership: A Reference Handbook*, edited by Karen O'Connor, 70–7. SAGE Publications, 2010.

Lavell-Harvard, D. Memee, and Kim Anderson. *Mothers of the Nations: Indigenous Mothering as Global Resistance, Reclaiming and Recovery*. Bradford, ON: Demeter Press, 2014.

Liss, Andrea. *Feminist Art and the Maternal*. Minneapolis: University of Minnesota Press, 2009.

McKenna, Elder Betty, Mary Hampton, Carrie Bourassa, Kim McKay-McNabb, and Angelina Baydala. "Voices from the Moon Lodge." In *Mothering Canada: Interdisciplinary Voices*, edited by Shawn Geissler, Lynn Loutzenhizer, Jocelyn Praud, and Leese Streifler, 231–41. Toronto: Demeter Press, 2010.

Rampton, Martha. "Four Waves of Feminism." Pacific University Center for Gender Equity website, 25 October 2015. https://www.pacificu.edu/about-us/news-events/four-waves-feminism.

Rich, Adrienne. *Of Woman Born: Motherhood as Experience and Institution*. New York: W.W. Norton & Company, 1976.

Stout, Madeleine Dion. "Healthy Living and Aboriginal Women: The Tension between Hard Evidence and Soft Logic." In *Women's Health: Intersections of Policy, Research, and Practice*, edited by Pat Armstrong and Jennifer Deadman, 79–90. Toronto: Women's Press, 2009.

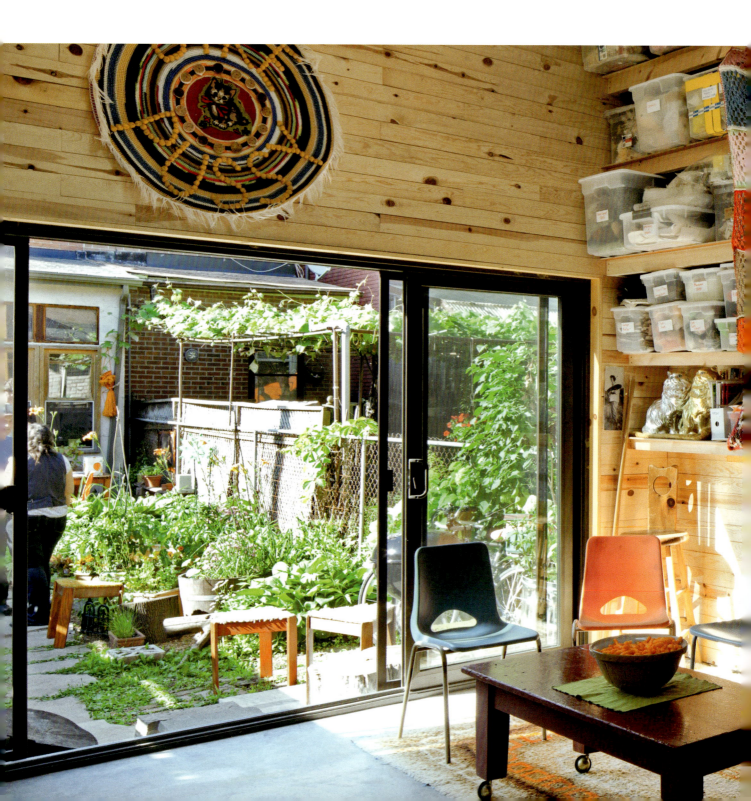

Forms of Desire
Institutional Critique and Feminist Praxis

Proposition 3: On Institutional Critique

Feminist art practices are at once an analytical and a political position. As such, feminist art has always been interested in the structural elements that condition the ways in which art is produced, accessed, and experienced. Critiquing the gated, stifling, and privileged structures of traditional art venues, such as galleries and museums, is necessary in thinking beyond art as capital to art as a valued and valuable practice within everyday life. Feminist art institutions use principles of feminist organizing through collective action to begin to build worlds of art practices that push at the edges of conventional spaces and work to transform the understandings of contemporary art. Building together has been and continues to be a central aim of feminist art practices that address not only questions of representation, but also questions of community and collective action. Contemporary institutional critique engages with the messy problems of institution building, of recognizing that we need to risk engagement by building the kinds of organizations that we want and need, from art centres to publications to platforms we haven't even imagined yet.

Kathleen Ritter in conversation with Lorna Brown, Allyson Clay, Marian Penner Bancroft, Kathy Slade, Jin-me Yoon, and Anne Ramsden

10 By the late 1980s, Vancouver, Canada, had become an important node of the international contemporary art world, characterized by a generation of artists making work that was both formally precise and intellectually rigorous. With strong ties to the universities, artists were active participants in the academic conversations of the day, ones largely informed by issues of identity and representation, the problematization of the canon, and the attack on grand narratives associated with Modernism – critiques emerging from feminist discourses. Within this milieu, many artists gravitated toward photography as a tool to critically foreground changing concepts of identity, race, and gender. In their hands, the camera was never neutral. It was a device used to unpack assumptions that were at the core of representation, and critical to both art and social politics.

A particular flashpoint for these activities was the summer of 1989, when Simon Fraser University (SFU) School for the Contemporary Arts hosted a Visual Arts Summer Intensive course led by Mary Kelly, an influential American conceptual artist, educator, and writer. Initiated by SFU faculty member Anne Ramsden, the intensive was titled "The Critical Practice of Art," and comprised a series of workshops concentrating on "issues of feminism and the implications of psychoanalytic theory in relation to cultural practice," which involved seminars and evening lectures by Mary Kelly, Victor Burgin, and Jo-Anna Isaak.[1] The first week of the intensive coincided with a course by art historian Griselda Pollock, organized by Judith Mastai at the Vancouver Art Gallery (VAG).[2]

The list of those enrolled in the intensive was impressive, to say the least, and describes a generation of artists, many of whom were women, who have had a lasting influence on visual arts practice in Vancouver and beyond. To broadly describe the art practices of this group, they were photo-, video- and text-based, heavily informed by semiotic theory, and driven by politics of gender, identity, and feminism. Their activities were not localized but in dialogue with the larger revolutionary eruptions of the late 1980s. In particular, 1989 was a year of enormous political change, from the Exxon Valdez oil spill on 24 March 1989 to the Tiananmen Square Massacre on 4 June 1989, the fall of the Berlin Wall on 9 November 1989 and the Montreal Massacre on 6 December 1989.

Little has been written on this moment in Vancouver's art history, and yet it looms large in the collective memory. It was a formative time for many artists in the early stages of their careers, and there was a resurgence of organizational initiatives, evidenced by the number of independent arts organizations that were founded in the 1980s, such as Artspeak (1986), Grunt (1984), and Or Gallery (1983). Vancouver's position on the West Coast of Canada, flanked on one side by the mountains and on the other side by the ocean, made it geographically isolated enough that collective efforts to effect change could have a surprisingly large impact on a condensed art scene. This was certainly the case with feminism. *Desire Change* provided both the impetus and occasion to look back and take stock of a time of intense, disruptive, and divergent feminist activity in Vancouver's art community, at a time when the tectonic plates of social and political relations were shifting around the world.

On 27 January 2015, I convened several women who participated in the summer intensive – Allyson Clay, Jin-me Yoon, Lorna Brown, Marian Penner Bancroft, Kathy Slade, and Anne Ramsden – for a conversation to revisit this moment. We met over brunch in a studio in Vancouver to discuss the key issues that were motivating artists at that time, the particular work that they were making, and the legacy of this activity today. The following is an edited transcript of that conversation.

KATHLEEN RITTER (KR): Since we are all artists, I want to anchor this discussion by talking about art. I thought we could start by going around the table and asking, simply: What were you making in 1989?

MARIAN PENNER BANCROFT (MPB): The work I did in 1989 was a piece called *SHIFT*. It was a photo-sculptural piece consisting of five lecterns, the face of each included a photograph and a block of text. The texts were lists of five letter words that functioned as both nouns and verbs, such as "shift" or "dance" or " judge" or "limit," any number of those words I was obsessively collecting at the time. The images were all derived from a single, tiny, photograph of my mother and my three sisters and me. I rephotographed each face and blew it up to about 18" x 24" and then I had the text included within the body of the image by means of a transparency with the text exposed onto the prints. I was thinking in terms of authority and wisdom and knowledge; how it was received and how it was given and who normally gave it.

LORNA BROWN (LB): In viewing the work, you had to stand in front of each lectern, which was important. So in relation to the space, you were immediately put into this position of the speaker.

MPB: Yes, you were meant, in a way, to become the speaker. It's curious now when I think about it … My father who took the photo was also a professor, so I think it was in some ways a gesture of taking that authority and spreading it around amongst the women in the family. [laughter]

10.1 Marian Penner Bancroft, *SHIFT*, 1989.

JIN-ME YOON (JMY): At that time I was a student at Emily Carr. I was trying to fig-ure out this relationship to the body and phenomenology and semiotics, how things made meaning in an arbitrary way, but always in relation to power. So I was mak-ing these works that were very direct. I was literally lying down on big pieces of black and white photo paper, making giant photograms. It took a lot of experimen-tation, but I figured out a system, a really rudimentary apparatus in order to pro-ject images onto my body. Over the outline of my body, I inserted images of the city and family photographs of my childhood. I have very few images of my childhood in Korea because there weren't many photographs circulating at that time. When I look back, I realize I am still grappling with similar things in terms of a kind of phe-nomenological relationship, one that's actively involved in history and the moment, socially and politically.

LB: In 1989 I had just finished a piece called *Mobility*. It was two photographic en-largements on photo-sensitive Mylar. It is an obsolete process now, unique in that you could see the image on either side, so when it hung in a space, it had a sculptural feel. The photographs were accompanied by an audio track. I'd had a longstanding inter-est in sound and the social dynamics of sound in space. There was a new phenomenon of cell phones on the street and I noticed that when people saw someone speaking on a cell phone, they would leave a big aural space around that person. It really disrupted the way people moved on sidewalks. So I was walking down Robson and I saw this guy on the top of the stairs at the Vancouver Art Gallery and he was talking on his

10.2 Jin-me Yoon, *Souvenirs of the Self* (Postcard Series), 1991.

cell phone and walking and pacing. I took a photograph of him, a very grainy photograph from a distance. Then I staged a photograph of a volunteer, a woman speaking on the phone – a landline – in the office of the Contemporary Art Gallery where I was working at the time. It was my voice on the audio track that played alongside the photographs, but it was meant to sound like her on the phone. She was retelling the story of Daedalus and Icarus, but in a really vernacular way.

KATHY SLADE (KS): I was a student at SFU in 1989. I'd been making work that was connected to literature. I was interested in blurring the boundaries between art and text, reading and seeing. So I found situations in narratives where an artwork would occur. I would then reinterpret or recreate the work, usually a painting or a sculpture, which was described in the text. I was working primarily in photo-collage so I would laminate photographs on canvas and frame them like paintings. Working from a feminist perspective, I focused on novels written by women for women. The work I presented for the intensive was a bit of a departure. I was working with ideas around photography, sculpture, monumentality, consumerism, and gender stereotypes. I made a work where I printed photographs onto marble. I enlisted the help of male friends – artists and writers – to pose nude and to assume "feminine" postures or engage in domestic activities. For example, there's one of a poet and he's naked and ironing a shirt, or another, a film critic taking a bubble bath, and another reclining like an odalisque. The photos were collaged with images from art history and fashion magazines and were erotic, bordering on pornographic. The piece was called *Deliberate Transgressions*, and it was very much a student work.

ANNE RAMSDEN (AR): I was working on two things at that time. I was working on a project for an exhibition at Powerhouse Gallery, now La Centrale, in Montreal and the show was called *Legitimation*. The work was about the idea of the museum and the collection – themes that continue to hold my interest today. The piece was called *Scent* and I was interested in creating a very loose narrative in the way that the viewer encountered the work, through an accumulation of objects. It was a fragmented work. At the time, there was a modernist discourse in Vancouver that proposed the idea of "the unified object," and this implied a certain kind of viewer and certain subject position. I was quite consciously making a work that was *not* that, and one that had a lot to do with the idea of the gaze. The work centered around the Metropolitan Museum in New York and their Egyptian collection. One of the elements was a take-away card that had words printed on it in silver ink, like "spectacle" and "specta-tor," words having to do with vision and the gaze, with looking. Glued to one of the three walls were strips of mirrored Plexiglas six feet high and half an inch wide, about six inches apart, so there was a mirror effect where you could partially see your re-flection. It was about the broken up or fragmented image, but also an image formed from this partially reflected experience. On the other side I had silkscreened an image onto Plexiglas, originally a photograph showing women in nineteenth-century dresses looking at exhibition cases. So the work was about looking very closely at objects.

I had also just finished doing a residency at the Western Front where I made a video work that was produced by Kate Craig. The video had almost no narrative at all; it was called *Urban Geography*. It was a story about a woman who comes to Vancouver and she has an assistant who is showing her around the city to look for places to shoot a film that she's working on. There is a lot of random footage driving around Vancouver, going to a used lumber yard, driving through Burnaby streets, to the Dr Sun Yat-Sen Classical Chinese Garden, etc. There is one scene set in a junkyard where the assistant is reading from a book about Godard, a passage about *La Chinoise*, and it was just after Tiananmen, which ties in, but it's very fragmented. I could hardly say there's a story there, but it's based around these women and the city.

Right
10.5 Anne Ramsden, *Urban Geography*, 1989–90.

Opposite
10.6 Allyson Clay, *Loci #1*, 1989–90.

Allyson Clay (AC): The work I made in 1988 was called *Lure* and I had shown it at Artspeak. It was composed of four small abstract paintings that were meant to be kind of reductive icons of Modernism. One had a square, one had a checkerboard, one had stripes, and one had kind of a labyrinth shape. Across the room were four texts; each text was matched to the painting directly across the gallery space from it. The texts described how you could make the corresponding paintings. They were recipes essentially: a recipe for a chequered painting, a recipe for a cross painting, etc. I was trying to work against precepts of this kind of Modernism that you referred to, Anne. However in the middle of these instructions were breakthroughs of subjective text, which were fragments of stories, or of situations. In certain sections of each text what you read made no sense as a straightforward recipe. You would be reading something like language poetry, although I hesitate to call my work poetry. There was an interplay between the recipe for making work, the instructions that one was supposed to follow to make an artwork, and the subject who brings to that making process some kind of disruption or disorder or disobedience.

This performance takes place in a lighted interior space with any number of entrances, exits and/or windows. This performance involves one person and incorporates a given object. The audience does not enter the room, but is outside the space, which has closed doors. There need not be an audience. The object can be any one of the following items: a cordless steam iron, avulsion a can opener either electric or awaken manual, a salad bowl full of water a propulsion of sleep, a highball size glass, empty, but not necessarily clean, myopia-touch a rubber doorstop, a battery powered screwdriver, marked with want; sharp, warm, resound, a handful of nails or screws, a sponge, grounding, winding, a full container of milk, she speaks a jar of wild honey his tongue, a pair of wooden chopsticks, in flux a spoon, cacophonic an electric beater, with a cord or cordless, his body a handwritten recipe, invisible in loss a handful of messages, gestures mistaken for passion, a small bowl of coriander seeds, laughter, impletion, visibly regenerative in her, a cactus plant, indulgent she poured it into the water, an aromatic scent filled the room while steam coated the mirror. She drew a thought bubble on the glass around the word penis. The performer enters, closing the door, and places the found object in any relation to the interior space. Leaving it behind, the performer exits the space, and closes the door.

I think it was timely that the intensive took place, because of the kind of work that Mary Kelly brought in from England and the ideas of Griselda Pollock and the importance of what was called "scripto-visual" practices that were, as we know, so much a part of feminist strategies. I was already doing that, but I didn't have a context for it. My context, the spur of *Lure*, was really Roland Barthes's *Mythologies*. It was this confluence of references that anchored me in this work.

It was 1988, and I was hired at SFU. I was terrified that I knew nothing, so I was quickly reading all the structuralist semiotics that I could possibly read. Kathy was there and I thought, "These kids, they know so much." I felt like I had to really behave like a teacher. [laughter]

KS: Ha! You told me that years later!

AC: Anyway it was really exciting, Anne, when you came in and you were asked by Grant Strate to organize a visual art component for an "arts festival" he was interested in doing at SFU. Anne's interpretation of an art festival was to create the kind of thing

we would want to do for our own research. So she had devised the summer intensive, which was brilliant.

KR: I've just realized that out of the six of you, five of you were working with pho-tographs, five of you were working with texts, and four of you were working with photographs and text together. So I think we need to return to this question of a "scripto-visual" schema later in our conversation. But before we get there, I'd like us to set the stage. How would you describe the scene in Vancouver in 1989? And how did the summer intensive come about?

AR: Well, Judith Mastai started to work at the Vancouver Art Gallery in 1988. And soon after she created a women's committee and asked me to be on it. It was the end of the summer in 1988 and I was just starting to work on the summer intensive. Mary Kelly was doing a residency at the Banff Centre at the time. So when I started to tell Judith what I was working on for the summer intensive, I think she just got in her car the next day and drove to Banff.

MPB: Yes! She met Mary in Banff, and they got on like a house on fire.

AR: Judith didn't really know anything about Mary, and I don't know what her in-vestment in feminist ideas at that point had been, but being Judith she was like, "this is interesting, this is what has to happen." She just intuited that this was an impor-tant person and that, in her role at the VAG, there was something that she could do there, which would intersect with the summer intensive.

MPB: Judith's position at the Vancouver Art Gallery as the Head of Public Programs was at the same level as the senior curators. So she had a lot of power there.

AC: Right. Judith spoke about locking horns with the curatorial people at the VAG. You know she had such a strong personality. And a real go-getter attitude, like "why do you sit around humming and hawing? Just make it happen." I admired that.

MPB: She had a lot of courage.

AC: Anne, how did Mary Kelly's name come to you as the person who was going to anchor this?

AR: I had communicated with Mary because when I was still working in Montreal, she did an interview for *Parachute* magazine. And when I was doing sessional teaching at Concordia, I had invited Griselda Pollock to come and give a lecture in 1986. I re-member that it was in a big auditorium that was packed – there was a huge amount of interest in her work. So when it came time to organize the summer intensive, I was thinking about that notion of a critical practice as something that was really current,

and a paradigm that I was interested in working out of myself. So we subtitled the summer intensive, "The Critical Practice of Art."

LB: 1986 was a big year for Griselda Pollock. While we were students at SFU we had a reading group that ran parallel to the curriculum because there wasn't any discussion of gender or identity politics or feminism or really much of anything in the curriculum at that time.

KR: This was something you organized on your own?

LB: Yes. It was the women students, of which we were the majority. [laughter] Me, Carol Williams, Margot Butler, Kati Campbell, Katherine Cowie, Judy Radul, and Donna Zapf. I think the reason we gravitated towards Griselda Pollock in contrast with someone like Linda Nochlin was because her approach was to work within the context of the social history of art. This was a big part of the program at SFU and the way Art History was taught: the arts in the context of social history. Pollock was making challenging claims within that discourse, but had legitimacy and credibility in terms of Marxist analysis. Her approach to feminist practice was that it is inadequate to just add women to the canon and stir.

AC: Which is Nochlin's approach.

LB: Exactly. Rather it is necessary to critique the formation of the canon altogether, to critique the discourse of Art History. Then it becomes a project that is not just pertinent to feminism, but to many other kinds of analysis.

AR: Right. In *Old Mistresses* Pollock and Rozsika Parker made the argument that the question, "Why have there been no great women artists?" was not appropriate or helpful. Instead we must reframe the question: "Why were the conditions of production not appropriate for producing women artists?" Women were not allowed to attend life-drawing classes, for example, when the depiction of the body in a certain way was the criteria of being a great artist. When I think of lightbulb moments in my life, reading *Old Mistresses* was one of them. Having an articulation of a position, which was analytical and critical of not just Art History, but the conditions of women artists working, was the first time I had encountered that. It was liberating.

JMY: I was an imposter at the talk with Griselda Pollock because I wasn't on the list. So I said I was Mary Kelly to get in. [laughter]

MPB: What a Korean name, Kelly! [laughter]

JMY: I was just busting in, I thought: "I deserve to be here. I want to be here. I'm going to be here!" You just had that kind of attitude. Now I would give that student

hell if I had someone like that in my class. [laughter] But seriously, as a student, it clicked in a certain way to this milieu that you're describing. I think it was so rich, because you really felt that it was inclusive and also porous. And there was agitation happening. Sexual difference and gender wasn't the only agenda, there was the local but also the global, the diasporic. It was an intensively generative moment. It was a moment when you felt as a student you could say, "I would like to propose that these things are also studied." You made it happen. You felt compelled. And whether you felt like you had agency or not, there was something going on that you felt you needed to contribute to.

MPB: I think *agency* was the key word of that time. There was a growing realization that you could make things happen. We were setting an agenda.

LB: Well that's the time when a lot of artist-run centres began. Laiwan had started the Or, Cate Rimmer had started Artspeak. There was a sense of, you know, "Why have you not started your own non-profit society?" So, everybody did.

KR: This period in Vancouver's art history is legendary. I'm impressed with these initiatives: the summer intensive, parallel reading groups that focus specifically on gender and the absences from regular curriculum, and the Women's Program Advisory Committee at the Vancouver Art Gallery. What struck me about this period – and why I wanted to focus our discussion on it – is because this explosion of activity seems unique. I can't imagine it happening today. My question is, was there a sense that there was a larger, more coherent, perhaps even unified, feminist project happening at that time? Or was it much more dispersed?

AC: Looking around the table I see some of you shaking your heads, but I think Judith was trying to make it unified.

MPB: Well, she was reaching out and connecting the Vancouver Art Gallery to artists and theorists from different places.

AC: She was trying to unite certain people in discussions, but I don't think it was unification.

LB: If that was the agenda I don't think it succeeded because I was on that committee too and I remember some really serious conversations, not confrontations per say, but …

MPB: … definitely polarized.

AC: … fraught.

LB: Yes, serious conversations about "feminisms." [agreement]

JMY: I think what you were saying earlier about the conditions of production and difference was definitely being highlighted. That's where there was a sort of paradox because Mary Kelly really took on Modernism and Griselda Pollock was looking at the structures in which women were systematically excluded. It opened the door for all sorts of differences in terms of queerness, in terms of race, and in terms of postcolonial discourses.

That's what was exciting, even though it was intense because they were emotional discussions, not just intellectual, but completely embodied, like you were on fire. You felt it because you wanted to be beside each other while there were still major differences in opinion, in thinking. But I think that was very productive and positive. It was hard, but you could hold those differences together at the same time. There was a sense of purpose. Because there was something to really push against. It was like genital panic.[3] [laughter]

AR: I know that board of the Vancouver Art Gallery wasn't always very happy with this idea of public discourse. They didn't like the Women's Committee. Some of those board members would mock the idea of the Women's Committee. They would say, "Why do we need it? We don't need it."

LB: It was like that with the whole discourse of "affirmative action," which also came up in discussion with the Acquisitions Committee. Whenever gender was brought up at the collection, it was the same thing. "Well, we don't need any affirmative action."

KR: To return to my question of whether or not there was any coherency in the feminist activity at that time …

LB: Don't be ridiculous! [laughter]

KS: No, I don't think there was, but there was a sense …

MPB: … there was a community.

KS: There was a sense of activity and a sense of energy around these questions. I felt I was part of a loose community of artists, students, and poets such as Catriona Strang, Dorothy Trujillo Lusk, and Lisa Robertson. We were reading some of the same books, like Djuna Barnes's *Nightwood*, and looking at each other's work, and collaborating.

AC: There was definitely a sense of urgency.

JMY: There was a kind of "I'm not going to take this anymore" attitude, and I think it was important that it wasn't unified. There were cross-currents and there were other

ways these histories would be worked through or layered. There was also a real questioning of the lineages the Vancouver Art Gallery attached itself to in terms of gender but also in terms of the Eurocentric colonial discourse. And that was happening at a time when you felt like you could be brave, really.

AR: I think one of the things that came out of the summer intensive was a kind of reinforcement of the notion of the empowered voice from a gendered position, from an ethnic position – the importance of public discourse, public space, and being there. I find that lacking in general now everywhere … I say that, but then I have to contradict myself because we've had the Occupy movements and that was exactly, finally, trying to recreate a notion of public space as a space of discourse, which means discussion and conflict. So even though there wasn't a unified feminist community here in the '90s, let's say, there was a *disunified* community, because everyone acknowledged that the presence of these conflicting voices was important.

LB: And there were different, duelling reading groups. There was the Lacan group, there was the Freud group, there was the Foucault group, and they got together and had meetings about the stuff they were reading.

KR: I wouldn't want to see that duel. [laughter]

AC: I remember walking around East Vancouver exchanging photocopies and thinking that it was a really subversive activity. [laughter] This was before the Internet of course.

AR: When I was hired at SFU and I was presented with the curriculum that I had to deliver, I remember thinking, "Ok, well, I have a lot of reading to do." But at the same time, I thought "How can I start changing this?" Maybe introducing a chapter from *Old Mistresses* or from Simone de Beauvoir or somehow rearranging the curriculum, slowly. Critical theory was also a tool, but the question was how to rearrange the curriculum and intervene and subvert it.

KS: Before Anne, Allyson, and Elspeth [Pratt] started at SFU – all within a year or two, it was an all male faculty. Before the artist was quiet during crits and didn't speak until the end. I remember, Anne, you asked me a question in the middle of my crit and I was like, "What? I'm supposed to answer now?" But it was really important to learn a new model that was more about discussion of ideas and less about the group figuring it out, as if that was some kind of mark of success, like a game. And what about Mary Kelly's crits! She took it to a whole new level.

LB: Her critique method was huge.

KS: You start with describing what is in front of you, no judgment.

MPB: The non-mimetic signifiers … This was my favourite phrase! [agreement] I would start off crits with my students and say, "Ok, we are first going to consider the non-mimetic signifiers," and I could see them all rebel. "Wait a minute," I would explain. "It's simple! It's what you can see. What you all agree about. It's starting from the outside in, starting with what you are all actually experiencing." That was a huge takeaway for me.

AR: It was about looking, really looking closely. A close reading.

LB: Those conversations were really interesting. I remember the discussions, usually in a crit context because there were some pretty solidified points of view about materialist practice pushing up against psychoanalytic theory.

KR: So, if I understand correctly, the summer intensive was organized like a seminar, you assigned readings, and you did crits of the artwork you were making at that time.

MPB: Yes, it was five days a week, for three weeks. And we all brought our work in.

AR: For the first week Mary had a talk every afternoon with readings and then she did the crit of artworks.

KR: How did the reading that you were doing at the time inflect your interpretation or your analysis of the work that you were making? Did it inform how you talked about art during those crits?

JMY: She didn't try to squeeze it into a psychoanalytic reading, if that's what you mean. That would have been too literal for Mary. It was just non-mimetic signifiers, and looking closely.

MPB: And from there we could see what would come to the surface, which allowed us to understand the layers in our own work.

LB: And then when interpretative speculation builds, you would bring it back to "Where is this located in the work?" So you were always pulling it back to its material.

KS: She would often say, "This is going too far," if you couldn't bring it back to the work.

MPB: *Overdetermined*, that was the word she used. It was like finding a new language for the things you intuitively understood, but hadn't been given the terms before. She provided this kind of articulation. I was grateful for that.

AR: It was very structural, her way of working.

KR: I want to talk about some of the ideas that came up in the conversation between Mary Kelly and Griselda Pollock at the Vancouver Art Gallery. In the transcription of their conversation,[4] they come to heads at a certain point when Kelly rejects any notion of coherent feminist practice – which is really consistent with how you've described the art scene at that time – in favour of something that she calls "feminist interventions in art practice." I'm curious about that phrase. To what extent did you think of the work that you were doing as a kind of intervention?

LB: Speaking personally, I don't. I didn't think of my work as an intervention into anything in particular. I felt like I was in it, like I was part of the art community. I would have conversations about my work or shows with people who were women, but who were not necessarily making work about gender or feminism. So it didn't feel like I was intervening per se. And, you know, intervention is a militaristic term. But on the other hand, I was very conscious that the work I was doing was unintelligible to some artists within the community. It was a blind spot. I could tell from comments that I received from some people that the work that I was doing was operating in some kind of blind spot in relation to a lot of other practices.

AR: I think blind spot is a really interesting phrase for something that this disunified feminist community was thinking about.

MPB: And I think artists were also using photography in new ways that had not been completely taken over by men, and that were not so burdened by history. This was Hal Foster's point about postmodernist practices: women were able to move into certain areas of art making without the burden of the historical.

LB: Like the troubled relationship to painting.

MPB: Yes, especially painting and sculpture. Which was completely identified with history.

LB: Right, you always had to work with this history, but needed to take it into account and feel the burden of that conversation.

MPB: Conversations could be new within this combination of photographs and text and sculpture.

KR: What also strikes me about the way that many of you were using a camera at the time is that it was never neutral. It was never a neutral device, but it was always implicated in the power dynamics of looking; it troubled the act of looking.

AR: Especially in thinking about the gaze through that apparatus.

AC: Plus Victor Burgin came along. And Laura Mulvey passed through town. And there was Kaja Silverman at SFU.

AR: But to get back to the idea of feminist intervention in art practice, I didn't recall that explicit phrase. I think it was about finding another way to express making art that didn't necessarily claim to be feminist art because of the way that expression becomes …

MPB: … limited.

JMY: … essentialist.

AR: Yes. Limited by the media or just pushed aside.

KS: It gets put into a blind spot.

AR: Exactly. So it was a really useful way of thinking about making art that's informed by a feminist position. But, on the other hand, not having to say explicitly, that I make "feminist art."

LB: Precisely. This term was reductionist because it pretended that feminism wasn't a school of thought. Nobody was claiming that they made "socialist art" or "structuralist art." It was not looking at feminism as a body of thought, but in the most reduced, stereotypical, twat-shot way, right? [laughter]

MPB: Well, the whole idea of essentialism was key at that point because there were *feminisms* and there were certain feminist trajectories that we weren't embracing.

JMY: Absolutely.

KR: Other terms came up in Kelly and Pollock's discussion that struck me as particular, such as "dis-affirmative" or "agitational" practices. Both of those terms speak to a sense of opposition – contrary to the canon, to what's considered normative or celebrated. Did you think of the work that you were doing as oppositional in any way?

MPB: Disruptive more than oppositional. Disturbing the surface to try and de-centralize. For me it was a desire to mess up that kind of unified presentation and acknowledge diversity; that a number of authorities can coexist.

AC: I actually did see my work as being interventionist in gesture. I think I was really self-examining because I had avoided being one of the Young Romantics,[5] like by a hair.

LB: Whew! [laughter]

work *SHIFT*, where you could make out a certain phrase, but it wasn't continuous. You couldn't put together a coherent statement; you had to wrestle with each fragment.

KS: I came of age in the early days of Artspeak and was closely aligned with that organization. It provided a context, a kind of a testing ground for me in thinking about text and image. I was really influenced by Barthes and by the death of the author as ransomed by the birth of the reader. And I was interested in this relationship between looking and reading and text and image. I was interested in translation and moments when there was slippage or shifts. It's interesting, Marian, that you keep saying "shift" because shift is a shifter. The idea of a shifter is using words like "I" that can shift their meaning so the I is always shifting.

MPB: Well, when I used words in that piece called *SHIFT*, I was thinking about the passive and the active voice, to use old grammar terms. Put "I" in front of every one of those words and as verbs, they are active. Remove "I" and as nouns they are passive.

AR: But in thinking about the death of the author, it was also a period when there was a critique of that idea. It opened up a certain discussion, like, "Oh, so now the author is dead, just when all these other authors are allowed to speak." There was a questioning of the death of the author, which at first was a productive idea, and then the realization of the limits of that concept.

KR: In terms of the use of text in your work, I also think about how reading generally directs or instrumentalizes vision, especially in the media. Whereas your use of text and image in tandem instead destabilizes vision and makes the viewer reflect on their own critical position of looking. Which very much comes out of a feminist critique of representation: the idea that looking is never neutral.

MPB: I think of that quote of John Berger's at the end of *The Uses of Photography* where he says there is never a single approach to a thing remembered, there must be radial approaches: the economic, the social, the personal, the historical. I'm paraphrasing, but that to me was a very significant position to take.

LB: I was thinking about language in terms of writing but also in terms of speaking. Kaja Silverman, in *The Acoustic Mirror*, talked about breaking the diegesis of film by separating the image from the sound and making the image static, how this gives the voice a privileged place in comparison to the image.[6] This takes apart the seamlessness of film and other media. *The Acoustic Mirror* was a really important book for me because she talked about how recorded voice can bring embodiment along with it without representing the body visually, and that was really key. I was also reading a lot of feminist literary criticism about how to create women's subjectivity within fiction and within other forms of writing, so that was generative in terms of thinking

MPB: Yes. Because Vancouver is such a young city, all of the issues around immigration were still very visible and present. These were issues I was working on before Mary Kelly arrived. So then it became part of that discussion.

LB: I thought that because there were a lot of lenses in terms of thinking about whether or not something was an intervention. There was a lot of conversation about politics of representation in terms of gender and other visible differences, so that was one set of things that you had to contend with if you were working with photography or you were representing the body.

JMY: Yes, with any depictive medium …

LB: But my memory of it is that when I imagined an audience, it was women. It wasn't like I imagined men looking at my work. I imagined other women and that community. I think that's who I made the work for.

JMY: And there was so much discussion with AIDS then too. I took a year off and lived in New York briefly during the '80s when people really didn't know what was going on and people you went to school with were dying.

KS: Act Up and Gran Fury, all those strategies. General Idea's AIDS poster …

JMY: Right, and masculinity was being questioned too … Black masculinity, the controversy around Robert Mapplethorpe's work. And Adrian Piper's work *Mythic Being* in the early '70s. There was all this work that happened into the '90s with people dealing with racialization and sexuality. There's a lot of people working in this community as well; working on postcolonial discourse, such as Laiwan, from way back. So it was complex, but that's what I value about this place. Because it keeps you on edge in a way that's positive. It keeps going because you've got your own blind spots.

LB: Yes. It's about curiosity.

KR: We've talked about photography and about painting. I'm wondering if we can return to this question of "scripto-visual" practices. Almost all of you have used text in your work during that period. Can you talk about why? And how?

MPB: I think some of the debates that were going on in visual art were also going on in the world of poetics and poetry, particularly among the Language poets. For me, it was pivotal to not take words for granted but to be able to defamiliarize certain linguistic tropes and pick them apart and reconfigure a use of language that was not dependent on metaphor.

It was in the mid-1980s when I began to use language in a particular way, as an image, with words having more weight than readable text. I extracted pieces of text, like in the

work *SHIFT*, where you could make out a certain phrase, but it wasn't continuous. You couldn't put together a coherent statement; you had to wrestle with each fragment.

KS: I came of age in the early days of Artspeak and was closely aligned with that organization. It provided a context, a kind of a testing ground for me in thinking about text and image. I was really influenced by Barthes and by the death of the author as ransomed by the birth of the reader. And I was interested in this relationship between looking and reading and text and image. I was interested in translation and moments when there was slippage or shifts. It's interesting, Marian, that you keep saying "shift" because shift is a shifter. The idea of a shifter is using words like "I" that can shift their meaning so the I is always shifting.

MPB: Well, when I used words in that piece called *SHIFT*, I was thinking about the passive and the active voice, to use old grammar terms. Put "I" in front of every one of those words and as verbs, they are active. Remove "I" and as nouns they are passive.

AR: But in thinking about the death of the author, it was also a period when there was a critique of that idea. It opened up a certain discussion, like, "Oh, so now the author is dead, just when all these other authors are allowed to speak." There was a questioning of the death of the author, which at first was a productive idea, and then the realization of the limits of that concept.

KR: In terms of the use of text in your work, I also think about how reading generally directs or instrumentalizes vision, especially in the media. Whereas your use of text and image in tandem instead destabilizes vision and makes the viewer reflect on their own critical position of looking. Which very much comes out of a feminist critique of representation: the idea that looking is never neutral.

MPB: I think of that quote of John Berger's at the end of *The Uses of Photography* where he says there is never a single approach to a thing remembered, there must be radial approaches: the economic, the social, the personal, the historical. I'm paraphrasing, but that to me was a very significant position to take.

LB: I was thinking about language in terms of writing but also in terms of speaking. Kaja Silverman, in *The Acoustic Mirror*, talked about breaking the diegesis of film by separating the image from the sound and making the image static, how this gives the voice a privileged place in comparison to the image.[6] This takes apart the seamlessness of film and other media. *The Acoustic Mirror* was a really important book for me because she talked about how recorded voice can bring embodiment along with it without representing the body visually, and that was really key. I was also reading a lot of feminist literary criticism about how to create women's subjectivity within fiction and within other forms of writing, so that was generative in terms of thinking

AC: Plus Victor Burgin came along. And Laura Mulvey passed through town. And there was Kaja Silverman at SFU.

AR: But to get back to the idea of feminist intervention in art practice, I didn't recall that explicit phrase. I think it was about finding another way to express making art that didn't necessarily claim to be feminist art because of the way that expression becomes …

MPB: … limited.

JMY: … essentialist.

AR: Yes. Limited by the media or just pushed aside.

KS: It gets put into a blind spot.

AR: Exactly. So it was a really useful way of thinking about making art that's informed by a feminist position. But, on the other hand, not having to say explicitly, that I make "feminist art."

LB: Precisely. This term was reductionist because it pretended that feminism wasn't a school of thought. Nobody was claiming that they made "socialist art" or "structuralist art." It was not looking at feminism as a body of thought, but in the most reduced, stereotypical, twat-shot way, right? [laughter]

MPB: Well, the whole idea of essentialism was key at that point because there were *feminisms* and there were certain feminist trajectories that we weren't embracing.

JMY: Absolutely.

KR: Other terms came up in Kelly and Pollock's discussion that struck me as particular, such as "dis-affirmative" or "agitational" practices. Both of those terms speak to a sense of opposition – contrary to the canon, to what's considered normative or celebrated. Did you think of the work that you were doing as oppositional in any way?

MPB: Disruptive more than oppositional. Disturbing the surface to try and de-centralize. For me it was a desire to mess up that kind of unified presentation and acknowledge diversity; that a number of authorities can coexist.

AC: I actually did see my work as being interventionist in gesture. I think I was really self-examining because I had avoided being one of the Young Romantics,[5] like by a hair.

LB: Whew! [laughter]

AC: One of the interesting things that came out of the discourses arising from the intensive was this show that Judith organized called *Women and Paint* and she was looking at the critical possibilities of painting, or possibilities of painting as a critical practice. And that's where she discusses how Kelly refers to "scripto-visual" techniques. I think this was an important moment for painting. Looking at these discourses in relation to painting might be interesting because one could ask, how critical is painting now? In the same way that one could ask, has all this been subsumed into another blind spot?

AR: I want to say something about oppositional work. Marian, you were saying that you thought of your practice as being disruptive … I remember that there was an alignment of feminism with Postmodernism, that I think we strongly embraced that kind of association because in Vancouver there was, and perhaps still is, a strong modernist position. And so there was a sense of eking out a different territory and an oppositional discourse. That was a conversation.

MPB: Right. There was a resetting of terms.

JMY: I think that the sophistication of the argument disallows any notion of unification – we talked about that – but also what an intervention is, what opposition is. I think even basic terms like these are always being undone, which is the deconstructive moment that we were in. But it wasn't just a way of chasing your tail around; it was because we were thinking about these things in overlapping ways, like palimpsests. We were also thinking about how we were implicated in what we were pushing against. I did see my work as interventionist in some ways, because I did feel like there was quite a bit to push against. I think that's what kept it lively. And I think that intelligence was reflected in the way people made art, like as a student learning the different strategies and it was really such a highly intellectual, but also quite emotional environment to grow up in as an artist. People took it so seriously!

AR: It was passionate.

KS: It was the '80s and when you look back on the '80s you think of feminism and AIDS. You think of Reagan and Thatcher.

AR: But you know that continued into the '90s, and it developed and changed. Maybe the word *difference* is a useful word because the differences that were at one point mostly about gender became very rapidly about the notion of the "Other," well, other "Others." It really developed within the space of a few years, into a much more diverse discourse. And Vancouver was a rich ground for that discourse because of immigration here.

about how to create a place to speak from within language without it being held down by the stereotypical conditions of the female subject in text.

JMY: I remember a lot of text works that you did. The tear sheets with the use of different initials, rather than the full name of the subject. It would always be "C," never "Caroline."

LB: I was making a place for the subject, but not revealing the total identity. For me the referents were the case study and the diary. The case study in the social sciences or in medicine protects anonymity. And the literary form of the diary, where you would refer to someone in your diary just by an initial is also a way to conceal identity.

AR: I came to use text and work in a way that wasn't entirely conscious. I was trained in a conceptual art school – NSCAD in the '70s – so I used text because that's what you did. It wasn't until later that I began to think about what that meant and how that might relate to images. One of the things that Mary was *not* doing was making images of women.

JMY: There was a moratorium on making images of the body.

AR: But that was part of the discussion ... how text is this privileged form of representation. I'd never thought of text as representation. So the issue of a politics of representation was very present within that intensive, and in general in the discourse. I mention conceptual art because that's something that Mary's work is strongly associated with. And certainly part of the discussion in the intensive was about language and representation and language and psychoanalysis.

JMY: The unconscious is structured like a language!

AR: Yes. Exactly. Those phrases. I'm sure I had dreams about those phrases. Waking up muttering that.

KS: Or as Kevin Davies said, "The unconscious is structured like a Shriner's convention."

KR: That explains so much! [laughter]

AC: For my work it was really important for the text to simply be in relation to the image, not to be a caption. I wanted to work against the caption. And when you're dealing with a two-dimensional image, you can't have a voiceover, so you can have it on top of or beside, but it's a different struggle to incorporate text with visuals and not have one dominate the other.

JMY: I was very literal in my approach because I wanted to create a kind of subjective position that knows it's being constructed, that knows that it's enfolded and exploited and dehumanized through scopic regimes and representation. It's like that kind of doubling when Frantz Fanon talks about the racialized body, or the sexualized body, the queer body, or the classed body, or whatever body that's in a scopic regime that literally flattens you. I never really bought into the idea of a moratorium on the body. I continued to use the surface of the body as a cipher, by turning myself into an object to become a subject of history. I don't disavow feminism – feminisms in the plural – because there is a kind of self-reflexivity there. I think that's important, that kind of level of doubt, constant doubt that isn't insecurity, but is a kind of productive, generative, generous doubt. I think that leaves room for the Other, that it is in relation to how you were *formed* as Lacan would say.

LB: I think there were a lot of people struggling with the use of the body. I think the degraded image was a strategy. The peeled or degraded or processed image … Or blurred. Or partial, which is something I used a lot of in my work. But the body was nonetheless something that you had to contend with. And taking the same approach to text in a sense, it was also, is also, a partial strategy. I'm thinking about the way text is used in your work, Allyson. It has always struck me as associative. I am thinking of the painted diptychs that you did where there are these phrases that are suggestive, associative, partial.

AC: I was thinking of how important the Brechtian paradigm was to the whole discourse of Mary Kelly and Griselda Pollock, so one can think of a figure in those terms, to fragment it.

MPB: So the body, your body, remains part of the conversation. I think that was one of the important things as well, that the agency of the viewer is part of the work. You don't want to lose yourself, you want to make a *place* for the viewer that's identifiable, so you don't efface the viewer and say, "It's only in the work."

KR: If you could summarize it, what is the legacy of the summer intensive?

MPB: I think it reinforced a lot of us. It gave us strength, resolve, confidence, and the ability to question and be questioned without being completely undone. We talked about the function of doubt, that was part of it. I also think of the word *courage*.

LB: I think it validated something that was already happening here. It validated and coalesced the feminist activity that was happening, so it gained a particular kind of legitimation that it hadn't had before. I think that that recognition also played out in the following years when artists like Martha Rosler came to town looking for feminists. "Where are all those feminists that I heard about in Vancouver?" Like they were on a feminist safari. [laughter]

AR: I think it produced a visible presence within the discourse in Vancouver that was there before. There was a second intensive also, which was reinforcing. I think the fact that it took place at sfu, which is an institution, legitimated it in a way that other positions were institutionally legitimated in the community. It recognized the presence of a high profile, intelligent, feminist debate that had been ongoing here for years.

MPB: Gave it form.

KS: I really felt that as a student. I was joking that Mary put me in a group with all of you, but really, it was like a validation on a personal level. I felt like there was something happening that I could belong to. And that feeling has continued.

LB: Well, I think it solidified all of these working relationships. We have since worked with one another in lots of different ways at different times.

AR: I think about that validation and how it operates in the everyday world of institutions. This is something I still think about. How are women represented in committees, or in faculty member numbers, or the fact that most of my students are women? I'm thinking quite critically about what I am teaching them, what artwork I'm showing them and who is producing it. So that consciousness has stayed with me. I think I had that position pretty well defined before the intensive, but it was a moment of people coming together.

MPB: Reinforcing each other.

AR: Yes. The language that Mary brought was really productive in terms of articulating critiques from a feminist position. It's been twenty-five years since then! Well, as a teacher, now I've gone through a stage when, maybe ten years after that, my students were denying that they're feminists and it was like an insult. I remember thinking, what happened?!

KS: I know. Postfeminism??

AR: Yes! But now, it's cycling back.

LB: There's a resurgence, a really great resurgence.

AR: You know my younger students are reclaiming the term *feminist* from a different point of view, and it's not troubled and it's very much a critical position. Meanwhile I've always tried to fight for the importance of that position.

LB: Yes, I taught gender studies after the summer intensive. It was the first course I taught at Emily Carr. After the intensive, I definitely had the sense that I could teach

it and that there was a framework for it. It gave me the confidence to be able to put up with some students in those courses that were there to just perform their resistance to the whole idea.

MPB: Gently put. [laughter]

LB: Like the guy that sharpened the arrows in my seminar.

JMY: Scary. Well, we agitated as students for those curricular changes and for those courses.

LB: Exactly. So this resurgence is really exciting and fabulous because I very well remember that era where talking about feminism was perceived as a form of complaining. And complaining meant that you were an unsuccessful artist, right? So people didn't complain. There was this perception of talking about gender in relation to culture, whether it's on this pragmatic, economic level of the gallery system, or in terms of representation in museum collections or exhibitions, or working conditions that was seen as complaining about women's lack of success.

JMY: When the market was in ascendency, I think it was a really bad career move to make pronouncements like, "I am a feminist." You wouldn't want to make such bald-faced statements anyway because we were talking about feminisms and what does that mean? But it is quite heartening today when I think of my seventeen-year-old daughter and she says, without hesitation, "Oh yeah, I'm a feminist." My nieces are in university and they're very sex-positive feminists and they don't have any problem with talking about these issues.

MPB: What do you mean "sex-positive"? [laughter] No, I'm serious. I've not heard this …

JMY: It's just appreciating your sexuality in an enjoyable way. Remember Annie Sprinkle back in the day? They're all looking at their cervix again. It's great! … But if the term *feminism* meant a kind of reductiveness, then of course, who would want that? But I don't think it ever was. It's a kind of stereotype. Who wants to be categorized? You don't want to be one thing – it's offensive. So I think that it's partly just the way that this monolith of feminism has been presented. In reality it's never been one thing. And globally, it's going on still, in various ways, all over the planet.

AC: I think that reductive definition of feminism was imposed from the outside, by the media. Everything lumped into one category.

MPB: And that definition of feminism went way beyond the confines of art making. In my activity as a feminist in the '70s with the media collective, we were dealing with

issues around birth control and stuff like that, so it wasn't limited to a visual art discussion. It was much more overtly political and sociological.

JMY: I think the legacy of the summer intensive was about making work for an art community that includes a larger public, and not necessarily feeling like you have to wait for someone, somewhere else, to come pat you on the back and say, "You're the one." And while there were hierarchies and power imbalances and those whose career is doing better than others, I think that it's instructive to remind ourselves that this is not why we make work. It's not for some other reason. It's about having certain kind of values not completely co-opted by these other conditions of production. I think that's very important. That's a legacy.

NOTES

1 Williams, "A Working Chronology," 203.

2 Participants in the intensive were Renée Baert, Marian Penner Bancroft, Claudia Beck, Jessica Bradley, Lorna Brown, Margot Leigh Butler, Kati Campbell, Anne-Marie Cosgrove, Sara Diamond, Stan Douglas, Nancy Frohlick, Don Gill, Annette Hurtig, Judi Lederman, Phillip McCrum, Joanne Ross, Nancy Shaw, Kathy Slade, Jin-me Yoon, and Donna Clark; see Baert, Bancroft et al., "Between Signifiers." Also in attendance were Anne Ramsden, who initiated and organized the intensive, and Allyson Clay.

3 Reference to Valie Export's work *Action Pants: Genital Panic*, 1969.

4 See Pollock et al., *Mary Kelly and Griselda Pollock in Conversation.*

5 The term *Young Romantics* refers to a group of painters in Vancouver in the mid-1980s, which included Graham Gillmore, Angela Grossman, Attila Richard Lukacs, Vicky Marshall, Philippe Raphanel, Charles Rea, Derek Root, and Mina Totino. *Young Romantics* was the title of an exhibition curated by Scott Watson at the Vancouver in 1985, which brought together the work of these eight young Vancouver artists in relation to Romanticism and new figurative painting, framed in terms of subjectivity and the representation of the body. See Watson, *Young Romantics.*

6 Silverman, *The Acoustic Mirror.*

BIBLIOGRAPHY

Baert, Renée, Marian Penner Bancroft, et al. "Between Signifiers." *Front* 1, no. 2 (1989): 8–10.

Pollock, Griselda, Mary Kelly, Judith Mastai, and Margaret Iversen. *Mary Kelly and Griselda Pollock in Conversation at the Vancouver Art Gallery, June 1989.* Vancouver: Vancouver Art Gallery, 1989.

Silverman, Kaja. *The Acoustic Mirror: The Female Voice in Psychoanalysis and Cinema.* Bloomington: Indiana University Press, 1988.

Watson, Scott. *Young Romantics.* Vancouver: Vancouver Art Gallery, 1985. Exhibition catalogue.

Williams, Carol. "A Working Chronology of Feminist Cultural Activities in Vancouver." In *Vancouver Anthology: The Institutional Politics of Art*, edited by Stan Douglas, 171–207. Vancouver: Talonbooks, 1991.

From Mentorship to Collaboration:
Art, Feminism, and Community in Winnipeg

Noni Brynjolson

11 Throughout most of its history, mentorships have formed the foundation of programming at Mentoring Artists for Women's Art (MAWA). They have connected established artists with emerging artists, and created a feminist arts community in Winnipeg. A diverse array of artistic projects have grown out of these mentorships since the 1980s. In this chapter I focus on one project that had its origins in MAWA's mentorship program: the Crossing Communities Art Project, which was established by artist Edith Regier in the late 1990s and ran until 2011.[1] Analyzing this project not only highlights the practical inner workings of the mentorship process, but also demonstrates some of the problematics of feminist community building. Crossing Communities was inspired by new genre public art, a term coined by artist and author Suzanne Lacy in the 1990s to refer to "art that uses both traditional and nontraditional media to communicate and interact with a broad and diversified audience about issues directly relevant to their lives."[2] While new genre public art grew out of diverse sources, one of its major inspirations was feminist activism of the 1970s, in which Lacy was involved. Collaboration and activism have become increasingly common concerns in contemporary art, with the genre of relational aesthetics gaining particular prominence in the 2000s.[3] Much of this work hints at the possibility of social change, but remains committed to the notion of aesthetics as a distinct sphere cut off from the social. In contrast, projects influenced by new genre public art, such as Crossing Communities, have attempted to stretch the boundaries between art and activism and open up new ways of thinking about community, conflict, and difference.[4] Boundaries are rarely stretched in a smooth or seamless manner, however, and it is inevitable that growing pains emerge. I examine some of these here, including critiques of community-based projects in general and Crossing Communities in particular. One point of contention involves identity-based community art projects, which are often viewed as essentializing. Another commonly repeated criticism is that leaders of community-based art projects tend to adopt the role of colonizers who condescendingly bestow art upon marginalized groups, and ultimately reap the lion's share of cultural cachet, critical attention, and grant money. It is worth looking at how such projects have negotiated these types of issues that almost inevitably arise. It is also worth highlighting the strengths of these projects, including the unique forms of activism that

emerge. According to some of the participants, Crossing Communities was frequently a site of conflict, much of it linked to disputes over leadership and creative control; yet it was also a platform that gave rise to many successful mentorships and activist projects that functioned, in part, due to the model established at MAWA.

MAWA's Origins

MAWA was established in 1984 in Winnipeg, and was initially named Manitoba Artists for Women's Art. It began as a women's program at Plug In Gallery (now Plug In ICA) and was formed to address gender inequalities in the arts and the lack of opportunities for women artists in the community. A research committee had been formed a year earlier "to look at ways of changing the perception that Plug In is an inaccessible 'boys' club' and to provide professional development support to emerging women artists."[5] From 1975 to 1980, only 38 percent of successful applicants to the Manitoba Arts Council were female. During the same period, between 10 to 25 percent of collected works in the Winnipeg Art Gallery were by women artists.[6] These statistics echo the structural inequalities that women artists have faced elsewhere, and which have not evened out despite years of attention. Concerns regarding the marginalization of women artists emerged in line with second-wave feminist organizing during the 1960s and 1970s. Around the time that MAWA was established, the Guerrilla Girls were initiating their first performances in New York City, which focused on the low representation of women in museum exhibitions and collections. In Canada, the Women's Art Resource Centre opened in Toronto in 1984, with the aims of documenting women's art, offering resources, and facilitating discussions around gender and inequality in the arts. MAWA was established around similar concerns, and its unique contribution was the mentorship program, which has generated a wide variety of relationships, collaborations, and community-building practices across generations and cultural backgrounds.

MAWA began by putting on workshops, lectures, and guest speaker events focused on women artists. In January 1985, MAWA's flagship mentoring program was initiated. According to artist Shawna Dempsey, currently co-director of MAWA, its origins were rooted in second-wave feminist ideals in alignment with a commitment to collectivism. Dempsey explains,

> MAWA's mentorship model was the brainchild of Plug In's Committee Members. Diane Whitehouse grew up working class in England and had a strong labour background. She was a practicing artist, an instructor at the University of Manitoba School of Art without tenure, and a mother, and she was really concerned about how difficult it would be for all of the young women she was teaching. She knew it was likely that, because of systemic misogyny, their careers would die. She was thinking about how to turn it around. Another Steering Committee member, Sheila Butler, originally from Pittsburgh, had a similar working-class

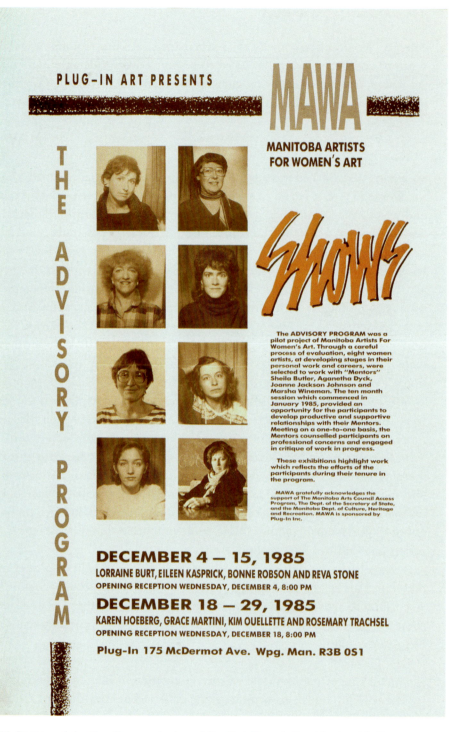

PLUG-IN ART PRESENTS

MAWA

MANITOBA ARTISTS FOR WOMEN'S ART

Shows

The ADVISORY PROGRAM was a pilot project of Manitoba Artists For Women's Art. Through a careful process of evaluation, eight women artists, at developing stages in their personal work and careers, were selected to work with "Mentors" Sheila Butler, Aganetha Dyck, Joanne Jackson Johnson and Marsha Wineman. The ten month session which commenced in January 1985, provided an opportunity for the participants to develop productive and supportive relationships with their Mentors. Meeting on a one-to-one basis, the Mentors counselled participants on professional concerns and engaged in critique of work in progress.

These exhibitions highlight work which reflects the efforts of the participants during their tenure in the program.

MAWA gratefully acknowledges the support of The Manitoba Arts Council Access Program, The Dept. of the Secretary of State, and the Manitoba Dept. of Culture, Heritage and Recreation. MAWA is sponsored by Plug-In Inc.

THE ADVISORY PROGRAM

DECEMBER 4 — 15, 1985

LORRAINE BURT, EILEEN KASPRICK, BONNE ROBSON AND REVA STONE
OPENING RECEPTION WEDNESDAY, DECEMBER 4, 8:00 PM

DECEMBER 18 — 29, 1985

KAREN HOEBERG, GRACE MARTINI, KIM OUELLETTE AND ROSEMARY TRACHSEL
OPENING RECEPTION WEDNESDAY, DECEMBER 18, 8:00 PM

Plug-In 175 McDermot Ave. Wpg. Man. R3B 0S1

11.1 Poster celebrating the conclusion of the first Foundation Mentorship Program at Mentoring Artists for Women's Art (MAWA), 1985.

Opposite
11.2 Flyer announcing the formation of Plug In's Women's Program, 1984. The first public meeting took place in May 1984.

background and a knack for fundraising. Both had experience growing up within labour movements and seeing how collectivism could change inequality. They viewed mentorship as the most effective way for senior artists to give emerging artists all the tools they've learned, so that each woman is not reinventing the wheel anew.[7]

The model of the organization is based on the idea that "mentorship, as a non-hierarchical, peer-based system of learning, is key to passing information, experience and confidence down from one generation of women artists to another, strengthening both artists simultaneously."[8] The first mentorship program featured four pairs of artists and culminated in an exhibition of work by the mentees at Plug In Gallery in December 1985. MAWA became an independent organization in 1990, and was renamed Mentoring Artists for Women's Art. Over the years, these relationships have helped young artists gain a footing in the local art community, receive exposure for their work, and develop their material and theoretical approaches to art making. The focus of its programming remains on anyone who identifies as a woman (as opposed to organizations like La Centrale gallery in Montreal or Feminist Art Gallery in Toronto that are open to anyone who identifies as a feminist). While trans-identified individuals who identify as women are welcome, they have not been actively involved.[9]

MAWA

MANITOBA ARTISTS FOR WOMEN'S ART

(FORMERLY THE PLUG-IN WOMEN'S PROGRAM)

NEWS RELEASE

MANITOBA ARTISTS FOR WOMEN'S ART is a new organization committed to the support, encouragement and exposure of women artists. The objectives of the organization are to encourage greater communication among women artists in the community and to create a new forum for the exchange of ideas and expression of concerns.

During the upcoming fall and winter MAWA will be putting on a series of events such as workshops, lectures and panel discussions which will examine and address issues of concern to women. As well, the organization will be generating exposure for women's art through exhibitions in new venues, and will be making available information resources on the contemporary arts.

Membership to the program is open to all those interested. For further information on memberships or upcoming events, contact Plug-In Gallery, 175 McDermot Avenue, 942-1043.

11.3 News release announcing that Plug In's Women's Committee will henceforth be known as MAWA (Manitoba Artists for Women's Art), August 1984. In September 1990, MAWA became an independent organization and changed its name to Mentoring Artists for Women's Art.

Mentor, Mentrix

What is a mentor, exactly? The figure of the mentor as educator and role model has existed since antiquity: the relationship between Socrates and Plato being a prime example. Not surprisingly, the etymology of the term displays a paternalistic bias, and the history of mentorship could be described as the history of men passing along their knowledge and power. The Latin term is composed of *men* – one who thinks – and *tor* – its masculine suffix. The feminized *mentrix*, woman who thinks, is not in our common vocabulary. Mentor was a minor character in Homer's *Odyssey* who provided wisdom and advice to Telemachus. The term did not come into popular usage until the seventeenth century though, when French archbishop and poet François Fénelon published *The Adventures of Telemachus*, in which Mentor is portrayed as a wise, elderly figure who teaches Telemachus how to be an ideal ruler.

As well as its pedagogical usages, today mentoring is a common practice in the business world. Successful CEOs take juniors under their wing to impart tricks of the trade, advise them on business matters, and introduce contacts. Mentorships are as much a part of professionalizing as internships: they create networks and build resumes. This is true of the mentorships that take place at MAWA, since they are intended, in part,

to advance one's professional career and status as an artist, perhaps leading to an exhibition, review, or job. Like Fénelon's Mentor, MAWA's mentors are trusted advisors who offer wisdom based on experiential knowledge. However, they also rework this classical model in significant ways. The mentorship model was developed at MAWA to address structural inequalities, not to advance power structures. Mentorships often have the effect of advancing individual careers, but this is not their sole reason for existence. MAWA aims to foster professionalism, but focuses on the self-defined goals of women artists. Its mentorships are formed around the transmission of knowledge from one woman to another based on technical expertise, practical concerns, and lived experience. However, there is also recognition that mentees are not empty vessels to be filled with knowledge. Instead, according to Dempsey, they "bring the perspective of their generations, and the energy and the perspective to say that it doesn't always have to be this way, we can change our practices and habits, which is really informative for the mentor as well."[10] Mentorships at MAWA are not solely about professionalizing, but instead, about strengthening the group and building community, and this comes by addressing issues and injustices specific to its constituents. Mentorships at MAWA might be seen as offering a distinctly feminist take on the age-old model, boosting the careers of individual women artists, but also becoming the building blocks of community. The mentorship model at MAWA is a product of second-wave feminism that seeks to redress structural inequalities around women in the arts. MAWA mentorships place women in positions of power that have historically been less available to them; yet they have also become catalysts for discussing localized gender inequalities. They have evolved to reflect the idea that abstract notions of social disparity are experienced in particular, concrete ways in everyday culture through intersections of gender, sexuality, race, ability, and socioeconomic status. How has MAWA's model been put into practice, and what are the products of feminist mentorships? Throughout its history, MAWA has nurtured hundreds of mentorships between women. Some have led to lifelong friendships, others have been maintained on a solely professional level, some were less successful and did not last. I turn to one project in particular now, which began as a mentorship and grew into a collaborative, community-based art project.

The Crossing Communities Art Project

In 1994, artist, theorist, and psychoanalyst Jeanne Randolph mentored several women at MAWA, including artist Edith Regier. Interested in prisons as sites of power and marginalization, Regier and Randolph began to visit youth correctional centres. Following this, Regier established an art program at the Portage Correctional Centre in Manitoba (a women's prison) that ran from 1996 to 1999 and involved weekly art workshops. She then developed a project titled Passing Pictures with Prisoners that was "designed on the methods of dialogue between senior artists and emerging artists that is the core of MAWA."[11] The project involved mentorships between four local artists – Connie Cohen, Colleen Cutschall, Shawna Dempsey, and Debby Keeper –

and six imprisoned women: Pat Aylesworth, Wendy Cook, Yvonne Johnson, Amanda Lepine, Erica Monias, and Michelle Nepinak. In the book that documents these exchanges, *Passing Pictures with Prisoners*, the artwork consists of drawings, letters, and poems. Some works are individual creations and some are collaborative – these are described as having been made "in conversation with" a particular artist. The book contains four essays, in which each writer was asked to respond to a different artist–prisoner exchange. In "Lost Objects/Lost Words," art historian Dot Tuer reflects on the exchange that took place between Connie Cohen and Yvonne Johnson. Cohen and Johnson exchanged letters and created dolls for each other. Johnson made a ceramic baby held together by a spare, wooden frame, while Cohen's doll was made of wrapped bandages on which a poem was written. Tuer wrote that these objects "reminded me of a voodoo doll, an object of sympathetic magic which passes consciousness from one site to another without contact."[12] She suggests that consciousness may be embedded in a material object, and implies that this object initiates communication and dialogue even without direct contact having been made between the women.

Regier describes the exchanges that took place as a kind of "visual listening," which involves "using art not as a mastering of formal concerns but as the action and the document of the communication made visible between the maker and the receiver."[13] This statement highlights the approach towards art making that Crossing Communities would take over the next decade, which involved established artists working with participants who had varying degrees of experience making art. The mentoring artists may have possessed more technical skills and a greater awareness of art history, but the exchange of knowledge and ideas worked both ways. While the relationships that developed at MAWA were conceived of as mentorships, Crossing Communities began with this model and then attempted to reconfigure them as collaborations. The artworks that emerged as documents of this communicative exchange, including *Passing Pictures with Prisoners*, illustrate a concept that is fundamental to new genre public art: the aesthetic sphere is not isolated from but is in fact inextricably linked to the social and political concerns of everyday life.

In 2000, Regier started the Crossing Communities Art Project, opening a downtown art studio for clients of the Elizabeth Fry Society, an advocacy organization for women and girls in the justice system. Crossing Communities continued the work that began at the Portage Correctional Centre, but involved women who had been in conflict with the law and were no longer incarcerated, more participants, a wider range of media, and a greater emphasis on collaboration and activism. A video project by Crossing Communities titled *Butterfly* exemplifies the working process that developed as the organization grew. In 2007, several participants created the piece during workshops facilitated by artist-mentor Jess MacCormack. In the video, faces of missing and murdered women in Canada were collaged into the form of butterflies, which flutter against a blue sky. The soundtrack was provided by Pat Rix and the Holdfast Community Choir, an Australian group of artists with disabilities. The jarring, anguished sounds contrast with the serene images, producing a memorial that simultaneously honours the

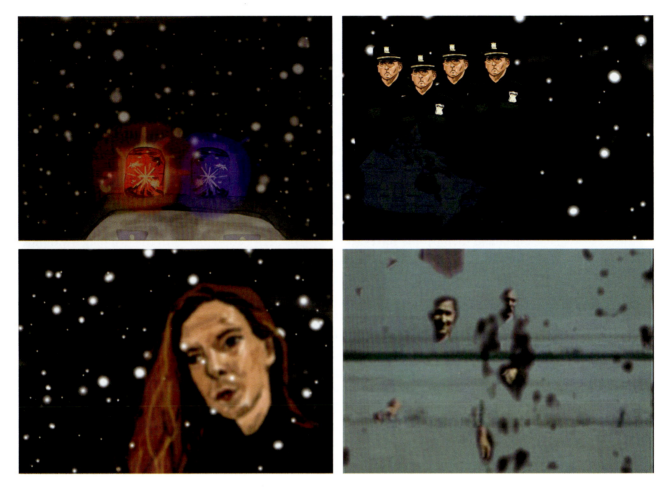

11.4–11.7 Jess MacCormack & Alexus Young, stills from *Where We Were Not: Feeling Reserved (Alexus' Story)*, 2012. This film was not created at Crossing Communities, although Young and MacCormack had both previously worked there (Young as a participating artist from 2005 to 2011 and MacCormack as an artist in residence from 2008 to 2009). It focuses on Young's experience of a "starlight tour" in Saskatoon, which involved being driven by police officers to the outskirts of the city and abandoned there in the freezing cold. The film screened at imagineNATIVE Film Festival in 2012.

women and unsettles the viewer. At the end of the video, the music ends and the names of nearly five hundred women roll across the screen in silence.

Jackie Traverse had the original idea for *Butterfly*. She is an Ojibway artist from Lake St Martin First Nation, Manitoba, and she began to visit Crossing Communities after getting out of prison in the late 1990s. She was one of the first participants and unlike most of the others, she already considered herself to be an artist when she began. She described her intentions for the video: "I wanted to honour the women through the butterfly, and show my anger and frustration. I also read a legend that says if you catch a butterfly and whisper to it and set it free, it will carry your wish to the creator, so that related to my wish that these women would not be forgotten, and that

their murders will be solved. I had never seen anything on missing and murdered women before then, and I started noticing what was going on and becoming frustrated with seeing the cases go cold."[14] *Butterfly* also held special significance for Pat Aylesworth, who like Traverse, was a participant at Crossing Communities from the beginning. According to Aylesworth, "the participants were thinking about the way that Aboriginal women were being killed and dumped places in the city, and thinking about what was happening in Vancouver with Robert Pickton. One participant talked about an experience that she had with a john, and told us that her sister had disappeared."[15] Aylesworth was enthusiastic about the attention that *Butterfly* received: "it was a big success in terms of how many people came, and in terms of what it was all about. All this media attention happened afterwards, and on February fourteenth of that year there was a march for missing women. You have something like that happen and then people start talking."[16] *Butterfly* contributed to the growing awareness of missing and murdered women across Canada, and its significance has reached outwards from the community that created it to a larger public concerned with the issue.

Similar ideas emerged during the project *Women and Girls in the Sex Trade*, made several years earlier in 2005. It involved seven participants: Alexus, Charlene, J.D., i-lay-a, Sandra, Roseanne, and Tonya, who were mentored by Shawna Dempsey, Lorri Millan, and Erika MacPherson. As mentors, Dempsey and Millan brought a wealth of experience in making performance art and provoking questions about gender and sexuality.[17] MacPherson is a filmmaker and video artist whose work has ranged from experimental, identity-focused narratives to documentaries exploring landscape and family.[18] The participants wrote and directed videos about their experiences as sex workers. Many of the videos feature the women walking around downtown Winnipeg, reenacting a typical night on the street and telling stories about their lives. They often incorporate stylized performance gestures and symbolic use of props. Tonya's video examines the intersection of this facet of her identity with being a mother. In it, she talks about struggling with addictions that she cannot control. In Alexus's video, she examines her two-spirited identity by juxtaposing archival photographs with shots of herself in glamorous attire. Several scenes are shot in front of the statue of Louis Riel that sits on the grounds of the Manitoba Legislative Building. These scenes reference the artist's Métis heritage and are also a nod to Riel's status as a rebellious historical figure.

Women and Girls in the Sex Trade counters the notion that its subjects are submissive and lack agency. The video project contrasts with numerous representations of prostitutes throughout the history of art in which women are shown as passive objects, from the courtesans and odalisques of Titian and Ingres to the modern Parisian prostitutes painted by the Impressionists.[19] As both the directors and the subjects of the videos, the participants played an active role in making the work, performing aspects of their identities in a conscious, self-aware manner. Their videos were initially screened at a public forum in 2005 that was followed by a discussion between participants and audience members. Hundreds of people were present and took part in the discussion, including front line social workers and First Nations Elders. The videos

have since been screened in different contexts, including both art galleries and non-profit-sponsored workshops focused on social work, mental health, addiction issues, and foster care. Throughout these different venues, the videos have facilitated discussions among individuals who might not otherwise have met, and they have brought attention to an issue important to Crossing Communities participants. *Women and Girls in the Sex Trade* was created through a collaboration with professional artists who were familiar with the theoretical lingo of gendered performativity, but it emerged from the desires and concerns of the participants, and was structured around their aesthetic decisions.

A final example demonstrates Crossing Communities' attempt to position itself in a growing dialogue surrounding feminism and globalization. In 2009, several members of Crossing Communities travelled to Nepal to make videos with members of the Women Foundation of Nepal. The project was a way for Winnipeg women to share their life experiences with Nepali women, and also become mentors in their own right after having learned some of the skills of video production and editing. Women from different caste backgrounds attended the screening, and the discussion that followed revolved around domestic violence, drug use, and prostitution. Jackie Traverse shared her video *Empty*, about her mother's alcoholism and its destructive effects on their relationship following her family's relocation from their reserve, Lake St Martin, Manitoba, to Winnipeg. After seeing Traverse's video, a Nepali woman named Rita Shrestha made a video titled *From White to Red*. In it, she discussed the white sari that women must wear after the death of their husbands. Women who wear this sari are seen as bad omens and are often the victims of unwanted advances in public because they are viewed as single yet sexually experienced females. In the video, Shrestha walks toward the camera wearing a white sari, which she slowly unwraps to reveal a red dress underneath. The video sparked a debate when it was publicly screened in Kathmandu, which is described in a 2011 essay by Emma Alexander and Edith Regier: "a young educated woman became very angry that Rita (who is uneducated and from a lower caste) dared to wear a red sari now and accused her of violating the traditions that women are charged to uphold."[20] This incident exemplifies the issues that surround both cross-cultural collaborations and the role of feminism in a global context. The Nepal video project saw several Crossing Communities participants step into the role of mentor (or perhaps mentrix) by offering up the technical, material, and conceptual skills they had acquired, while also allowing the potential for community building across cultures and geographical distances through shared experiences of racism, sexism, and domestic abuse.

The projects I have described highlight some of the positive aspects of community-based art. However, this type of practice also has its pitfalls and complications. Many of the participants I spoke with told me that as the project grew, conflicts emerged around leadership and control. Hierarchies surrounding class, race, and education became more visible, and eventually began to seem insurmountable to those involved.[21] The question of who held power and who was getting paid was an uncomfortable issue for everyone involved. In addition, Jess MacCormack told me in an interview

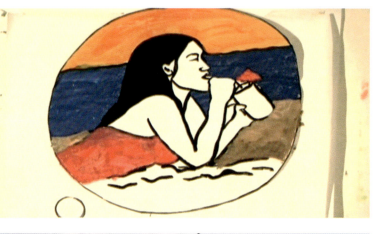

11.8–11.11 Jackie Traverse and the
Crossing Communities Art Project,
stills from *Empty*, 2009.

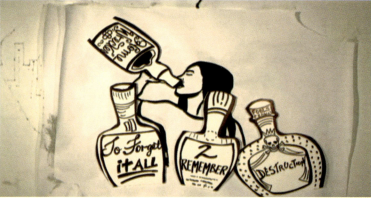

that "there was not the kind of infrastructure to cope with the needs of the partici-
pants. My opinion was that we really needed to have an actual therapist there at least
one day a week."[22] This was echoed by Aylesworth, who believed that "we just didn't
have enough supports. It was an art space, but we didn't have enough supports in
terms of the needs of people who were using the services and participating. I think that
was its downfall, is that we just didn't have the capacity to deal with people's needs
that were beyond our control."[23] It turns out that what made Crossing Communities
unique and unlike other community-based art projects – its flexibility, its commitment
to addressing structural inequality through activism, its ability to respond and react
to the needs of participants – also made it into an unstable and frequently conflict-
filled environment. It was a polarizing trade-off, since as Aylesworth points out, the
"unstructured nature of it is what made people that participated get really involved."[24]

Building Feminist Community

The question remains, what exactly constitutes a feminist community? And what kind
of model did MAWA's mentorships set in place for this community to emerge? The
concept of identity-based community has been theorized and deconstructed across
different disciplines. Suspicion of its unifying aspects has informed discussions of col-
laborative art, with the assumption that unity inevitably washes over individual dif-
ferences, or that the only possible role for community artists to play is that of colonizer
or aesthetic evangelist.[25] Poststructural interpretations of community portray the term
as totalitarian or nostalgic, as the yearning for a divine communion that never truly ex-
isted. For Jean-Luc Nancy, community is a fantasy brought on by modern alienation
and the belief that contemporary society has devolved into rampant individualism,
which drives a desire for pre-modern forms of togetherness. A return to order is a de-
sire that drives many conservative ideologies, whether they are derived from principles
of Christian brotherhood, ancient philosophy, or supposedly natural family values.
While Nancy ultimately avoids defining a theory of community, he argues that it is
characterized by the revelation of its impossibility – the realization that togetherness
does not bring salvation. He writes that "community therefore occupies a singular
place: it assumes the impossibility of its own immanence, the impossibility of a com-
munitarian being in the form of a subject. In a certain sense community acknowledges
and inscribes – this is its peculiar gesture – the impossibility of community. A commu-
nity is not a project of fusion, or in some general way a productive or operative proj-
ect – nor is it a *project* at all."[26] Nancy argues that authentic community must not
come through a recognition of the self in the other, but in a recognition of difference:
"I experience the other's alterity, or I experience alterity in the other together with the
alteration that 'in me' sets my singularity outside me and infinitely delimits it."[27] In
this understanding of the concept, the bonds of community must never be too strong;
they must always be provisional, contingent, weak, and never cohere or solidify around
any one identity or cause. This is in order to prevent the essentializing of any one

individual's identity, but it is also to avoid the kind of conflict that can arise through identity-based communities, for example, ethnic violence that emerges around "us" versus "them" mentalities. If community seems to be such a problematic concept, both driven by a conservative impulse to return to a harmonious sense of order and unity, and implying a consolidated, closed-off unit capable of doing violence to others, then what is its recuperative value? Collaborative art projects that seek to build community have been criticized by numerous authors who draw on the points mentioned above: these types of projects are seen as producing a false sense of harmony in togetherness, and they essentialize their members by adopting a collective identity. Nancy's arguments are often cited in discussions of community-based art, and it is worth bringing them up to critique romantic visions of community that seek an escape from the alienating effects of modernity but ultimately result in new forms of hierarchy and exclusion. However, not all projects function in this manner, and it is worth noting here the disjunction between theory and practice. Community-based art projects are typically criticized or dismissed through an attack on theories of community, without any attention paid to the complexities of localized practice. It is true that community solidarity taken to the extreme might lead to the violence of ethnic nationalism, for example, but this is not inevitable and it depends on a complex set of situational factors. While theories of community provide a useful frame of reference, the value of the projects I discuss here comes not from how well they exemplify or contest specific theories, but from what it is they have actually managed to do.

The unifying impulses of community are well known in the context of feminist art practice. Discussions of difference and unity lie at the heart of these debates, and have their roots in the emergence of second-wave feminism. Art historian Arlene Raven describes the feminist community that emerged in Los Angeles in the 1970s. She writes, "we were women. We were art professionals. We shared a sense of social justice. We believed in the possibility of social change."[28] It was a moment of great hope in which change seemed imminent. Linda Nochlin's essay "Why Have There Been No Great Women Artists?" had recently been published; the Feminist Art Program had begun at California Institute of the Arts with Womanhouse as one of the inaugural projects; Suzanne Lacy was beginning to make process-based work exploring the prevalence of sexual violence. The critique of this moment is by now familiar: while this was incredibly important for feminist consciousness-raising, it mainly reflected the concerns of white, middle-class women. Looking back on her experiences from the perspective of the 1990s, Raven discusses the seduction of community for women at that time, whose private experiences of oppression were beginning to become public. The notion of community offered women the opportunity to share these experiences with others, and join together to confront dominant viewpoints regarding their roles in society. Raven points out that problems emerged when associated notions of unity were taken too far. As many scholars have argued, as these movements grew and coalesced, the concerns of white, middle-class, heterosexual women won out over others, thereby creating hierarchies and divisions.

Amelia Jones writes that while feminism in the 1970s united women behind a common cause, it also "enacted the same kind of damaging universalizing logic that had excluded women from dominant cultural activities in the first place."[29]

Many scholars have written about the negotiations that have taken place between feminism and other aspects of identity, arguing for a more intersectional approach. Verna St Denis has written about conflicts between feminism and Indigenous cultural practices. She argues that many Indigenous women have understood feminism as "not only irrelevant but also racist and colonial," and that Indigenous women who identify as feminists risk being seen as having given up their traditional values.[30] However, she believes that this mode of thinking does not acknowledge the multiple positions that women occupy. For St Denis, becoming familiar with work by women artists and writers of colour, including Audre Lorde and bell hooks, changed her opinion on the place of feminism within her cultural tradition. She writes, "I once thought that to be feminist meant that one had to choose between gender and culture or nation. I no longer hold this view. Increasingly more Aboriginal women are beginning to identify as feminists, or at least with some of the goals of feminism, such as ending violence against women and children."[31]

This goal-oriented, activist sense of feminist community building, rather than identity-based community formation, was behind the projects developed by Crossing Communities. Recognizing the different positions that women occupy and how they intersect was a crucial marker within feminist theory, and it continues to affect discussions of contemporary culture. Finding a way to come together, to form community despite and through difference, to initiate social change is also crucial. Collective identities offer incredible political potential – disparate voices become stronger. As community-based art projects learn from the experiences of second-wave feminism, it is important that lessons about community identity be integrated into practice, and that unifying tendencies and negations of difference are counteracted. In projects such as *Butterfly*, *Women and Girls in the Sex Trade*, and the video project in Nepal, communal bonds were formed through shared experiences of domestic violence, misogyny, and racism, and not solely through identity. Gayatri Spivak's discussion of "strategic essentialism" is worth considering here as part of this tactic of counter-action. It is the self-conscious binding together of a group, which preserves its heterogeneity at the same time that it allows individuals to act together and make political demands.[32] This concept of community does not promise the romantic fusion that will heal our alienated selves, yet this is perhaps its greatest strength. It is contingent, localized, and adaptive, and comes from the margins. It can allow for conscious mobilization without subsumption into a pure, unified group identity. Certain aspects of strategic essentialism are visible within the feminist community that has emerged at MAWA. Growing out of feminist activism of the 1970s, concerned with structural inequality and misogyny, MAWA adopted the politics of the second wave. Women joined together around a cause and built a community of like-minded thinkers. Later, the organization adopted a more diverse and inclusive structure focused on intersectional

identities. It has worked to diversify its membership through introducing programming focused on Indigenous women, newcomers, artist-mothers, and rural women.

Building a feminist community at MAWA involved a shift in programming tactics, which were established through the bonds of second-wave feminism but have been redefined and restructured around more complex understandings of identity. These ideals were visible in the development of Crossing Communities as well: relationships between artists and participants were designed on the model of MAWA mentorships, which are not just about the transmission of expertise but about collaborative exchange as well, meant to strengthen both artists simultaneously. The collaborative working methods of Crossing Communities fostered a model of artistic creation that recognized multiple identities and focused on the specificities of women's everyday lives. Within the prison exchange project, most of the women did not consider themselves to be artists when the project began. The aim was not necessarily to further individual art practices, but instead, to create an outlet for self-expression – to communicate through words, images, and objects – and to build a community around particular issues important to women's lives. As Crossing Communities grew, it experienced conflicts amongst participants, personality clashes and struggles over power and leadership. In interviews with Aylesworth and Traverse, they told me that they felt excluded from decisions related to the structure and functioning of the organization.[33] In contrast, Dempsey has emphasized the collaborative and horizontal leadership structure of MAWA.[34] As well as these issues, Crossing Communities also suffered from a persistent lack of resources. It relied on funding from Status of Women Canada, which had its federal funding cut by about a third in 2006 (along with numerous other organizations focused on the health and well-being of women and children).[35] Both of these factors led to the demise of Crossing Communities in 2011.[36] Despite internal and external conflicts, the organization fostered valuable community projects and long-lasting relationships between women. Instead of focusing solely on individual healing, its projects were directed outwards and engaged in activism through practices of strategic essentialism. It became a forum that encouraged discussion around structural issues of poverty, racism, and colonialism that many women in Winnipeg experience as individual problems.

The mentorship model developed at MAWA was adapted and activated by Crossing Communities. Within both organizations, it was utilized as a means of developing individual art practices, but also became a way to organize collectively around specific issues. The unifying tendencies of community are worth addressing in relation to these projects, especially when they lead to social exclusion or the erasure of differences. These critiques have been extremely valuable in restructuring feminist activism and opening it up to intersectional concepts of identity. They have also informed critiques of community-based art which seek to undermine its political potential. Yet other voices, including Spivak's, have noted that coherency may be used in an instrumental manner. This is important to contemporary critics interested in activist practices, who seek an integration of the strong bonds of second-wave feminism with difference and

alterity. MAWA's mentorships are a valuable case study in the context of current debates surrounding social engagement, marginalized communities, and activism in art, and may be viewed as a model for collaborative art practice in which community is built through feminist theory and activism. As one outcome of these mentorships, Crossing Communities adopted the feminist principles of MAWA, and directed these outwards in a series of collaborative, community-based public art projects.

NOTES

1 While the Crossing Communities Art Project continues to exist as an organization, the Winnipeg studio closed in 2011.

2 Lacy, *Mapping the Terrain*, 19.

3 There have been numerous names given to art made since the 1960s involving forms of collaboration, interaction, or activism, including but not limited to *relational aesthetics*, *new genre public art*, *community-based art*, and *social practice*. Relational aesthetics was defined by French curator Nicolas Bourriaud as a form of art that "takes as its theoretical horizon the realm of human interactions and its social context" (14). Social practice has been used to describe art made through similar means, but it encompasses a broader range of exchanges among individuals, communities, and institutions and focuses more on systemic change through activism and education. See Bourriaud, *Relational Aesthetics*; Helguera, *Education for Socially Engaged Art*; and Sholette, "After OWS."

4 Research for this chapter was carried out as part of the author's master's thesis at Concordia University, "Community, Conflict, Difference: New Genre Public Art in Winnipeg," which was completed in September 2012. Research for the thesis included interviews with seven individuals affiliated with Crossing Communities: Edith Regier (26 July 2011 and 29 September 2011), Pat Aylesworth (27 August 2011), Adele Breese (4 November 2011), Jess MacCormack (20 September 2011), Jackie Traverse (19 June 2012), and Alexus Young (14 December 2011). Some of these in-

terviews are quoted directly in this essay, while others have been used as general references.

5 Nickel and Dahle, "Chronology," 96.

6 Ibid., 94.

7 Shawna Dempsey, interview with the author, 27 August 2014.

8 Lemecha, MAWA, 6.

9 Dempsey interview.

10 Ibid.

11 Regier, *Passing Pictures with Prisoners*, 5.

12 Tuer, "Lost Objects/Lost Words," 28.

13 Regier, *Passing Pictures with Prisoners*, 19.

14 Jackie Traverse, interview with the author, 19 June 2012.

15 Pat Aylesworth, interview with the author, 27 August 2011.

16 Ibid.

17 Shawna Dempsey and Lorri Millan began collaborating on performance art in the early 1990s. Their work includes the music video *We're Talking Vulva* (1990); the video *Day in the Life of a Bull Dyke* (1995); and recurring performances as Lesbian National Parks and Services rangers (1997–present). See http://www.fingerinthedyke.ca/.

18 Erika MacPherson's work is distributed by Video Pool and the Winnipeg Film Group. See www.videopool.org and www.winnipegfilmgroup.com.

19 There are countless depictions of prostitutes throughout the history of European art. Classic examples include Titian's *Venus of Urbino* (1538), Ingres's *Grand Odalisque* (1814), and Renoir's *Odalisque* (1870).

20 Alexander and Regier, "Speaking Out on Violence and Social Change," 39.

How to Review Art as a Feminist and Other Speculative Intents

Amy Fung

12 We strive to understand ourselves by understanding our past. Place the past in a language that can hold us closer together in the present.

Writing a feminist art review does not make any sense. I have tried and tried again. Art reviews are largely steeped in a capitalist system of power and white male privilege, promoting and propagating its own lineages and legacies. What does the state of art reviewing have to do with feminism? How do you enter a house that was built to exclude you?

I have been thinking about how feminism has been dominated by middle-class and university-educated white women who have fought to be equal to white men instead of standing up for those being oppressed by them.

I have been thinking about the inextricable connection between class conditions and race and gender positions, and how most of my left-leaning peers strive for middle-class comforts.

I have been thinking about the shattered legacies for my generation of queer and feminist artists, writers, and curators, who are still piecing together our histories in the void of HIV/AIDS, in the perpetuation of systematic discriminations, erasing those who came before us.

Thinking is not writing but writing is thinking through the past into a language that is present.

every show looks the same
writhing
in my mouth
should I write it out
in linear notes
for eager readers scanning each line
to see their names

sion and Empowerment in Contemporary Community Art." *Afterimage* 22 (January 1995): 5–11.

Lacy, Suzanne. *Mapping the Terrain: New Genre Public Art*. Seattle: Bay Press, 1995.

Lemecha, Vera, ed. MAWA: *Culture of Community*. Winnipeg: Mentoring Artists for Women's Art, 2004.

Nancy, Jean-Luc. *The Inoperative Community*. Minneapolis: University of Minnesota Press, 1991.

Nickel, Grace, and Sigrid Dahle. "Chronology." In MAWA: *Culture of Community*, edited by Vera Lemecha, 95–133. Winnipeg: Mentoring Artists for Women's Art, 2004.

Raven, Arlene. "Word of Honor." In *Mapping the Terrain: New Genre Public Art*, edited by Suzanne Lacy, 159–70. Seattle: Bay Press, 1995.

Regier, Edith. *Passing Pictures with Prisoners*. Winnipeg: Mentoring Artists for Women's Art, 2001.

Sholette, Gregory. "After OWS: Social Practice Art, Abstraction, and the Limits of the Social." *e-flux* 31 (January 2012). http://www.e-flux.com/journal/31/68204/after-ows-social-practice-art-abstraction-and-the-limits-of-the-social/.

Spivak, Gayatri. "Subaltern Studies: Deconstructing Historiography." In *Selected Subaltern Studies*, edited by Ranajit Guha and Gayatri Chakravorty Spivak, 3–32. New York: Oxford University Press, 1988.

St Denis, Verna. "Feminism Is for Everybody: Aboriginal Women, Feminism and Diversity." In *Making Space for Indigenous Feminism*, edited by Joyce Green, 33–52. Black Point, NS: Fernwood Press, 2007.

Tuer, Dot. "Lost Objects/Lost Words." In *Passing Pictures with Prisoners*, edited by Edith Regier, 27–9. Winnipeg: Mentoring Artists for Women's Art, 2001.

How to Review Art as a Feminist and Other Speculative Intents

Amy Fung

12 We strive to understand ourselves by understanding our past. Place the past in a language that can hold us closer together in the present.

Writing a feminist art review does not make any sense. I have tried and tried again. Art reviews are largely steeped in a capitalist system of power and white male privilege, promoting and propagating its own lineages and legacies. What does the state of art reviewing have to do with feminism? How do you enter a house that was built to exclude you?

I have been thinking about how feminism has been dominated by middle-class and university-educated white women who have fought to be equal to white men instead of standing up for those being oppressed by them.

I have been thinking about the inextricable connection between class conditions and race and gender positions, and how most of my left-leaning peers strive for middle-class comforts.

I have been thinking about the shattered legacies for my generation of queer and feminist artists, writers, and curators, who are still piecing together our histories in the void of HIV/AIDS, in the perpetuation of systematic discriminations, erasing those who came before us.

Thinking is not writing but writing is thinking through the past into a language that is present.

every show looks the same
writhing
in my mouth
should I write it out
in linear notes
for eager readers scanning each line
to see their names

alterity. MAWA's mentorships are a valuable case study in the context of current debates surrounding social engagement, marginalized communities, and activism in art, and may be viewed as a model for collaborative art practice in which community is built through feminist theory and activism. As one outcome of these mentorships, Crossing Communities adopted the feminist principles of MAWA, and directed these outwards in a series of collaborative, community-based public art projects.

NOTES

1 While the Crossing Communities Art Project continues to exist as an organization, the Winnipeg studio closed in 2011.

2 Lacy, *Mapping the Terrain*, 19.

3 There have been numerous names given to art made since the 1960s involving forms of collaboration, interaction, or activism, including but not limited to *relational aesthetics*, *new genre public art*, *community-based art*, and *social practice*. Relational aesthetics was defined by French curator Nicolas Bourriaud as a form of art that "takes as its theoretical horizon the realm of human interactions and its social context" (14). Social practice has been used to describe art made through similar means, but it encompasses a broader range of exchanges among individuals, communities, and institutions and focuses more on systemic change through activism and education. See Bourriaud, *Relational Aesthetics*; Helguera, *Education for Socially Engaged Art*; and Sholette, "After OWS."

4 Research for this chapter was carried out as part of the author's master's thesis at Concordia University, "Community, Conflict, Difference: New Genre Public Art in Winnipeg," which was completed in September 2012. Research for the thesis included interviews with seven individuals affiliated with Crossing Communities: Edith Regier (26 July 2011 and 29 September 2011), Pat Aylesworth (27 August 2011), Adele Breese (4 November 2011), Jess MacCormack (20 September 2011), Jackie Traverse (19 June 2012), and Alexus Young (14 December 2011). Some of these interviews are quoted directly in this essay, while others have been used as general references.

5 Nickel and Dahle, "Chronology," 96.

6 Ibid., 94.

7 Shawna Dempsey, interview with the author, 27 August 2014.

8 Lemecha, MAWA, 6.

9 Dempsey interview.

10 Ibid.

11 Regier, *Passing Pictures with Prisoners*, 5.

12 Tuer, "Lost Objects/Lost Words," 28.

13 Regier, *Passing Pictures with Prisoners*, 19.

14 Jackie Traverse, interview with the author, 19 June 2012.

15 Pat Aylesworth, interview with the author, 27 August 2011.

16 Ibid.

17 Shawna Dempsey and Lorri Millan began collaborating on performance art in the early 1990s. Their work includes the music video *We're Talking Vulva* (1990); the video *Day in the Life of a Bull Dyke* (1995); and recurring performances as Lesbian National Parks and Services rangers (1997–present). See http://www.fingerinthedyke.ca/.

18 Erika MacPherson's work is distributed by Video Pool and the Winnipeg Film Group. See www.videopool.org and www.winnipegfilmgroup.com.

19 There are countless depictions of prostitutes throughout the history of European art. Classic examples include Titian's *Venus of Urbino* (1538), Ingres's *Grand Odalisque* (1814), and Renoir's *Odalisque* (1870).

20 Alexander and Regier, "Speaking Out on Violence and Social Change," 39.

21 The presence of conflict and the role it played in the demise of Crossing Communities was noted by several participants in the interviews cited above. Pat Aylesworth described "a lot of conflict in the end"; Jackie Traverse said, "I knew that this thing was coming to an end, it was just ugliness"; for Adele Breese, "the intentions were good right to the end, we were just working with strong personalities"; Jess MacCormack stated that "dynamics were just unhealthy."

22 Jess McCormack, interview with the author, 20 September 2011.

23 Aylesworth interview.

24 Ibid.

25 See Foster, *The Return of the Real*; Kester, "Aesthetic Evangelists."

26 Nancy, *The Inoperative Community*, 15.

27 Ibid., 33.

28 Raven, "Word of Honor," 163.

29 Jones, *The Feminism and Visual Culture Reader*, 116.

30 St Denis, "Feminism Is for Everybody," 34.

31 Ibid., 50.

32 Spivak, "Subaltern Studies."

33 Aylesworth and Traverse interviews.

34 Dempsey interview.

35 A joint statement published by the Canadian Federation of University Women and the National Council of Women Canada outlines the cuts made to women's organizations over the past decade: "Funding for Status of Women Canada (swc) was cut significantly in 2006, resulting in the closure of 12 of 16 offices across the country. The mandate of swc was changed to exclude "gender equality and political justice" and to ban advocacy, policy research and advocacy. The Women's Program of swc previously funded women's groups to undertake research and advocacy to promote women's active participation in policy development and systemic change. The program now focuses on training oriented projects and service provision. It no longer funds advocacy or research. The cuts and change in focus of swc left many women's organizations without funding." Canadian Federation of University Women (cfuw) and National Council of Women Canada (ncwc), "Joint Submission on the Occasion of Canada's Universal Periodic Review," 5 October 2012, http://www.ncw canada.com/2014/03/22/statement-20121005-ncwc-cfuw/.

36 In the July 2011 interview, Edith Regier told the author that Crossing Communities was still open as an organization, but was considering dissolving or restructuring. In her opinion, "this was mostly because of funding. There were a lot of changes in the Federal Status of Women grant and we didn't get our funding. We were also planning to apply for more National Film Board grants to continue lookinginandspeakingout.com, but the office was closing in Winnipeg and our producers were not there, so those were the two main funding challenges."

BIBLIOGRAPHY

Alexander, Emma, and Edith Regier. "Speaking Out on Violence and Social Change: Transmedia Storytelling with Remotely Situated Women in Nepal and Canada." *Canadian Theatre Review* 148 (2011): 38–42.

Bourriaud, Nicolas. *Relational Aesthetics*. Dijon: Les presses du réel, 2002.

Canadian Federation of University Women (cfuw) and National Council of Women Canada (ncwc). "Joint Submission on the Occasion of Canada's Universal Periodic Review." 5 October 2012. http://www.ncw canada.com/2014/03/22/statement-2012 1005-ncwc-cfuw/.

Foster, Hal. "The Artist as Ethnographer." In *The Return of the Real: The Avant-Garde at the End of the Century*. Cambridge, MA: MIT Press, 1996.

Helguera, Pablo. *Education for Socially Engaged Art*. New York: Jorge Pinto Books, 2011.

Jones, Amelia. *The Feminism and Visual Culture Reader*. New York: Routledge, 2003.

Kester, Grant. "Aesthetic Evangelists: Conver-

update their CVs
get more shows
so we can do it all again

When I think about my professional lineages, I can only think of texts by women I have never met. I think about articles by Helen Molesworth and Miwon Kwon and I think about living in a place where I could belong. I think about an anecdote from Marcia Tucker's autobiography written in the last years of her life.[1] During the installation of a Marsden Hartley painting as the Whitney's curator of painting and sculpture in the 1970s, she was openly mocked by the installers for her requested adjustments, as either a cunt's hair to the left or a cunt's hair to the right, a scale that is neither metric or imperial, but universal, in making women feel less human.

A feminist is formed through dissent against a system failing. Feminists have disappointed me. Feminists have saved me. Not all women are equal in their inequality. Victorian moralists argued in favour of eugenics in the same breath as for personhood. bell hooks has been saying the exact same thing for over thirty years and we are still hearing her for the first time, every time. That is white supremacist ideology. Working it.

There are lots of people who hate feminists. Enough to hurt them. Kill them. There are also people who hate art reviews. Most of these people are artists. Disdain towards art reviews is a negotiable frustration and this reveals something important in understanding the difference between a feminist and an art reviewer. There is an imbalance of perceptible power between a reviewer and a feminist. The former has perceived power: the gatekeeper. The latter has no power, a redundant obstacle between you and your entitlement. A feminist is so socially degraded that there is no power in identifying as one, no consequences in excluding one. Especially when you have the option to align with Modernists or Minimalists or other Monied white male lineages. People see you better; History treats you kinder.

There is no such thing as apolitical art. Everything is political; the power and privilege to not engage in politics is a position held only by those who can afford to do so.

The actions of history are in and of themselves
compromised,
mediated,
through the rules of language and coded signification. Language governs and regulates meaning; destroy language and you destroy meaning. To dissent is to render oneself incomprehensible.

A noun is not art,
how you use it is.[2]

Extra-linguistic communication is one way to begin. Associate alliances touching coalescing
 contagious connections
 beyond linear lines
spreading tangential sprouting
history depleting chronology crumbling into movements moments influences
disrupting rules of who where when
ONE may speak.

A regurgitation of power cascading babbling infinitum.

Let feminism be this girl raging at a chandelier.
A miniaturist, a Benedictine, a prisoner.[3]

Re-place absences in your syntax detached. Your omissions of history, art, experiences, endured by women, made under the influence. How we move through this world becomes how we are recording, reflecting, remembering.

A verb is not art,
the way you write through it is.
You can contest this anyway you like. Use your hands and tell me something new.
It doesn't even have to be new, but tell me something.
Anything. Everything.
I don't want to write your criticism anymore. I want nothing to do with your lineages.
I am over it.
I am on the strike that no one is noticing.
I won't compete[4]
Do Less With Less[5]
An ethics of contingency.[6]

A feminist art review could only be a killjoy times a thousand.
I have been thinking about respectability politics in relationship to writing. Professionalism is a form of xenophobia upholding the rules of exclusion. Who are we holding up these standards for and what we are gaining and losing?

We attempt to define feminism as a dynamic state of being, of resisting hierarchal power structures and oppressive systems and ideologies. Art reviews have been more slippery, rooted into a labour of commerce and middle-class meanderings, a neoliberal sinkhole. The politics of aesthetics have nothing to do with either.

To write is to respond
Not posture or promote.
Art reviews may be inherently non-feminist even with the likes of Lucy Lippard and Rosalind Krauss in an old boy's club. To understand the world through only one gen-

der is why Eros is ill.[7] I am ready for more voices reverberating and not echoing: sharp, shimmer, ignite.

For a speaking subject, the practice of enunciation is a socio-historical embodiment.

Writing making base symbolic markings of an electronic scratch and wink. Connect us across interstices of thoughts, actions, and feelings fuelled by an ongoing rage, by the undesirables, by society's most vulnerable. Non-linear legacies are less swayed by power and more through shared ethics. Between the chora and the Internet, non-linearity flourishes. Non-linear communities united form impossible communities, infiltrating each other's nodes of knowledge and desire.

How we write matches what we are going to write.

This is where I am writing from if I am to write at all. How to review art as a feminist is to understand the world and our relative positions within it. How have we come to this position and how will we engage? The limits of language are the limits of knowledge, and we are never outside of language.

NOTES

1 Tucker, *A Short Life of Trouble*, Chapter 7, "1970–1974," covering her early years at the Whitney Museum. Tucker went on to found the New Museum before leaving that institution in 1999, trying stand-up comedy, and writing her autobiography before passing away at the age of sixty-six.

2 Julia Kristeva's *Revolution in Poetic Language*, specifically the chapter "Through the Principles of Language," has informed much of this essay in deciphering that the process of signifying is dialectical to the identification of the subject; poetic language as a signifying practice is generated by a subject within a socio-historical context. When language becomes subject, it means language is held accountable in both a semiotic and symbolic order.

3 Robertson, *Cinema of the Present*.

4 "I Won't Compete" – First seen as cross-stitched parade banners by the Feminist Art Gallery (FAG) in Vancouver's Access Gallery, 2013. See also Amber Christensen, Lauren Fournier, and Daniella Sanader's conversation with Deirdre Logue and Allyson Mitchell in this volume, "A Speculative Manifesto for the Feminist Art Fair International."

5 "Do Less With Less" – Limited silkscreen print by the Ladies Invitation Deadbeat Society (LIDS) for the cover and last issue of *FUSE Magazine* (RIP 2013).

6 "An ethics of contingency" is borrowed from a writing workshop led by Cara Benedetto, with gratitude.

7 "Eros is Ill" is the kernel summary of Deleuze and Guattari's *A Thousand Plateaus*.

BIBLIOGRAPHY

Deleuze, Gilles, and Felix Guattari. *A Thousand Plateaus: Capitalism and Schizophrenia*. Minneapolis: University of Minnesota Press, 2007.

Kristeva, Julia. *Revolution in Poetic Language*. New York: University of Columbia Press, 1984.

Robertson, Lisa. *Cinema of the Present*. Toronto: Coach House Books, 2014.

Tucker, Marcia. *A Short Life of Trouble: Forty Years in the New York Art World*. Berkeley: University of California Press, 2008.

How Not to Install Indigenous Art as a Feminist

cheyanne turions

13 The National Gallery of Canada (NGC) did a remarkable thing in the summer of 2013: they presented an international survey of contemporary Indigenous art entitled *Sakahàn*, "one of the most ambitious contemporary art exhibitions in its history," and the first iteration in what the gallery has called an "ongoing series" focusing on Indigenous art from across the world.[1] The exhibition was curated by a team composed of two of the gallery's permanent staff – Greg Hill, the NGC's Audain Curator of Indigenous Art; and Christine Lalonde, Associate Curator of Indigenous Art – as well as Candice Hopkins, the Elizabeth Simonfay Guest Curator, and an international team of curatorial advisors including Arpana Caur (India), Brenda Croft (Australia), Lee-Ann Martin (Canada), Reiko Saito (Japan), Irene Snarby (Norway), Jolene Rickard (United States), Megan Tamati-Quennell (Aotearoa New Zealand), and Yuh-Yao Wan (Taiwan).

While *Indigenous* has specific connotations in Canada, referring to descendants of the first peoples of this land, the term implicates different histories depending on where it is used.[2] The way that Indigenous identification functioned the context of *Sakahàn* was not only a claim of being from a place since time immemorial; it also marked an inextricable connection to experiences of colonization as can be read through the political histories of many of the nations represented therein – Australia, Brazil, Canada, Columbia, Finland, Greenland, Guatemala, India, Kenya, Mexico, New Zealand, Taiwan, the United States, and others.[3] Considering Canada's history of colonization, *Sakahàn* was aptly situated at the country's national gallery, an institution that has often acted as a mechanism of colonial subjugation by way of its perpetuation of Eurocentric art-historical values and the subsequent omission of artworks and narratives that emerge from other cultural traditions, notably those of the Indigenous peoples of Canada.[4] At the NGC, *Sakahàn* represented a rightful kind of historical redress. Unsurprisingly, many of the works within the exhibition were themselves acts of resistance to the gruesome inheritance of colonization and expressions of the continuing struggles against it. Although this chapter focuses on the implications of the exhibition in a Canadian context, it is important to acknowledge that the complexity of addressing colonial histories extends far beyond the borders of this country.

Theoretically, the exhibition was an expression of the difficult, hopeful work that is our living responsibility as cultural workers, gallery visitors, thinkers, and citizens

13.1 Opening disclaimer for *Sakahàn* exhibition at National Gallery of Canada, 2013.

today in addressing the injustices of colonization, a project that I see as central to contemporary feminism. It is important to acknowledge that feminism is about more than ending sexism – it's also about abolishing interconnected systems of oppression that affect different people in different ways, and in a Canadian context this importantly means working to acknowledge and then abolish colonial forms of dispossession. And yet, like a trailing stitch of wool hanging from a sweater, the NGC undid at least some of this work through a repeated gesture. At the entrance of the exhibition, where the spirit of "sakahàn" – an Algonquin word meaning to light a fire – was put forward as the organizing principle of the show, was this disclaimer: "The views and opinions expressed in this exhibition are those of the artists and do not reflect the views of the National Gallery of Canada." Such disclaimers are not in regular use at the NGC, nor are they common practice for exhibitions generally.[5] The appearance of an additional disclaimer, directly next to the didactic panel for Nadia Myre's *For those who cannot speak: the land, the water, the animals and the future generations* (2013), was therefore notable: "The views expressed in this work are those of the artist and do not reflect the views of the National Gallery of Canada." In both cases, the language enacts a strict demarcation between the views of the NGC and the artists. The politics of the works on display *do not* align with the politics of the gallery itself.

The disclaimer's reappearance next to Myre's work lacked any subtly that the plaque at the show's entrance may have attempted. Greeting visitors as they entered the exhibition, the initial disclaimer was divorced from any specific project. Next to Myre's didactic panel, the NGC forcefully asserted its distance from the content of a work that was "inspired by a statement read by a group of Algonquin kokoms

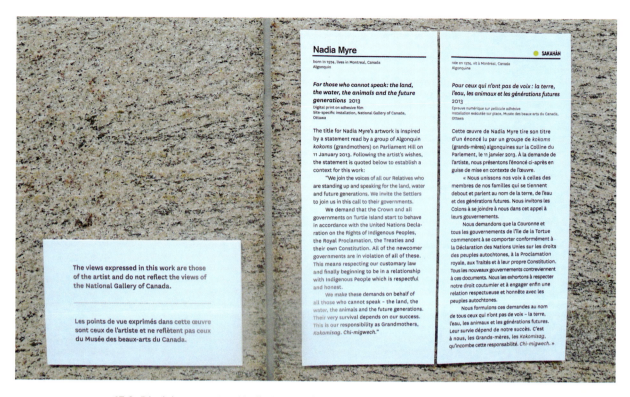

13.2 Disclaimer next to Nadia Myre's didactic panel, 2013.

Opposite

13.3 Nadia Myre, *For those who cannot speak: the land, the water, the animals and the future generations*, 2013.

(grandmothers) on Parliament Hill on 11 January 2013."[6] Here, historical context is key, for, as the artist Jimmie Durham has noted, it should be "impossible, and I think immoral, to attempt to discuss American Indian art sensibly without making the political realities central."[7] The day of the kokoms' speech, 11 January 2013, marked the one-month duration of Attawapiskat Chief Theresa Spence's hunger strike, an action taken to draw attention to the degradation of treaty rights by the Canadian government. Camped in a tipi on Victoria Island, very near Parliament Hill in Ottawa, Spence had been provoked by Bill C-45, a 457-page omnibus budget bill passed without Indigenous consultation despite the fact that it included numerous changes in legislation that would directly affect Indigenous communities.[8] The protest movement Idle No More gained traction in supporting Spence's call to meet with Prime Minister Stephen Harper and Governor-General David Johnston to discuss Canada's treaty relationship with Indigenous leadership. Rooted in expressions of Indigenous sovereignty and coalescing around Spence's actions, Idle No More put pressure on the Canadian government to differently conceptualize their relationship to the country's Indigenous peoples.

On 11 January 2013, after weeks of shamefully refusing to meet with Spence, Harper sat instead with members of the Assembly of First Nations to discuss treaty rights, and it was on this day that the kokoms read their statement:

We join the voices of all our Relatives who are standing up and speaking for the land, water and future generations. We invite the Settlers to join us in this call to their government.

We demand that the Crown and all governments on Turtle Island start to behave in accordance with the United Nations Declaration on the Rights of Indigenous Peoples, the Royal Proclamation, the Treaties and their own Constitution. All of the newcomer governments are in violation of all of these. This means respecting our customary law and finally beginning to be in a relationship with Indigenous People which is respectful and honest.

We make these demands on behalf of all those who cannot speak – the land, the water, the animals and the future generations. Their very survival depends on our success. This is our responsibility as Grandmothers, Kokoamisag. Chi-migwech.[9]

Throughout this period of intense activism, it is important to acknowledge the central role that the affective and physical labour of women played: "Bills like C-45 and other colonial politics aren't just issues of environmental destruction or state-sponsored corporate greed, but fundamentally about which people are valued in settler colonial societies and which are seen as superfluous or resistant in the onward march of capital … Spence's hunger strike was a bold and definitive illustration of

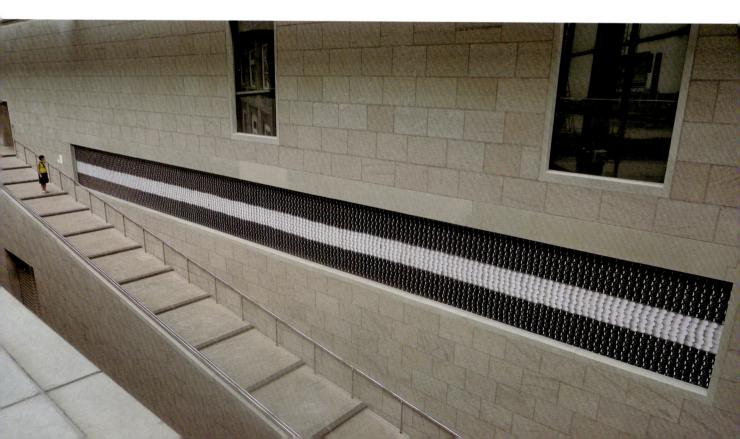

how it is women's bodies and women's leadership [that] are so degraded by colonial society, and are so crucial to the survival of Indigenous peoples."[10] This centrality can be traced from the first articulations of the Idle No More movement from its four founding members – Nina Wilson, Sheelah Mclean, Sylvia McAdam, and Jessica Gordon – to Spence's radical protest, to the kokoms' speech, to Myre's politico-aesthetic response.

Delivered to the NGC as a commission for *Sakahàn*, Myre's work seems to materialize the spirit of inextinguishable, generational responsibility evoked in the kokoms' speech. A skilled beadworker, Myre constructed alternating rows of black and white beads on a loom into a long woven band composed of six horizontal rows of white beads held between eight rows of black beads atop and below, evoking a horizon separating land from sky. Photographed and then enlarged, a vinyl depiction of the final beadwork was installed along the gallery concourse where it measured over twenty-two metres in length, becoming a kind of mural conjuring the infinite, as though the beadwork could continue on without end. According to the didactic panel, Myre insisted that the statement quoted above be reproduced there, in full, to establish a context for the work.

Spence's hunger strike carried on for two more weeks, ending on 24 January 2013. She was not granted a meeting with Harper and Johnston, and instead concluded her action when "members of the Assembly of First Nations and the Liberal and New Democrat caucuses agreed to back a list of commitments supporting aboriginal issues"[11] articulated in a Declaration of Commitment. The Conservative caucus was noticeably absent in this constellation of support.

Sakahàn opened less than four months later, in May 2013. The site of Spence's protest, memorialized in Myre's work, was not just the backyard of Parliament, but the backyard of the NGC as well, and the political and social climate of the time seemed to have influenced the forceful distance inserted between the politics of the work on display in *Sakahàn* and the gallery by way of the disclaimers. If not for the financial support of the government of Canada, the NGC would literally not exist. It is the country's national art museum, and tax dollars, delivered through appropriations, constituted 79 percent of the gallery's budget for the 2012–13 operating year, which amounted to just over $48 million.[12] Might there have been an imagined or literal directive to ideologically distance the gallery from the political implications of the works in the exhibition so as not to offend a government already in the throes of political challenges levelled through the uprising of Idle No More?[13] Commenting on the conditions of presenting the exhibition, Candice Hopkins, *Sakahàn*'s guest curator, points toward this possibility, noting that "The climate of self censorship [at the NGC] was so high I think because of the summer of idle no more protests and the fear somehow that the statement associated with Nadia's work would be seen as supportive of the movement."[14]

While researching this essay, I contacted the gallery to inquire about their disclaimer policy, and Greg Hill, a permanent staff member of the NGC and part of the curatorial team for the exhibition, responded that "from what I recall, the disclaimer

for Myre was put in place because of the political nature of the work, given the in-clusion of the statement read out on the steps of Parliament Hill along with the work … A statement also appeared near the entrance of the exhibition. This was a general disclaimer to ensure visitors were aware that views expressed by artists were those of the artist. Disclaimer statements are an exception and are used only when deemed necessary by the Gallery. I cannot speak to the decision to include the disclaimers as I was not involved in the decision."[15] In a separate, later conversation Hopkins com-mented that "the disclaimers, which were sprung upon us [the curators] less than two weeks before the show's opening, were first just for Nadia's work then added to the entire exhibition. It was made clear to me, within the extreme hierarchical framework at this the NGC, that this was not a point of discussion."[16] It was the NGC who, with-out consultation with the exhibition's curators, insisted such a sign be among the first things a visitor would see at *Sakahàn*. This is a strange moment of discord on the gallery's behalf, to instigate an exhibition such as *Sakahàn* without a corresponding commitment to support the artists and their curators through the difficult conversa-tions their work may provoke. Or rather, it points toward a gap between managerial priorities and curatorial responsibility, where the fundamental character of curatorial work – to care for, and in this case to care for the difficult knowledge of undoing an ongoing settler colonial project in Canada – is neutered by PR concerns and the main-tenance of funder relationships. Furthermore, the implementation of the disclaimers give the impression of interference with the arm's-length governing principles upon which the relationship between the gallery and the government is founded.[17] However hostile the government of the day may be, it is critical for the gallery, as a national in-stitution and therefore an example for all other museums and galleries across the coun-try, to defend this principle.

Hopkins begins her curatorial essay in the exhibition catalogue by stating the fol-lowing: "For the artists in *Sakahàn*, history is not a given but a site of contention – something to be questioned to expose its biases and reveal the ideologies from which it was scribed."[18] But to what extent is history not given for the gallery itself? There was a notable near absence of the word *colonization* from the press materials pro-duced by the gallery for *Sakahàn*, or in the framing of the exhibition itself. The NGC's website makes reference to the artists engaging with "ideas of self-representation to question colonial narratives and present parallel histories; place value on the hand-made; explore relationships between the spiritual, the uncanny and the everyday; and put forward highly personal responses to the impact of social and cultural trauma."[19] But embedding "colonial narratives" amongst so many other concerns plays as a di-versionary tactic, negating the centrality of colonization as one of the core organizing principles of the show. As previously mentioned, the term *Indigenous* was deployed throughout *Sakahàn* as a synonym for those who continue to experience the insidious consequences of colonization, and many of the exhibition's artists dealt explicitly with this inheritance (not as a historical narrative and not as some parallel phenomenon, but colonization as an ongoing reality, here and now).[20] The conspicuous absence of the term *colonization* in the promotional materials seems to be related to the presence of

the disclaimers as some sort of institutional power play that resolved itself through a careful parsing of language that intentionally left some things unsaid (*colonization*) and other things blatant (a distancing between the political allegiances of the gallery and the political content of the works through the disclaimers).

Furthermore, there is precedent for using this kind of loaded linguistic trickery at the NGC. The NGC's director and CEO Marc Mayer appeared on the CBC's *The National* in October 2010 to state that "unlike the nation itself, the National Gallery of Canada is blind to cultural diversity: it only sees 'excellence.'"[21] A petition that circulated shortly thereafter, signed by hundreds of Canadian cultural workers (myself included), laid bare the destructive force of Mayer's comments: "This begs the question: Whose excellence? This is what women and ethnic minorities have been asking for centuries. In the 1960s, when cultural institutions like NGC only showed the work of white men, we were told it was because there were no women or people of colour making 'good art.' Today you tell us that NGC doesn't show ethnic minorities because they are not achieving 'excellence.'"[22] Criteria of excellence, despite being totally opaque in any real evaluative sense, often replicate historical biases known to be exclusionary and alleviate a responsibility to think critically about how exhibitions and collections are made. "Excellence" is in no sense universal or given; it is a precise instrument of hegemony.

Mayer's foreword for the *Sakahàn* catalogue suggests that the NGC is well positioned to take on an international survey of contemporary Indigenous art practices due to the gallery's record of presenting the work of Indigenous artists. He then cites a number of historical examples that he interprets *Sakahàn* being in alignment with, beginning with the *Exhibition of Canadian West Coast Art: Native and Modern* from 1927. However, implying a simple continuity between these shows overlooks many important realities. The *Exhibition of Canadian West Coast Art* has been critiqued for the way that it implied that Indigenous artworks had value only insofar as they could be read through Western aesthetic standards.[23] Mayer notes that this exhibition "was the first in Canada to attempt to reframe First Nations' aesthetic practices,"[24] but he neglects to mention that it was to reframe them in the language of a settler art history, and furthermore, as art historian and curator Diana Nemiroff has noted, that despite the "significant institutional validation … afforded to native artistic traditions as art … these traditions were portrayed as dead and dying."[25] It is telling that the lasting artistic legacy of this show actually belongs to Emily Carr, having introduced her work to a broad Canadian audience, and not the single, still unknown Indigenous artist whose work the gallery collected from the exhibition.[26] Mayer goes on to note that "in 1990 the Gallery featured its first solo exhibition of an Aboriginal artist with *Pudlo: Thirty Years of Drawing*,"[27] without any sense of historical memory that this event happened over one hundred years after the gallery was formed. If the NGC was well positioned to take on *Sakahàn*, it is not because of its robust history supporting Indigenous artists but rather because *Sakahàn* interrogates both the contemporary legacy of colonization and the dominance of Eurocentric art historical perspectives, histories the NGC is irrevocably steeped in.

Although it may seem like a contradiction to place an impetus for critical self-reflection about Canada's settler colonial project with the country's national gallery, given that the gallery is a mechanism of the state's attempt to articulate (rather than critique) Canadian cultural values, the NGC is actually precisely the location where such reconsiderations must take place. Colonization is a relational process, albeit a deeply unbalanced and inherently violent one that exploits a constructed difference between a colonial authority and an Indigenous population. The space *Sakahàn* occupied within the NGC, as a collection of projects enacting an entwined cultural and political Indigenous self-determination, deserves to be complemented by a significant measure of unsettlement, or a decentring of settler perspectives, privileges, and comfort. Instead, it was met with a notable gesture of self-censorship. Decolonization in Canada is not properly the work of Indigenous peoples, but of settlers, as a material, cultural, psychological, political, and economic undoing of settler colonial power and privilege. Although the NGC cannot grant many of the political demands necessary for Indigenous self-determination, such as the repatriation of lands and resources, it can recognize its own complicity in the settler colonial project and work to materially reconfigure the distribution of aesthetic/cultural power and privilege that it traffics in.

Work has been done to address the predominance and violence of settler art-historical narratives at the NGC, most notably with the paradigm shifting exhibition *Land, Spirit, Power*, which Mayer also briefly mentions in his foreword. Curated by Diana Nemiroff, Robert Houle, and Charlotte Townsend-Gault, and presented at the gallery in 1992, it was the NGC's first foray into presenting the work of international Indigenous artists as contemporary production rather than as historical artifacts. Nemiroff has highlighted the liminal position of many Indigenous artists at that time, not exactly practicing cultural production in terms of tradition, nor willing to assimilate fully into Western culture. This was a generation of artists that, "while their relationship to Indian traditions and history may be more abstract and intellectual, their experience of Indian-ness forms an important part of the content of their work. Typically, this experience is seen not in isolation but rather in relation to the larger social and cultural context."[28] Here, culture was used to explore identity, taking firm root in a modern context of production and with the explicit aim of presenting self-articulations of Indigenous experience from a non-ethnographic perspective. *Land, Spirit, Power* presented work that needed the contextualization of a white-cube gallery, thereby effecting transformation within the institution itself by challenging Western notions of Indigenous art production. Given this history, it is curious that the NGC framed *Sakahàn* in a lineage of mega-exhibitions – the first in a series, a quinquennial[29] – rather than a continuation of the work initiated with *Land, Sprit, Power*. However, this framing speaks directly to the contemporary cachet of mega-exhibitions where a display of contemporary Indigenous art from around the world marks a unique contribution to a rapidly expanding field.

Okwui Enwezor, a writer and curator of quite a few mega-exhibitions (including *documenta 11* in 2002, 2008's Gwangju Biennale, 2012's Triennale d'Art Contemporain of Paris and 2015's Venice Biennale), offers a possible explanation that can be

applied to the NGC's institutional motivation to construct another massive and regularly occurring exhibition series in the midst of their rampant proliferation. He suggests that, "the desire to establish such exhibition forums is informed by a response to traumatic historical events and ruptures occasioned by the dissolution of an old order."[30] In Canada, this old order can be understood as settler colonialism, and *Sakahàn* can be understood as an attempt to support Indigenous cultural self-determination in response. That the resources of the country's national gallery be deployed to support the practices of Indigenous artists and their self-determined contextualization (where Indigenous identity is self-articulated, and where contextualization is authored by Indigenous curators[31]) is a fitting first step toward an art historical or aesthetic redress, one that must be compounded by institutional reconfigurations if it is to take hold in reshaping the institution itself.

However, there is something profoundly unresolved between the force of *Sakahàn* and the NGC's unwillingness to accept the ways the gallery itself is implicated in the ongoing settler colonial project in Canada, both as a mechanism of cultural proliferation and a federal institution. These contradictions cannot be neatly resolved because they are symptoms of a split in priorities and politics at the NGC, between the inertia of bureaucratic and ideological practices as is, and the radical restructuring required to address Indigenous self-determination in a settler colonial institution, a project that the NGC is helping to shape. Indigenous artists are still considered to be "other" and their ideas out of step with the gallery's – at least according to the gallery itself. And yet their presence at the NGC, and the gallery's material contributions and ongoing commitments to showing this work, confers a unique value to the institution, a certain kind of cultural cachet reflected in this line from the 2013–2014 annual report: "*Sakahàn* afforded the Gallery the opportunity to raise its national profile and expand and leverage partnerships with key art community stakeholders."[32]

A full three years before *Sakahàn* opened, the group of cultural workers responding to Mayer's comments on "excellence" predicted this schism between the prestige that would accrue to the NGC through showing the work of Indigenous artists and the avoidance of meaningfully engaging the politics of their work:

> There is a difference between being blind and just shutting your eyes. Ours have certainly been opened. After you [Mayer] left the Aboriginal Curatorial Collective's conference [held at the NGC in 2009] there was a heated discussion concerning the differences between eurocentric curatorial practices and those of Aboriginal curators. Robert Houle took the podium and addressed a younger generation of curators in the audience. He urged them to watch out for people in positions of power who only wanted to capitalize on their work. We now understand the real purpose of an Aboriginal quintennial [which Mayer had announced when speaking at the conference], and we understand why the National Gallery is still so sadly out of touch. Thank you for showing us your true colour.[33]

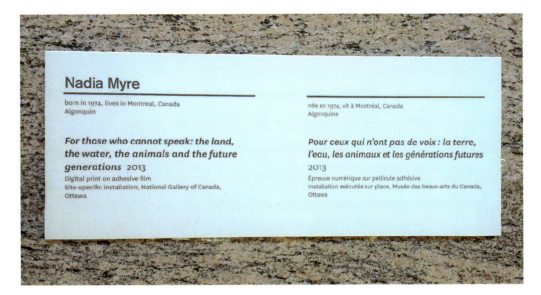

13.4 Label installed next to Myre's *For those who cannot speak,* as of 3 June 2015.

The disclaimers used for *Sakahàn* emerge directly out of this uncomfortable, interstitial space.

For those who cannot speak: the land, the water, the animals and the future generations remains on display at the gallery (as of May 2015), although the disclaimer as well as the extended didactic panel have been removed, leaving only the tombstone label indicating the artist's name and the title of the work. Without the contextualization offered by the extended label and the inclusion of the kokoms' speech, it is nearly impossible to interpret the work for what it is. Without the extended label, the work is neutered as a political gesture, though it remains as an aesthetic object. The opportunity for a viewer to wonder at the relation between the title and the material form is still there – they may choose to seek out the speech of the kokums and to piece together their own reading of what it means that Myre's work takes up such a large and visible space within the gallery – but this connection has deliberately been made more difficult to follow.

It is impossible to measure the precise effect that the disclaimers had on the audience of *Sakahàn*, though it is interesting to imagine what the exhibition might have been without them. If the NGC had refrained from marking the distance between their own ideologies and those of the artists, then the radical politics of the works probably would have been seamlessly absorbed in a self-congratulatory kind of way. Imagine Myre's work had been displayed with only her didactic panel beside it. There would be no reason to pause to consider the NGC's funding structure. Imagine there was no disclaimer to greet visitors at the show's entrance; there would have been no reason to pause to consider the NGC's continued investment in upholding settler colonial aesthetic and political standards.

Sakahàn curator Christine Lalonde, in an interview conducted on the eve of the exhibition's opening, pointed toward some of the social consequences of having organized an exhibition of international Indigenous art:

> It was really important that a national institution created a show like this, because even in many of the countries where we travelled, the [Indigenous] artists are excluded from the national institutions. So I think not only is the scope of this show unprecedented, the international component of it is more extensive than was perhaps possible before. It's really important that we are a national institution recognizing these artists and their place in our shared world. It's part of our commitment to indigenous art here in Canada. At the same time, the gallery has been transformed by this experience.[34]

The effect of the quinquennial exhibition series, of which *Sakahàn* was just the first, is transformative of both the NGC as an institution and of art histories. The disclaimers can be interpreted as indicating points of rupture, between what the institution has been and what it is becoming, and it is precisely in these spaces that new ways of being emerge. For the next iteration of the exhibition series, the revolutionary effects of the Idle No More movement could be endorsed; perhaps the NGC will be willing to risk funding for curatorial integrity; the institution may cede full interpretive power to the curators; the NGC may even acknowledge the incommensurability of the embedded politics of an exhibition series dedicated to showcasing international Indigenous art and the ongoing colonial history of the institution hosting it. If the disclaimers are an example of how not to install Indigenous art as a feminist, given that they undercut the political impetus of the work, then they also point toward areas of possible redress, indicating how, in the future iterations of the exhibition series, the NGC can install Indigenous art as feminists by respecting and supporting the transformative propositions of the work on display.

AUTHOR'S NOTE
Thank you to Pip Day, Alissa Firth-Eagland, Barbara Fischer, Greg Hill, Laurie Kang, and Nadia Myre for their support in thinking through the complexity of *Sakahàn*.

NOTES

1 National Gallery of Canada, *"Sakahàn*: International Indigenous Art," http://www.gallery.ca/sakahan/en/index.htm. The first version of this essay was submitted on 7 December 2014.

2 Throughout this chapter, I have used the term *Indigenous* to refer generally to descendants of those peoples who occupied the lands now known as Canada before the arrival of the European settlers. I have avoided the use of the term *aboriginal* out of respect for a growing movement, centred in Ontario (from where I write), that "[condemns] the word as a form of assimilation, which places Metis, Inuit, and First Nations Peoples into one category." Whitehawk, "Anishinabek Condemn Term 'Aboriginal.'" Further, the latin prefix *ab*– means "away from" or "not," incorrectly implying that Indigenous peoples are not "original" to this land. I have also avoided the use of *Indian* and *First Nations*, as those words tend to be used to imply legal definitions of identity as articulated by the Canadian

state. Sources quoted throughout do not necessarily use language in this way.

3 In Greg Hill's catalogue essay, which is a speculative look back at *Sakahàn* from twenty-five years in the future, he comments on the complexity of Indigenous identification in general and the experiences of colonization that the artists in *Sakahàn* shared: "The conflict in Canada [referring to Theresa Spence's hunger strike and the Idle No More movement] was a reminder of the spectrum of social and political conditions affecting all of the artists in the exhibition. That Indigenous artists living in Canada, Norway, Mexico, Japan, India, Guatemala and Australia had different lived experiences in relation to the colonial histories of their respective geographies was no surprise … However, the relationship between colonial experience and formations of indigeneity is direct." "Afterword: Looking back to *Sakahàn*," 137.

4 Art historian Anne Whitelaw has analyzed the NGC's attempt to acknowledge Indigenous art practices within a narrative of Canadian art history: "In June 2003, the National Gallery of Canada (NGC) re-opened its Historical Canadian Galleries with a new display that included, for the first time in the institution's 125-year history, the exhibition of Aboriginal objects … While the acknowledgment of the importance of Aboriginal material culture is admirable, the display of Canadian and Aboriginal art in these galleries is not a complete success. Much of the Aboriginal work included in the exhibition is ceremonial in nature and can only be truly understood in the context of its use. The privileging of the visual that characterizes the art museum effectively erases the multisensory experience these objects demand, requiring them to conform to Western ways of seeing." "Placing Aboriginal Art at the National Gallery of Canada," 197, 212.

5 In my personal experience, I cannot recall ever having seen such disclaimers used at an exhibition – where a gallery

expressly delineates between the politics of the work on display and their own institutional ideologies – before or since. I believe that it is commonly understood that the decision to exhibit a work, whatever its politics might be, means to carefully tend to the conversations a work raises, and not to deflect potential political or ideological repercussions. However, I have encountered warnings, advising of sensitive or potentially objectionable content, leaving the decision to encounter work with a viewer. Such a warning was also used in *Sakahàn* with Fiona Pardington's photographic series *Āhua: A Beautiful Hesitation*, which features life-casts of the heads of some Maori and other South Pacific Indigenous peoples. According to Greg Hill, "curators were however involved in the decision to include a warning text for Maori viewers that there were images in the work of Fiona Pardington they may want to choose not to view. This text was put in place on the advice of our Maori curatorial advisor, and past practice in relation to this work and its display in previous exhibitions." Greg Hill, curator, personal communication (email), 2 December 2014.

6 From the didactic panel.

7 These words of Jimmie Durham's are quoted in Diana Nemiroff's essay "Modernism, Nationalism and Beyond," 1.

8 Some of the most contentious aspects of Bill C-45 for Indigenous communities were changes in the Navigable Waters Protection Act (NWPA) of 1882, renamed the Navigation Protection Act (NPA). In effect, this aspect of Bill C-45 removed environmental protections on over 99 percent of Canada's lakes, rivers, and oceans (reduced from over three million to just ninety-seven bodies of water). Many of the deregulated lakes and rivers passed through Indigenous reserve lands. The effect of the NWPA had been de facto environmental legislation and its reformulation as the NPA essentially weakened environmental protection laws

across the country. Given the resistance some Indigenous communities have posed to resource extraction, particularly pipeline construction, the NPA in effect removes many legal opportunities for this resistance to take hold. In a press release put out by the chiefs of Treaty 6 First Nations, "pipelines will now be able to proceed across hundreds, even thousands of water course crossings without the necessary environmental scrutiny. These changes will increase the impact of development on First Nations Reserve lands, many of which rely on rivers and lakes to practice their Treaty rights to hunt, fish, trap and continue a traditional way of life." Meekis, "Treaty No. 6 First Nations." In addition to changes in the NWPA, Bill C-45 included amendments to the Fisheries Act, the Canadian Environmental Assessment Act, and the Indian Act, the latter of which permits the "lease out/surrender reserve lands based on votes taken at a single meeting, rather than a majority vote from an entire First Nation (community consent)," thereby significantly increasing the ease with which industry can access reserve lands and resources. McFarlane, "Bill C-45 Affects all Canadians."

9 From the didactic panel.

10 Cornum, "First Women, Then the Nation," 76.

11 CBC News, "Chief Theresa Spence to End Hunger Strike Today."

12 National Gallery of Canada, "Financial Resources," 6.

13 It is either puzzling or predictable that nowhere did the gallery make mention of Idle No More within the context of the exhibition itself, a coincidence that, as a curator, I would have found utterly remarkable for the opportunity it presented to connect the civic space of the gallery with the civic spaces of protest rising up around the country, outside of the gallery's walls. Idle No More was mentioned obliquely on the *Sakahàn* website (in the description of Alanis

Obomsawin's film *The People of the Kattawapiskak River* [2012], where the film is described as providing a context for the movement; and in a reference in the description of Michael Wesley's work *Dancer – Jingle Dress* [2011], which was part of the youth programming) and directly in the catalogue in Hill's speculative afterword.

14 Candice Hopkins, comment posted on Facebook, 23 April 2015, in response to a public status update posted by the author. Attempts to solicit further comments from Hopkins were unsuccessful.

15 Greg Hill, personal communication (email), 2 December 2014.

16 Candice Hopkins, comment posted on Facebook, 23 April 2015, in response to a public status update posted by the author.

17 The National Gallery of Canada's Corporate Plan clearly states that "under the Museums Act, the Gallery is a distinct legal entity, wholly owned by the Crown. While it functions at arm's length from the Government in its daily operations, as a member of the Canadian Heritage Portfolio, it contributes to the achievement of the Government's broad policy objectives." National Gallery of Canada, "Governing Legislation," 5.

18 Hopkins, "On Other Pictures," 22.

19 National Gallery of Canada, "Sakahàn: International Indigenous Art."

20 A few obvious examples of work from the exhibition that deal explicitly with colonization include Lawrence Paul Yuxweluptun's *An Indian Act Shooting the Indian Act, Healey Estate Northumberland September 14th, 1997* (1997), Kent Monkman's *The Triumph of Mischief* (2007), photographs from Terrance Houle's *Urban Indian* series, Nicholas Galanin's *The Good Book Vol. 15* (2006), Sonny Assu's *1884–1951* (2009), Vernon Ah Kee's *cantchant* (2009), and Nadia Myre's other contribution to the exhibition *Indian Act* (2000–02). I must also note that the exhibition's catalogue does address colonization directly. Pub-

lished by the NGC, it could be argued that the complexity of the conversation was displaced to the printed materials rather than being taken up explicitly in the exhibition's framing. But, this act of remove, displacing the ideological complexity into a media that is essentially removed from the material form of the exhibition, and that would only be consulted by far fewer viewers, makes the statement that colonization was not integral to the experience of the show. However, I would argue that the ideas presented in the catalogue are vital to comprehending the scope and implications of *Sakahàn*.

21 Excellence at the National Gallery of Canada, "An Open Letter to Marc Mayer."

22 Ibid.

23 In discussing *West Coast Art: Native and Modern* and other exhibitions that presented Indigenous and Western art objects alongside each other, including *Primitivism in the Twentieth Century: Affinity of the Tribal and the Modern* held in 1984 at the Museum of Modern Art in New York City, Anne Whitelaw notes that "the value of Aboriginal objects lay in their ability to testify to the creative products of a vanishing culture, and to an imagined pre-contact authenticity that could not be recovered. As artifacts, then, such objects had no place in an art gallery, where the significance of works was based on a conception of the aesthetic that, although putatively universal in designation, is effectively both historically and geographically specific to nineteenth- and twentieth-century Euro-North American conceptions of artistic and economic value. For Aboriginal works to obtain aesthetic value under these terms would require a complete reinvention of the notion of the aesthetic and, more importantly, a reassessment of First Nations societies as themselves having value." Whitelaw, "Placing Aboriginal Art," 204.

24 Mayer, Foreword, 9.

25 Nemiroff, "Modernism, Nationalism and Beyond," 419.

26 The work that was collected is archived on the gallery's website as *Model Crest Pole* by Unknown (Haida Artist). Further documentation of the work can be found on the National Gallery of Canada website: http://www.gallery.ca/en/see/collec tions/artwork_viewer.php?mkey=14335.

27 Mayer, Foreword, 9.

28 This quote is taken from the unpublished initial proposal that Diana Nemiroff submitted to the National Gallery of Canada for the *Land, Spirit, Power* exhibition.

29 According to Michael J. Tims, the chair of the Board of Trustees at the NGC, "the National Gallery presently intends to offer an exhibition of contemporary Indigenous art every five years." National Gallery of Canada, *Annual Report 2013–14*, 4.

30 Enwezor, "Mega-Exhibitions," 108.

31 Of *Sakahàn*'s three curators, Greg Hill and Candice Hopkins identify as Indigenous.

32 National Gallery of Canada, *Annual Report 2013–14*, 50.

33 Excellence at the National Gallery of Canada, "An Open Letter to Marc Mayer."

34 Mclaughlin, "Curator Q&A."

BIBLIOGRAPHY

CBC News. "Chief Theresa Spence to End Hunger Strike Today." 24 January 2013. http://www.cbc.ca/news/politics/chief-theresa-spence-to-end-hunger-strike-today-1.1341571.

Cornum, L. "First Women, Then the Nation: Confronting Colonial Gender Violence in Canada and the US." *LIES II: a journal of materialist feminism*, edited by LIES Collective (2015): 75–93.

Enwezor, Okwui. "Mega-Exhibitions and the Antinomies of a Transnational Global Form." *Manifesta Journal* 2: 94–110.

Excellence at the National Gallery of Canada. "An Open Letter to Marc Mayer, Director, National Gallery of Canada." *Excellence at the National Gallery of Canada* (blog), 1

March 2010. http://excellenceatthenational-gallery.blogspot.ca/2010/03/open-letter-to-marc-mayer-director.html.

Hill, Greg. "Afterword: Looking back to *Sakahàn*." In *Sakahàn: International Indigenous Art*, edited by Greg A. Hill, Candice Hopkins, and Christine Lalonde, 135–40. Ottawa: National Gallery of Canada, 2013.

Hopkins, Candice. "On Other Pictures: Imperialism, Historical Amnesia and Mimesis." In *Sakahàn: International Indigenous Art*, edited by Greg A. Hill, Candice Hopkins, and Christine Lalonde, 21–32. Ottawa: National Gallery of Canada, 2013. Exhibition catalogue.

Mayer, Marc. Foreword to *Sakahàn: International Indigenous Art*, edited by Greg A. Hill, Candice Hopkins, and Christine Lalonde, 9. Ottawa: National Gallery of Canada, 2013.

McFarlane, Christine Smith. "Bill C-45 Affects All Canadians, Not Just First Nations." *Shameless* (blog), 16 January 2013. http://shamelessmag.com/blog/entry/bill-c-45-affects-all-canadians-not-just-first-na.

Mclaughlin, Bryne. "Curator Q&A: How Indigenous Art Took Centre Stage in *Sakahàn*." *Canadian Art*, 23 May 2013. http://canadianart.ca/features/sakahan-national-gallery-of-canada/.

Meekis, Devon. "Treaty No. 6 First Nations Do Not Recognize Laws and Enactments of the Government of Canada." *Idle No More* (blog), 17 December 2012. http://www.idlenomore.ca/articles/latest-news/alberta-news/item/56-treaty-no-6-first-nations-do-not-recognize-laws-and-enactments-of-the-government-of-canada?tmpl=component&print=1.

National Gallery of Canada. *Annual Report 2013–14*. http://www.gallery.ca/documents/planning%20and%20reporting/AR_NGC_2013-14.pdf.

– "Governing Legislation" and "Financial Resources." In *Summary of the Corporate Plan for 2012–13 to 2016–17 and Operating and Capital Budgets for 2012–13*, 5–6. http://www.gallery.ca/documents/planning%20and%20reporting/NGC_CORP_PLAN_SUMMARY_MAY4_ENG_FINAL.pdf.

– "*Sakahàn*: International Indigenous Art." http://www.gallery.ca/sakahan/en/index.htm.

Nemiroff, Diana. "Modernism, Nationalism and Beyond." In *Thinking About Exhibitions*, edited by Reesa Greenberg, Bruce W. Ferguson, and Sandy Nairne, 411–36. London: Routledge, 1996.

Whitehawk, Michaela. "Anishinabek Condemn Term 'Aboriginal.'" *First Nations Drum*, 7 August 2008. http://www.firstnationsdrum.com/2008/08/anishinabek-condemn-term-aboriginal/.

Whitelaw, Anne. "Placing Aboriginal Art at the National Gallery of Canada." *Canadian Journal of Communication* 31, no. 1 (2006): 197–214. http://www.cjc-online.ca/index.php/journal/article/viewFile/1775/1898.

A Speculative Manifesto for the Feminist Art Fair International: An Interview with Allyson Mitchell and Deirdre Logue of the Feminist Art Gallery

Amber Christensen, Lauren Fournier, and Daniella Sanader

14 In 2010 artists Deirdre Logue and Allyson Mitchell opened the Feminist Art Gallery (FAG) in their renovated garage in the Parkdale neighbourhood of Toronto. Through exhibitions, workshops, screenings, dinners, residencies, parties, free schools, and more, FAG has extended beyond their backyard, serving as a dynamic example of how queer-feminist artist-run culture might be put into practice locally and internationally. It is, to borrow from Logue and Mitchell's phrasing, "a response, a process, a site, a protest, an outcry, an exhibition, a performance, an economy, a conceptual framework, a place, and an opportunity" that continues to find new homes, allies, and support networks throughout Toronto and beyond.

14.1 Deirdre Logue and Allyson Mitchell, FAG *Feminist Art Gallery* (interior), 2010.

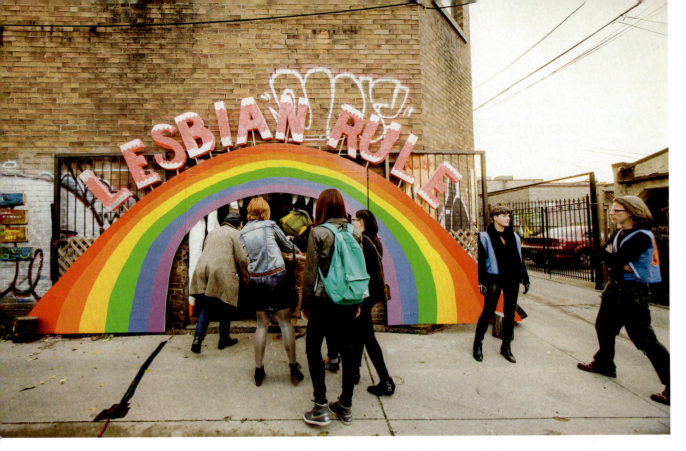

14.2 Allyson Mitchell in collaboration with Deirdre Logue and the AGYU, *KillJoy's Kastle: A Lesbian Feminist Haunted House* (entrance), 2013.

The year 2015 marked the thirtieth anniversary of the first masked appearance of the Guerrilla Girls, the New York–based arts collective that have been working to draw attention to the lack of gender and racial equality within the art world. Yet, in the same year, *Canadian Art* published an article that statistically confirmed the continued dominance of white male artists in solo exhibitions at major arts institutions across Canada. This was also the year that Logue and Mitchell (as FAG) completed an artists' residency at the Art Gallery of Ontario (AGO), where one of their objectives was to explore the feasibility of a feminist art fair in Toronto, tentatively titled the Feminist Art Fair International (or FAFI for short). By radically parodying the international art market, could a feminist art fair propose an alternative to the systems of heteropatriarchal settler capitalism? Mitchell's 2013 project *KillJoy's Kastle*, the lesbian-feminist haunted house supported by the Art Gallery of York University, also mimicked a site of power (evangelical Christian spaces designed to moralize through fear) and generated much discussion around the contexts for feminist art in the city, which bodies they include and exclude, and which funds support them. Through similar tactics, a FAG–organized Feminist Art Fair International could potentially reinvigorate conversations about alternative economies and the communities they represent.

Many questions arise while exploring a speculative model for the Feminist Art Fair International. Would FAFI operate within the same forms of exchange that the main-

stream art market is aligned with? How might we reconcile the wealthy patronage model that has characterized the current patriarchal art market with feminist values? And, of course, there are the nitty-gritty concerns of arts organizing to contend with: How would this art fair function, and what practices would it represent? What spaces would it inhabit and what communities would it support? How will it *pay artists*?

We sat down with Deirdre Logue and Allyson Mitchell in their backyard on a sunny afternoon to speculate about the FAG, alternative art economies, and feminist art fairs. We asked them about the place of feminist art in the contemporary Canadian art market and what a Feminist Art Fair International might look like in practice. Just as the Feminist Art Gallery and the Feminist Art Collection – two of Logue and Mitchell's ongoing projects – represent and enact a different kind of economy for "doing art," so too might the Feminist Art Fair International.

AMBER CHRISTENSEN, LAUREN FOURNIER, DANIELLA SANADER (AC, LF, DS): As the Feminist Art Gallery, you completed a residency at the Art Gallery of Ontario in 2015. One of your intended research projects was to consider the possibility of a Feminist Art Fair International in Toronto. What was the impetus for this project and how did you intend it to function?

DEIRDRE LOGUE (DL): When we started FAG we had to describe what we meant by a Feminist Art Gallery, but we avoided – I think very strategically – the definition of feminist art in doing so. But then, over the course of the first couple of years, people wanted to have us define feminist art more clearly. I think we avoid defining feminist art pretty well, but we do have a Feminist Art Collection and we have conceived of the Feminist Art Fair International. Both the Feminist Art Collection and FAFI are moments for us to challenge the public and celebrate the cultural producers that we are most excited about. It's a challenge to get artists to say that they are making feminist art, and that they don't have to explain it or describe it or define it for anyone: it's feminist art because they say it is. We did two focus groups with the folks at Whippersnapper on what they thought a Feminist Art Fair should look like or could be.[1] We ended up spending most of our time talking the group into having more capacity to call themselves feminist artists, to put feminist in their bios, and to not worry about the fact that someone might not want to show their work … [noise of a neighbour's lawnmower interrupts conversation] … This is a classic situation for feminist discourse: when you start talking someone will turn on a giant machine and it will drown out your voice instantly.

ALLYSON MITCHELL (AM): The Feminist Art Fair International or FAFI was actually proposed to us as a semi-joke by Andrew Harwood when we opened FAG. Andrew Harwood is an artist who we love, and he said "you guys should start the FAFI," because he ran TAAFI, which was the Toronto Alternative Art Fair International. TAAFI was beloved and amazing for the few years that it ran. So, I want to credit Andrew with the name of FAFI, and the way that you say it: FAFI!

DL: Initially we were going to do FAFI in the fall of 2015. We did some research last year when we were at the AGO. Our intern helped us look at possible models for FAFI to figure out which, if any, of the kinds of art fair models or festival models could work best as a framework, a geography, and an economy. What we are really after with FAFI is the same thing that we are after with the Feminist Art Collection, it's the same thing we are after with the Feminist Art Gallery, and it has to do with looking at what is wrong with this picture. We are looking at the art world from a critical perspective but without a total rejection. It is a way of problematizing, troubleshooting, analyzing, in a participatory way, what it is that is wrong with the art system as it relates to feminism, as it relates to access, as it relates to work by women, people of colour, queers, trans people, Indigenous people, etc.

AM: Which is really easy to do. But what is not easy to do is to try and participate in a way that is generous without replicating those kinds of problems. We said that we wanted to do FAFI as the swan song of the Feminist Art Gallery. When we opened FAG five years ago, we said that it was only going to be a five-year project. We took the model from LTTR, a collective of friends and artists from New York, who collapsed their project after five years because they didn't want to become institutionalized. That is what we thought we would do too. When we plunged into it we had no idea how much energy it would take up, if people were really interested in it or wanted it. It immediately took an enormous amount of time, space, energy, money, affect …

DL: Defect, reject.

AM: And we actually have clawed back a little bit of the labour of it in the last year because we couldn't handle it. We also needed to make some of our own work as artists. But we did decide that we wanted FAFI to be kind of like the "Ta Da!" of the Feminist Art Gallery. As we are thinking of it, FAFI is going to work as satellites, which is how FAG has really worked in the last three years. We started off in a space we created in our backyard as a kind of gallery, workshop, classroom, think-tank – whatever we needed it to be. And then, through our practice-based research, we learned that FAG doesn't have to physically be here, and that we can parasitically use some of the resources of other institutions that have funding, and structure, and administrative help, and a larger microphone than we have. The giant utopic dream of FAFI is to have FAFI exist as these satellites that happen all over the place, not just in one physical space, which is a way of exploding the model of the gallery or the art fair. It would be for us the perfect ending but also the beginning.

DL: There are two things I wanted to talk about. One is how I think you are right that FAFI is our attempt at – another attempt at – ceding this model. But I also want to talk about how we thought that that would have happened already. I thought that there might be some feminist art galleries *already*. So when I asked you guys if you thought more feminist art activity is happening in Toronto, I was hoping that you would say

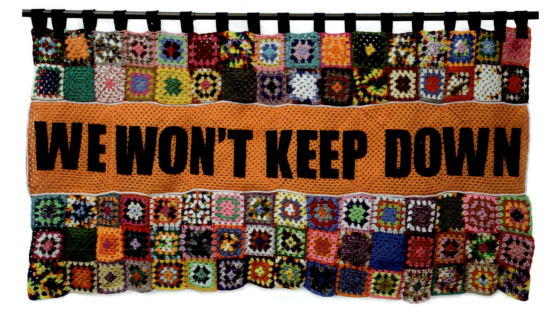

14.3 Deirdre Logue and Allyson Mitchell, *WE WON'T KEEP DOWN*, 2012.

yes, because I think there is. I think that more people have been interested in what we do than I ever thought they would, more people have asked us to talk about feminist cultural production and its lack of economy or its communities or its vast potentials than I ever thought they would.

AM: In fact, sometimes people wanted us to talk about it so much that we didn't have time to do it [the FAG] because we were running around talking about it.

DL: Right. So the first three and a half to four years were really intense, and I think if we look at what we've accomplished, I think we would be very happy. We asked the community "do you think we should start a Feminist Art Gallery?" before we had anything here and they were like "yes absolutely!" And I was like, so we're going to have a feminist art gallery in our garage, and you're going to have a feminist art gallery in your garage, and you're going to have a feminist art gallery in your garage, and you're going to have a feminist art gallery in your garage. I felt like it could have been a model that more people would have tried to utilize. Like the LTTR model, we asked how long we could keep this going. We feel like we flew as close to the sun as we possibly could. We have worked with the Tate Modern. We have worked with SF-MOMA. We have exhibitions in catalogues and other things that, in art terms, are measures of success. And in every case we have tried to resist the institutional essence, while working to build a bridge between an institution and artists that are otherwise underrepresented.

AM: At the same time we didn't say yes to everything we were asked to do. There were some things that felt like they were too much of a compromise that we could not subvert from within. It was impossible.

DL: We're not sure what to do right now. We have explored the models that we thought were interesting. We have staged almost every single type of cultural activity you could imagine. A book launch, a writer's residency, artist talks …

AM: Free school …

DL: Free schools, exhibitions, production workshops …

AM: Performances …

DL: Performances, openings. Cheesies coming out your ears. Parties. So, we've done these things, and we've done the Feminist Art Collection model, which is still one of the most provocative models that we have ever proposed. How FAC is articulated is clear, and we are doing it regardless of how well the model might work outside of our own personal economy. The Feminist Art Collection model is that we buy work from artists and/or work comes to us through various donations or contributions, and we call it part of the Feminist Art Collection and we exhibit it and the artists have an exhibition and get into a catalogue. The FAFI is one more model to test, but it has come at a time where we are kind of at a loss as to how this particular economy …

AM: Well it's the ultimate model to test.

DL: The labour to put it together seems out of reach. So on the one hand we are waiting to find the right model, on the other hand the groundswell, the people that we thought would be here with us at this point in time are not really clear to us.

LF: I'm curious, with regards to the utopic dream of FAFI as existing as satellites, and your vision of FAG as something in other peoples's garages as well as your own garage, how does one "brand" themselves as a feminist art gallery? Is this something that anyone can do? You have noted the lack of definitions around "feminist art gallery" as part of the overall effort to resist institutional ossification and colonization, so how does one ensure consistency with the mandate? Are there certain parameters, or a kind of toolkit, or a means of facilitating this?

AC: When we first met you mentioned one of your models for FAFI is that you were going to have a manifesto of some sort that would indicate some of the, I don't want to say parameters, but …

AM: Dimensions. Yeah. I guess we are asking, you never want to say *blueprint* for "how do you do a feminist thing," but I guess there has to be some sort of conversation around what that would look like.

LF: Deirdre, when you said that you wished we would say that there are indeed more feminist art spaces, what are the logistics of naming oneself? Say if I were to start a feminist art gallery it couldn't be "The Feminist Art Gallery" because that's you guys.

AM: Sure it could. Why not?

DL: Maybe that's something we should re-articulate or make more explicit. FAG isn't an art gallery, it's …

AM: An idea.

DL: It's an idea that we need a more visible or sustainable or provocative or, dare I say, aggressive space for feminist art in Toronto or abroad. So if there is a thing that should be happening it's that thing. We didn't say we are going to start FAG as a franchise or a model that you should all take up, but we did explicitly say that this is not a women's art project, it is not exclusively a feminist art gallery. It is a political statement. We wanted as many people as possible to hear and then to be moved by that, to be changed …

AM: Or fed by it.

DL: Or fed by that somehow. And I think that that's actually happening. But it is less tangible than I thought it would be.

AC: You felt this dissatisfaction with this particular project as there wasn't this uptake that you thought there would be. But in practical terms, how do you make that dissemination happen? With a manifesto, is there something tactile that organizers can grab on to?

AM: You are asking about the manifesto, which hasn't been written yet, which hasn't been hammered out between the two of us yet, although we've been living it for many years. I have an experience with this, where I tried out a political platform and wanted to see what would happen. I named it Deep Lez, and I put it out there in the world to see what would happen, and people really did pick it up. But there came a point that was very notable to me, after it was whirling out in the world for four or five years, that I had to put something down in words which expressed – even in a loosey-goosey and open-ended and all about potentiality way – what the thing was. I had to take

some responsibility for it. And this is a similar experience. To be able to come to the language, we curated two exhibitions that were about trying to understand what feminist art is so that people could use that as a model, or reject that as a model. The first exhibition we worked on, we started with curating work on the theme of "what is feminist art" by only curating work that used words. We were trying to be really literal. So if it used words in its own manifestation that expressed itself as feminist, we put this in a collection together to give us something to be able to think about. And in the next exhibition we chose what I felt is the opposite: abstraction. So, rather than it being explicit in that way, it was like going way out on a limb or on another end of a continuum. So by doing these two practice-based research exhibitions, now we can cull the language of what that is. We can talk about not only the practicalities, which I think are really important to archive – of the money spent, the hours in, who was consulted, the nitty gritty, which is fascinating and really important for us to understand how things happen – but also more these ideas of what feminist art is. So, I don't know if it will end up being called a manifesto or a guideline or a how-to. We'll try to think of something witty to subvert any of those things. We'll probably be working on that in the next year. We'll have to.

14.4 Deirdre Logue and Allyson Mitchell, *CAN'T/WON'T* banner at the Vancouver 2nd Annual Craft Pride Parade, 2012.

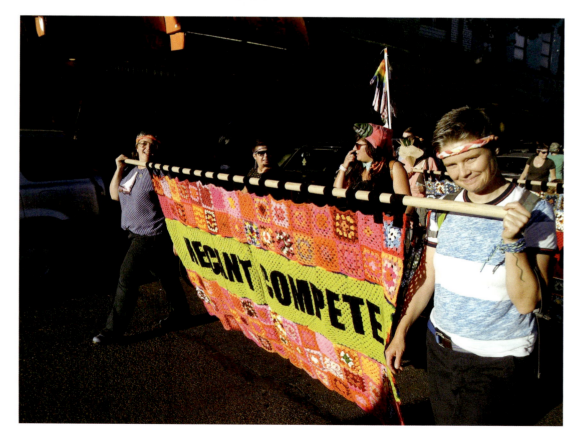

DL: I want to reiterate one thing. We aren't disappointed that there aren't feminist art galleries all over Toronto. We don't give a shit really. We are determined, we remain excited, we remain persistent, diligent, in the project of addressing the world through the model of the feminist art gallery: whether it is full of garbage, whether there is an exhibition in it, whether we're here in Toronto doing it or we're somewhere else, whether we're doing it through our own work as artists or not doing it at all, it exists. It's a thing. It's smart. We believe in it. And it is doing something. The FAFI we think could advance FAG's scale. The *Complex Social Change* show we operated as a satellite and showed and articulated what we thought the Feminist Art Collection could be and could do. You'll see that our work is in that show because we needed it to be. The "We Can't Compete" banners are the manifesto. This is an art object that we made, and as Allyson mentioned, all of these works have text and speak for themselves in that they are their own manifesto. We did similar things at the Art Gallery of Windsor and the Art Gallery of Ontario. We continued to bring the Feminist Art Gallery into institutions and kind of eat our way out. We mark it down, we draw a line, we say, "after this, when you step into it, it's the Feminist Art Gallery." It's not the Art Gallery of Windsor, it's not the University of Lethbridge Art Gallery. I feel like the manifesto for the FAFI could be very similar. You say, "this is a feminist space." For one hour, for one day, for one week. As long as you are paying an artist's fee so that you are not exploiting the artist's work and that you and your participants have a definition of feminism that feels autonomous.

AM: We did say that there would be parameters, so that not just anybody could take the name for their own benefit.

DL: What I'm saying is that the model doesn't need to be complicated. You don't need to prescribe to something. You need to be aligned, politically. You need to have the political will to do it and you need to work within the parameters that we would establish. And we would establish them based on the experiences that we've had but we also would establish them based on some of the things that we want to try and figure out that we don't really know yet. We could work with institutions, we could say "okay, it's the Feminist Art Fair International: Mercer Union,[2] are you in?" And they'll say, "the show that we have would work really well for FAFI." And the criteria would be: Are you paying artist's fees? Does this artist identify as queer, feminist, racialized? Are they Indigenous? Do they identify as feminists? And if it seems that they meet some of the expectations of a feminist art exhibition, we could say: OK, Mercer is one venue. The same could be true for a one hour-long performance or a writing group. Those are other ways for how it could be approached. So, yes, there will have to be some sort of way of figuring out where it happens and its economy so that everyone is paid fairly for their work, and there will have to be some kind of manifesto that people can get on top of, behind, can celebrate and recognize. But I think it can be in a variety of

spaces, with a variety of types of work and time frames, as long as it takes place during the Toronto International Art Fair to offer a critique.

AM: And it's not even specifically the Toronto International Art Fair.

DL: It's all art fairs.

AM: It's all art fairs, art scenes, museums, and artist-run culture.

DL: It's all of the models that exclude.

DS: I think this carries pretty directly from what you are just talking about, because I wanted to ask about the "international" in FAFI. It is a direct response to TAAFI, but you are also speaking of these satellite models that exist in places like Lethbridge and Windsor. Is FAFI a response to the dissatisfaction in what's happening in Toronto, or is it going to have a number of satellites that move beyond the space of this city, or the space of this country?

DL: The answer is yes. We have already established a willingness on the part of La Centrale Galerie Powerhouse in Montreal.[3] We're hoping when we're in Los Angeles to continue talking to friends and queer family to see if something could happen there.

AM: I see it as a Day Without Art.

DL: Yeah, A Day Without Art. I think we could in fact entertain a conversation around what a FAFI could be as it relates to the absence of feminist art as opposed to the presence. We really haven't gone that far yet. So maybe every feminist artist just stays home on a sick day as one of the elements of the FAFI. To illustrate the labour: the loss of labour.

AM: That's a really good idea.

DL: Yeah. I'm taking a personal feminist day off.

DS: Self-care.

LF: Like a mental health day.

DL: I'm sick of this bullshit, I'm staying home.

LF: You have emphasized the need to pay artist fees as a means of valuing feminist art as labour. This is an important point. And yet, I can think of two feminist art projects in Toronto that I have been involved in recently, in which artist fees are not adminis-

tered. There are these fleeting feminist art collective-type projects happening that are not institutionalized and have no money.

AM: When we started we had a matronage program and we worked with people to pay artists for their exhibition. And people either gave us money, or we explicitly asked people who are connected to the artists, maybe one of their teachers or a friend who have an interest in the work. We always managed to pull in enough money to pay an artist's fee and a little bit of money for materials.

DL: We rounded up about $1,200 per show.

AM: This was a particular moment which was just before all of those self-funding programs started on the internet, like Kickstarter and Indiegogo, which I feel people are becoming exhausted by. There was a sweet moment. And since then, we have not had to do that kind of fundraising because we have often partnered with institutions that had some money. One of the main philosophies of the FAG is that artists should be remunerated for their work. And in this system, we know that people need money to go to the dentist, to pay their rent, to buy their art supplies, and so on. You have to put in your money with the promise that you'll pay people, whatever, you know $50, $100, when you do make that money back. Or you pay them up front.

DL: But here's another answer to the question. We spent our own money, a lot of it. We decided, first of all, we are childless. Second of all, we are middle-aged. And thirdly, we didn't really have a choice. You know, the idea was to try and establish the FAG, give it an actual physical footprint, go into debt doing it. And when it came to buying booze and cheesies and when it came to figuring out the costs of the exhibition, if there was a shortfall, we used our privilege. That's what we did. And it doesn't make our privilege any less problematic, but it does put our privilege into some practical, tangible use for a project. We felt it would be worth trying to situate that privilege in such a way that it would be an artist's fee, or a dinner party, or a plane ticket. For the exhibitions and artist talks, we continue to ask people to help, but eventually people were like, meh. At the beginning people were like, oh my god I can't wait to throw money at this! But in the end, one of the events we did in January, we asked eight people and only one gave us enough money for the film rental. So we paid money out of our own pockets for the film rental.

AC: How do you propose an alternative model, because along with FAFI there is an economical model that involves monetary remuneration, you are asking for the artists to be paid. But what is this alternative model, if you are not in the position to pay?

DL: It is the public. It is supported by the public. If, as part of FAFI you wanted to have a show at your space, but you didn't have any money we would ask someone who has money but who doesn't want to have a show. They give you $500; you have your show.

AM: I don't know any of those people though. Anymore.

DL: So maybe, it's not one person for $500. Maybe it's five people at $100 each. But you help me figure that out. You help with the labour. There's not going to be some grand overseer. There would have to be some kind of place for people to put money to make it happen, some sort of repository of cash that can be divided. There would have to be organizations willing to sponsor, there would have to be institutions that have space and were willing to take that on: artist-run centres, dare I say commercial galleries, alternative venues. So let's say the minimum artist's fee is $100. It doesn't matter what you're doing – a painting on the wall, a one-hour performance – it's $100 per artist per exhibition. We would have to find a way to generate that money. But what I'm thinking about is, obviously paying artists is one of the problems of this model. Not everybody can do it because they don't have the cash, the time, the resources. But for FAFI, some of the festival models we researched were ones where people pay for a pass to go to everything as a way of subtly crowdfunding, a bit like "passing the hat." Some of those models were more reasonable than a traditional art fair model where vendors would pay, and there would be potential sales. We are looking for the opposite of the art fair model in every way. Just like we looked at the opposite of the way institutions collect art for the Feminist Art Collection. It's just the opposite. They make it invisible, we make it visible. They own it, we don't own it. The model has a kind of oppositional framework. Or should, or could. In every other situation artists do not get paid, so in this situation artists get paid.

DS: You're speaking about this as a sort of swan song for the FAG. I'm wondering if you see FAFI as a one-time model or if ideally there could be sustainability built into it to be a yearly phenomenon or a biennial or something like that.

AM: I would think that if someone wanted to do something like that it would be fine. But, let's wait and see. We don't know what's going to happen, what it's going to be like, if it's going to be nourishing or if it will be a painful experience. We don't know. We'll try it out and then decide. But we don't have a business plan. And there's a lot of pressure to do that kind of yearly festival. And then it becomes like the "Festival Industrial Complex." And that's not what we're interested in. That's the whole reason why we try to keep the admin as low as possible.

DL: It's actually easier to plan it as a one-hit wonder. Where it is more like a protest or a performance. I think that if, as Allyson says, it feels generative, if it feels restorative, if it feels like something that really excites or ignites the feminist and queer cultural production community in Toronto in a way that is real and meaningful, it will sustain itself.

AM: But it's meant to be more direct action than an institutionalized yearly or bi-yearly thing.

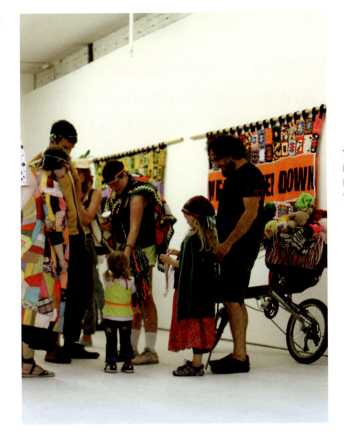

14.5 Deirdre Logue and Allyson Mitchell, opening reception for FAG *Satellite* @ Access Gallery, Vancouver, 2012.

DL: It's direct action. We're not looking to start an art fair.

AM: Hell no. It's not meant to be an art fair for real. But if anyone says it's not, we're going to get really mad.

[Laughter]

NOTES

1 Whippersnapper Gallery is an artist-run centre in Toronto that is "committed to the cultivation of inclusive spaces for emerging visual and media arts, community arts, and experimental forms of exhibition making" (www.whipper snapper.ca/about).

2 Mercer Union, A Centre for Contemporary Art, is an artist-run centre established in Toronto in 1979 that exhibits Canadian and international contemporary art.

3 La Centrale Galerie Powerhouse was founded in 1973 in Montreal, Quebec: "Its mandate expands on a history of feminist art practices and aims to provide a platform for contemporary art that is informed by feminist and gender theory, as well as intercultural and transdisciplinary practices" (www.lacentrale. org/en/who-is).

Appendix: There Is No Feminism (A Love Letter) Or, A Working Chronology of Feminist Art Infrastructures in Canada

Gina Badger

Introduction

This chronology outlines a history of feminist art in service of collective liberation, drawing on intersectional thought and action outside of obvious disciplinary bounds. It is woven through the stories of artist-run culture, of new media, of performance art, of emergent and experimental forms. Through stories of Indigenous cultural resurgence under colonialist frameworks of fine, visual, and contemporary art. Through stories of black women and women of colour genius in the face of white supremacy within mainstream white feminist art. Through stories of trans people's relentless creativity despite the transphobia that perennially threatens to invalidate their work.

My research method was a grassroots, collaborative one. The chronology is grounded in personal accounts collected via two survey questions: Which institutions, galleries, events, exhibitions, publications, festivals, collectives, etc. do you think have been the most important for fostering the production of feminist art in Canada? And, which have been the most significant to your own practice?

The survey was distributed via email to over one hundred people whose contributions to feminist cultural production I deeply respect. Of these, I received fifty-seven responses that provided the foundation for the chronology, supplemented by research conducted primarily through the online archives of galleries, artist-run centres and other organizations, and select published sources.[1] Because of this research method, the timeline reflects idiosyncratic and conflicting histories that weave around and across each other. There is no definitive structure, only connective tissues. It's messy, inconsistent, and partial, but no less beautiful for its dropped threads, holes, and frayed edges.

It is my hope that with this methodology, I've been able to respectfully weave together diverse threads while avoiding the colonialist gestures of white and cisgender feminists that are all too common in both academia and pop culture – namely, non-consensually claiming the cultural production of trans, black, Indigenous, and racialized people in the name of a feminism that's never cared if they are dead or alive. White supremacy and transphobia remain the festering wounds of feminism's present. Simultaneously, trans, women of colour, black, and Indigenous feminisms offer learning and healing for all those who are invested in feminist politics and the movements we build together.

I want to honour some forms of silence that cannot be plotted onto a timeline. Several potential respondents got back to me only to say that they couldn't participate; sometimes because their work schedules were overloaded; sometimes because they didn't identify as feminists or agree with feminism as a framework (one elder whom I respect immensely wrote that, in Canada, rather than feminist politics, "there have been feminisms, fragmented along racial lines"); sometimes because feminism seemed too interpersonal, too effusive for them to enumerate items for a list. These three reasons illustrate different types of tensions and conflicts that likely account for most of the people who never responded at all, and they are important to note here.

This chronology begins in 1963 with Edith Josie's newspaper column *Here Are the News*. It begins with Edith Josie, an Elder from the Gwich'in nation, because no matter what, any story about feminism in North America is indebted to the labour and cultural production of Indigenous women. It begins in Old Crow because life in cities does not exist apart from small towns and remote rural areas. It begins with a gesture towards the news, current events, and gossip, because so much not-art is required for art to exist, and because each entry is more or less a headline – incomplete fragments that appear and disappear just as suddenly, each pointing beyond the boundaries of this chronology towards its own nuanced story.[2]

NOTES

1 Entries are followed by the initials of all respondents who mentioned them. I have often included a list of key names along with an entry, which frequently cuts across decades of an organization or project's history.

2 My sincere thanks to this book's editor, Heather Davis, and to Janice Anderson, Anne Bertrand, Lorna Brown, Nicole Burisch, Kristina Huneault, Michelle Jacques, Jayne Wark, Zainub Verjee, and to the peer reviewers who all generously reviewed this chronology in its entirety and provided invaluable support during its production.

Survey Respondents

Zainab Amadahy ZA

Janice Anderson and Kristina Huneault JA/KH

Sharlene Bamboat SB

Amber Berson AB

Anne Bertrand ABe

Anthea Black ABl

Ianna Book IB

Lorna Brown LB

Alvis Choi ACh

Michèle Pearson Clarke MPC

Alison Cooley AC

T.L. Cowan TLC

Randy Lee Cutler RLC

Aimée Elizabeth (a.d.) Darcel AD

Sally Frater SF

Jeneen Frei Njootli JFN

Kandis Friesen KF

Amy Fung AF

Francisco-Fernando Granados FFG

Maggie Groat MG

Coco Guzman CG

Gita Hashemi GH

Gloria Hickey GHi

Tarah Hogue TH

Maria Hupfield MH

Michelle Jacques MJ

Alice Ming Wai Jim AJ

Michelle Lacombe ML

Kama La Mackerel KLM

Yaniya Lee YL

Sophie Le Phat Ho SLPH

JJ Levine JJL

Cheryl L'Hirondelle CLH

Jenny Lin JL

Milena Lye MLy

Jess MacCormack JM

Liz MacDougall LM

Nahed Mansour NM

Ashok Mathur AM

Gabrielle Moser GM

Morgan M. Page MMP

Sheila Petty SP

Lido Pimienta LP

Kathleen Ritter KR

Kirsty Robertson KRO

Denise Ryner DR

Trish Salah TS

Robin Simpson RS

Stephanie Springgay SS

Thérèse St-Gelais TSG

Maiko Tanaka MT

Camille Turner CT

Jayne Wark JW

Jenny Western JWe

Charlotte Wilson-Hammond CWH

Yan Wu YW

Zainub Verjee ZV

1963

Edith Josie's column *Here Are the News* debuts in *The Whitehorse Star* (until 2005) JFN
Fusion des arts established (Montreal, Kanien'kehá:ka, and Algonquin territory); first
 artist-run centre

1967

Candian Artists' Representation / Le front des artistes canadiens (CARFAC) established
 (London, ON, Algonquin, Iroquois, and Attawandaron territory)
Intermedia established (Vancouver, unceded Coast Salish territory of the Musqueam,
 Squamish, Tsleil-Waututh nations); first artist-run centre to receive funding from the
 Canada Council for the Arts

1968

Equal Rights for Native Women established by Mary Two-Axe Early
Criminal Law Amendment Act decriminalizes homosexuality and legalizes abortion
 and contraceptives

1970

Mount Saint Vincent University Art Gallery established with a mandate to represent
 women's art (Halifax, Mi'kmaq territory). Key names: Ingrid Jenkner, Mary Sparling
 GHi, CWH
Photographers Gallery established with the journal *Blackflash* (Saskatoon, Nêhiyawak,
 Nahkawininiwak, Sioux, and Métis territory)
Special Events programming slot established at the Vancouver Art Gallery (VAG) (until
 1975). Key names: Marguerite Pinney, Dorothy Metcalfe
Publication of the Royal Commission on the Status of Women in Canada, with 167
 recommendations for promoting gender equality

Treaty Numbers 23, 287, 1171: Three Indian Painters of the Prairies opens at the
 Winnipeg Art Gallery (Winnipeg, Anishinaabe, Cree, Dene, Dakota, Métis, and
 Oji-Cree territory). Key names: Daphne Odjig, Alex Janvier, Jackson Beardy

1971

A Space Gallery established (Toronto, Anishinaabe, Haudenosaunee, Huron Wendat
 territory) AB
The Body Politic monthly periodical established
Open Space established (Victoria, unceded Songhees and Esquimalt territory)
Women in Photography / Women's Photography Coop established (Toronto)
First National Conference on Native Women's Rights (Ottawa, unceded Algonquin
 territory) JA/KH
Publication of Linda Nochlin's essay "Why Have There Been No Great Women Artists?" TH
Joyce Wieland is the first woman to have a retrospective exhibition at the National Gallery
 of Canada (NGC) (Ottawa) AC
First feature-length fictional film by a woman director is made, *Madeleine Is...* by Sylvia
 Spring

1972

Inventions Gallery established (Halifax) (until 1973). Key names: Sarah Jackson and
 Charlotte Wilson-Hammond CWH
Newfoundland and Labrador Crafts Development Association established (St John's,
 Beothuk and Mi'kmaq territory)
Optica established (Montreal) TSG
Plug In established (Winnipeg)
Professional Native Indian Artists Association, colloquially known as the Native Group of
 Seven, established (Winnipeg). Key names: Daphne Odjig, Alex Janvier, Jackson Beardy,
 Eddy Cobiness, Norval Morrisseau, Carl Ray, and Joseph Sanchez JWE
Shoestring Gallery established (Saskatoon)
Véhicule Art established (Montreal)

1973

Canadian Advisory Council on the Status of Women established by the federal government
 (until 1995) JA/KH
Femmedia: The Independent Film and Video Festival established (Montreal)
Forest City Gallery established (London)
Powerhouse Gallery and Studio / Galérie et atelier la Centrale Électrique, now La Centrale
 Galerie Powerhouse, established (Montreal). Key names: Elizabeth Bertoldi, Leslie Busch,
 Isobel Dowler-Gow, Margaret Griffin, Clara Gutsche, Billie-Joe Mericle, Stasje
 Plantenga, Nell Tenhaaf, Pat Walsh AB, IB, JA/KH, JJL, JL, JM JW, KF, ML, TS, TSG, YL

Latitude 53 established (Edmonton, Blackfoot, Cree, Métis, Nakota Sioux, Nahkawinini-wak, and Saulteaux territory)

National Action Committee on the Status of Women (NAC) established in order to lobby for the implementation of the recommendations made in the 1970 report of the Publication of the Royal Commission on the Status of Women in Canada

ReelFeelings women's film and video collective established (Vancouver)

Satellite Video Exchange Society, now VIVO, established (Vancouver) LB, KR

SAW Gallery established (Ottawa)

Toronto Women's Bookstore established (Toronto) (until 2012). Key names: Anjula Gogia, Rosina Kazi, Patti Kirk, May Lui, Marie Prins, Janet Romero-Leiva TS

Toronto Women and Film Festival established

Trinity Square Video established (Toronto)

VidéoFemmes established by Helen Doyle, Nicole Giguère, Hélène Roy (Quebec City, unceded Abenaki and Wabenaki Confederacy and Wolastoqiyik territory) JA/KH, ZV

Video Inn established (Vancouver). Key names: Renée Baert, Karen Henry, Shawn Preus, Jeanette Reinhardt, Barbara Steinman, Peg Campbell RLC, ZV

Western Front established (Vancouver). Key names: Martin Bartlett, Hank Bull, Kate Craig, Henry Greenhow, Glenn Lewis, Eric Metcalfe, Michael Morris, Vincent Trasov, Mo van Nostrand LB, KR

Women's Film and Video Festival established (Vancouver) (until 1977)

International Festival of Women and Film 1896–1973, cross-Canada tour of 19 centres (w/catalogue). Key names: Kay Armatage, Lind Beath, Marguerite Duras, Marien Lewis, Susan Sontag, Sylvia Spring, Lisa Steele, Deanne Taylor, Agnes Varda RS, JW

1974

Art Metropole established by General Idea (Toronto)

Artspace established (Peterborough, Anishinaabe Mississauga territory)

The Association for Native Development in the Performing and Visual Arts established (Toronto)

Eyelevel Gallery established (Halifax)

Kinesis: News about women that is not in the dailies feminist magazine established by the Vancouver Status of Women Society (until 2001)

Native Women's Association of Canada established (Akwesasne, Kanien'kehá:ka territory)

Studio D, dedicated to producing the work of women filmmakers, established by the NFB (Montreal (until 1996). Key names: Katherine Shannon, Ginnie Stikeman, Rina Fraticelli RLC, ZV

Warehouse Gallery established by Chester Beavon and Daphne Odjig (Winnipeg) JWe

Women and Film, a BC-wide festival of media and visual art, established by ISIS: Women and Film

Women in Focus AV tape library and productions established by the University of British Columbia. Key name: Marion Barling ZV

Women's Office established (Vancouver). Amasses a collection of 32 tapes between 1974
 and 1976 LB
Barbara Steinman's video *Dr. Morgentaler Speaks* screened in association with ReelFeelings
Women's Works exhibition at Anna Leonowens Gallery, NSCAD (Halifax) JW
"Women and the Art School: An Introductory Analysis of Masculinism at NSCAD," un-
 published paper by MFA student Barbara England argued for the inclusion of feminist
 courses at art school JW

1975

International Women's Year declared by the United Nations
Clouds and Water Gallery and Visual Production Society, now The New Gallery, estab-
 lished (Calgary, Niitsitapi, Nakoda and Tsuut'ina, and Métis territory). Key names:
 Cheryl L'Hirondelle, Sandra Vida CLH
Five Feminist Minutes Cabaret / FemCab established (Toronto). Key name: Rina Fraticelli
 TLC
Groupe Intervention Vidéo (GIV) established (Montreal). Key names: Hélène Bourgault,
 Ryofa Chung, Bernard Émond, Louise Gendron, Michel Sénécal, Michel Van De Walle
 AB, IB, JA/KH, JL, JM, KF, ML
Helen Pitt Gallery established (Vancouver)
The Parachute Centre for Cultural Affairs established (Calgary)
Makara Canadian feminist art journal established by the Pacific Women's Graphic Arts
 Cooperative, in cooperation with feminist Press Gang Publishers (until 1980)
Parachute revue d'art contemporain _ contemporary art magazine established (until 2007).
 Key name: Chantal Pontbriand
Some Nova Scotia Women Artists, Mount Saint Vincent Art Gallery (Halifax) CWH
Women's Affairs Committee (later, Student Union Women's Committee, Women's Collec-
 tive, Chicks for Change, and Feminist Collective) of NSCAD established (Halifax)
Powerhouse Gallery hosts Some Women Filmmakers / Quelques Femmes Cinéastes Festival
ArtFemme '75, a series of events, exhibitions, lectures, and performances for International
 Women's Year, organized by La Centrale, Musée d'art contemporain de Montréal, and
 the Saidye Bronfman Centre (now SBC) (w/catalogue) ABe, JA/KH, RS, TSG
Woman as Viewer is independently presented by the Committee for Women Artists in re-
 sponse to the Winnipeg Art Gallery's exhibition, *Woman as Image* (Winnipeg). Key
 names: Sharron Zenith Corne, Marian Yeo
International Women's Day Festival is held by the Women's Bookstore, proceeds go to the
 BC Federation of Women (Vancouver)
Dorothy Farr and Natalie Luckyj curate *From Women's Eyes: Women Painters in Canada*
 at the Agnes Etherington Art Centre
Some Canadian Women Artists, curated by Mayo Graham at the National Gallery of
 Canada (Ottawa). Key names: Gathie Falk, Sherry Grauer, Mary Pratt, Leslie Reid,
 Shirley Wiitasalo, An Whitlock, Colette Whiten

Buffy Ste Marie appears regularly on *Sesame Street* (until 1980) JFN

Luke Rombout, as new director of the VAG, discontinues special events programming slot

1976

Canadian Research Institute for the Advancement of Women (CRIAW/ICREF) established (Ottawa)

Centerfold, later *FUSE* Magazine, established (until 2014). Key names: Anthea Black, Gina Badger, Dionne Brand, Petra Chevrier, Randy Lee Cutler, Sara Diamond, Andrea Fatona, Amy Fung, Janna Graham, Michelle Jacques, Richard W. Hill, Michael Maranda, Amber Landgraff, Clive Robertson, Trish Salah, Lisa Steele, Syrus Marcus Ware, M. NourbeSe Philip, Milena Placentile, Clive Robertson, Dot Tuer, Jessica Wyman, Izida Zorde AB, ABe, KF, MG, MJ, SP, TS

Charles Street Video established (Toronto)

ED Video established (Guelph, Attawandaron territory)

Lesbian Organization of Toronto (LOOT) established (Toronto) ABl

Parallélogramme, later *MIX: The Magazine of Artist-Run Culture*, established by Paralléllogramme Artist-Run Centre and Publishing (until 1995). Key name: Lynne Fernie CLH, TS, ZV

Powerhouse Performance Series established by Powerhouse members ABe, ZV

Western Front's video production studio established by Kate Craig. Key names: Daina Augaitus, Elizabeth Chitty, Margaret Dragu, Jane Ellison, Karen Henry, Annette Hurtig, Mary Beth Knechtel, Susan Milne, Babs Shapiro, Elizabeth Vander Zaag, Cornelia Wyngaarden RLC, ZV

Women and Video Art exhibition at Video Inn

Women's Interart Co-op holds their first exhibition at the Helen Pitt Gallery (Vancouver). Key name: Ellie Epp

"Woman as Image and Image-Maker" first feminist art history course offered at NSCAD (Halifax) JW

1977

The Western Front's Special Productions Program established by Kate Craig (Vancouver)

The *2nd Annual Women's Interart Exhibition* at the Helen Pitt Gallery

Rape; *Video Inn Women's International Exhibition*, at Video Inn RS

Vidéo de femmes / Women's Video, organized by Barbara Steinman of Video Inn, is La Centrale's first exhibition of video art

Provincial Council of Women of Manitoba claims bias against women in the arts; advocates the inclusion of an equal number of women artists at the Winnipeg Art Gallery and 50 percent quota for women on faculty at the University of Manitoba's school of art JA/KH

All criminal charges dropped against pro-choice activist Dr Henry Morgentaler

1978

A Room of One's Own: A Feminist Journal of Literature and Criticism established by the
Growing Room Collective

Buddies in Bad Times Theatre established by Matt Walsh, Jerry Ciccoritti, Sky Gilbert
(Toronto) MMP

Centre for Art Tapes (CFAT) established (Halifax, Mi'kmaq territory). Key names: Heather
Anderson, Becka Barker, Rita McKeough, Catherine Phoenix, Christine Swintak, Jayne
Wark, Anne Verrall MJ

East End Artists Association, a women-artist support group, established (Vancouver)

Fireweed: A Feminist Quarterly of Writing, Politics, Art & Culture established by Fireweed
Collective. Key names: Gay Allison, Lynne Fernie, Rina Fraticelli, Hilda Kirkwood, Liz
Brady, Elizabeth Ruth, Makeda Silvera, Carolyn Smart, Rhea Tregebov ABl, JA/KH, MPC

Simone de Beauvoir Institute at Concordia University established (Montreal) TSG

Vancouver Women's Media Collective established JW

Vancouver Women's Video and Film Festival established with a steering committee based
in Women in Focus

Womanspirit established (London) JA/KH

Women's Labour History Project established by Sara Diamond (Vancouver) (until 1995)
JA/KH

4th Dalhousie Drawing Show includes work by Charlotte Wilson-Hammond, *"Male
Nudes": A Woman's Perspective* CWH

Selections from the Vancouver Women's Video and Film Festival are screened at the VAG

The first Take Back the Night marches held in Vancouver, Halifax, Ottawa

Video Inn Women's International Exhibition at Video Inn MR

Publication of the report *Indian Women and the Law in Canada: Citizen Minus*, by
Kathleen Jamieson, by the Canadian Advisory Committee on the Status of Women

Publication of Avis Lang's "Women Artists and the Canadian Artworld: A Survey," in
Criteria, with follow-up in 1980 by *Kinesis* and *FUSE* JA/KH

"Women in Art" symposium, NSCAD. Key names: Peggy Gale, Helen Winer, Elizabeth
Weatherford, Martha Wilson JW

1979

Amelia Productions established (Vancouver) (until 1982). Key names: Billie Carroll, Sarah
Davidson, Sara Diamond, Ellen Frank, Gay Hawley JA/KH, JW

articule established (Montreal) AB, IB, KLM, JL

Broadside feminist newspaper established (until 1989)

EMMEDIA established (Calgary)

The Feminist Party of Canada established (Toronto)

Mercer Union established (Toronto)

Rhubarb! Festival established by Buddies in Bad Times (Toronto)

Théâtre expérimental des femmes established (Montreal). Key names: Nicole Lecavalier, Louise Laprade, Pol Pelletier JW

Women's Art Gallery established by Women in Focus (Vancouver)

YYZ Artist Gallery established (Toronto)

Feminist Tapes exhibition at Video Inn

Publication of *Centerfold* 3, no. 4, "Women and Infanticide"

The Women's Bookstore (Vancouver) is destroyed by an arsonist

The periodical *Body Politic* faces the first of two obscenity trials (the second in 1982). The trial is covered extensively by Lisa Steele in *Centerfold* 3, no. 3

1980

Vtape established (Toronto). Key names: Susan Britton, Colin Campbell, Louis Liliefeldt, Dierdre Logue, Clive Robertson, Lisa Steele, Wanda Vanderstoop, Rodney Werden NM

Women's Media Night at Video Inn established (Vancouver)

Publication of *FUSE* 4, no. 2, "Developing Feminist Resources"

1981

SAW Video cooperative established by SAW Gallery (Ottawa)

Tangente established (Montreal). Key names: Dena Davida, Silvy Panet-Raymond JW

Women's Cultural Building Collective established (Toronto). Key names: Lynee Fernie, Rina Fraticelli, Johanna Householder, Joyce Mason, Svetlana Zylin

Women's File established at NSCAD by the Women's Affairs Committee, to document their own and other feminist activities at NSCAD (Halifax) JW

Sistren, a theatre troupe co-founded by Honor Ford-Smith in 1977, performs *Domestik* and *QPH (Queenie, Pearlie and Hopie)*, and is subsequently featured on the cover of *FUSE* 5, no. 8

Women's Bookworks Show, curated by Dorren Lindsay and Sarah McCrutcheon, originates at Powerhouse Gallery and tours the country

Publication of Jane Martin's "Women Visual Artists on Canada Council Juries, Selection Committees, and Arts Advisory Panels; and amongst grant recipients, 1972–73 to 1979–90" for CARFAC RS

Publication of Sasha McInnes-Hayman's *Contemporary Canadian Women Artists: A Survey* for Womanspirit Art Research and Resource Centre RS

Publication of the "Statement By Native Women's Association of Canada on Native Women's Rights" in *Women and the Constitution*

Lifesize Women and Film series established NSCAD (Halifax). Key names: Rosalee Matchett, Paula Fairfield, Liz MacDougall, Marusya Bociurkiw, Wendy Geller (until 1989) LM

Publication of "The Issue of Women's Art," *Visual Arts Nova Scotia* CWH

1982

Arts Manitoba, now *Border Crossings*, established

The Dinner Party by Judy Chicago is exhibited at the Musée d'art contemporain de Montreal (MAC), then the AGO and the Glenbow JA/KH

Art et féminisme group exhibition at the MAC, to coincide with exhibition of *The Dinner Party*, w/catalogue including text by Rose-Marie Arbour and Johanne Lamoureux outlining the relation of Quebec women artists to North American feminism JA/KH, JW, RS, TSG

Powerhouse exhibition *Celebration* marks the exhibition of *The Dinner Party*, along with two panels and a talk by Judy Chicago JA/KH

Toronto Women's Cultural Building Collective organizes the panel After the Dinner Party's Over. Key names: Kay Armitage, Carole Condé, Carlyn Moulton, Lisa Steele, Joyce Mason JA/KH

Five exhibitions by the *Réseau art-femme* (in Montreal, Quebec, Sherbrooke, Chicoutimi), with accompanying publications. Key name: Diane-Jocelyne Côté JW, RS, TSG

Mirrorings: Women Artists of the Atlantic Provinces exhibition at the Mount Saint Vincent University Gallery, w/publication (Halifax), curated by Avis Lang Rosenberg: included work by Charlotte Wilson-Hammond and Susan Gibson Garvey; toured to Women in Focus (Vancouver), Powerhouse Gallery (Montreal) RS, CWH

Woman to Woman exhibition of lesbian art at Women in Focus gallery JA/KH

Publication of "A History of Feminism at NSCAD" in *Parallélogramme* 8, no. 1 JA/KH

Wimmins Fire Brigade fire-bombs three Red Hot Video outlets (Vancouver)

Indigenous and treaty rights are included in amendments to the Constitution of Canada

1983

Little Sisters Book and Art Emporium established (Vancouver). Key names: Jim Deva, Bruce Smythe, Janine Fuller LB

Or Gallery established by Laiwan (Vancouver). Key names: Arni Haraldsson, Lori Hinton, Ken Lum, Michelle Normoyle, Petra Watson FFG, KR

Plug In Art forms a Women's Committee (Winnipeg)

Truck Gallery established by Second Story Art Society (Calgary) CLH

Video Pool Inc. established (Winnipeg)

Alter Eros festival organized at A Space JA/KH

Women and Words conference and festival (Vancouver) organized by the West Coast Women and Words Society (w/publication) TLC

Women's Building Culture feminist art festival organized by the Women's Cultural Building Collective JA/KH

Women's Perspective '83 feminist art festival organized by the Partisan Women's Collective JA/KH

Publication of Eleanor Wachtel's report "Feminist Print Media: Feminist Collections" in *Women's Studies Library Resources in Wisconsin*

Alanis Obomsawin Abenaki is named Officer of the Order of Canada ABl

1984

Centre des arts actuels Skol established (Montreal). Key names: Pascale Beaudet, Marie-France Beaudoin, Anne Bertrand, Nicole Burisch, Stéphanie Chabot, Sylvie Cotton, Martine Lauzier, Myriam Merette, Adriana de Oliveira, Robin Simpson

Diasporic African Women Artists (DAWA) established by Buseje Bailey and Grace Channer (Toronto) (until 1989) JA/KH

Emma Productions established (Toronto). Key name: Marusya Bociurkiw JA/KH, ZV

Grunt Gallery established (Vancouver). Key names: Glenn Alteen, Kempton Dexter, Susan MacKinley, Daniel Olsen, Danielle Peacock, Dawn Richards, Garry Ross, Billy Gene Wallace, Hillary Wood AM, KR, TH

Kootenay School of Writing established (Vancouver) LB

MAWA: Manitoba Artists for Women's Art established by the Plug In Women's Committee (Winnipeg). Key name: Diane Whitehouse AB, AC, RLC, KF, MLY, GM, JM

Multicultral Womyn in Concert established (Toronto)

Sister Vision: Black Women and Women of Colour Press established (Toronto). Key names: Makeda Silvera and Stephanie Martin MPC, CT

Tessera, bilingual journal of feminist theory, established (until 2005). Key names: Katherine Binhammer, Martine Delvaux, Lauren Gillingham, Barbara Godard, Lise Harou, Jennifer Henderson, Nadine Ltaif, Nicole Markotic, Daphne Marlatt, Catherine Mavrikakis, Kathy Mezei, Lianne Moyes, Julie Murray, Patricia Seama, Gail Scott TS

Women's Art Resource Centre (WARC) established (Toronto) (until 2015) GH

WARC's Curatorial Research Library established

First annual exhibition of MAWA members' work

Cinémama festival, a retrospective of 37 films by women filmmakers based in Quebec, from 1900–84, co-organized by Powerhouse Gallery, Cinémathèque québécoise, the NFB, and the Women's Collective of Concordia University

Féministe, toi-même; féministe quand meme, two exhibitions and a colloquium at La Chambre Blanche (Quebec City) (w/publication, 1986) JA/KH, RS

Manitoba Arts Council establishes the Access Program to fund projects for women, artists of colour, and Indigenous artists

Eastern Edge Gallery established (St John's) GHi

1985

Inuit Art Foundation established

MAWA's mentor program established. Key names: Lorraine Burt, Sheila Butler, Aganetha Dyck, Karen Hoeberg, Grace Horosko, Joanne Jackson, Eileen Kasprick, Kim Ouellette, Bonnie Robson, Reva Stone, Rosemary Trachsel, Marsha Wineman

Society of Canadian Artists of Native Ancestry (SCANA) established

The Sex Group, later Kiss and Tell, established (Vancouver)

Worksite: A Feminist Artist Collective established (Vancouver). Key names: Margot Butler, Carol Williams, Lorna Brown JA/KH, LB

VoiceOver: Kati Campbell, Sara Diamond, Amy Jones, Ingrid Koenig, exhibition at the Contemporary Art Gallery (CAG) (Vancouver) (w/catalogue)

The Heat Is On: Women on Art and Sex conference hosted by Women in Focus (Vancouver). Key names: Sara Diamond, Pat Feindel, Karen Henry, Caffyn Kelley, Kellie Marlowe

Symposium on Feminism and Art (Toronto) (w/publication, see also *Parallélogramme* 10, no. 4). Key names: Heather Dawkins, Sara Diamond, Sheena Gourlay, Silvia Kolbowski, Gerta Moray JA/KH, RS

Publication of *Feminism Now: Theory and Practice*, edited by Arthur and Marielouise Kroker, Pamela McCallum, and Mair Verthuy's RS

Latitude 53 establishes a Women's Programming Committee JA/KH

Canada Customs seizure of books and magazines destined for bookshops Little Sisters (Vancouver) and Glad Day (Toronto)

Thanks to the activism of many Indigenous women, including Mary Two-Axe Early, the passage of Bill C-31 returns Indian status to Indigenous women who had lost it due to the 1951 Amendment to the Indian Act; Early is the first person to regain status JFN

1986

Artspeak established (Vancouver). Key names: Lorna Brown, Dana Claxton, Allyson Clay, Jeff Derksen, Andrea Fatona, Mona Hatoum, Kay Higgins, Monika Kin Gagnon, Laiwan, Shirin Neshat, Jeanne Randolf, Anne Ramsden, Cate Rimmer, Lisa Robertson, Marina Roy, Nancy Shaw, Kathy Slade LB, MJ, KR, RS

Graphic Feminism exhibition at A Space, produced in cooperation with the Canadian Women's Movement Archives JA/KH

Songs of Experience exhibition at the National Gallery of Canada, curated by Jessica Bradley and Diana Nemiroff

Women in Focus programs a portion of the Vancouver Film Festival, bringing in work by Alanis Obomsawin, Louise Carré, and Anne Wheeler

Video School, a series of nine video workshops, is organized by Kelly Marlowe at Women in Focus

Publication of Janice Hayes's book *A Bibliography on Canadian Feminist Art* by the Graduate School of Library and Information Studies, McGill University

1987

(f.)Lip national newsletter of feminist writing established. Key names: Sandy (Frances) Duncan, Erica Hendry, Angela Hryniuk, Jeannie Lochrise, Betsy Warland

Dykes on Mykes radio show established (Montreal)

Femmes en Focus video festival established (Moncton) CWH

Onzième Festival Femmes et Vieux (Quebec City) CWH

Sleeping Beauty Club Cabaret established as part of the Fringe Festival (Winnipeg) TLC

Women Artists in Video (WAIV) established (Winnipeg). Key names: Chris Hawkes, Maureen Margaret Smith, Rosalie Bellefontaine

Katherine Knight, Sandra Meigs, Colette Urban: Trigger, exhibition at the CAG (w/catalogue) RS

Sight Specific: Lesbians and Representation exhibition at A Space RS

Women, Art and the Periphery exhibition at Women in Focus, Video In, and the Western Front. Key names: Diamela Eltit, Nelly Richard

Visual Evidence: A Series of Video Screenings, Workshops and Multimedia Events about Sexuality and Sexual Images at Video Inn, Pitt International Galleries, Women in Focus, Heritage Hall, and the Western Front

WARC organizes their Feminism and Art Conference, which leads to the publication *Locations: Feminism, Art, Racism, Region: Writings and Art Works*, in 1989 JA/KH, RS

Publication of *Work in Progress: Building Feminist Culture* edited by Rhea Tregebov by The Women's Press RS

Publication of *From Sea to Shining Sea: Artist-Initiated Activity in Canada 1939–1987*, edited by AA Bronson with René Blouin, Peggy Gale, and Glenn Lewis

1988

Black Film and Video Network established (Toronto) CT

Recherches féministes journal established TSG

Beyond History exhibition of contemporary Indigenous artists at the VAG. Key names: Carl Beam, Bob Boyer, Joane Cardinal-Schubert, Domingo Cisneros, Karen Duffek, Tom Hill, Robert Houle, Mike MacDonald, Ron Noganosh, Jane Ash Poitras, Edward Poitras, Pierre Sioui

In Visible Colours, film/video festival and symposium, established by Zainub Verjee in cooperation with Lorraine Chan of the NFB. First festival is held the following year. Key names: Joy Hall, Yasmin Jiwani, Sadie Kuehn, Pinky Manji, Nora Patrich, Gulzar Samji, Loretta Todd, Viola Thomas ZV

Kiss and Tell Collective create and subsequently tour the exhibition *Drawing the Line: Lesbian Sexual Politics on the Wall*. Key names: Persimmon Blackbridge, Lizard Jones, Susan Stewart FFG

Politically Speaking exhibition at the Women in Focus Floating Curatorial Gallery. Key names: Marcella Bienvenue, Christine Conley, Rita McKeough, Mary Scott

Women's Labour History Project, Photo and Video Exhibition curated by Sara Diamond at Women in Focus as part of the first Mayworks: A Festival of Culture and Working Life (Vancouver)

Female Representation panel and Roundtable on Feminism at the VAG

The conference Telling It: Women and Language across Cultures is held at Simon Fraser University, w/publication by Press Gang Publishers. Key names: Sky Lee, Lee Maracle, Daphne Marlatt, Betsy Warland

Publication of Sara Diamond's article "The Boys Club," in *FUSE*

Betty Julian begins tenure as administrative coordinator/director at A Space

Catherine Harding, Louisa C. Matthew, Lynda Jessup join the art history faculty at
 Queen's University MJ

1989

Herland Film Festival established (Calgary) (until 2007) ABl

Pleasure Dome established (Toronto). Key names: Philip Hoffman, Mike Hoolboom,
 Jonathan Pollard, Gary Popovich, Barbara Sternberg

Ragweed Press/gynergy, lesbian-run publishing company, established (PEI, unceded
 Abegweit Mi'kmaq territory). Key name: Louise Flemming JFN

St John's Women's International Film Festival established GHi

Studio 303 established (Montreal). Key names: Martha Carter, Isabelle Van Grimde,
 Jo Leslie, Miriam Ginestier ML

Women in View: A Festival of Performing Arts established (Vancouver) LB, TLC

A Space travelling exhibition *Black Wimmin: When and Where We Enter*, organized by
 Toronto's DAWA: Diasporic African Women's Art collective. Key names: Grace Channer
 and Buseje Bailey YL, JA/KH

Others among Others multimedia and collaborative works at Women in Focus. Key names:
 Yoly Garcia, Sher Azad Jamal, Susan S.C. John, Shani Mootoo, Haruko Okano, Janice
 Wong, Jin-me Yoon, Chin Yuen

*Rebel Girls: A Survey of Canadian Feminist Videotapes/Les Rebelles: Un aperçu des
 oeuvres vidéo de féministes canadiennes*, exhibition at the NGC RS

The Zone of Conventional Practice and Other Real Stories, exhibition at Optica
 (w/catalogue). Key names: Nicole Jolicoeur, Nina Levit, Susan McEachern RS

Mary Kelly and Griselda Pollock in conversation at the VAG, June 1989 (w/proceedings)
 RLC, RS

Publication of *Locations Feminism, Art, Racism, Region: Writings and Artworks/Sites:
 Féminisme, art, racisme, région: Écrits et oeuvres* by WARC. Key names: Shonagh
 Adelman, Gail Bourgeois, Margot Butler, Dawn Dale, Sheena Gourlay, Paige Prichard
 Kennedy, Michelle Mohabeer, Pauline Peters

Publication of *Parallélogramme* 14, no. 4, a special issue on art and feminism co-produced
 with WARC

École Polytechnique massacre. Victims: Geneviève Bergeron, Hélène Colgan, Nathalie
 Croteau, Barbara Daigneault, Anne-Marie Edward, Maud Haviernick, Barbara Klucznik-
 Widajewicz, Maryse Laganière, Maryse Leclair, Anne-Marie Lemay, Sonia Pelletier,
 Michèle Richard, Annie St-Arneault, Annie Turcotte (Montreal) AB, AF

1990

Institut de recherches et d'études feministes at the Université du Québec à Montréal
 established (Montreal) TSG

Matriart magazine established by WARC

New Initiatives in Film established as part of Studio D. A program for women of colour and First Nations Women, co-created by Sylvia Hamilton

Under the Volcano Festival of Art and Social Change established (North Vancouver, Tsleil-Waututh territory) (until 2010). Key name: Irwin Oostindie MG

Vancouver Performance Art Series established by Grunt

Dangerous Goods: Feminist Visual Art Practices exhibition at the Edmonton Art Gallery (w/catalogue) RS

Lorna Brown: Reading exhibition at Artspeak (w/catalogue) RS

The Woman's Voice: Feminist Films of the 1970s and 1980s, exhibition curated by Sheila Petty at the Dunlop Art Gallery (Regina, Nêhiyawak, Nahkawininiwak, Nakota, Saulteaux, and Métis territory) RS

WARC organizes the conference *Empowerment and Marginalization*

Instabili: La question du sujet / The Question of Subject published by La Centrale and Artextes Editions; includes chronology of programming at La Centrale. Key names: Marie Fraser, Christine Ross, Mary Kelly, Céline Baril, Catherine Bédard, Martha Fleming, Lesley Johnstone, Lyne Lapointe, Lani Maestro, Liz Magor, Joanna Nash, Thérèse St-Gelais, Nancy Spero, Céline Surprenant, Nell Tanhaaf AB, TSG

MAWA becomes an independent organization and changes its name to Mentoring Artists for Women's Art

1991

Inside Out LGBT Film Festival established (Toronto)

Loud & Queer Festival established (Edmonton). Key names: Ruth Smillie, Guys in Disguise (Darrin Hagin and Kevin Hendricks) TLC

Rungh Cultural Society established (Vancouver); began publishing the journal *Rungh Magazine: A South Asian Quarterly of Culture, Comment and Criticism*. Key names: Lillian Allen, George Elliot Clarke, Chris Creighton-Kelly, Ramabai Espinet, Yasmin Jiwani, Ali Kazimi, Ashok Mathur, Shani Mootoo, Ian Iqbal Rashid, Shahid Quadri, MG Vassani ZV

Publication of *"By a Lady": Three Centuries of Canadian Women Artists* by Maria Tippett CWH

Vtape launches *Fresh Looks: Anti-Racist Film and Video* series and study guides

Cheryl L'Hirondelle begins tenure as programming coordinator at Truck Gallery (Calgary, Niitsitapi, Nakoda, and Tsuut'ina territories) (until 1993)

First annual February 14th Women's Memorial March is held in Vancouver's Downtown East Side to mourn the loss of murdered and missing women, especially Indigenous women TS

1992

Full Circle: First Nations Performance established (Vancouver)

Gallery Gachet established as a cooperative with a mandate focused on mental health and

the arts (Vancouver). Key names: Mary Ann Anderson, Anita Nairne, April Porter,
Christian Stenfors, Tamara Szymanska, Lillith Walker

Land, Spirit, Power at NGC includes work by Rebecca Belmore and Faye HeavyShield,
with curatorial essays by Diana Nemiroff and Charlotte Townsend-Gault MG

First Nations Performance Series organized by Grunt TLC

Publication of *Piece of My Heart: A Lesbian of Colour Anthology*, edited by Makeda
Silvera, by Sister Vision Press MPC

The Canada Council for the Arts establishes the Aboriginal Arts Office in response to a
report detailing the exclusion of Indigenous work, and lays the groundwork for centres
like TRIBE, Sâkêwêwak, and Urban Shaman AC

Women in Focus closes and donates all of its tapes to Video In MR

Lillian Allen joins the faculty at Ontario College of Art and Design (now OCAD University)
FFG

Much Sense: Erotics and Life at the Walter Phillips Gallery in 1992, curated by Sylvie
Gilbert, is the target of censorship and controversy

1993

Collective of Black Artists (COBA) established (Toronto). Key names: Charmaine Headley,
BaKari I. Lindsay, Junia Mason, Mosa Neshama

FADO Performance Inc. established (Toronto) AC, MLY, GM

Gender Trash from Hell, radical trans zine, established (until 1995). Key names: Mirha
Soleil Ross and Xanthra Phillippa Mackay TS

South Asian Visual Arts Collective, now the South Asian Visual Arts Centre/SAVAC,
established by members of Desh Pardesh South Asian arts festival AB, MLY, AM, SB

Strange Sister cabaret established by Buddies in Bad Times; runs on and off for years, and
is revitalized as *Insatiable Redux* (2013) and *Insatiable Sisters* (2015) TLC, AC

Queer City Festival / Two Spirit Performance Series organized by Grunt TLC

Racy-Sexy: Race, Culture and Sexuality, exhibition at Centre A and programming at vari-
ous venues (Vancouver). Key names: Jennifer Abbot and David Odhiambo, Mercedes
Baines, Michael Balser, Persimmon Blackbridge, Dionne Brand, Lorraine Chan, Grace
Channer, Andrea Fatona, David Findlay, Richard Fung, Sheila James, Karin Lee, Brenda
Joy Lem, Haruko Okano, Sur Mehat, Shani Mootoo, Raj Pannu, Henry Tsang, Paul
Wong, Zainub Verjee AJ, ZV

Instability of the Feminist Subject residency at the Banff Centre for the Arts results in the
production of a series of twenty-two postcards by participating artists. Key names: Ingrid
Bachmann, Joanne Bristol, Pauline Cummins, Myra Davies, Shawna Dempsey and Lorri
Millan, Gitanjali (Kaspar Saxena), Gudrun Gut, Marlene Klassen, Genevieve Latarte,
Ruth (Ozeki) Lounsbury, Meena Nanji, Michelle Normoyle, Judy Radul, Elsa Stansfield
and Madelon Hooykaas, Leila Sujr, Hiroko Tamano, Mina Totino, Zainub Verjee,
Sandra Vida, Laurel Woodcock, Alexa Wright, Marina Zurkow, Zucchini Mamma
(Lori Weidenhammer) ZV

Minquon Panchyat, a people of colour and Indigenous caucus within ANNPAC/RACA, walks out of the organization's AGM, leading to the dissolution of the meetings and ultimately ANNPAC/RACA itself. Key names: Lillian Allen, Shirley Bear, Dana Claxton, Chris Creighton-Kelly, Monica Kin Gagnon, Cheryl L'Hirondelle, Marrie Mumford, Paul Wong, David Woods AM, CLH

1994

CAMP SIS: Sisters in Struggle established by Toronto Multicultural Womyn in Concert, now Toronto Women of Colour Collective (Kawartha region, Algonquin and Anishi-naabe territory)

Le Boudoir cabaret established (Montreal) (until 2008). Key name: Miriam Ginestier TLC, YL

Gendai Gallery at the Japanese Canadian Cultural Centre established (Toronto). Key names: Banri Nakamura, Michiko Nakamura, Louise Noguchi, Aiko Suzuki, Walter T. Sunahara YW

High Risk Committee, established by the Zenith Foundation; mandated to protect the human rights of trans people

Mois de la performance established by La Centrale (Montreal) ABe, ML, KLM, JM

The Status of Canadian Women in the Arts conference organized by WARC

Images des Femmes, annual exhibition on International Women's Day, established (Montreal) YL

Writing Thru Race conference sponsored by the Writers' Union of Canada and organized by a large coalition of Indigenous writers and writers of colour (Vancouver) AM

Publication of WARC's report *Who Counts and Who's Counting*, detailing gender representation at the NGC

1995

TRIBE: A Centre for the Evolving Aboriginal Media, Visual and Performing Arts Inc. established (Saskatoon). Key names: Lori Blondeau, April Brass, Bradlee La Rocque, Denny Norman AM, AC

Women & Paint exhibition at the Mendel Art Gallery (Saskatoon)

Edgy Women established by Studio 303 (Montreal; until 2016); began as a one-night dance event in 1994, and develops into a full-blown festival by 2005. Key names: Karen Bernard, Nathalie Claude, Jess Dobkin, Miriam Ginestier, Lamathilde, Tonija Living-stone, Dayna McLeod, Alexis O'Hara, Karen Sherman, Coral Short. ACh, ML

1996

Blood Sisters/Zone Rouge Coalition/Zona Roja Coalicion established (Montreal). Key names: Robin Akimbo, Sivan Bar-Server, Zed Bee, Zoe Casino, a.d., Courtney Dailey, Maureen Grant, James Levoi, Leila Pee, Hope Peterson, Sam Semper, Laurie Sluchinski,

Tricia Sprawling Sage, Amanda Stony Chick, Kristine Sunday, Amanda Watson, Shawnda Wilson, Vanessa Yanow AD

Cheap Queers cabaret established by Hardworking Homosexuals (Toronto) (until 2009). Key names: Shelley Brazier, Keith Cole, Jonathan Da Silva, Moynan King TLC

File This cabaret established by Amber Dawn (Vancouver) (until 2000). Cabaret for performers who were gender variant and/or who had experience as sex workers TLC

Queer City Cinema established (Regina)

Sâkêwêwak Artists' Collective established (Regina). Key names: Âhasiw Maskêgon-Iskwêw, Edward Poitras, Robin Brass, Reona Brass, Sherry Farrell Racette

Studio XX established (Montreal); bilingual feminist artist-run centre for technological exploration, creation, and critical reflection AB, RLC, SLPH, IB, KF, JJL, JL, ML, JM, YL

Urban Shaman: Contemporary Aboriginal Art established (Winnipeg), Aboriginal artist-run centre designated for the exhibition and discussion of contemporary First Nations, Métis, and Inuit art. Key names: KC Adams, Melissa Wastasecoot, Niki Little, Leah and Lita Fontaine KF, MLy, JM, JWe

XX Files Radio established by Studio XX (Montreal). Key names: Kathy Kennedy, Deborah Van Slet

Postcards from the Feminist Utopia, online collaboration between MAWA and the Western Front. Key names: Lori Blondeau, Joanne Bristol, Sue Bustin, Susan Chafe, Lori Weidenhammer, Marina Zurkow

Trans-Mission: Nouveau-Post-Trans-Féminisme group exhibition at La Centrale (w/catalogue) RS

Vera Frenkel … from the Transit Bar, curated by Jean Gagnon at the National Gallery of Canada

Publication of *"World Enough in Time": Conversations with Canadian Women* by Andrea Fawcette

Jessica Bradley begins tenure at the Art Gallery of Ontario's contemporary art department, and brings feminist artists to the museum, including Betty Goodwin, Cindy Sherman, Jin-me Yoon, Doris Salcedo MJ

1997

7a*11d International Festival of Performance Art established (Toronto). Key names: Shannon Cochrane, Johanna Householder, Louise Liliefeldt, Tanya Mars FFG, MH, GM, NM

Counting Past 2 (CP2): Performance/film/video/spoken word with Transsexual Nerve! established by Mirha Soleil Ross (Toronto) (until 2002). Key names: Petra Chevrier, Cat Grant and Boyd Kodak, Jordy Jones, Mark Karbusicky, Valentina Kotogovona, Christopher Lee and J. Zapata, Xanthra Phillippa Mackay, Shadmith Manzo, Aiyyana Maracle, Lulu Ogawa, Clover Paek, Ray Rae, Trish Salah, Kaspar Jivan Saxena, Hans Scheirl, Christina Strang, Del LaGrace Volcano TH, TLC, MMP, TS

Femmes branchées / Wired Women salons established by Studio XX (Montreal)

HTMlles festival established by Studio XX (Montreal) SLPH, ACh, KF, ML

Lesbian National Parks and Services established. Key names: Shawna Dempsey and
 Lorri Millan
Mary Kelly: Social Process/Collaborative Action, 1970–1975, exhibition curated by Judith
 Mastai at the Charles H. Scott Gallery (w/catalogue)
Meow Mix cabaret established by Miriam Ginestier (Montreal) (until 2012) TLC, ACh, YL
Studiolo: The Collaborative Work of Matha Fleming and Lyne Lapointe, retrospective
 exhibition
Crossing Borders, Mapping Boundaries conference organized by WARC with Women's
 Caucus for Art
Grunt produces *Positive+*, with the Roundhouse Community Centre, to look at issues of
 HIV/AIDS after the introduction of anti-retroviral therapy

1998

Clit Lit monthly reading series established by Elizabeth Ruth (Toronto) MPC
Elle Corazon Centre, feminist activist art and health space, established by a.d. (Montreal).
 Key names: Robin Akimbo, Belinda Aged, Georgia Damond, Natasha Doyon, Naledi
 Jackson, Nadia Moss, Jessica Moss, Deirdre Wilson, Vanessa Yanow AD
ImagineNATIVE Film and Media Arts Festival (Centre for Aboriginal Media) established
 Cynthia Lickers-Sage, with the support of Vtape (Toronto)
Pride in Arts (PiA), later the Queer Arts Festival, established (Vancouver) LB
Publication of *Ma-Ka Diasporic Juks: Contemporary Writing by Queers of African
 Descent* by Sister Vision Press. Key names: Debbie Douglas, Courtenay McFarlane,
 Makeda Silvera, Douglas Stewart ABl
Publication of *Material Matters: The Art and Culture of Contemporary Textiles* by Ingrid
 Bachmann RS
Publication of Joyce Zemans's article "A Tale of Three Women: The Visual Arts in
 Canada/A Current Account/ing" in *RACAR: revue d'art canadienne / Canadian Art
 Review*, which outlines the status of women in the arts based on quantitative analysis.
 The article is followed up in 2013 with "Where Are the Women? Updating the Account,"
 co-authored with Amy Wallace and also appearing in *RACAR*

1999

Valentine's Cabaret established by Les Scandelles (Sasha Van Bon Bon, Kitty Neptune
 and collaborators) (Toronto) TLC
Visualeyez, Canada's annual festival of performance art established by Latitude 53
 (Edmonton) JM
Nadia Myre facilitates *Indian Act* workshops at Concordia University and Oboro,
 (Montreal) (until 2002)
Women with Kitchen Appliances established by Coral Short (Montreal). Key names: Annie
 Gauthier, Mathilde Geromin, kg Guttman, Anneessa Hashmi, Darsha Hewitt, Onya

Hogan-Finlay, Julie Keller, Anna-Louise Luego, Audrey Robinson, Marie-Eve
Robitaille, Erin Stanfield, Dagmara Stephan AD

Grunt hosts Live at the End of the Century festival TLC

Publication of *Scratching the Surface: Canadian, Anti-Racist, Feminist Thought*, edited by
Enakshi Dua and Angela Robertson

The Trans Action Society holds their first conference on trans legal issues in Vancouver

Mamela v. Vancouver, historic legislation favouring trans woman Susan Mamela, who was
dismissed from her volunteer position at the Vancouver Public Library on transphobic
grounds

Canada Council for the Arts begins awarding grants through its newly established Equity
Office ZA

2000

The Laboratory of Feminist Pataphysics established (Calgary) by Mireille Perron

High Tech Storytellers/High Tech Encounter organized by AKA and TRIBE TLC

First Person Plural symposium organized by MAWA. Key names: Ruth Cuthand, Aganetha
Dyck, Elizabeth MacKenzie, Louise Willow May, Leslie Reid, Barbara Todd, Martha
Townsend, Jin-Me Yoon

Other Conundrums: Race, Culture and Canadian Art by Monika Kin Gagnon published
by Arsenal Pulp Press SF

Governor General's Awards in the Visual and Media Arts, established by the Canada
Council for the Arts and the Governor General of Canada in 1999, go to three women
of seven total laureates: Jocelyne Alloucherie, Ghitta Caiserman-Roth, Doris Shadbolt

2001

Bookmobile Project / Projet Mobilivre established (Montreal/New York City) AD, KF, RS

Kiss My Cabaret established by Danette MacKay (Montreal) TLC

Mountain Standard Time Performative Art Festival (M:ST) established (Calgary)

Sista'Hood established by Rachel Flood, produced by the Working Arts Society
(Vancouver) TLC

Trans/Planting: Contemporary Art by Women From/In Iran, curated by Gita Hashemi and
Taraneh Hemami for A Space Gallery

7a*11d organizes ReciproCity/Réciprocité programming series linking Toronto, Vancou-
ver, and Montreal

Locating Feminism symposium organized by MAWA. Key names: KC Adams, Lori
Blondeau, Shawna Dempsey and Lorri Millan, Jennifer Fischer, Sheryl N. Hamilton,
Ann Newdgate, Mireille Perron

Publication of Marina Roy's article "Corporeal Returns: Feminism and Phenomenology in
Vancouver Video and Performance 1968–1983," in *Canadian Art* 18, no. 2

Janet Cardiff wins the NGC Millenium Prize for *40-Part Motet*

Jamelie Hassan awarded the Governor General's Award in Visual and Media Arts ABl, NM

2002

Antidote: Mutiracial and Indigenous Women's Network established by Jo-Anne Lee
 (Victoria) AJ

Festival Voix d'Amériques established by Les filles électriques (until 2011). As of 2012,
 Festival Phénomena. Key name: D. Kimm YL

La Pharmacie Esperanza and La Salle D'Attente established by a.d. (Montreal) AD

Talking Stick Festival established by Full Circle (Vancouver) MH

Rebecca Belmore presents *Vigil* as part of the Talking Stick Festival (Vancouver) JFN

Camille Turner begins performing as Miss Canadiana KRO

7a*11d launches Éminences Grises, an aspect of the festival honouring influential
 performance artists. Key names: Cheryl L'Hirondelle, Rita McKeough, Robin Poitras,
 Glenn Lewis, Sylvie Tourangeau, Margaret Dragu FFG

Indian Acts: Aboriginal Performance Art Conference at Grunt Gallery. Key names: Warren
 Arcan, Lynne Bell, Rebecca Belmore, Lori Blondeau, Reona Brass, Dana Claxton, Marie
 Clements, Marcia Crosby, Dolores Dallas, Guy Sioui Durand, Anthony McNab Favel,
 Floyd Favel, Greg Hill, Margo Kane, Steven Loft, James Luna, Aiyyana Maracle, Âhasiw
 Maskêgon-Iskêw, Beatrice Medicine, Shelley Niro, Edward Poitras, Bently Spang,
 Lawrence Paul Yuxweluptun. Online exhibition subsequently curated by Tania Willard
 and Dana Claxton

IntraNation: Race, Politics and Canadian Art conference at Emily Carr Institute of Art and
 Design. Part of the larger IntraNation Project: Struggles, Negotiations, Conflicts in the
 Arts. Key names: Sara Diamond, Tseen Khoo, Ashok Mathur, Roy Miki, Brian Rusted.
 Followed by a thematic residency at the Banff Centre for the Arts (2004) and a
 publication by *West Coast Line* (2006)

Michelle Jacques begins tenure as director of programming at the Centre for Art Tapes
 (Halifax)

2003

Hysteria: A Festival of Women established by Moynan King at Buddies in Bad Times
 (Toronto) TLC

No More Potlucks info and events website established

Publication of *Pitseolak: Pictures Out of My Life* illustrated autobiography, celebrating
 the work of Ashoona Pitseolak MG

Publication of Emi Koyama's "The Transfeminist Manifesto" in *Catching a Wave:
 Reclaiming Feminism for the Twenty-First Century*

Emelie Chhangur begins curatorial tenure at the Art Gallery of York University (AGYU) SS

2004

.dpi: Feminist Journal of Art and Digital Culture established by Studio xx. Key names:
 Sarah Brown, Anna Friz, Sophie Le-Phat Ho, Marie-Christiane Mathieu, Caroline
 Martel, jake moore, Miriam Verberg AB, SLPH, JJL

Ethnoculture established (Montreal), volunteer-run, not-for-profit organization coordinating community-based events for and about two-spirited, lesbian, gay, bisexual, trans, and queer people from racialized and Indigenous communities living in Montreal

Psychopathia Transsexulalis: Transsexual News, Information and Culture, hosted by Xanthra Phillippa, is broadcast biweekly on CIUT community radio (Toronto)

Publication of *Caught in the Act: An Anthology of Performance Art by Canadian Women*, edited by Johanna Householder and Tanya Mars FFG, MG, TH, ML, GM

Publication of *Native North American Art*, edited by Ruth Phillips and Janet Berlo MG

SAVAC celebrates its tenth anniversary and launches the annual screening program Monitor: South Asian Experimental Film and Video

Kim Simon begins curatorial tenure at Gallery TPW SS

2005

aPOSTeRIORI established by Dominique Fontaine

Brunt magazine established by Grunt Gallery (until 2009) TH

MPENZI: Black Women's International Film and Video Festival established by Adonica Huggins (Toronto) (until 2009)

Shameless magazine established

Whippersnapper Gallery established by Luke Correia-Damude and Patrick Stuys (Toronto)

Publication of Vivian Namaste's book *Sex Change Social Change* by Toronto's Women's Press

Rebecca Belmore represents Canada at the Venice Biennale FFG, TH

2006

Ladies Invitational Deadbeat Society established by Anthea Black, Nicole Burisch, Wednesday Lupypciw

St Emilie Skillshare, a community art collective devoted to empowerment, self-determination, and collective liberation run by and for people who are trans, two-spirit, queer, Indigenous, and/or people of colour and friends, established (Montreal) CG, KLM

VIVA! Art Action, collaborative performance art festival, established (Montreal) by artists Alexis Bellavance and Patric Lacasse with the support of La Centrale, DARE-DARE, articule, Skol, Clark, Praxis AB, JL, ML

Jamelie Hassan's exhibition *Orientalism and Ephemera* at Art Metropole (Toronto) NM

Studio XX, Femmes Autochtones du Québec, and Upgrade Montreal present a panel for International Women's day SLPH

Publication of Jayne Wark's *Radical Gestures: Feminism and Performance Art in North America*

B&D Press, run by Eloisa Aquino, publishes its first book, *Big Head Has a Problem*, by Eloisa Aquino and Jenny Lin DR

Vicky Moufawad-Paul begins tenure as artistic director at A Space SF

Sobey Art Award goes to Annie Pootoogook for the Prairies and the North, the first time it is awarded to a woman

Lisa Odjig wins World Champion Hoop Dancer

Ontario Arts Council begins awarding targeted grants to Indigenous and people of colour arts professionals through its Access and Career Development program ZA

2007

Pervers/Cité, the radical queer counter-response to Divers/Cité, the city's corporate Pride, established (Montreal) SLPH

Prairie Artsters blog established by Amy Fung MH

Liz Park's exhibition *Limits of Tolerance: Re-Framing Multicultural State Policy* at the Morris and Helen Belkin Art Gallery (Vancouver). Key names: Dana Claxton, Stan Douglas, Laiwan, Paul Lang and Zachary Longboy, Âhasiw Maskêgon-Iskwêw, Anne Ramsden, Ruby Truly, Hanery Tsang, Paul Wong

Double Date performance event produced by AKA and SAVAC (Saskatoon and Toronto). Key names: Faisal Anwar, Deanna Cuthand, Gaya Ganeshan, Frances J. Ferdinands, Noni Kaur, Rosina Kazi, Jackie Latendresse, Laura Margita, Jesus Mora, Megan Morman, Nick Murray, Tazeen Qayyum, Mehta Youngs TLC

Michèle Pearson Clarke wins Inside Out's Best Canadian Female award for *Black Men and Me*

2008

Canadian Women Artists History Initiative (CWAHI) established (Montreal). Key names: Janice Anderson, Kristina Huneault, Melinda Reinhart

Queer Between the Covers bookfair established by the Qteam collective (Montreal) JL

Art Institutions and the Feminist Dialectic conference hosted by the Ontario Association of Art Galleries (OAAG). Key names: Carla Garnet, Christine Conley, Pamela Edmonds, Johanna Householder, Kristina Huneault, Sophie Hackett, Suzy Lake, Emelie Chhangur, Allyson Mitchell, Carmen Mörsch ZV

Gender Alarm! Nouveau féminismes en art actuel group exhibition at La Centrale. Key names: The After Party, Arwa Abouon, Anthea Black, Lynne Chan, Insoon Ha, Emily Laliberté, Noam Lapid, Jacinthe Loranger, Will Munro, Fereshteh Toosi ML

Persistence: An Archive of Feminist Practices in Vancouver exhibition at Artspeak

WACK! Art and the Feminist Revolution is presented at the VAG, stimulating a moment of feminist dialogue in Vancouver through official and unofficial events FFG, GM

Fantasia Affair queer cabaret performance events (Winnipeg)

Hot Topic vs. Wednesday Lupypciw, at the ARTery (Edmonton), as part of Exposure: Queer Arts and Culture Festival. Key names: Amy Fung, Kirsten McCrea AF

MAWA holds Art Building Community conference. Key names: Roewan Crowe, Robin Pacific

Live in Public: The Art of Engagement conference, hosted by Grunt Gallery

First Trans March in Toronto, self-organized by the trans community despite Pride's
 non-cooperation, is allowed to march but is relegated to the sidewalk
Pip Day begins tenure as director and curator at SBC Gallery of Contemporary Art MH

2009

No More Potlucks journal established by a volunteer collective. Key names: Mél Hogan,
 Dayna McLeod, M-C MacPhee
Third Space Art Projects established by Pamela Edmonds and Sally Frater (Toronto)
Daphne Odjig is the first Indigenous woman to have a retrospective exhibition at the NGC
Thrift Store Cowboy exhibition and performances at Red Shift, curated by Cindy Baker
Artivistic organizes their last biennial event, TURN*ON, a three-day gathering on sexuality,
 technology, and politics SLPH
Publication of *C Magazine* 104, "Contemporary Feminisms"
Tamara Toledo begins tenure organizing public programs at Prefix ICA (until 2011) SF

2010

Feminist Art Gallery (FAG) established by Allyson Mitchell and Deirdre Logue (Toronto)
 SB, ACh, MPC, RLC, GM, MMP, KRO, SS
Howl! Arts Collective established (Montreal) SLPH
Jamelie Hassan's exhibition *At the Far Edge of Worlds* at the Morris and Helen Belkin Art
 Gallery (Vancouver). Includes the billboard work *Because there was then there wasn't
 a city of Baghdad* NM
Close Encounters: The Next 500 Years, co-produced by the Winnipeg Art Gallery, Plug In
 ICA, and Urban Shaman. Key names: Shuvinai Ashoona, Marie Anne Barkhouse,
 Rebecca Belmore, Faye HeavyShield, Candice Hopkins, Steven Loft, LeeAnn Martin,
 Kent Monkman, Skawennati, Marie Watt, Jenny Western MG
Femmes artistes. L'éclatement des frontières exhibition at the Musée national des beaux-
 arts du Québec TSG
Pandora's Box exhibition, curated by Amanda Cachia, at the Kitchener-Waterloo Art
 Gallery. Key names: Laylah Ali, Ghada Amer, Shary Boyle, Amy Cutler, Chitra Ganesh,
 Wangechi Mutu, Annie Pootoogook, Leesa Streifler, Kara Walker, Su-en Wong SF
Extra–Curricular: Between Art and Pedagogy organized by Maiko Tanaka at the Justina
 M. Barnicke Gallery. Key names: Annette Krauss, Carmen Mörsch, Janna Graham,
 La Lleca MT
Skeena Reece represents Canada at the 17th Biennale of Sydney FFG
Cultural Pluralism in the Arts Movement Ontario (CPAMO), a Toronto-based arts-service
 organization, holds its first Town Hall on Pluralism in Performing Arts
First Trans March as part of Vancouver Pride
Sheila Sampath begins tenure as editor of *Shameless* magazine
Performing Feminist Culture conference, organized by WIAprojects, OCAD University's

Diversity and Equity and Faculty of Art, and XSPACE Cultural Centre. Key names: Erika DeFreitas and Leena Raudvee, Spy Dénommé-Welch, Stephanie Fielding, Maggie Flynn, Leah Houston, Carolyn Jervis, Catherine McGowan, Vicky Moufawad-Paul, Jane Ngobia, Kalli Paakspuu, Pam Patterson, Bev Pike, Farah Yusuf

Publication of Charmaine Nelson's book *Representing the Black Female Subject in Western Art* SF

2011

About a Bicycle, Marxist-feminist reading group, established (Vancouver) DR

Adaka Cultural Festival established (Whitehorse) JFN

Réseau québécois en études feministes established by the Université du Québec à Montréal TSG

Vancouver Indigenous Media Arts Festival established JFN

Optica exhibition *Archi-féministes*. Key names: Sophie Belair Clément, Olivia Boudreau, Marie-Ève Charron, Sorel Cohen, Vera Frenkel, Raphaëlle de Groot, Clara Gutsche, Marie-Josée Lafortune, Suzy Lake, Emmanuelle Léonard Claire Savoie, Jana Sterbak, Thérèse St-Gelais ABe, TSG

M: Stories of Women, exhibition of Shelley Niro's work curated by Sally Frater at Gallery 44

La Centrale establishes the first edition of Prix Powerhouse Prize, a $5,000 cash prize awarded to a self-identified woman artist in mid-career or later, based on peer-nomination and jury. Key names: Catherine Bolduc, Marie-Claude Bouthillier Marie-France Brière, Manuela Lalic, Renée Lavaillante, Dayna MacLeod, Thérèse Mastroiacovo, jake moore, Aude Moreau, Monique Moumblow, Nadia Myre, karen elaine spencer

FUSE Magazine launches its States of Coloniality series, under the direction of editor Gina Badger MG

Rémy Huberdeau wins Inside Out's Best Canadian Film or Video for *Home of the Buffalo*

Srimoyee Mitra begins tenure at the Art Gallery of Windsor SS

2012

2qtpocmontréal, now Qouleur, established (Montreal) by Kama La Mackerel and Elisha Lim. Arts festival showcasing the work of QTPOC artists SLPH, KLM, JL, ML

Dames Making Games established (Toronto) MT

Feral Feminisms journal established, first issue published in 2013. Key names: Danielle Cooper, Ela Przybylo, Sara Rodrigues

Perfomatorium: Festival of Queer Performance established (Regina) by Queer City Cinema

The STAG Library, a semi-public, semi-private lending and reference library run out of the home of Aja Rose Bond and Gabriel Saloman, established by the STAG (Strathcona Art Gallery) (Vancouver) (until 2015)

TWAT Fest (Trans Women's Arts Toronto), the first dedicated trans women's arts festival,

established by Morgan M. Page (Toronto). Key names: Raphaëlle Frigon, Isz Janeway, Kiley May, Mirha-Soleil Ross, Morgan Sea

Unapologetic Burlesque established by Kumari Giles (Vena Kava) and Shaunga Tagore (Scorpio Rising) (Toronto) ACh

Videofag established by Jordan Tannhill and William Ellis (Toronto) LP, MMP

28 Days: Reimagining Black History Month at the Justina M. Barnicke Gallery (w/panel discussion). Key names: Pamela Edmonds, Sally Frater NM

Nina Arsensault presents *40 Days 40 Nights: Working Towards a Spiritual Experience* as part of SummerWorks (Toronto) MMP

Launch of *Walking With Our Sisters* project and travelling exhibition. Key names: Kim Anderson, Tracy Bear, Rebecca Beaulne-Stuebing, Christi Belcourt, Shane Belcourt, Tony Belcourt, Nathalie Bertin, Maria Campbell, Sherry Farrell Racette, Maria Hupfield, Tanya Kappo, Tara Kappo, Christine King, Erin Konsmo, Kara Louttit, Tracie Louttit and Jodi Stonehouse, Laurie Odjick, Tracey Pawis, Lisa Periard, Ryan Rice, Doreen Roman, Gregory A. Scofield, Lisa Shepherd, Karon Shmon JFN

Wikimedia NYC organizes the first Art and Feminism Wikipedia Edit-a-Thon at Eyebeam Art and Technology Center in New York, with satellite locations worldwide, including at the Eastern Bloc in Montreal (2014) and the Art Gallery of Ontario in Toronto (2015) GM

Access Gallery hosts FAG satellite programming (Vancouver). Key names: Sharlene Bamboat, Chase Joynt, Alexis Mitchell, Heidi Nagtegaal, Valerie Salez AF

Ladies Invitational Deadbeat Society celebrates Joyce Wieland Day as part of their Incredisensual Panty Raid Laff Along at The New Gallery's John Snow House (Calgary) AF

No More Apologies: Queer Trans and Cis Women Coming/Cumming Together conference (Toronto). Part of Sex Talk, a project of Planned Parenthood Toronto in partnership with the 519 Community Centre and Sherbourne Health Centre. Key names: Morgan M. Page, Mara Pereira, Savannah Garmon, Rebecca Hammond, Kate Klein

Transforming Feminisms: Trans Access conference at Trent University (Peterborough)

Publication of *Interpellations: Three Essays on Kent Monkman* by the Leonard and Bina Ellen Art Gallery

La Centrale publishes *Féminismes Électriques*, edited by Leila Pourtavaf, a critical review of exhibitions and programming at La Centrale from 2000 to 2010 SB, TSG

Publication of Kristina Huneault and Janice Anderson's *Rethinking Professionalism: Women and Art in Canada, 1850–1970* by McGill-Queen's University Press

Michelle Jacques begins tenure as chief curator at the Art Gallery of Greater Victoria

Is There a Queer Feminist Art History? panel, Universities Art Association of Canada Conference held at Concordia University (Montreal). Key names: Erin Silver, Amelia Jones

Centre for Feminist Pedagogy established (Montreal), summer workshops presented at Skol in summer of 2013. Key names: Jennifer Kennedy and Ania Wroblewski

Idle No More movement established (Saskatoon) during a teach-in held in response to the Harper government's introduction of Bill C-45, and later spreads across Canada and the United States. Key names: Jessica Gordon, Sylvia McAdam, Sheelah Mclean, Nina Wilson

2013

The Black Lives Matter movement established by Alicia Garza, Patrisse Cullors, and Opal Tometi; movement spreads to Canada and is particularly active in Toronto

Feminist Art Conference (FAC) established by Ilene Sova (Toronto) ACh, MMP, LP

Passenger Art blog established by Reilley Bishop-Stall and Natalie Bussey MH

Allyson Mitchell's *KillJoy's Kastle* is presented as an offsite project of the AGYU, followed by a lively autonomous critical conversation on social media GM, MPC

They Made a Day Be a Day Here, curated by Amy Fung, for the Art Gallery of Grande Prairie, subsequently tours to The Mendel Art Gallery (Saskatoon) and The School Of Art Gallery (Winnipeg) (w/publication and panel). Key names: Amalie Atkins, Heather Benning, Jennifer Bowes, Tammi Campbell, Brenda Draney, Sarah Anne Johnson, Wednesday Lupypciw, Maria Madacky, Mary-Anne McTrowe, Divya Mehra, Jennifer Stillwell, Leesa Streifler AF

articule's Fabulous Committee, mandated to develop anti-oppression strategies for the gallery, organizes the first annual Montreal Monochrome? conference. Key names: Pierre Beaudoin, Charmaine Nelson, Karen Tam JL

FUSE publishes their last in-print issue, featuring a new edition of the Ladies Invitational Deadbeat Society (LIDS) poster, *Do Less with Less / Do More with More* (2012–13) AF

La Centrale celebrates its fortieth anniversary with a programming series, including *Archives Cannibales*, *Loom Music*, *Homage to the City of Women: Leaves of Gold*, *Hot Topic Redux*, *Performative Feast*, and a series of research residencies

Maggie Flynn begins tenure as director at Whippersnapper and Alvis Choi begins working with the gallery ACh, MT

cheyanne turions begins a year-long curatorial residency at SBC Gallery of Contemporary Art SS

Largest trans march in world history at Toronto's Pride

GUTS Canadian Feminist Magazine established. Key names: Nadine Adelaar, Cynthia Spring, Natalie Childs, Rebecca Blakey

2014

Publication of Anne Dymond's article "Gender Counts: A Statistical Look at Gender Equity in Canadian Art Institutions" in MAWA's newsletter. Amongst other statistics, her research shows that between 2000 and 2010 no major gallery across the country reached even 40 percent solo shows by artists gendered female AC

#BUSH Rezidency established by Tania Willard and the New BC Indian Welfare Society (Neskonlith, Secwepemculecw) JFN

Transgender Studies Quarterly journal established

De la parole aux actes/Actions Must Match Words group exhibition at the Musée d'art contemporain des Laurentides, curated by Anne-Marie St-Jean Aubre. Key names: Nadège Grebmeier Forget, Maggie Groat, Sharon Hayes, Faye HeavyShield, Maria Hupfield and Scott Benesiinaabandan, Sophie Jodoin, Michelle Lacombe, Leisure

(Susannah Wesley and Meredith Carruthers), Alanis Obomsawin and le Wapikoni
Mobile (Saint-Jérome, Kanien'kehá:ka and Algonquin territory) IB

Divya Mehra's exhibition *Pouring Water on a Drowning Man* at Georgia Scherman
Projects (Toronto) MPC

Kwe: Photography, Sculpture, Video, and Performance by Rebecca Belmore, curated by
Wanda Nanibush, at the Justina M. Barnicke Gallery. Includes her performance *One
thousand One hundred & eighty One*, dedicated to 1,181 missing and murdered
Indigenous women NM, MPC

In honour of MAWA's thirtieth anniversary, visual arts centres throughout Manitoba
present twenty-nine exhibitions and events featuring Manitoba and Indigenous women
artists, including *MAWA: Celebrating 30 Years of Women's Art* at the Winnipeg Art
Gallery

Stage Set Stage: On Identity and Institutionalism performances, screenings, talks, and
workshops at SBC Gallery of Contemporary Art (Montreal). Curated by Barbara
Clausen. Key names: Pablo de Ocampo, Katrina Daschner, Andrea Geyer, Sharon Hayes,
Maria Hupfield, Oliver Husain, Adam Kinner and Jacob Wren, Dorit Margreiter, Josiah
McElheny, Jeanne Randolph, Monique Régimbald-Zeiber, Anne-Marie St-Jean Aubre,
cheyanne turions, Wu Tsang MH

Trans Time: Time for Trans Visibility in Contemporary Art*, curated by Ianna Book,
Virginie Jourdain, Marie-Claude Olivier. Key names: Sam B. Atman and Bruce, Ianna
Book, Alec Butler, Heather Cassils, J'Vlyn D'Ark, Zackary Drucker, Rhys Ernst,
Raphaëlle Frigon, Yishay Garbasz, Kris Grey, Rémy Huberdeau, Kama La Mackarel,
JJ Levine, Amos Mac, Leon Mostovoy, Morgan Sea, C.W. and Z.F. ML

Wendy Coburn: Anatomy of a Protest exhibition at the Justina M. Barnicke Gallery MPC

We Won't Compete, the second iteration of the FAG's Feminist Art Collection, at the Art
Gallery of Windsor. Key names: Abstract Random, Sonja Ahlers, Eleanor Bond, Allyson
Clay, Erika DeFreitas, Servulo Esmeraldo, Andrew Harwood, Jesi The Elder, Hannah
Jickling, Margaret Lawrence, Rita Letendre, Johnson Ngo, Bodo Pfeifer, Adee Roberson,
Arthur Secunda, Fiona Smyth

Moving Trans* History Forward symposium hosted by the University of Victoria's
Transgender Archives

The State of Blackness: From Production to Presentation conference at the Harbourfront
Centre (Toronto). Key names: Lillian Allen, Wayde Compton, Julie Crooks and
Dominique Fontaine, Erika DeFreitas, Pamela Edmonds, Andrea Fatona, Honor
Ford-Smith, Camille Isaacs, Michelle Jacques, Betty Julian, Olivia McGilchrist, Heidi
McKenzie, Charmaine Nelson, Abdi Osman, Sheila Petty, Rema Tavares, Rinaldo
Walcott, Ellyn Walker MPC

MAWA hold their thirtieth anniversary conference, Who Counts? A Feminist Art Throw-
down. Key names: Sharlene Bamboat, Joan Borsa, Sigrid Dahle, Amy Fung, Seema Goel,
Stephanie Poruchnyk-Butler, Cathy Mattes, Kristin Nelson, Praba Pilar, Dominique Rey,
Jennifer Smith, Sheila Spence, Diana Thorneycroft SB

Revue Possibles publishes special issue, *Les Féminismes d'hier à aujourd'hui* ABe

Elisha Lim awarded Inside Out's Emerging Canadian Artist award for *100 Crushes Chapter 6: They*

Trish Salah is awarded the Lambda Literary Award for Transgender Fiction for the 2013 edition of her book *Wanting in Arabic* ABl

2015

Media Queer Database Canada-Quebec, online database of queer media artists, established

ReMatriate, photo campaign by Indigenous women opposing appropriation of their cultural identities, established. Key names: Claire Anderson, Angela Code, Kelly Edzerza-Babty, Jeneen Frei Njootli, Anna McKenzie, Avis O'Brien, Raven Potchka, Peyton Straker, Taylor Whale JFN

Arise, presented by Eventual Ashes and directed by Catherine Hernandez and Gein Wong, at Buddies in Bad Times for Toronto Pride. Key names: Rodney Diverlus, Troy Jackson, Rehana Tejpar, Kai Cheng Thom aka Lady Sin Trayda, Akhaji Zakiya ACh

An Annotated Bibliography in Real Time: Performance Art in Quebec and Canada research exhibition and speaker series (Montreal). Key names: Sylvette Babin, Jade Boivin, Emmanuelle Choquette, Barbara Clausen, Tim Clark, Sylvie Cotton, Doyon/Demers, Rachel Echenberg, Michelle Lacombe, Tanya Lukin Linklater, Tanya Mars & Johanna Householder, Clive Robertson, Alain-Martin Richard, Sonia Pelletier, Joëlle Perron-Oddo, Julie Riendeau, Guy Sioui Durand, Julie-Andrée T. ML

Feminist Hard On: A Double Zine Baby Shower for the first issues of Bonerkill Collective's *Weapon* and *Theory Boner*. Co-presented by the Art Gallery of Ontario and FAG DR

Missing Justice benefit show at La Sala Rossa (Montreal), organized by Howl Arts Collective

Twenty Years of Writing thru "Race" symposium at the AGO (Toronto)

Canadian Art publishes "Canada's Galleries Fall Short: The Not-So Great White North," by Alison Cooley, Amy Luo, and Caoimhe Morgan-Feir, on their website TH

Publication of La Centrale's fortieth anniversary catalogue, *Feminist Impact on Contemporary Art*

Publication of *C Magazine* 126, "Predecessors," includes many nods to feminist inheritance, including Liz Park honouring Cornelia Wyngaarden and Maiko Tanaka on feminist citation practices

BIBLIOGRAPHY

Broadhurst, Maura Lesley. "Strategic Space: Toward a Genealogy of Women Artists' Groups in Canada." MA thesis, Concordia University, 1997.

"Chronology." In *MAWA: Culture of Community*, edited by Vera Lemecha, 95–133. Winnipeg: MAWA, 2004.

Cowan, T.L. "Cabaret Performance and the Social Politics of Scene-Making: A Little Show That We Would Do for Our Riff-Raffy Freaky Friends." In *More Caught in the Act: An Anthology of Performance Art by Canadian Women*, edited by Johanna Householder and Tanya Mars. Toronto: YYZ Books, 2016.

Dykhuis, Claire. "From Protests to Tea Parties: A Survey of Feminist Organizing at NSCAD." Unpublished research report, 2012.

Fanian, Sahar. "Building Toronto's Feminist Film Scene: A Collaborative Effort." *Local Film Cultures: Toronto* (January 2015). https://localfilmculturestoronto.wordpress.com/building-torontos-feminist-film-scene-a-collaborative-effort/.

Lerner, Loren Ruth. *Canadian Film and Video: A Bibliography and Guide to the Literature.* Toronto: University of Toronto Press, 1997.

Namaste, Vivian. "Beyond Image Content: Examining Transsexuals' Access to the Media." In *Sex Change, Social Change: Reflections on Identity, Institutions, and Imperialism*, 2nd ed., 51–74. Toronto: Canadian Scholars' Press, 2011.

Roy, Marina. "Corporeal Returns: Feminism and Phenomenology in Vancouver Video and Performance 1968–1983." *Canadian Art* 18, no. 2 (2001): 58–65.

Salah, Trish. "Notes toward Thinking Transsexual Institutional Poetics." In *Trans/acting Culture, Writing, and Memory: Essays in Honour of Barbara Godard*, edited by Eva C. Karpinski, Jennifer Henderson, Ian Sowtow, and Ray Ellenwood, 168–89. Waterloo, ON: Wilfrid Laurier Press, 2013.

Simpson, Robin. "Canadian Art: 1847–1985." In *Oh, Canada: Contemporary Art from North North America*, edited by Denise Markonish, 54–62. Cambridge, MA: MASS MOCA and MIT Press, 2012.

Wark, Jayne. "The Origins of Feminist Art." In *Radical Gestures: Feminism and Performance Art in North America*, 27–57. Montreal and Kingston: McGill-Queen's University Press, 2006.

Williams, Carol. "A Working Chronology of Feminist Cultural Activities and Events in Vancouver: 1970–1990." In *The Vancouver Anthology*, 2nd ed., edited by Stan Douglas, 173–215. Vancouver: Or Gallery, 2011.

Except where other otherwise noted, photographs are courtesy of the artist. Every effort has been made to credit the photographers; anyone with more information is invited to contact the publisher so it can be included in subsequent editions.

Contributors

JANICE ANDERSON is one of the founding members of the Canadian Women Artists History Initiative at Concordia University. The organization creates online resources for feminist research, organizes conferences, and publishes feminist texts.

GINA BADGER is a kitchen witch who makes her living as an artist and editor. Born and raised in Edmonton, Badger is a settler of Norman, Huguenot, and Anglo-Saxon ancestry living in Anishinaabe and Haudenosaunee territory, in Toronto.

NONI BRYNJOLSON is a writer and curator from Winnipeg. She is a PhD candidate in art history, theory, and criticism at the University of California, San Diego, and an editorial collective member of FIELD: *A Journal of Socially Engaged Art Criticism*.

AMBER CHRISTENSEN is a researcher, librarian, and independent media arts/moving image curator. She holds an MA in cinema and media studies from York University and a master's of library and information studies from the University of British Columbia. She has curated screenings and exhibitions around western Canada and Toronto.

KARIN COPE is a poet, sailor, photographer, scholar, rural activist, blogger, and an associate professor at NSCAD in the Division of Art History and Contemporary Culture. Her publications include scholarly works, popular histories, short stories, policy papers, and poetry; her artworks include photographs, installations, guerrilla theatre, and online works.

LAUREN FOURNIER is a writer, artist, and independent curator based in Toronto. She is a PhD candidate at York University where she focuses on "auto-theory" as contemporary feminist practice across media. http://laurenfournier.net.

AMY FUNG is currently a Toronto-based writer and curator working across a multitude of artistic disciplines and social genres. Fung publishes nationally and internationally in journals, magazines, monographs, and artist projects, and has been the principle organizer for multifarious events, exhibitions, and projects.

KRISTINA HUNEAULT is professor of art history at Concordia University in Montreal, a co-founder of the Canadian Women Artists History Initiative, and a former Concordia University Research Chair. Her writings on art, gender, and colonialism combine close looking and detailed historical research with theoretical questions about identity, difference, and the formation of the self.

ALICE MING WAI JIM is associate professor of contemporary art history at Concordia University in Montreal. She is founding co-editor of the scholarly journal *Asian Diasporic Visual Cultures and the Americas* (Brill). Jim received the second annual Centre de documentation d'Artexte Award in 2015 for research in contemporary art.

TANYA LUKIN LINKLATER's performance collaborations videos, photographs, and installations have been exhibited nationally and internationally. She is compelled by relationships between bodies, histories, poetry, pedagogy, Indigenous conceptual spaces (languages), and institutions. She is a doctoral student at Queen's University and has published in various publications in Canada.

SHEILA PETTY is professor of media studies at the University of Regina. She has written extensively on issues of cultural representation, identity, and nation in African and African diasporic screen media, and has curated film, television, and digital media exhibitions for galleries across Canada. She is the author of *Contact Zones: Memory, Origin and Discourses in Black Diasporic Cinema* (2008).

KATHLEEN RITTER is an artist based in Vancouver and Paris. Her art practice broadly explores questions of visibility, especially in relation to systems of power, language, and technology. Ritter has organized exhibitions in Canada and abroad. Her writing on contemporary art has appeared in numerous journals and catalogues.

DANIELLA SANADER is a writer and arts worker who lives in Toronto. In her work, she regularly explores associative and speculative modes for thinking and writing about contemporary art, ones that emphasize queer/feminist frameworks, messy feelings, and embodied experience. She holds an MA from McGill University, and has written essays and reviews for arts publications and galleries across Canada.

THÉRÈSE ST-GELAIS is a professor of art history at l'Université du Québec à Montréal (UQAM). Her curatorial work and publications focus on feminist art production and its representations of sexual and gendered identities.

CHEYANNE TURIONS is a curator and writer based in Toronto. She sits on the board of directors for Kunstverein Toronto, the Editorial Advisory Committee for *C Magazine*, and the Education and Community Engagement Committee at the Art Gallery of Ontario. She is the director of No Reading After the Internet and the artistic director at Trinity Square Video.

ELLYN WALKER is a curator and writer based in Toronto. Her work explores intersectional questions of settler colonialism and anti-blackness in the arts. Her projects have been presented by the Art Gallery of Mississauga, Prefix ICA, ImagineNATIVE, and the Art Gallery of Ontario. Her writing has been widely published in books, academic journals, and art magazines, and by galleries and museums.

JAYNE WARK is professor in art history and contemporary culture at the Nova Scotia College of Art and Design University. She is the author of *Radical Gestures: Feminism and Performance in North America* (2006) and co-author of *Traffic: Conceptual Art in Canada 1965–1980* (2012).

JENNY WESTERN is an independent curator, writer, educator, and mother living in Winnipeg, Manitoba. She is a member of the Brothertown Nation of Wisconsin and is of European, Oneida, and Stockbridge-Musee descent.